Treasures of Botanical Art

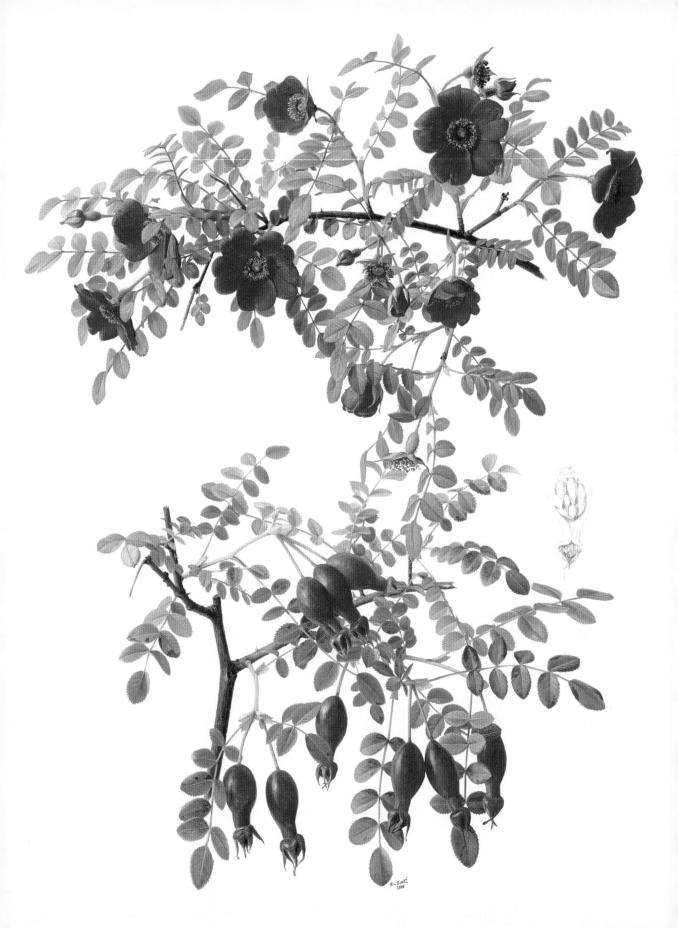

Treasures of Botanical Art

Icons from the Shirley Sherwood and Kew Collections

Shirley Sherwood and Martyn Rix

Kew Publishing
Royal Botanic Gardens, Kew

Revised edition published 2019
First published in 2008 by
Royal Botanic Gardens, Kew
Richmond, Surrey, TW9 3AB, UK
www.kew.org

ISBN 978 1 84246 663 6

British Library Cataloguing in Publication Data
A catalogue record for this book is available from the British Library.

Front cover: Paul Jones, Camellia 'Paul Jones Supreme' (page 97).
Back cover: Company School, Sunflower (page 66).
Frontispiece: Raymond Booth *Rosa moyesii* (see page 107)

Production management: Georgina Hills
Design and page layout: Nicola Thompson, Culver Design
Original design: Jeff Eden

For information or to purchase all Kew titles please visit shop.kew.org/kewbooksonline or email publishing@kew.org

Kew's mission is to be the global resource in plant and fungal knowledge, and the world's leading botanic garden.

Kew receives approximately one third of its running costs from Government through the Department for Environment, Food and Rural Affairs (Defra). All other funding needed to support Kew's vital work comes from members, foundations, donors and commercial activities, including book sales.

Printed and bound in Italy by L.E.G.O. S.p.A.

Contents

Preface

Dr Shirley Sherwood

It is now ten years since Sir David Attenborough opened the Shirley Sherwood Gallery of Botanical Art at Kew. I fervently hoped it would be a success and would prove a good forum for today's botanical artists as well as displaying some of Kew's many archival treasures.

Since 2008 we have had 50 exhibitions in the six galleries, usually lasting about five months. The shows have been widely sourced including the work of artists from Australia, Brazil, Italy, Japan, Thailand, USA, South Africa, and of course the British Isles. Twice a year there have been complementary shows from the Shirley Sherwood Collection, usually in one of the bigger galleries, occasionally filling all six exhibition spaces with larger shows like The Art of Plant Evolution. Usually there is a component from Kew's archives, involving the history of its gardens and plant collectors. It has been particularly revealing to show old and new works of botanical art side by side.

In 2018 we were able to count the one millionth visitor through the Gallery doors. The Shirley Sherwood Collection now numbers 1,000 works by 298 artists from 35 countries, collected since I started in 1990. I keep saying I must stop…

Botanical art today is flourishing as never before. The astonishing reach of the internet has made the subject so much more available. The success of the Worldwide Day of Botanical Art on 18 May 2018 amazed both me and the American initiators. The American Society of Botanical Artists proposed that individual countries selected 40 plant portraits of native species from their local artists. These were digitised to create a two and a half hour display of art from the 25 participating countries. This slide show was run in art galleries, exhibition halls and museums across the world, starting with New Zealand and ending with California. At Kew there were eight demonstrations of teaching and painting in the Shirley Sherwood and Marianne North galleries, plus talks, with 1,000 visitors staying in the galleries all day long. Many previously unknown artists emerged — who would have thought that Thailand would be such a star or that there were so many enthusiasts painting fungi from St Petersburg in Alexander Viazmensky's classes?

Many of the artists being shown in the Shirley Sherwood Gallery have made long journeys to visit the exhibitions and the happy buzz at the private views gives me great pleasure. I have always tried to meet the artists in my collection and really do know most of them. It's been a big part of my life and the Worldwide Day of Botanical Art has been a fitting way to celebrate ten years of the Shirley Sherwood Gallery.

Bronwyn Van de Graaff,
b. Australia 1964
Grass tree: *Xanthorrhoea johnsonii*
Watercolour on paper, 580 mm x 483 mm
Signed *B Van de Graaff*
Shirley Sherwood Collection

Xanthorrhoea johnsonii is found in Queensland and New South Wales. The leaves can be 1.8m long. The dried flower stalks were often used as firesticks.

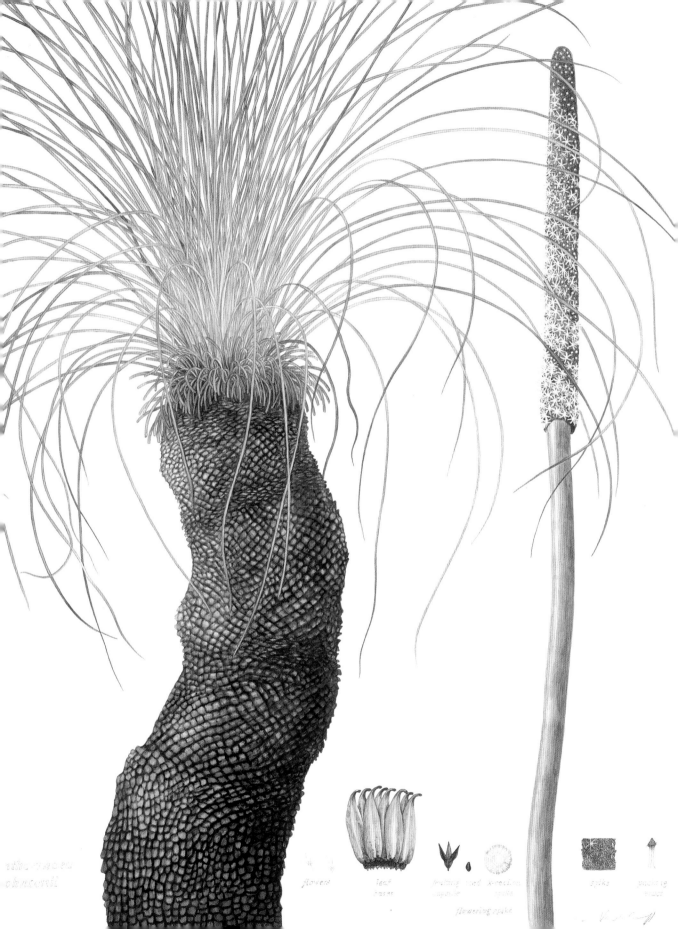

Xanthorrhoea
johnsonii

flowers leaf
 cross
 section

fruiting and bracts
 capsule

flowering spike

spike flowering
 spike

The Shirley Sherwood Gallery of Botanical Art

Dr Shirley Sherwood

Before 2008 there was no gallery in London, or indeed, in the world, available to view old or new botanical art easily at all times. A few commercial galleries had shows occasionally, with some, like Jonathan Cooper of Park Walk Gallery and The Tryon in London, encouraging and showing excellent and innovative work of contemporary artists. There were many important collections of old material in a wealth of superb museums – but it was necessary to write ahead so that the librarian could prepare for a visit, and it was also important to know what was wanted beforehand. Then there was the great problem of browsing. No one wants to let loose a potential thief amongst their precious treasures and it is extraordinarily difficult to detect a clever 'enthusiast' with a razor blade prepared to slice out the decorative frontispiece of an ancient volume. So it is easy to understand why there were difficulties in accessing the libraries such as Kew which has tens of thousands of loose paintings and a superb collection of botanical and horticultural books.

Clearly there was a crying need for a gallery where both contemporary and historical material could be shown on a permanent basis. Shortly after Peter Crane was appointed Director of Kew in 1999 I asked him why Kew had stopped exhibiting botanical art in Cambridge Cottage (where I had my first show in 1996). One reason was 'functions' when the building was closed to the public for private events such as weddings. Another was that the gallery was not adapted to showing watercolours for a prolonged time, as the windows were not shielded from UV light and there was no adequate temperature control. I told him how important I felt it was to have some place where old and new botanical art could be shown safely at Kew.

Dr Shirley Sherwood

In 2005 Peter Crane approached my husband asking him to support the building of a gallery to exhibit botanical art. My two sons and five grandchildren also became involved and in September 2006 the ground-breaking ceremony was held on a lovely autumn evening.

The Shirley Sherwood Gallery opened in 2008 and is specially designed to show watercolours safely. It is sited to the south of the Victoria Gate entrance of Kew close to the Marianne North Gallery. The two buildings are linked by a long gallery with a courtyard in between them, shaded by a maple tree.

Marianne North was a redoubtable Victorian lady who painted plants all over the world in an age when travel was a great deal slower and more difficult than today. She offered to build Kew a gallery to hang her paintings and provided enough works to cover the walls completely from floor to ceiling. As she worked with oils (surprisingly, on paper) her works were not so vulnerable to fading and the gallery

is lit naturally from skylights. She made it a condition of her gift that the paintings could not be rearranged in any way so her gallery today is an extraordinary example of Victorian style, unchanged since the 1880s.

In contrast the Shirley Sherwood Gallery is the latest, 'state of the art' building designed to show watercolours in ideal conditions. Even so the works on display are changed every three to six months.

The Link Gallery between the two buildings always contains a changing selection of contemporary botanical works from the Shirley Sherwood Collection and one major exhibition from the Collection generally fills the whole gallery each year.

As my collection grew in size I became concerned about what I might eventually do with it. By 2004 it had reached about 570 works and I was beginning to have trouble storing them when they were framed.

I discussed its future with my family and a number of colleagues and friends in the museum world. So few libraries actually show work on a regular basis that there was a real danger that it would be simply tucked away in some basement storage, never to be seen again. I felt it should remain in the UK as it has always been the centre of botanical art. But few of the major institutions exhibited their natural history treasures to the public, let alone collected contemporary botanical work or supported today's artists.

It was not that in an arbitrary way libraries refused to allow their works out but rather that, as most were watercolours on paper, the paintings were very vulnerable to light and temperature fluctuations. Works on vellum are particularly difficult as the natural skin can stretch or contract in quite an unnerving fashion, making mounting and display very difficult.

One exception was the Royal Botanic Gardens, Kew which has employed artists over many years to paint studies for *Curtis's Botanical Magazine* and for some beautifully illustrated monographs. Kew had also shown its collection by Margaret Mee (1909-1988) in various venues in the USA and in Paris. I decided to loan the Shirley Sherwood Collection to Kew.

The new gallery, designed by Walters and Cohen, London, consists of a central light-tight cube framed by four outer galleries which connects to the Marianne North building by the Link Gallery. Temperature is controlled by circulating air into an immense borehole beneath the building. Two of the outside walls are clad in UV resistant glass, the rest is faced with Portland stone. The overall appearance is of a pavilion, echoing in some ways the appearance of the Marianne North Gallery and reflecting Kew's glasshouses nearby. Of course the areas inside the glass walls cannot be used for hanging watercolours but form the reception area, leading to the light-tight galleries where the intensity of illumination is strictly controlled. Blinds will lower automatically on the outside of the glass panelled walls if the temperature gets too high.

Exhibitions in the Shirley Sherwood Gallery of Botanical Art

2008

APRIL–OCTOBER
Treasures of Botanical Art: Icons from the Shirley Sherwood and Kew Collections

NOVEMBER–MARCH 2009
Kew's Hidden Trees
Chelsea Physic Garden Florilegium

NOVEMBER–JULY 2009
Down Under: Contemporary Botanical Art from Australia and New Zealand – Shirley Sherwood Collection

2009

MARCH–JULY
The Power of Plants
Curtis's Botanical Magazine
In Search of Gingers – Sandy Ross Sykes

AUGUST–APRIL 2010
The Art of Plant Evolution – Shirley Sherwood Collection

2010

MAY–AUGUST
Old and New South American Botanical Art – Mutis Collection and Shirley Sherwood Collection

AUGUST–JANUARY 2011
Bulbmania – Kew Collection
Portraits of a Garden – The Brooklyn Botanic Garden Florilegium

AUGUST–JUNE 2011
Hidden Treasure: Bulbs – Shirley Sherwood Collection

2011

FEBRUARY–JUNE
From Eye to Hand – Kew artists
The Botanical Brush – Hampton Court Palace Florilegium
The Secret Garden – Leicestershire Society of Botanical Illustrators

JUNE–OCTOBER
The Smallest Kingdom – Liz Fraser
Losing Paradise – The American Society of Botanical Artists

JUNE–MARCH 2012
Plants in Peril – Shirley Sherwood Collection

NOVEMBER–APRIL 2012
Joseph Hooker: Botanical Trailblazer

2012

MARCH–APRIL
The Pressed Plant – Rachel Pedder-Smith

JUNE–APRIL 2013
A Natural Gallery: wood sculpture – David Nash
Portraits of Leaves and Fungi – Shirley Sherwood Collection

2013

MAY–SEPTEMBER
Rory McEwen: The Colours of Reality – Rory McEwen

MAY–JANUARY 2014
The McEwen Legacy: Artists Influenced by Rory McEwen – Shirley Sherwood Collection

OCTOBER–JANUARY 2014
Botanicals: Environmental Expressions in Art – The Ailsa & Isaac M. Sutton Collection
Black and White in Colour – Sue J. Williams and Sue Wickison

2014

FEBRUARY–AUGUST
Botanical Art in the 21st Century – Shirley Sherwood Collection and contemporary Italian artists
Overleaf – Susan Ogilvy

JANUARY–AUGUST
Magnolias – Barbara Oozeerally

AUGUST–JANUARY 2015
Inspiring Kew from the Kew Archives
The Pressed Plant: Herbarium Specimen Painting – Rachel Pedder-Smith
Inspired by Kew – Shirley Sherwood Collection

2015

FEBRUARY–AUGUST
Kew's Heritage Trees – Masumi Yamanaka
The Joy of Spring – Shirley Sherwood Collection
Flowering Bulbs and Tubers – Dutch Society of Botanical Artists

AUGUST–JANUARY 2016
Nature's Bounty: Fruit and Vegetable Portraits – Shirley Sherwood Collection and Kew Collection

2016

FEBRUARY–AUGUST
Brazil: A Powerhouse of Plants – Shirley Sherwood Collection
Brazilian artists in the Shirley Sherwood Collection
Margaret Mee: Portraits of Indigenous Plants

SEPTEMBER–MARCH 2017
Flora Japonica: Portraits of Indigenous Plants - Japanese artists
Japanese Artists – Shirley Sherwood Collection

2017

MARCH–SEPTEMBER
British Artists – Shirley Sherwood Collection
Joseph Hooker: Putting Plants in their Place

OCTOBER–MARCH 2018
Abundance: Dispersal of Seeds, Pods and Autumn Fruits – Shirley Sherwood Collection
Life in Death – Rebecca Louise Law
Plantae Amazonicae – Lindsay Sekulowicz

2018

MARCH–SEPTEMBER
The Florilegium: Royal Botanic Gardens, Sydney Celebrating 200 Years
Down Under II – Shirley Sherwood Collection
Plans and Plants: The Making of the Temperate House
Worldwide Day of Botanical Art, 18 May

OCTOBER 2018–MARCH 2019
Rankafu: Masterpieces of Japanese Woodblock Prints of Orchids
Botanical Theatre: the Art of Pandora Sellars – Pandora Sellars
A Legacy of Ancient Oaks – Mark Frith
Trees: Delight in the Detail – Shirley Sherwood Collection

The enduring importance of botanical painting

Professor Sir Peter Crane FRS

It is impossible to trace the beginning of botanical painting to a single moment, a single artist or a single piece. The illustration of plants for science, to help communication and to aid identification, goes back to the ancients. And representations of plants are ubiquitous in the art of the world's early civilisations. But toward the end of the Renaissance these two traditions came together. The result was a new art form, botanical painting: painting of botanical subjects that offers both beauty and accuracy. Painting that satisfies the spirit as well as the mind.

The artistry of Maria Sibylla Merian, from the mid-seventeenth century, is one example of the confluence of these two traditions. Her work epitomises the best of scientific illustration – keen and patient observation. But it is also wonderful art. She mastered her technique in the golden age of Dutch flower painting, when this genre was at its height. But then she took an intrepid journey to Surinam, and she was among the earliest Europeans to observe the plant and animal life of the tropics with care. The exquisite images that she created show the merger of her artistic skills with scientific acuity. They rank among the great early works of botanical painting and capture intricate details of plants and flowers, as well as different stages in the life histories of insects.

In the three centuries that separate Merian from the great botanical painters of today, other explorers and artists have travelled to the most remote places on our planet. They have returned with extraordinary botanical novelties, and many tens of thousands of new plant species. Knowledge of the variety of plant life now extends far beyond anything that eighteenth century naturalists, even Linnaeus himself, could possibly have imagined. But all through the centuries, human sensibilities and the needs of science have remained the same. The skills that can capture the essence of a plant, document its structure, and at the same time create a work of great beauty, are still in demand. They have not been displaced; not even by the most sophisticated of modern cameras.

Botanical painting remains as important today as it was three hundred years ago. It is still the medium of choice for professional botanists wishing to illustrate their scientific work. And it is particularly in demand when new species are to be described. A painting brings to life even the driest botanical description and the most uninspiring pressed specimen. But beyond science, botanical painting also connects to a broader public. It is an art form of which we have not yet tired. On the contrary, public appreciation continues to grow, not just for classical work from the eighteenth and nineteenth centuries, but for great contemporary botanical painting. The superb selection of works in this book presents some of the best of both: this collection is a testament to the enduring importance of botanical painting as well as its current flowering.

Maria Sibylla Merian,
b. Frankfurt, Germany 1647–1717
Polyanthus, cowslips and primroses
Watercolour on vellum, 340 mm x 265 mm
Signed *M. S. Merian*
From the Sir Arthur Church Collection
Kew Collection

Primula vulgaris, Primula veris and the hybrid, *P.* x *variabilis* are shown here. Primroses are found in different colours in eastern Europe, Turkey and Iran, pink, white and purplish flowers being as frequent as the usual pale yellow. Cowslips and polyanthus, hybrids between primrose and cowslip, were, and still are, popular garden plants. Polyanthus were raised from crosses between different coloured primroses and cowslips, and selected for unusual characters such as hose-in-hose flowers and doubles.

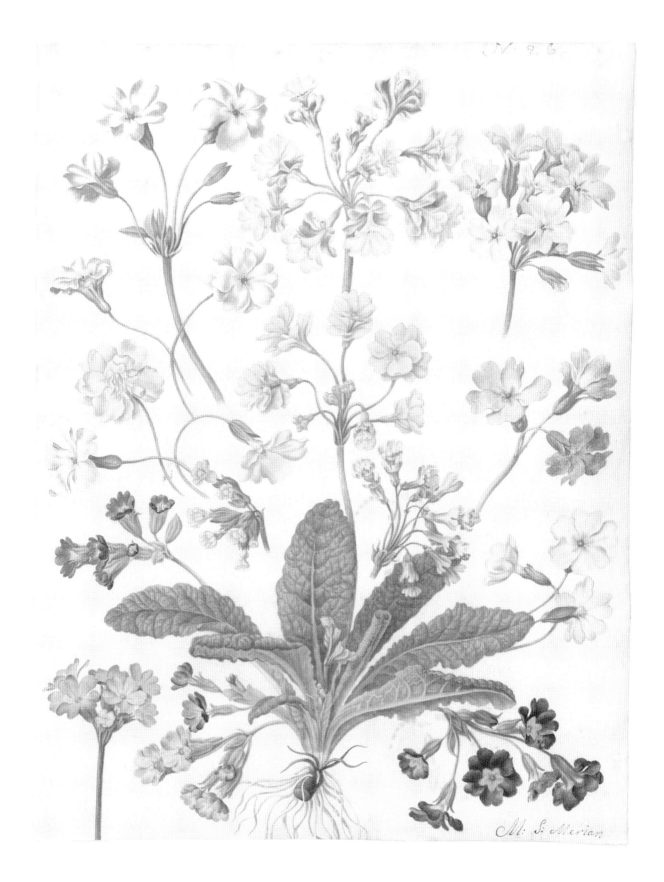

M. S. Merian

The Shirley Sherwood Collection

Dr Shirley Sherwood

I am always being asked how I became interested in botanical art and how I started my collection of contemporary works, which has now become the Shirley Sherwood Collection.

Perhaps surprisingly I know exactly when I became fascinated with nature. I was nine years old and had been given a large magnifying glass which had opened up a new world. I peered at plants as well as insects and became that most boring of children, a plant-spotter from the moving car. The car would brake and I would make a frantic dash into the countryside to find out if that flash of colour was a 'new' specimen – or just new to me.

I went on to read Botany at Oxford, where the emphasis was on genetics and the new study of ecology but I did have time to admire the original works of Ferdinand Bauer for the *Flora Graeca* and explore the botany department's other superb historical material. Years later I returned to look at them again, this time selecting them for an exhibition of Oxford's botanical treasures at the Ashmolean Museum in 2005.

After my degree I changed course, spending several years in the Sir William Dunn School of Pathology, Oxford and later worked as a scientist on a drug development programme that changed the course of gastric medicine, initiated by Professor James Black who was to go on to win the Nobel Prize for Medicine.

In the early 1980s I started the Orient-Express magazine, a publication about the hotels and trains developed by my husband James Sherwood. Looking for magazine material I attended a lecture at the Royal Horticultural Society (RHS) given by Dr Brinsley Burbidge. I tracked him down at Kew and persuaded him to write me an article.

In the late 1980s Dr Burbidge started organising exhibitions of botanical painting by the best contemporary artists in Britain. These shows were hung in Cambridge Cottage at Kew by Laura Giuffrida. The paintings were for sale and this is where I bought my first work for what has now become the Shirley Sherwood Collection.

It was July 1990 and this first important acquisition was by Pandora Sellars. It is a complex work with orchids emerging from a mass of tropical leaves which Burbidge appropriately called Botanical Theatre. At that time I had absolutely no idea, or intention, of starting a collection. My hope was simply to help Kew by purchasing from their gallery.

But then I became bitten by that extraordinary bug that attacks collectors, the bug that had made me amass fossils as a nine year old. I think too that my mother had

Pandora Sellars,
b. Herefordshire, England
1936–2017
Laelia tenebrosa
Watercolour on paper, 410 mm x 600 mm
Signed *Pandora Sellars '89*
Shirley Sherwood Collection

Laelia tenebrosa is an epiphytic orchid from Brazil, mainly in the state of Espiritu Santo, north of Rio. It grows wild in low-level tropical Atlantic rainforest, a habitat of especially rich biodiversity, now threatened by destruction.

The beautifully marked leaves are species of *Calathea*, also from Brazil.

This dramatic painting was the first acquisition for the Shirley Sherwood Collection, entitled 'Botanical Theatre' by Brinsley Burbidge when bought from Kew in July 1990.

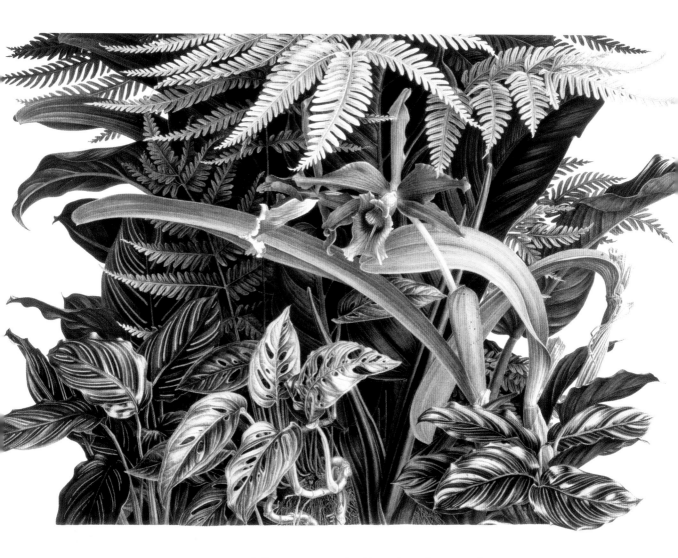

a great influence on me. I had been brought up in a home where she painted every day, generally in oils or watercolour; painting flowers beautifully and she was brilliant at catching a likeness in quick sketches.

I decided to commission plant portraits of my favourite plants that I had grown at our home at Hinton. These included Cedar of Lebanon and Swamp Cypress by Annie Farrer, *Streptocarpus* by Jo Hague, *Monstera deliciosa* by Coral Guest and the magnificent Blue Water Lily by Pandora Sellars.

I started looking at contemporary work on my travels and acquired a number of paintings by Margaret Mee in Rio. I now have 15. One of the most interesting from an historical point of view of the development of her work was her painting of the Cannon Ball Tree, her first work in the Amazon.

I started searching for painters in South Africa and Australia when I visited each year. I also discovered the Hunt Institute for Botanical Documentation at

Pittsburgh, which had exhibitions every few years with works from artists worldwide. James White, the Institute's enthusiastic and knowledgeable curator, was unfailingly helpful and we 'networked' on new artists.

By the mid-nineties I had amassed quite a number of works from a range of artists in the UK and abroad. I had not thought out how to progress further when I was visited at Hinton by James White, Brinsley Burbidge and Vicky Matthews. They proposed that I had an exhibition in Cambridge Cottage at Kew in 1996. This was quite a bombshell. It needed lists of works, framing, photographing and writing a book to accompany the show.

Over 40,000 visited the exhibition at Kew and the visitor book showed that many were astonished at the new group of artists and the remarkable quality of their work. *Contemporary Botanical Artists* became the first book on the subject and has been an excellent tool for aspiring artists and teachers and has been reprinted many times.

I felt there was a real current of interest and enthusiasm so followed up on the Hunt Institute's invitation to exhibit in Pittsburgh. Having committed to sending the bulk of the collection to the USA I started negotiating with other

Coral Guest, b. London, England 1955
Edible pomegranate
Two watercolour sketches, 668 x 523 mm
Signed *C Guest '99*
Shirley Sherwood Collection

The pomegranate, *Punica granatum*, is found wild on rocks and cliffs in north-eastern Turkey and southern Caucasia, but has been cultivated at least since the Bronze Age for the beautiful and delicious juicy pulp which surrounds the seeds. Biblical and classical references to delicious apples probably refer to pomegranates, not to edible apples which originated in central Asia.

These two sketches were used to demonstrate Coral Guest's watercolour technique in one of the first classes organised by Shirley Sherwood, at the Cipriani Hotel in Venice; the pomegranates were picked from the garden.

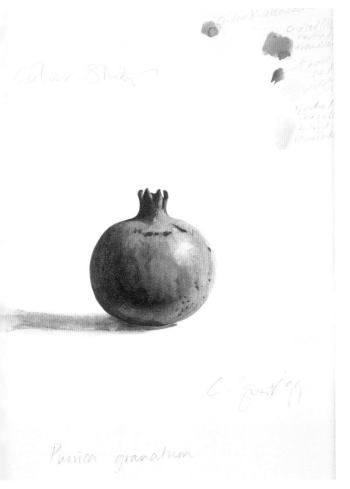
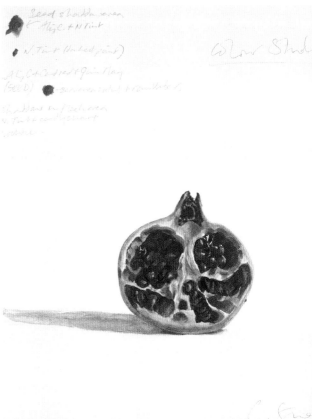

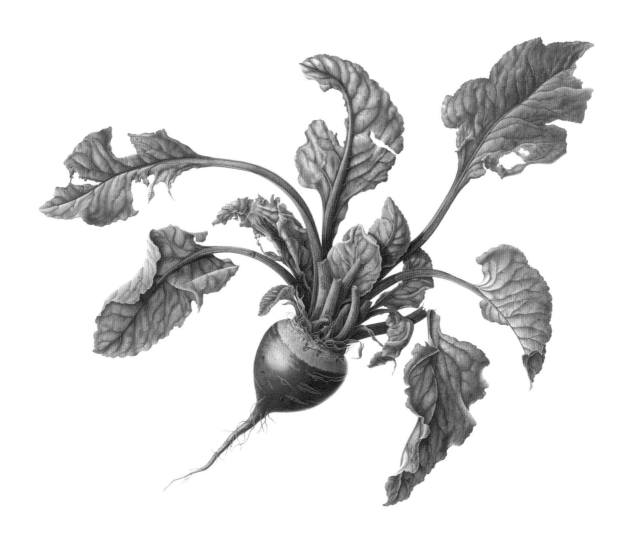

Susannah Blaxill, b. Armidale, New South Wales, Australia 1954
Beetroot
Watercolour on paper, 480 mm x 640 mm
Signed Artist's stamp SB (undated)
Shirley Sherwood Collection

Here Susannah Blaxill has made a spectacular and marvellously intense painting from a common beetroot.

venues in an attempt to show the paintings to a wider audience. Using *Contemporary Botanical Artists* as a visiting card I arranged for exhibitions in the Gibbes Gallery, Charleston, South Carolina, New Orleans Museum of Art and Wave Hill, New York, all in 1997.

The dynamic and innovative director of the National Galleries of Scotland, Sir Timothy Clifford, suggested I select about 30 larger works to open a new gallery in Edinburgh in 1997. This converted gymnasium became part of the Museum of Modern Art and I was delighted that these contemporary works by living artists were shown under such an august mantle.

In addition I introduced some botanical painting master classes in Orient-Express hotels in Charleston and New Orleans. I aimed to find excellent teachers and have the tuition balanced by trips to nearby gardens.

I organised three wide-flung shows in 1998 in the Ervin Gallery, Sydney, the Yasuda Kasai Museum of Art, Tokyo (the van Gogh 'Sunflowers' were hanging in the same gallery) and in Kirstenbosch National Botanical Gardens, Cape Town. In

Margaret Meen, b. Suffolk, England,
fl. 1775–1824
Dahlias
Watercolour on vellum, 410 mm x 335 mm
Kew Collection

Dahlias were introduced from Mexico, where they had been cultivated by pre-Columbian civilisations, in 1789 by Lord Bute. This painting shows the very first cultivars to be introduced.

Margaret Meen made hundreds of paintings of Kew plants and founded the journal *Exotic Plants from the Royal Gardens at Kew* in 1790; sadly it ceased publication after only two issues.

each I gave lectures and walk-throughs and urged my audience to support the excellent work being done locally.

My exhibition programme continued in the Millesgarden Museum in Stockholm and the Dixon Gallery and Gardens in 1999 and 2000 respectively. One of my most intriguing exhibitions was at the Marciana Library in Venice. This immensely imposing gallery stands parallel with the Doges Palace, overlooking the Piazetta of St Mark's.

The next shows were both in the States. Denver Art Museum is a splendid building whose ultra modern annexe designed by Daniel Libeskind was being constructed at that time. The show had been allocated eight galleries and it took careful planning to work out such a big hang. Intrigued and enthused by the Denver show Professor John Kress suggested that I brought it to the Smithsonian in Washington, where he modified the presentation into a sequence of works showing the evolution of plants. We both enjoyed the combination of art and science and the exhibition was a resounding success with over half a million visitors.

In 2005 I curated a remarkable show in the Ashmolean Museum, Oxford. I had long been anxious to show hidden-away treasures in the libraries of Oxford - and indeed the treasures of many other institutions with far too much to exhibit and

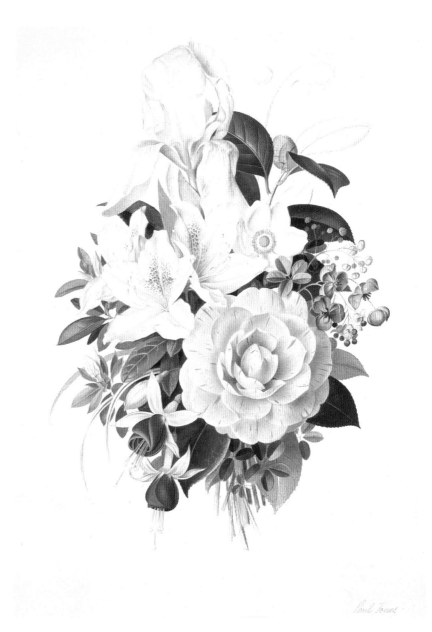

Paul Jones, b. Sydney, Australia
1921–1997
Flowers of Eryldene
Watercolour on paper, 410 mm x 310 mm
Signed *Paul Jones*
Shirley Sherwood Collection

Eryldene was the garden of Professor E.G. Waterhouse (1881–1977), professor of German at the University of Sydney and grower and breeder of camellias. The wonderful clarity and highlights in Paul Jones's painting particularly suited camellias, and he illustrated several books on them. Paul Jones frequently visited Eryldene, and painted camellias from the garden. One of Waterhouse's camellias is named after him.

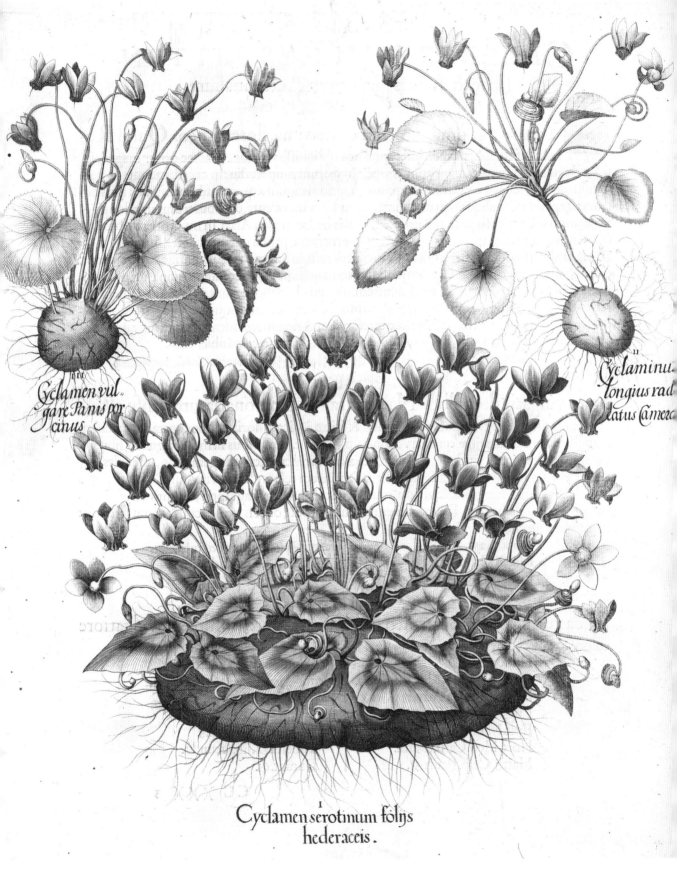

Cyclamen vul=
gare Panis por=
cinus

Cyclaminu.
longius rad
=catus Camera

Cyclamen serotinum folijs
hederaceis.

Francesca Anderson,
b. Washington DC, USA 1946
Cyclamen (*Cyclamen hederifolium*)
Pen and ink, 730 mm x 580 mm
Signed *Francesca Anderson 12/92*
Shirley Sherwood Collection

The autumn-flowering *Cyclamen hederifolium*, from Italy and the Mediterranean area grows in dry woods and crevices in rocks and old walls. Summer-flowering *Cyclamen purpurascens* is commoner in central Europe. Both species are sometimes called sowbread (*panis porcinus*), because the fleshy corms are eaten by pigs.

Francesca Anderson has faithfully portrayed the chaotic stems of the cyclamen, which, while they are growing, rely on the leaves for support. While painting a series of poisonous plants, Francesca felt that the cyclamen were spitting at her.

→

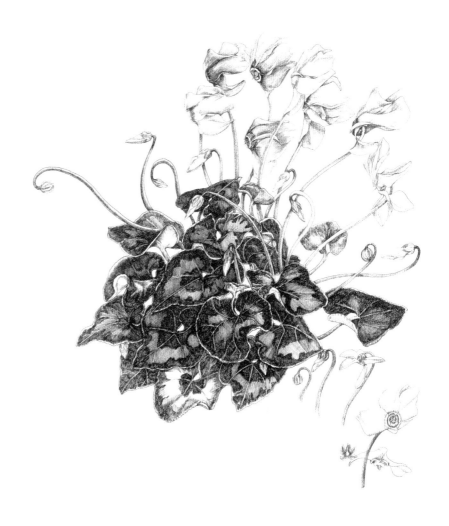

Basilius Besler, b. Nürnberg, Germany 1561–1629
Hortus Eystettensis (1613)

1. Cyclamen serotinum foliis hederaceis (*Cyclamen herderifolium*).
2. Cyclamen vulgare panis porcinus (*Cyclamen purpurascens*).
3. Cyclamen longius radicatis Camerary (*Cyclamen purpurascens*).

Copper engraving, hand-coloured in some copies. 570 mm x 460mm
Kew Collection

←

nowhere to show it. The final selection spanned over a thousand years as I matched and contrasted these old works with paintings from my contemporary collection. It was an elaborate and tricky jigsaw puzzle eventually called *A New Flowering: 1000 years of Botanical Art* with the first part of the title emphasising the current renaissance of botanical art shown in my collection.

I have made a real effort to show the Shirley Sherwood Collection in a variety of venues, from the scientific like Kew, the Hunt Institute and the Smithsonian to the predominately artistic like the National Galleries of Scotland's Museum of Modern Art and the art galleries of New Orleans and Denver. Yet in most of them botanical art had never been shown before. Indeed some of the curators were not even aware that there was something important happening in the field and had never contemplated exhibiting such material. Many were surprised at the enthusiastic response.

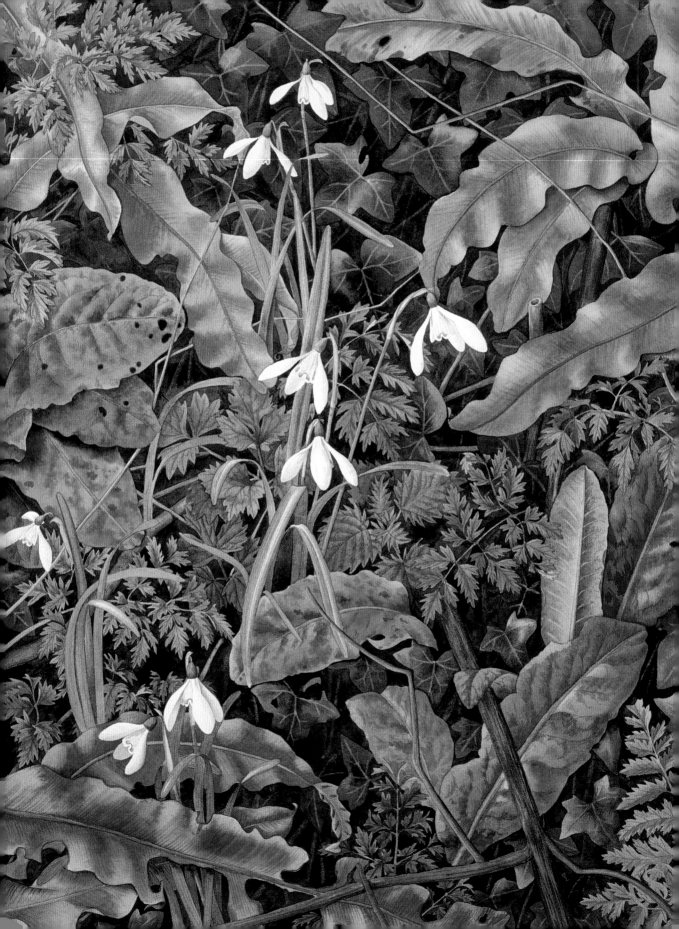

Botanical Art Today

Susan Ogilvy, b. Kent,
England 1948
Snowdrops, churchyard
Watercolour on paper, 457 mm x 360 mm
Signed with monogram 'S' inside O
Shirley Sherwood Collection

Snowdrops (*Galanthus nivalis*) and
Hart's tongue (*Asplenium
scolopendrium*) are part of a series in
which Susan Ogilvy painted the
flowers and leaves growing on one
bank throughout the season; this
shows the bank in January.

I started collecting contemporary botanical art in 1990. I was astonished at the quality of the work available from a relatively few artists in the UK, Australia, South Africa and Brazil. I bought works by Paul Jones, Pandora Sellars, Coral Guest, Annie Farrer and Susannah Blaxill as well as by Margaret Mee, Rory McEwen and Brigid Edwards. These artists still form the core of my collection but I have added numerous others from over 30 different countries, as widely scattered as Sweden, the Philippines, Mexico, Russia, India, Thailand and the United States.

I now have work from over 300 different artists and 1,000 works, forming a comprehensive sampling of the current field. I have concentrated on contemporary work and have met nearly all the artists. We have had a million visitors to the Shirley Sherwood Gallery since its opening in 2008, showing 50 exhibitions.

I am often asked why I have restricted myself to today's artists. The reason is that I felt it foolish to try to compete with the many institutions like the Royal Botanic Gardens, Kew, the Natural History Museums of London and Washington, the V&A or the Oxford and Cambridge libraries who all have wonderful collections of historical material. When I compare the remarkably high standards of many of the artists today with the past masters I am encouraged by the quality of the material in my collection and I feel that its tight time span will be interesting in the future, occurring as it does in this current renaissance.

Why is there this sudden surge of interest in botanical art? In the past it had always seemed a rather 'English' enthusiasm, associated with an aristocratic passion for gardening and the competitive growing of new, exciting specimens arriving from abroad. But today the artists come from all over the world and gardening has become an almost universal obsession. The constant emphasis on global warming has added an urgency to documenting endangered species and recording local flora which may be disappearing.

As a result a number of valuable florilegium societies have been formed, where artists donate a portrait of a listed plant in a botanical garden. At the same time a pressed specimen is prepared and the painting is conserved in the garden's library or archive. The first was initiated by the gifted teacher, Ann-Marie Evans, who started the Chelsea Physic Garden Florilegium. There are now flourishing florilegia in Brooklyn Botanical Garden, Highgrove (the garden of the Prince of Wales), Sydney Botanical Garden and most recently the Transylvania Florilegium (volume 1 published in 2018). Both Brooklyn and Sydney Florilegia have been shown at the Shirley Sherwood Gallery as well as wonderful material from Japan.

Another strand of the current renaissance has been the changing attitude of artists engaged in other fields. There has been a swing back to realism and I have met several artists who, disappointed by the teaching in art schools, have sought instruction in botanical art classes such as the ones I set up in various parts of the world years ago.

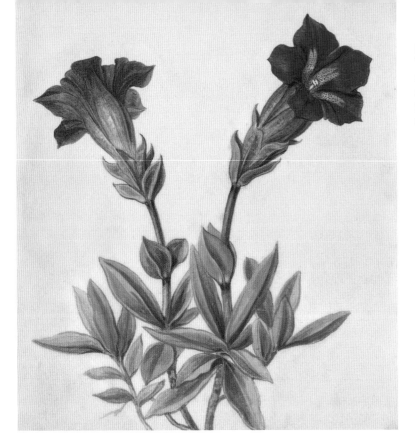

Simon Verelst, b. ?Antwerp,
The Netherlands 1644–1721
Gentiana acaulis

Watercolour on paper, 300 mm x 210mm
From the Sir Arthur Church Collection
Kew Collection

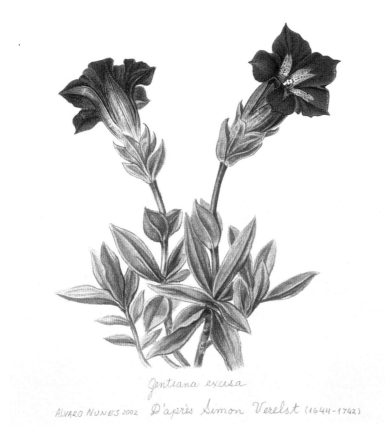

Gentiana excisa

ALVARO NUNES 2002 D'après Simon Verelst (1644-1742)

Álvaro Nunes, b. Anápolis,
Goiás, Brazil 1945
Gentiana excisa (D'apres Simon
Verelst 1644–1721)

Watercolour on paper, 300 mm x 210 mm
Signed *Álvaro Nunes 2002*
Shirley Sherwood Collection

The spectacular gentians of the
Gentiana acaulis group are a feature
of meadows in the Alps, and high
mountains as far south as the Sierra
Nevada in Spain, and east to
Romania and Albania. They flower in
late spring and summer. The one
shown here is an old garden variety,
which does not quite match any of
the wild species. Brazilian artist
Álvaro Nunes (see page 259) painted
this gentian as a homage to Verelst,
and it is an example of how
contemporary artists return to
historical images.

Criteria in collecting

From the start of my collecting in 1990 I have been anxious to acquire the best possible works from any particular artist. I certainly did not intend to build up a collection, but I grew fascinated with the range and quality of the paintings on display. I never chose the cheapest work because it was the least expensive, but tried to acquire the painting which I liked best. I valued good lay-out, superb technique, truthful colour and originality. I became interested in 'wall appeal' when I started showing my collection and would respond to a 'gut reaction' when I entered a gallery, as I often found the first painting that attracted me would be the one that I would eventually purchase. I did not restrict my collecting to watercolours but acquired pen and ink, oil on paper, work on vellum, pencil studies, egg tempera and works on glass.

Brigid Edwards, b. London, England 1940
Primulas

Watercolour over pencil on paper,
450 mm x 330 mm
Signed *Brigid Edwards* (undated)
Shirley Sherwood Collection

Primula (section Proliferae). *Primula ioessa* var. *subpinnatifida* (top left), *P. prenantha* (top right); (from left to right below) *P. japonica*, *P. pulverulenta*, *P. burmanica*, *P. poissonii*.

The first botanists to visit the Himalayan mountains were amazed by the beauty and diversity of the genus *Primula* in the area, and gardeners in Europe faced the challenge of growing them, but the Himalayan candelabra primulas shown here are among the easiest to grow in gardens, provided that the ground is permanently wet. This painting is one of a series Brigid Edwards painted to illustrate John Richards' monograph *Primula* (Batsford 1993, 2002). Her wonderful white poppy and poppy seed head are shown on page 59 and 60.

The quality of the old and new paintings of primulas is very comparable, with both artists using watercolours superbly.

The Kew Collection

Dr Martyn Rix

The library at Kew is a working collection of books and journals and papers on botany and horticulture, for the use of the staff of Kew and visiting scientists. There are three main components: the printed library, the archives and the illustrations.

The oldest items in the library are some of the printed books, dating from the fifteenth century and the early years of printing. Illustrated herbals were among the first books to be printed using flower pictures, and *Hortus Sanitatis*, printed in Germany in 1491 (see page 40) is one of the earliest.

With increasing wealth in northern Europe and more sophisticated printing, the Florilegium appeared. This was a celebration of ornamental flowers and was the result of the excitement felt by gardeners for the exotic flowers - tulips, irises, hyacinths, opium poppies and many others - introduced from Ottoman Turkey in the late sixteenth century. Basil Besler's *Hortus Eystettensis*, illustrations of plants grown in the garden of the Prince-Bishop of Eichstadt, was published in 1613. It is still one of the most magnificent (and expensive) flower books ever produced. An uncoloured copy is shown here (see pages 20, 50, 64). Several artists were involved, and one was Sebastian Schedel (1570–1628). His *Calendarium*, a manuscript with 289 folios of coloured drawings of flowers, is one of the most unusual books in Kew's collection, all the more so as the circumstances of its arrival at Kew, in the late nineteenth century, are unknown (see pages 43, 58).

Georg Dionysius Ehret, b. Heidelberg, Germany 1708–1770
Iris bulbosa
Gouache on vellum, 495 mm x 350 mm
Signed *G. D. Ehret 1757*
From the Tankerville Collection, purchased 1934. Kew Collection

Iris latifolia, the English iris, grows wild in meadows in northern Spain, but is commonly cultivated in England. The moth may be a bright specimen of a pine-tree lappet moth, a rare immigrant from Europe, first recorded in Richmond Park in 1748.
→

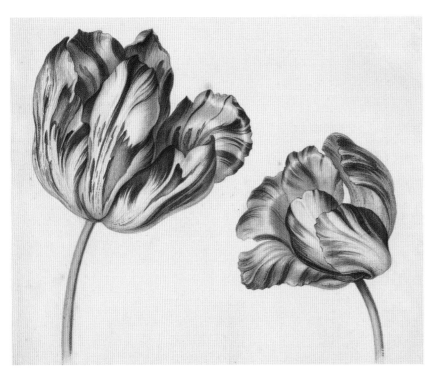

Simon Verelst, b. ?Antwerp, The Netherlands 1644–c.1721
Tulips
Watercolour on paper, 195 mm x 215 mm
From the Sir Arthur Church Collection
Kew Collection

These striped tulips were wildly fashionable in the 17th and 18th centuries, first in Holland, later in England. Gardeners were intrigued by the instability of the stripes and stipples, now known to be caused by virus infection.
←

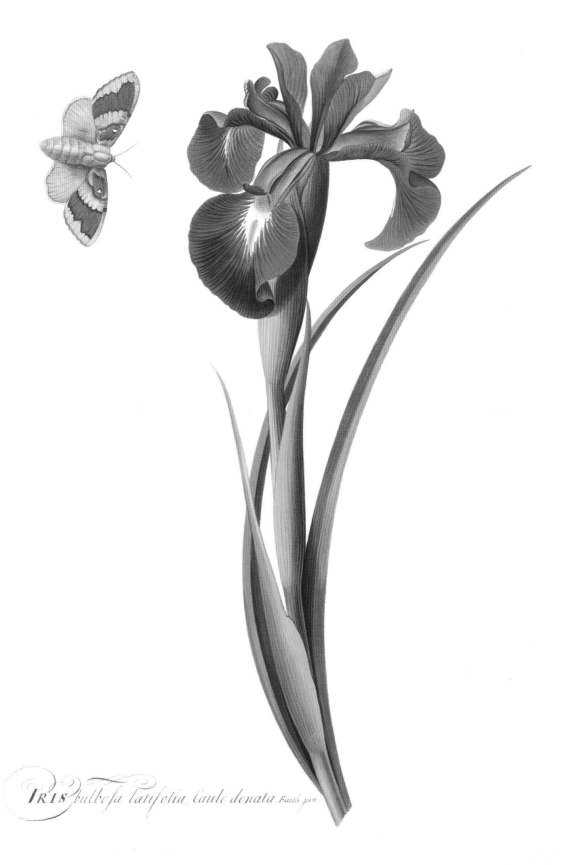

Iris bulbosa latifolia, caule donata *Barrel. pin.*

G. D. Ehret pinxit
1757

The enthusiasm for horticulture, and particularly for different cultivars of tulips, reached its height in Holland in the 1630s; at the same time it became fashionable to have paintings of large, decorative vases of flowers. Simon Verelst (1644– c. 1710) left his native Holland and sought his fortune in London, producing paintings of bouquets of flowers in the Dutch style, which were praised by Samuel Pepys for their realism.

Pepys records the meeting in his dairy (11 April 1669, Easter-day):

> '…to Loton, the landscape-drawer, a Dutchman, living in St James's market, but there saw no good pictures. But by accident he did direct us to a painter that was then in the house with him, a Dutchman, newly come over, one Verelst, who took us to his lodging close by, and did show us a little flower-pot of his drawing, the finest thing that I ever, I think, saw in my life; the drops of dew hanging on the leaves, so I was forced, again and again, to put my finger to it, to feel whether my eyes were deceived or no. He do ask £70 for it: I had the vanity to bid him £20; but a better picture I never saw in my whole life; and it is worth going twenty miles to see it.'

The Kew Collection contains some of Verelst's preliminary sketches of tulips and anemones; later Verelst turned to portraiture, and his painting of Nell Gwynn (c 1680) is in the National Portrait Gallery.

The Royal connection with Kew started in 1718, when the Prince and Princess of Wales (later George II and Queen Caroline) were banished from St James's Palace by the King and moved to Ormonde Lodge. Queen Caroline's relaxations were theological speculation and gardening, and she was responsible for extending the royal property at Kew, and for the laying out of the original gardens, in the formal style of Le Nôtre. Initially the gardens were intended merely to provide flowers and fruit for the royal household and as a proper environment for the palaces and other houses on the estate, and there was no plan to create a botanic garden. Other gardens, founded earlier, such as the University of Oxford Botanic Garden in 1620 and the Chelsea Physic Garden in 1673, were already growing a wide range of plants both for medicine and for scientific study.

Kew's metamorphosis into a botanic garden is credited to Augusta, wife of Frederick, Prince of Wales, son of George II and Queen Caroline. In 1731 Frederick bought a house near the present-day Kew Palace, whose small park already possessed some rare trees. In the fashion of the time, the gardens were stocked with exotic animals, including the now-extinct, zebra-like quagga and Indian pheasants, and planted with more rare trees. After Frederick died in 1751, at the early age of 42, from a cold caught directing planting at Kew, Augusta took advice on her garden from the Revd Stephen Hales, a pioneer of plant physiology and curate of nearby Teddington, and John Stuart, Earl of Bute. Bute became her trusted advisor and friend, and it was under his care that the gardens first became famous for their rare plant collection. Bute commissioned paintings from G. D. Ehret and after Ehret's death mainly from Simon Taylor who had been trained as a botanical artist by Bute and Ehret.

Margaret Meen, b. Suffolk, England, fl. 1775–1824
Fagus castanea
Watercolour on vellum, 270 mm x 180 mm
Inscribed: *M. Meen 1783 Common Chestnut Tree Native of England*
Kew Collection

Castanea sativa L., the edible sweet chestnut, was brought to England by the Romans, and probably grew here from that time, as both husks and the remains of nuts have been found near Hadrian's Wall. Each tree can live for at least 500 years, and the oldest alive today, at Tortworth, Gloucester. is thought to date back to Norman times.

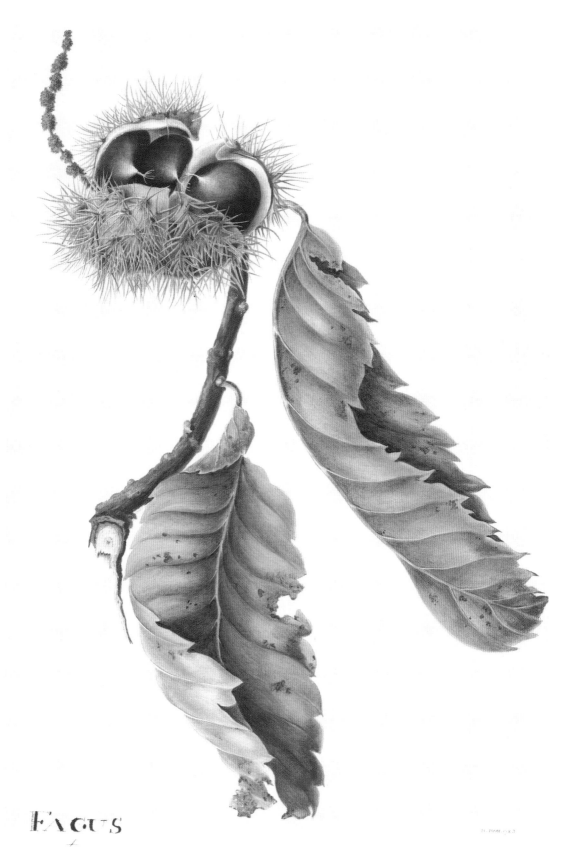

FAGUS

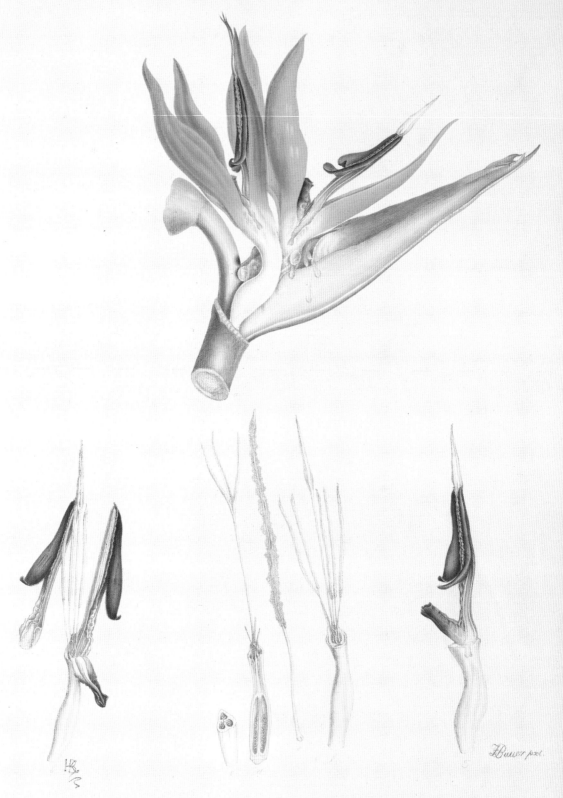

N.IV.

Another artist who recorded plants for Lord Bute was Margaret Meen, who came from Bungay in Suffolk. She founded and illustrated the short-lived journal *Exotic Plants from the Royal Gardens at Kew*, published in 1790, and a number of her paintings are now back in the Kew Collection, including her particularly elegant study of a sweet chestnut (see page 29).

The twenty years from 1751 to the 1770s can be seen to have been the first phase of great energy and expansion at Kew, under the influence of Lord Bute; John Bartram was collecting in North America and Francis Masson's first expedition to the Cape in 1772–4 introduced hundreds of new and beautiful plants; the artists Ehret and then Taylor recorded the new introductions as they flowered. The nurserymen Lee and Kennedy at Hammersmith were also active introducers of new plants, and there was continual exchange of plants between the two establishments. Ann Lee, daughter of James Lee, and a pupil of Sydney Parkinson, also made paintings of Kew plants. Hardy North American trees and shrubs, and tender pelargoniums, bulbs and Cape Heaths from the Cape were the fashion of the day. John Hill, a botanist friend of Bute, was also associated with Kew and in 1768 published the first Catalogue, *Hortus Kewensis*, listing 3,400 species.

The second great influence on Kew was that of Sir Joseph Banks (1743–1820). Banks was a very rich landowner, who was interested in plants from his schooldays at Harrow and Eton, where he began to make a herbarium. At Christ Church he continued his interest in botany, and both arranged and paid for lectures from a young Cambridge botanist, as the Sherardian Professor at the time, Humphrey Sibthorp, did no teaching.

When he was 24, Banks visited Newfoundland on board a naval frigate and made collections of plants and other objects of interest. His taste for travel stimulated, he joined Captain Cook's expedition to observe the transit of Venus from the Pacific; Cook also had secret instructions to find the continent, *Terra Australis* then rumoured to exist in the southern Ocean. Banks took his own entourage, including the botanist Daniel Solander and the artist Sydney Parkinson. The *Endeavour* left Plymouth in August 1768, and reached Tahiti in April 1769, returning to Europe via the coasts of New Zealand and eastern Australia, where they made a large collection of plants. They arrived back in England in July 1771.

After his triumphant return from Australia, Banks met King George III and the two became friends, meeting regularly at Kew to walk through the gardens and discuss gardening and farming, particularly sheep and wool production, which Banks practised on his Lincolnshire estates. From this time Banks's influence at Kew increased and he worked hard to improve the Royal Gardens; it is suggested that Masson was sent to the Cape at his prompting, as he had seen the richness of the flora when he stopped there on his way home in 1771. Masson's Cape plants proved a great source of interest, and he was soon dispatched again to collect in the Canaries, the Azores and the West Indies. The reputation of William Aiton, curator of Kew, as a skilled plantsman, meant that both new plants and visitors came regularly to the Gardens. Carl Thunberg from Uppsala, also a

Francis Bauer, b. Austria 1758–1840
Strelitzia
Hand coloured lithograph, late 18th–early 19th century
555 mm x 405 mm
Kew Collection

Strelitzia reginae was introduced by Francis Masson in 1773 from the Cape where it grows in sandy, peaty places. It was named by Sir Joseph Banks after the wife of George III, Queen Charlotte, who was born Princess Sophie Charlotte of Mecklenburg-Strelitz in 1744. The unusually shaped flowers open in succession from the green bract; they are pollinated by sunbirds and weaverbirds; the orange petals attract the bird which perches on the blue stamens, releasing the pollen onto its breast. Bauer painted a superb series of *Strelitzia*, some of which were produced as hand-coloured lithographs in *Strelitzia Depicta* (1818).

pioneer collector in the Cape, visited Kew in 1778, and L'Heritier from Paris in 1786. L'Heritier brought with him the young artist Redouté, and their visit is recorded in the book, *Sertum Anglicum* (1788), many of the plants being Masson's collections grown at Kew, painted by Redouté, and by James Sowerby. L'Heritier's great study of pelargoniums made use of the plants growing at Kew and of Banks's herbarium and library in Soho Square; many of L'Heritier's pelargonium names were first published in Aiton's *Hortus Kewensis* in 1789.

Banks's greatest artistic influence was due to his encouragement and employment of Franz, later Francis, Bauer (1758-1840). The Bauer brothers' paintings are the high point of late eighteenth and early nineteenth century botanical art. Francis Bauer arrived in London from Austria in 1788, where he and his brother had been working as artists at the Imperial Gardens in Vienna. When their father died the brothers had been taken under the wing of a monk Brother Boccius and their early work is collected in the Liechtenstein codex, published in *A Garden of Eternity* by H.W. Lack (2000).

Franz visited England in 1788 with Jacquin's son, and was persuaded by Banks, with the promise of a salary, to stay on in England, and from 1790 until his death in 1840 was employed to draw new plants flowering at Kew, and by John Lindley to draw orchids, large numbers of which were being imported from the tropics to be grown by enthusiasts around London. Though he became known as 'Botanick painter to His Majesty', it was Banks who paid his salary, and arranged for his estate to continue payment until Bauer's death. Banks's influence at Kew lasted until his own death in 1820, and he left his library at Soho Square and all his botanical effects to the botanist Robert Brown for his lifetime, and after that to the British Museum.

It has long been a sadness to historians at Kew that so few of Bauer's paintings of Kew plants remain in the library there. Banks initially intended that they be left at Kew, but by the end of the 1830s the future of Kew was so uncertain that Bauer's will directed that they go to the British Museum. They were handed over in May 1841, and the rest of Bauer's drawings were sold at Christies in November of that year. Apart from the paintings in the Natural History Museum, the rest of Bauer's drawings and papers are now in the University Library at Göttingen, to which they were presented by the Duke of Cumberland when he became King of Hanover.

Many of Franz Bauer's paintings, as well as others by Ehret, J.F. Miller, J.P. Nodder and James Sowerby were published in the various later editions of *Hortus Kewensis* (1789, and 1810–1813). During Bauer's later years, two Kew gardeners made large numbers of paintings in the Gardens: Thomas Duncanson drew around 300 plants between 1822 and 1826, and George Bond made 1,500 drawings of plants between 1826 and 1835.

After the deaths of Joseph Banks and George III in 1820, the Royal Gardens began a period of serious decline. There were rumours that they would close and the surviving plants were offered to the then thriving Horticultural Society. In 1838 a working party was set up under the chairmanship of John Lindley to survey the Royal Gardens. Within a month, Lindley presented his report

Francis Bauer, b. Austria 1758–1840
Strelitzia reginae
Hand-coloured lithograph on paper, 555 mm x 405 mm
See larger reproduction on p182.

William Jackson Hooker,
b. Norwich, Norfolk, England
1785–1865
Lilium
Watercolour on thin card,
505 mm x 380 mm
Signed *W. Hooker*
Kew Collection

This looks like an unusually broad-leaved form of the Japanese *Lilium longiflorum*, and is close to var. *alexandrae* which comes from the Liukiu islands. See larger reproduction on page 152.

recommending that the state should take over the botanic garden and make it 'worthy of the country' and 'a means of promoting national science'. After considerable delay, rumours and machinations in government, in 1840 the Gardens were brought under the control of a government body, the Office of Woods and Forests, and in 1841, Lindley's friend, William Jackson Hooker, Professor of Botany at the University of Glasgow, was appointed director at the age of 56. Hooker brought his own herbarium and library from Glasgow to Kew, and accepted a very modest salary, £300 a year, the same as that paid to Bauer by Banks.

It was the energy and single-mindedness of William Hooker and his son Joseph that enabled Kew to become the pre-eminent scientific and horticultural establishment that it remains today. William Hooker was not only a hard-working botanist and expert of ferns, but had a reputation for tact. This enabled him to take over at a difficult time and steadily expand the Gardens. A living memorial to this period can still be seen in the Gardens, the magnificent Caspian oak, *Quercus castaneifolia,* planted in 1846. In addition Lindley cannot have been unaware that Hooker's son Joseph, then 24, already qualified MD from Glasgow, was also a knowledgeable and intrepid botanist, and was at that time serving as assistant surgeon and naturalist on HMS *Erebus* and HMS *Terror*, to South America and the Antarctic. Furthermore father and son were happy working together. In addition to his considerable library and herbarium, William Hooker also brought to Kew from Glasgow a young artist who was to have a huge influence for the next 35 years, Walter Hood Fitch.

Fitch's skill and speed of working meant that he produced most of the botanical illustrations of Kew plants during the Hookers' directorships of Kew, from 1841 onwards. This was the period when lithography became the chief medium of reproduction of plant paintings, and Fitch could not only produce paintings of the plants, but could draw directly onto the stone. His skill on a small scale can be seen in plates for *Curtis's Botanical Magazine*, then edited and mostly written by William Hooker. On a large scale he was equally impressive, as is shown by the drawings of rhododendrons of the Sikkim Himalaya, expanded from Joseph Hooker's field drawings sent back from India in 1847.

One of Kew's most important sets of drawings was commissioned by Nathaniel Wallich, an East India Company surgeon who was Superintendent of the Company's botanic garden in Calcutta from 1815 to 1841. His beautiful *Plantae Asiaticae Rariores*, using some of these plates, was published in 1830 and 1832. These paintings of plants from India and the Far East, mostly drawn by Indian artists under European supervision, became known as the Company School. Sometimes the name of the Indian artist is known, (for example Vishnupersaud who worked for Wallich), but most of these paintings are unsigned. They are easily distinguished from European painting by their impression of flatness combined with an excellent sense of design and fine detail, in the tradition of Indian miniature paintings.

When Hooker arrived at Kew there was no formal library and he kept his books and herbarium in his own house; five rooms were allocated to the herbarium and

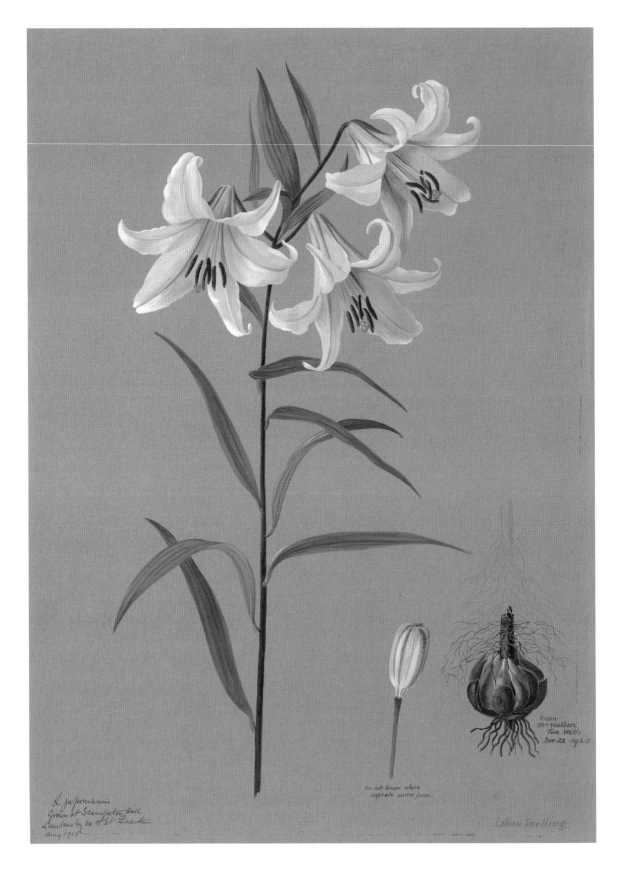

L. japonicum
Grown at Scampston Hall
Lent me by W H St Quintin
Aug 1915

no not know where
capsule came from

From
Mr Wallace
Tun Wells
Nov 22 1920

Lilian Snelling

three to books. The present library was begun in 1852 when the Revd W.A. Bromfield presented his herbarium and library and this was considerably enlarged in 1854 when the botanist George Bentham (1800-1884) presented his library and herbarium of over 100,000 specimens. Bentham continued to work at Kew and collaborated with Joseph Hooker, producing two famous works, *Genera Plantarum* (1863–83) and *Handbook of the British Flora* (1858), revised by Hooker in 1886, last reprinted in India in 1997. The collection grew fast, with Sir William Hooker's library and herbarium being purchased in 1866 after his death in 1865, and the East India Company herbarium being added in 1858, with 400,000 duplicates being distributed to other herbaria.

After 24 years as director, William Hooker handed over to his son Joseph in 1865. Joseph's output was prodigious, in organising the herbarium and the garden, in correspondence with other scientists and in taxonomic research, and he continued this after retirement in 1885, until his death in 1911. Apart from *Curtis's Botanical Magazine* and *Hooker's Icones Plantarum*, which concentrated on drawings of plants from the herbarium, he specialised in Indian plants, especially the seven volumes of *Flora of British India*, making use of the collection of paintings by Indian artists. Joseph, however, was less tactful than his father, and relations with Fitch deteriorated; he felt undervalued and finally resigned in 1878, having produced over 2,700 plates for *Curtis's Botanical Magazine* and thousands for other Kew publications; his work was taken over by Hooker's daughter, Harriet, and then by a distant cousin, Matilda Smith, who herself did more than 2,300 paintings for the Magazine.

On Bentham's death in 1880, a considerable legacy came to Kew, to be invested in a trust for the preparation and publishing of botanical works, for the purchase of books and specimens, or more generally for the promotion of botanical science. Edouard Morren's collection of paintings of Bromeliaceae were purchased in 1887 (see page 191) and *Hortus Sanitatis* was bought for the library in 1903. In 1932 the Bentham fund was augmented by the residue of the estate of Margaret Louisa Moxon and James Edward Moxon, so the trust now combines both names. Since 1890 the Trust has assisted in the purchase of botanical paintings and illustrated books for the Kew Collection, and other funds have been added. Many of the paintings illustrated here were purchased by the Trust. A major addition in 1932, was the Tankerville Collection, which included 648 drawings by Ehret, Margaret Meen and others, possibly the same paintings that had belonged to Lord Bute. Forty-seven paintings by Simon Taylor were added in 1933, and another 100 by Margaret Meen in 2001. The fund helped towards the expenses of plant collecting expeditions such as that of the Furses to Iran in 1960, and a large number of Paul Furse's flower paintings are now in the collection.

Other bequests have contributed to Kew's collection; in 1915 the widow of Sir Arthur Church gave 67 paintings which he had collected by many famous artists including Verelst, Redouté, James Sowerby and Sydenham Edwards, as well as *Erica cerinthoides* by Pancrace Bessa. Church and Thiselton-Dyer, director of Kew from 1885 to 1905, were both professors at the Royal Agricultural College, at Cirencester, and Church appears to have lived at Kew in his retirement.

Lilian Snelling, b. St Mary Cray, Kent, England 1879–1972
Lilium japonicum
Watercolour on grey paper, 563 mm x 380 mm
Grown at Scampston Hall by W. H. St Quentin, from a bulb supplied by Wallace's, Tunbridge Wells, 1915.
Kew Collection

Lilium japonicum is found in Honshu, growing in bushy places and in long grass or dwarf bamboo. It is usually pink-flowered, but it can be white in the wild.

Throughout the latter half of the nineteenth and the whole of the twentieth century, the focus of botanical painting at Kew was *Curtis's Botanical Magazine* in which new or exciting plants flowering in the Gardens were, and still are, illustrated. After Fitch's resignation in 1878, Matilda Smith became the chief artist, under the editorship first of Sir William Thiselton-Dyer and then of Sir David Prain. Otto Stapf became editor in 1921, and Lilian Snelling the chief artist. Since then many artists have contributed paintings to the Magazine, the chief ones being Stella Ross-Craig from 1932, Margaret Stones, from 1958, and Christabel King, from 1975.

The life and work of Marianne North (1830–1890), the bulk of whose work is in her special gallery at Kew, are in great contrast to the other artists mentioned here. After years looking after her invalid father, Marianne North took her paints and canvasses, and from 1871, travelled the world, staying in embassies and with friends, and painting the local vegetation, often with detailed flowers in the foreground. Many of the plants were new, and one genus and four species are named in her honour. Her paintings are a striking record of vegetation that in many areas has now almost disappeared. Her work must have appeared even more remarkable when her gallery opened in 1882. Colour photography was unknown, and travel restricted to only a few. Visitors to Kew could now see the plants cultivated in the glasshouses, as they looked when growing in their native habitat

Margaret Mee (1909–1988) was equally remarkable in a different way. Her expeditions on the Amazon and its tributaries, usually by boat, resulted in hundreds of botanical paintings, and played a major part in increasing awareness of the destruction of the Brazilian rainforest in the minds of the public in Europe and North America. The library was given 62 original watercolours and gouache paintings, and several sketchbooks, and more paintings have recently been added. The Margaret Mee Fellowship Programme now brings a student artist from Brazil to Kew each year, to be trained in botanical illustration.

In more recent years, under the direction of the illustrations curators Marilyn Ward and Lynn Parker, Kew's collection of paintings has been widened with the purchase of important works by other artists. Recent acquisitions include a group of auriculas on vellum by Celia Hegedüs, a large composite painting of the seeds of Leguminosae by Rachel Pedder-Smith, a group of paintings of *Passiflora* by Georita Harriott, and paintings of roses by Regine Hagedorn. Many of these artists are also represented in the Shirley Sherwood Collection.

Stella Ross-Craig, b. Aldershot, Hants, England 1906–2006
Banksia serrata
Watercolour on paper, 302 mm x 227 mm
Inscribed: *cult. Roy. Bot. Gard. Edinburgh, S. Ross-Craig del. 14. 6. 39.*
for *Curtis's Botanical Magazine* t. 9642.
Kew Collection.

Banksia serrata is widespread in eastern Australia, forming a shrub or small tree in rocky places from the coast into the mountains, flowering in mid-summer. The genus is named after Sir Joseph Banks, who was the first to collect this and other species.

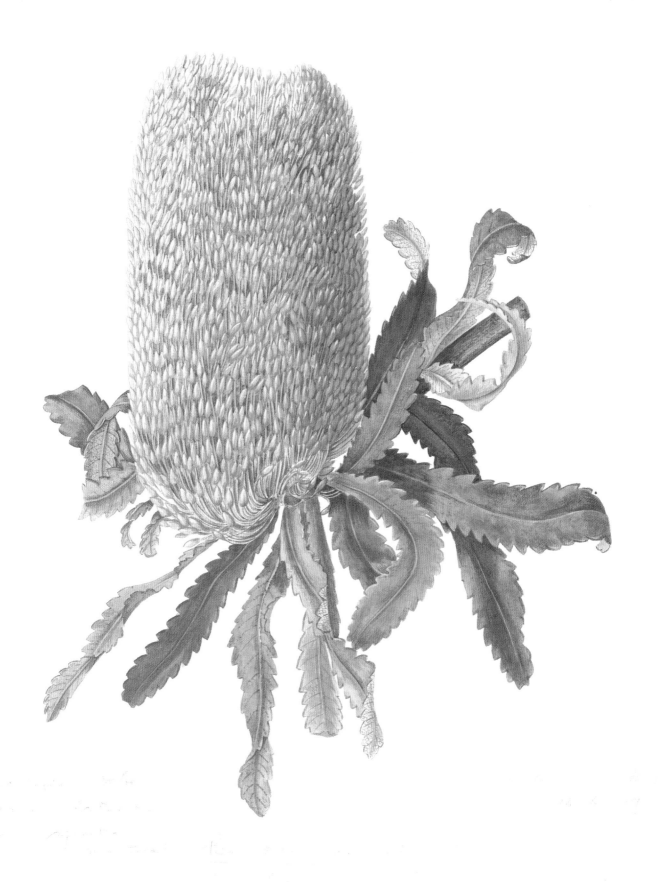

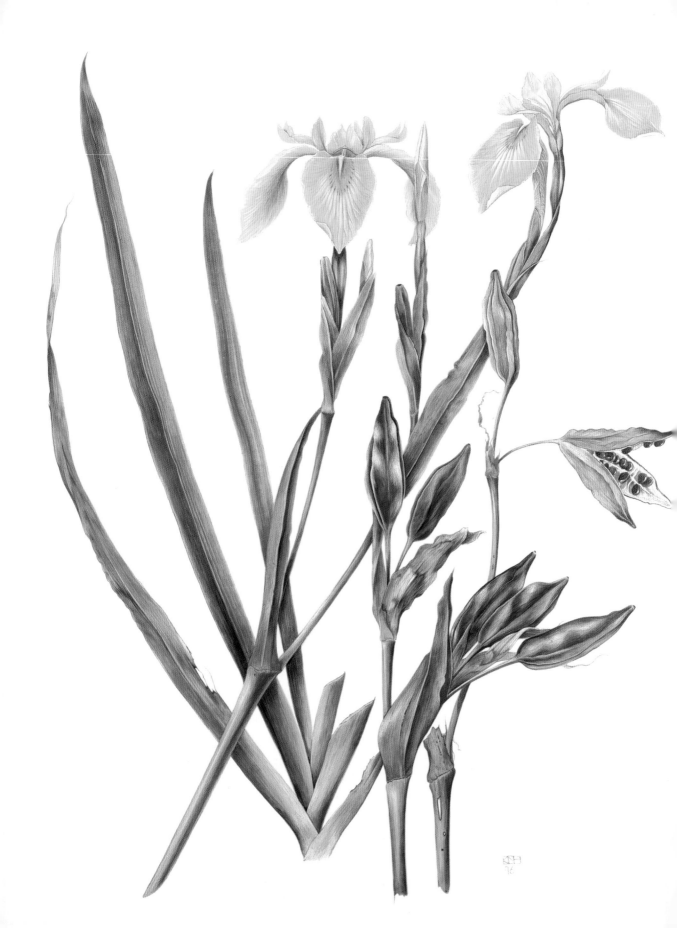

The age of antiquity

Herbals and mandrakes

Ever since humans began using plants for medicine, they had to learn to name both useful and deadly ones, and the first botanical paintings were made as part of treatises on herbs. In primitive societies, knowledge of plants and their names is passed down the generations; in a literate society, plants are named and described, sometimes with a drawing alongside to aid identification.

Both Dioscorides, a physician in Nero's army, and Pliny the elder, who died in the eruption of Vesuvius, mention the famous paintings of the botanist Crateavus, who was active in c.50 BC. Amazingly, over 2,000 years later, we can get some idea of how they looked, from a manuscript of Dioscorides written in Constantinople in around 500 AD, now in Vienna.

Herbals were also the first plant books to be printed. Shown here is a page from *Hortus Sanitatis*, the Garden of Health, printed in Mainz in 1491.

Yvonne Edwards, b. South Australia 1942
Mandrake *Mandragora autumnalis*
Watercolour on paper, 390 mm x 525 mm
Signed *Yvonne Edwards*
Shirley Sherwood Collection

Mandragora officinarum L., the spring-flowering mandrake, has greenish flowers and round orange fruit, in contrast to the autumn-flowering *Mandragora autumnalis*, which has purplish flowers and oval fruit.
\rightarrow

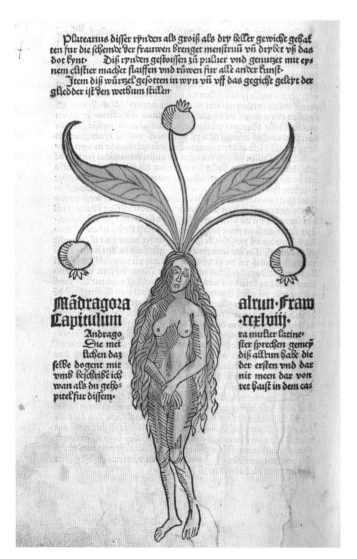

Hortus Sanitatis (1485–90)
A female mandrake in fruit
Printed by Peter Schoffer in Mainz in 1491
Hand-coloured woodcut, 271 mm x 191 mm
Kew Collection
Mandragora officinarum L.
\leftarrow

Mandragora autumnalis Ivane Edwards

The most influential herbal in the sixteenth century was published by John Gerard in 1597 or 1598, and was so popular that it was reprinted, enlarged and revised several times, notably by Thomas Johnson in 1633.

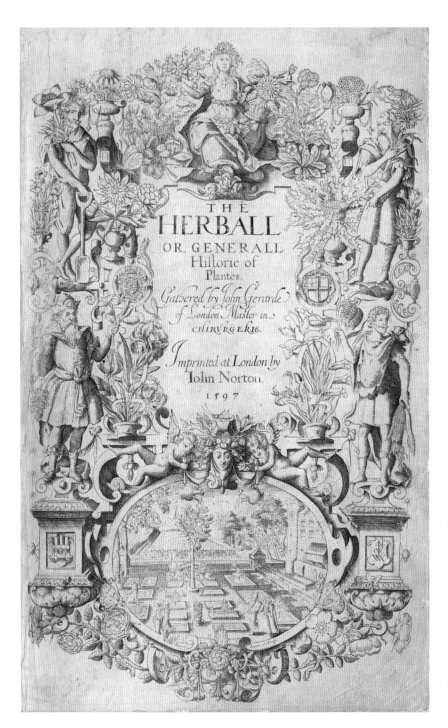

John Gerard, b. Nantwich, Cheshire 1545–1612
***The Herball** or General Historie of Plantes* (1597)
Title-page, designed and engraved by William Rogers, 310 mm x 192 mm
Kew Collection

This engraving shows the layout of a small town garden and many popular garden flowers, including *Fritillaria imperialis*, *Iris susiana*, *Iris persica* and different forms of *Anemone coronaria*, as well as a fine cob of maize.

Florilegia and the Renaissance in northern Europe

Sebastian Schedel, b. Germany
1570–1628
Calendarium (1610)
Watercolour on paper, 184 mm x 200 mm
Kew Collection

Viola tricolor, Dianthus, Hyacinthus orientalis, Vicia faba (broad bean) and a flower of a stock (*Matthiola* sp.).

Irises and members of the genus *Viola*, which includes pansies and violets, were popular garden plants in the Middle East, and in Europe from the Middle Ages onwards. Irises, and particularly the bearded species, were associated with the Virgin Mary, and often appear near her in Renaissance painting. Scented violets were also cultivated, and had a special place in Persian poetry. Pansies and violas were developed later from the northern European species, *Viola tricolor* and *V. lutea*, and the various colours and very round flowers which are familiar nowadays were bred in the nineteenth century.

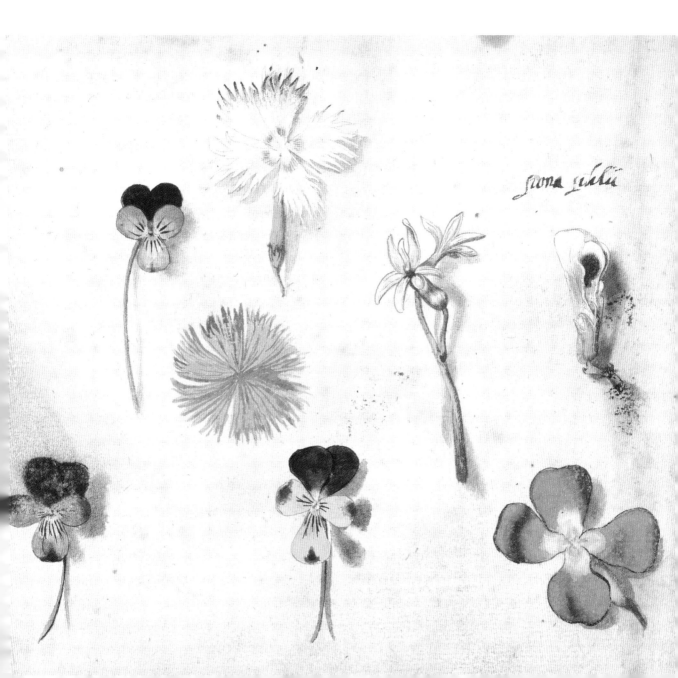

The paintings in Schedel's *Calendarium* show various spring flowers: pinks, some small pansies, a hyacinth, bean flower and a stock. This charming book of watercolours was perhaps a calendar record of plants from gardens in northern Germany, and particularly from the Prince-Bishop's garden in Eichstadt, featured in *Hortus Eystettensis*; indeed of the many artists who contributed to this huge project, Sebastian Schedel is the only one whose name is known.

Coral Guest's magnificent black *Iris* 'Superstition' recalls the life-sized irises by painters such as Hugo van der Goes in the Portinari altarpiece in Bruges (c.1475), or Dürer's great Iris in the Kunsthalle in Bremen and in Monasteriode El Esconal, near Madrid.

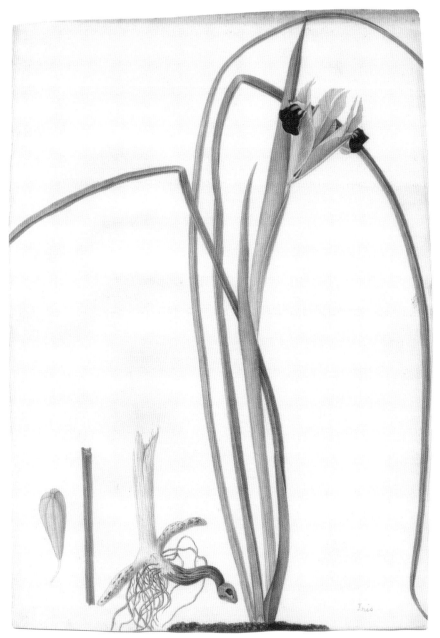

Artist and date unknown
Iris hermodactylus
Watercolour on vellum, 320 mm x 225 mm
Kew Collection

Iris tuberosa, often called *Hermodactylus tuberosus*, is a native of southern Europe and western Asia; it has creeping tuberous rhizomes and flowers, smelling sweetly of violets, in early spring. This painting is reminiscent of a study by Jacob Ligozzi (1547–1626) in Florence, but the handling is less assured.
←

Coral Guest, b. London, England 1955
Iris **'Superstition'**
Watercolour on paper, 1525 mm x 1025 mm
Signed *Coral Guest '05*
Shirley Sherwood Collection

This superb, blackish-purple bearded iris, was raised by Schreiner's Iris Gardens in Oregon in 1977.
→

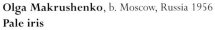

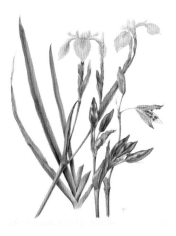

Celia Hegedüs, b. London, England 1949
Yellow flag: *Iris pseudacorus*
Watercolour on vellum, 540 mm x 410 mm
Signed *CNH 96*
Shirley Sherwood Collection

Iris pseudacorus is common in wet fields and in shallow water throughout Britain and Europe east to Turkey. See larger reproduction on page 38.

Olga Makrushenko, b. Moscow, Russia 1956
Pale iris
Mixed media on paper, 500 mm x 350 mm
Signed *O Makrushenko 2002*
Shirley Sherwood Collection

Susannah Blaxill, b. Armidale,
New South Wales, Australia 1954
Pansies

Watercolour on paper, 290 mm x 360 mm
Signed *Susannah Blaxill* (undated)
Shirley Sherwood Collection

These modern, round-faced pansies
can be compared with Schedel's
17th century varieties.

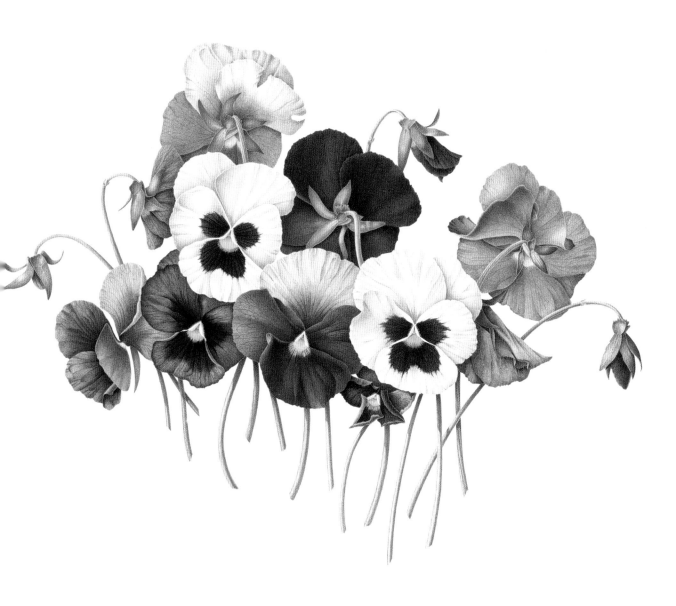

Josephine Hague, b. Liverpool,
England 1928
Pansies and *Tropaeolum speciosum*
Watercolour on paper, 380 mm x 280 mm
Signed *Josephine Hague* (undated)
Shirley Sherwood Collection

Tropaeolum speciosum is a climber from
southern Chile; it grows especially well
in Scotland, climbing into shrubs and
over hedges.

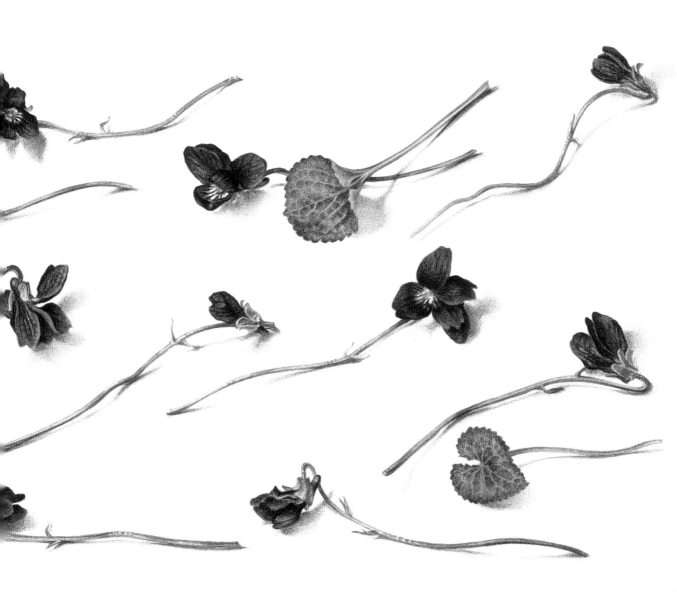

Susan Christopher-Coulson, b. Durham,
England 1955
Sweet violet scattering
Coloured pencil on paper, 380 mm x 470 mm
Signed *SMCC Apr.06*
Shirley Sherwood Collection

Viola odorata, the sweet violet, is a common wild
flower on roadsides and hedgebanks in England;
it can have dark purple, white or rarely pink or
pale yellow flowers. This study shows violets
scattered in a very similar way to those painted
in the borders of early Books of Hours.

Hortus Eystettensis

The two huge volumes of Basilius Besler's *Hortus Eystettensis*, published in 1610–13, are a wonderful record of what was growing in a plantsman's garden in the early seventeenth century. Most of the plants shown are now familiar, but the range is most impressive for such an early date, featuring plants from as far away as Spain, Corsica, Turkey and the Americas. Furthermore, the large size of most of the specimens shows great skill on the part of the gardeners who worked for Johann Conrad von Gemmingen, the Prince-Bishop of Eichstadt in Brandenberg, northwest of Berlin. The garden was started by the botanist Camerarius in 1596 and, after his death, continued by Basilius Besler, an apothecary from Nürnberg. The palace itself

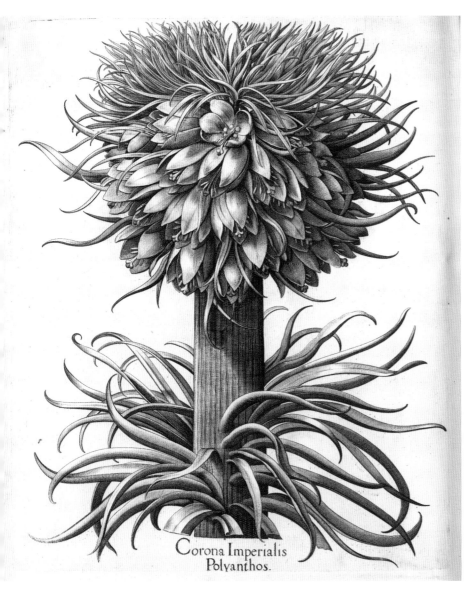

Corona Imperialis
Polyanthos.

Basilius Besler, fl. Nürnberg, Germany 1561–1629
Corona imperialis polyanthos
Hortus Eystettensis (1613)
Copper engraving, hand-coloured in some copies, 570 mm x 460mm
Kew Collection
Fritillaria imperialis
←

Rory McEwen, b. Berwickshire, Scotland 1932–1982
Crown imperial: *Fritillaria imperialis*
Watercolour on vellum, 780 mm x 565 mm
Signed *Rory McEwen 1965*
Shirley Sherwood Collection

The crown imperial, *Fritillaria imperialis*, was introduced to Europe in the late 15th century from Istanbul, where it was cultivated by the Turks. It grows wild in dry, rocky places in the mountains of eastern Turkey and Iran.
→

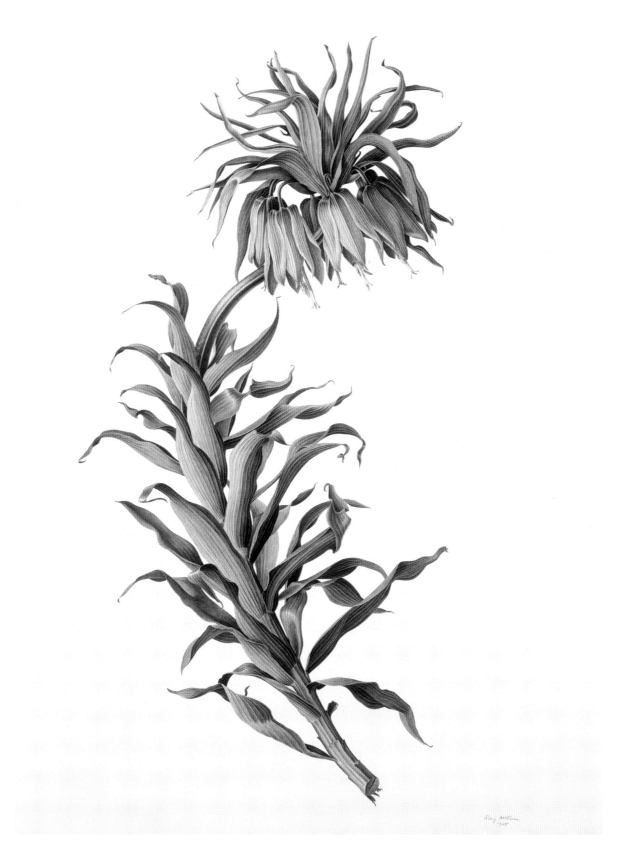

is built on a hill, and the garden was divided into eight sections, arranged on terraces down the hill; the plants were positioned geographically, one section for each area of the world.

The book *Hortus Eystettensis* was produced in Nürnberg, and 300 copies were printed, on the largest size paper then available; some deluxe copies, printed on special paper were hand-coloured, but most were black and white.

Striped tulips and double anemones

Cultivated tulips were brought to Europe from Turkey in the mid-sixteenth century, and by 1634, particularly in Holland, tulip breeding and growing had become a major craze, since called tulipomania by Wilfrid Blunt.

Striped and flared tulips were especially prized, and very expensive as they seemed to arise sporadically from plain coloured varieties. We now know that the striping is caused by infection with tulip-breaking virus. These early studies on rough paper

Illustration by an unknown artist, 17th Century
Striped tulips and double anemones
Watercolour on paper, 215 mm x 330 mm
Kew Collection

This, and the painting opposite are almost certainly by the same artist and are strongly reminiscent of Giovanna Garzoni (died1670).

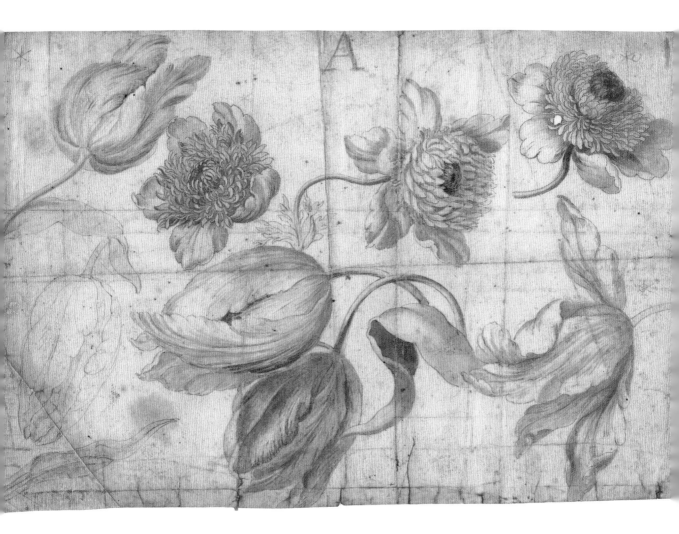

Illustration by an unknown artist, 17th Century
Double anemones

Watercolour on paper, 240 mm x 190 mm
Kew Collection

Both these paintings appear to be preliminary studies or designed to be used as patterns.

Like garden tulips, these Mediterranean anemones were first cultivated by the Ottoman Turks, and introduced to Europe in the 16th century. They were bred from *Anemone coronaria*, and those with double and semi-double flowers in various shades of red, pink or purple were the most popular.

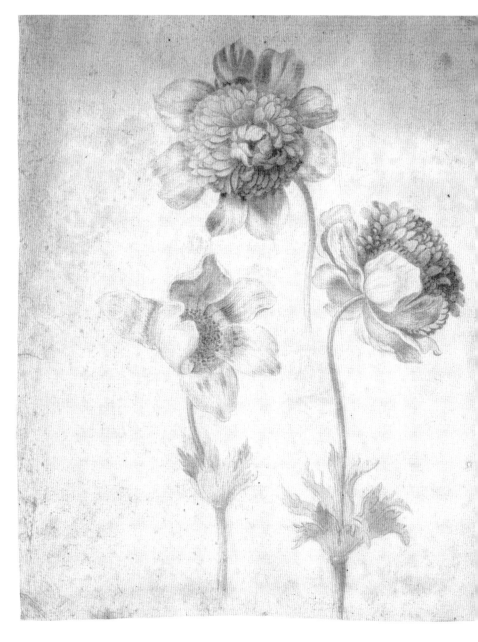

may have been copied into a more substantial painting. Two of the anemones have tiny pinpricks– suggesting they may have been used as an embroidery pattern, or transferred onto another paper; similar prick marks can be seen on some of Leonardo's plant drawings at Windsor, perhaps used for transferring them to a studio painting.

Rory McEwen made a special study of the surviving varieties of old tulips, grown by the Wakefield and North of England Tulip Society, and painted several, in extra large size, for the splendid revision of Wilfrid Blunt's *Tulips and Tulipomania* published by Basilisk Press in 1979.

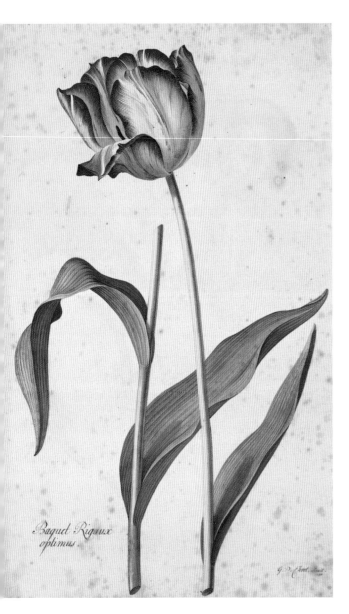

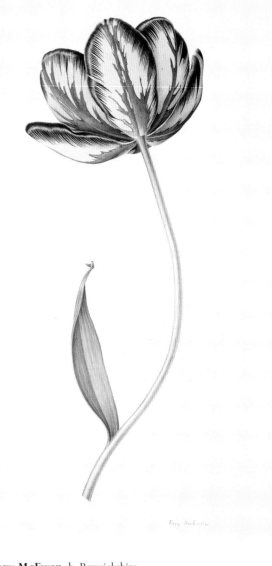

Georg Dionysius Ehret,
b. Heidelberg, Germany 1708–1770

Tulip 'Baquet Rigaux optimus'

Watercolour with gum Arabic glazes and ink
inscription on vellum,
482mm x 307 mm
Signed: *G.D. Ehret pinxit 1740*
From the Tankerville Collection, purchased
1934
Kew Collection

Rory McEwen, b. Berwickshire,
Scotland, 1932–1982

**Old english florist tulip 'Sir
Joseph Paxton' 1962**

Watercolour on vellum, 380mm x 260mm
Signed *Rory McEwen*
Shirley Sherwood Collection

Sir Joseph Paxton (1803–1865) is
famous as head gardener to the
Duke of Devonshire at Chatsworth
and as designer of the Crystal Palace.

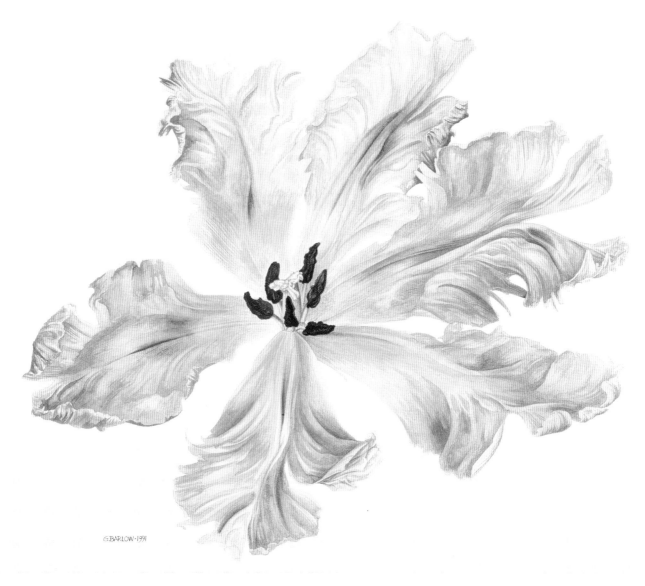

G.BARLOW·1991

Gillian Barlow, b. Khartoum,
Sudan 1944
Yellow parrot tulip
Watercolour on paper, 260 mm x 365 mm
Signed *G. Barlow 1991*
Shirley Sherwood Collection

Parrot tulips are characterised by
having irregularly cut and twisted
petals, as well as arresting colours,
mainly in reds and yellows.

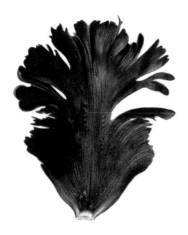

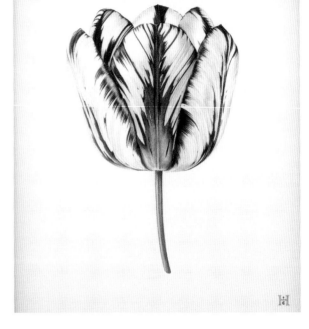

Graham Rust, b. Hertfordshire,
England 1942
'Black Parrot' tulip petal
Watercolour on paper, 225 mm x 170mm
Signed *Graham Rust* (undated)
Shirley Sherwood Collection

Celia Hegedüs, b. London, England 1949
Tulip 'Rory McEwen'
Watercolour on vellum, 508 mm x 458 mm
Signed *CH*
Shirley Sherwood Collection

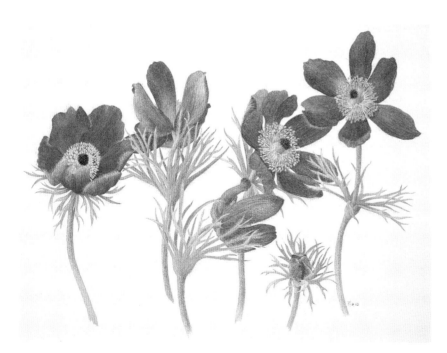

Katie Lee, b. Eldoret, Kenya 1942
Pasque flower: *Pulsatilla vulgaris*
Gouache on paper, 280 mm x 360 mm
Signed *KT 2002*
Shirley Sherwood Collection

Pulsatilla vulgaris, the pasque flower, is a rare native of central England, growing in chalk and limestone grassland, and flowering in spring. Pulsatillas are steppe and mountain plants and differ from *Anemone* in having long feathery styles, which continue to grow as the seeds mature and then act as sails to help distribute the ripe seed.

Graham Rust, b. Hertfordshire,
England 1942
Daffodils and narcissus
Watercolour on paper, 240 mm x 165 mm
Signed *Graham Rust 1994*
Shirley Sherwood Collection.

This charming study calls to mind
the work of 17th century painters in
Italy, such as Nicholas Robert
(1614–1685) and Nicolaus
Guillelmus (fl. 1638)

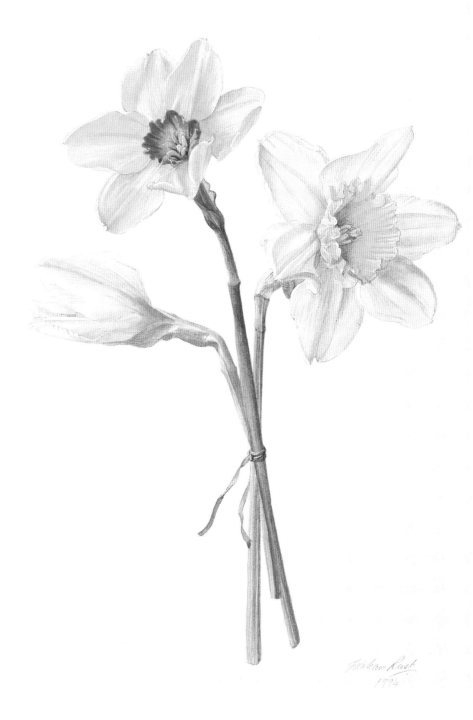

Poppies

The bright colours and crinkled petals of poppies have long attracted both botanical artists and gardeners, and the narcotic properties of the opium poppy have been known for many millennia; it has been cultivated for so long that the wild opium poppy is unknown, though a small red-flowered species from Turkey and Mesopotamia, *Papaver glaucum*, is a possible candidate as its ancestor.

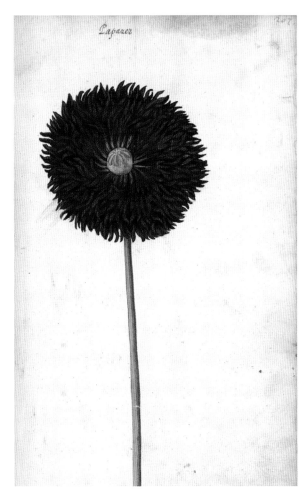

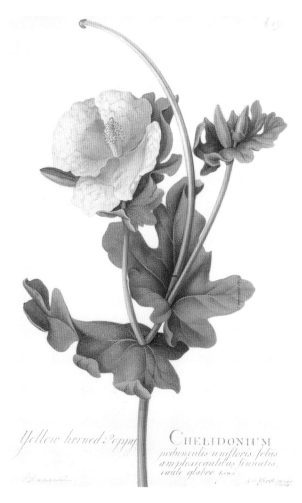

Sebastian Schedel, b. Germany
1570–1628
Calendarium (1610)

Papaver flore multiplice incarnato
Watercolour on paper 313 mm x 200 mm
Kew Collection

Papaver somniferum. A double,
fimbriated opium poppy: a very
similar poppy flower is illustrated in
Hortus Eystettensis.

Georg Dionysius Ehret, b. Heidelberg,
Germany 1708–1770
Chelidonium

Watercolour on vellum, 255 mm x 173 mm
Signed *G.D. Ehret pinxit 1764*
Kew Collection

Glaucium flavum, the yellow horned poppy, is
a common plant of seaside shingle, with
characteristic long curved seed pods and
bluish-green leaves.

Brigid Edwards, b. London,
England 1940
Poppy seed head
Watercolour over pencil on vellum,
381 mm x 305 mm
Unsigned 1999
Shirley Sherwood Collection

The structure of this dried and
enlarged seed head of the opium
poppy, *Papaver somniferum*, is revealed
in detail in this arresting painting.

Gardeners selected opium poppies for their ornamental flowers, and many colours
and flower shapes were grown by the sixteenth century, probably, like so many
other garden plants, imported from Turkey. Eight different double-flowered
varieties are illustrated in *Hortus Eystettensis* (1613); one of them is this double
red, with a white centre, as shown in Schedel's painting, opposite.

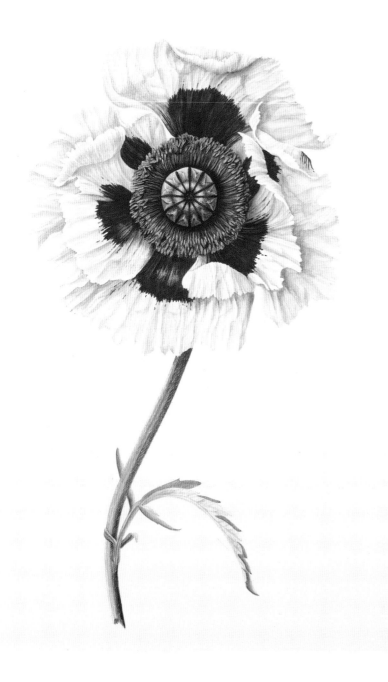

Brigid Edwards, b. London,
England 1940
Oriental poppy
Watercolour over pencil on vellum,
530 mm x 405 mm
Unsigned and undated
Shirley Sherwood Collection

Papaver orientale 'Perry's White'.
Oriental poppies are perennials,
wild in the hay meadows of eastern
Turkey, Armenia and Iran; in the
wild they are crimson, scarlet or
bright orange, but white, pink and
purple-flowered varieties are grown
in gardens. Though usually planted
in herbaceous borders, they thrive
and look wonderful in rough grass.
←

Rodella Purves, b. Paisley,
Scotland 1945–2008
Meconopsis x *sheldonii*
Watercolour on paper, 720 mm x 540 mm
Signed *Rodella* (undated)
Shirley Sherwood Collection

Hybrid Himalayan poppy, between
Meconopsis betonicifolia and *M. grandis*.
These wonderful plants need deep
acid soil and cool summer
temperatures; they flourish in
Scotland.
→

Meconopsis x sheldonii
(Betonicifolia x grandis).
R.B.G. Edin. June 1999.

Rodella

Peonies

Their large flowers and ease of cultivation have made peonies popular as medicinal and as ornamental plants at least since the fifteenth century and they have also been favourite subjects for painters. A wonderful painting of *Paeonia officinalis* dated 1472 or 1473 by Martin Schongauer, a forerunner of Albrecht Dürer, is in the Getty Museum in Malibu. It was perhaps a preliminary study for *The Madonna of the Rose Bower*, and is shown on the cover and endpapers of Blunt and Stearn's *The Art of Botanical Illustration* (1994). No less than eleven different peonies are illustrated in *Hortus Eystettensis*.

European peonies are all herbaceous, so gardeners were thrilled when tree peonies arrived from China in the late eighteenth century.

Lillian Snelling, b. St Mary Cray, Kent, England 1879–1972

Paeonia clusii

Watercolour on paper, 290 mm x 230 mm
Inscribed: *May 15th 1934, from a plant grown by G.P. Baker at Sevenoaks, Kent,* for *Curtis's Botanical Magazine* t. 9594. (1940).
Kew Collection

Paeonia clusii is found throughout the island of Crete and on Karpathos. It usually has white flowers, though in some populations the flowers are pale pink.

Paeonia Moutan

Sydenham Edwards, b. Usk, Wales, 1768–1819

Paeonia moutan

Watercolour on paper, 346 mm x 418 mm
For *Curtis's Botanical Magazine*, t. 1154 (1809)
Kew Collection

Paeonia suffruticosa is found wild on rocks and cliffs in north-western China, but was commonly cultivated from the 8th century onwards in the east of the country, with Chinese gardeners going to great lengths to protect the young shoots from frost. The first introductions from China were made at the instigation of Sir Joseph Banks, and its importation proved very difficult, with most plants failing to survive the voyage.

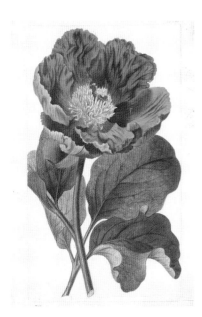

Sydenham Edwards, b. Usk, Wales,
1768–1819

Paeonia daurica

Watercolour on paper, 346 mm x 418 mm
For *Curtis's Botanical Magazine*, t. 1441 (1812)
Kew Collection

Paeonia daurica is a herbaceous species,
found wild from Bosnia to the Crimea
and in Turkey; introduced to England in
the late 18th century.

Coral Guest, b. London,
England 1955

Peony 'Sarah Bernhardt'

Watercolour on paper, 880 mm x 600 mm
Signed *Coral Guest '93*
Shirley Sherwood Collection

These large double peonies, cultivars of
the Chinese *Paeonia lactiflora*, were long
grown by the Chinese as medicinal plants,
and reached their greatest popularity as
ornamentals in the 11th century. They
were very popular again in Edwardian
gardens in Europe, where their satiny
frilly petals matched the fashions of the
time; this variety was named after the
great actress Sarah Bernhardt by the
French nurseryman Lémoine in 1906.

Sunflowers and Compositae

The huge seventeenth century florilegium, *Hortus Eystettensis*, contains a number of the earliest introductions of American plants to the gardens of northern Europe. Most of these are vegetables and were first cultivated in the warmer climate of Spain, which was closer to that of the Gulf of Mexico, but the colonists in New England found some cultivated plants already grown there, and the giant sunflower was one of these.

The library at Kew has a large collection of paintings by Indian artists, painted for European botanists, the so-called Company School. The sunflower on page 66 is one of the most striking, as the artist has attempted to show both the face of the flower, and the swollen top of the stem at the same time. This was one of the Indian paintings collected by Joseph Hooker while he was director of Kew.

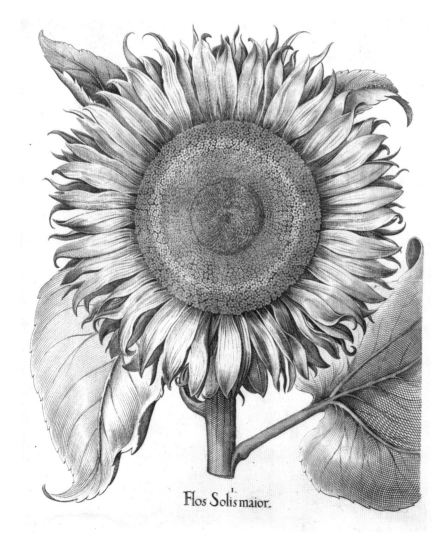

Flos Solis maior.

Basilius Besler, fl. Nürnberg, Germany 1561–1629
Flos Solis maior
Hortus Eystettensis (1613)
Copper engraving, hand-coloured in some copies. 570 mm x 460 mm
Kew Collection
Helianthus annuus

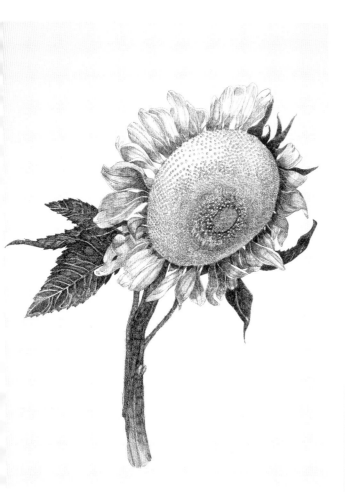

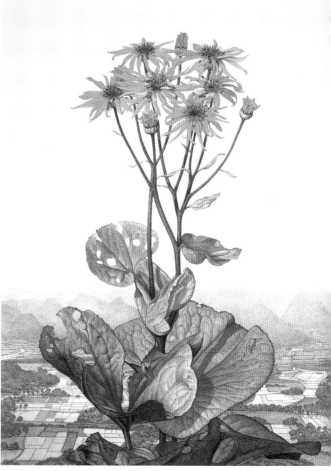

Francesca Anderson, b. Washington
DC, USA 1946
Sunflowers series No. 4

Pen and ink, 690 mm x 580 mm
Unsigned
Shirley Sherwood Collection

Helianthus annuus is the large cultivated
annual sunflower, probably originally
native of south-western North America.
Helianthus giganteus is an equally tall, but
perennial species with smaller flowers,
found in prairies and meadows further
north.

John Wilkinson, b. Northampton,
England 1934
Ligularia clivorum **'Desdemona'**
with silver Y moth and other
insects

Watercolour on paper, 570 mm x 422 mm
Signed *John Wilkinson*
Shirley Sherwood Collection

The genus *Ligularia* contains around 125
species of large, usually late-flowering,
daisies from central Asia to Japan. Many
grow in wet places, including this
Ligularia dentata which is found both in
China and Japan. This dark-leaved
cultivar is called 'Desdemona', perhaps
because it was a sister seedling to
'Othello'. The silver Y moth (*Autographa
gamma*) is a common autumn migrant to
the British Isles, and feeds mainly in the
daytime. In warm autumns there may also
be a second generation.

Company School
Artist and date unknown
Sunflower
Watercolour on green laid paper,
430 mm x 280 mm
Inscribed: *Helianthus giganteus* Lin: sp. pl.
"Indian Plants" ex Bell. Hook. 1867.
Siraje mukki.
Kew Collection
Helianthus annuus
←

Helianthus giganteus Lin: sp. pl.

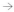

Paul Jones, b. Sydney, Australia
1921–1997
Sunflower
Acrylic on paper, 700 mm x 510 mm
Signed *Paul Jones '78*
Shirley Sherwood Collection
Helianthus annuus
→

Thistles

Barbara Regina Dietzsch (1706–1783) and Johann Christoph Dietzsch (1710–1769), her brother, were painters in Nürnberg; Johann was also a landscape painter, engraver, and etcher. Both appear to have painted flowers on a dark brown background and thistles with butterflies were among their favoured subjects, so it is difficult to be certain which sibling painted this picture as well as the one on page 236. There are similar paintings to the ones shown here in the Fitzwilliam Museum in Cambridge.

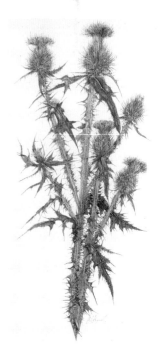

ONOPORDUM *Arabicum. Sp. Pl. 1159.*

Simon Taylor, b. England fl. 1760–1777
Onopordon arabicum
Watercolour on paper laminated to an album page,
615 mm x 455 mm
Inscribed *Onopordum arabicum* Sp. Pl. 1159
Kew Collection

Onopordon acanthium is a common weed of dry places throughout Europe.

Helen Haywood, b. London, England 1964
Thistle
Watercolour on paper, 330 mm x 180 mm
Signed *H A Haywood* (undated)
Shirley Sherwood Collection

Cirsium vulgare, spear thistle, is common in meadows and waste places, even growing along roads high in the mountains of Scotland.

Johann Christoph Dietzsch, b. Nürnberg, Germany 1710–1769
Thistle with butterflies
Watercolour and bodycolour on prepared vellum, 288 mm x 207 mm
Shirley Sherwood Collection

Onopordon arabicum, with a female clouded yellow butterfly (*Colias hyali*) and a painted lady (*Vanessa cardui*) and its caterpillar; also a lacewing, a spider and a cardinal beetle. The painted lady is a common migrant to the British Isles from southern Europe. In warm summers it will raise a generation in England, the larvae feeding on various thistles. The plant is draped with a tracery of cobwebs, very characteristic of the Dietzsch family works.

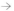 →

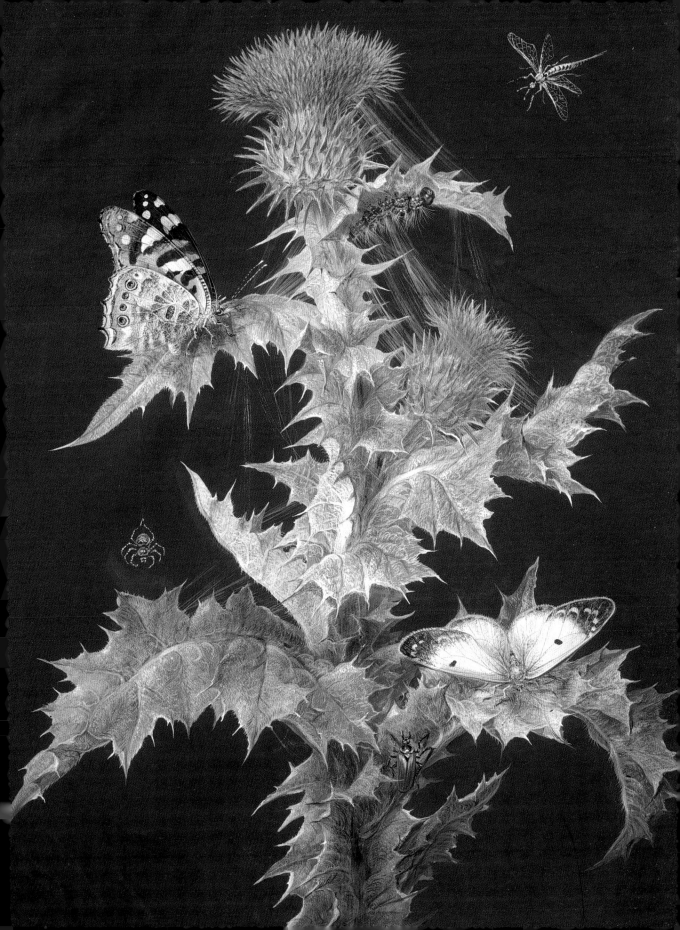

Yellow Granadilla. Passiflora laurifolia 1995

Geraldine King Tam

The age of discovery

Geraldine King Tam, b. Toronto,
Canada 1920–2015
Yellow granadilla: *Passiflora
laurifolia*

Watercolour on paper, 610 mm x 510 mm
Named & signed *Geraldine
King Tam 1995*
Shirley Sherwood Collection

Passiflora laurifolia, the water lemon
or golden apple, is native in the West
Indies and central America, but now
commonly cultivated elsewhere in
the tropics for its fruit.

Climbers

The portrayal of climbers gives the artist the opportunity to fill the page with elegant curling and twisting stems or tendrils, adaptations that enable the plant to climb.

The genus *Passiflora* is one of the few in which all the species are climbers; they are found primarily in the Americas, growing on the margins of forest, or sometimes into the tops of huge trees. Many species of passion flower are hosts to butterflies of the genus *Heliconius*, and the relationship between flower and butterfly is so involved that some *Passiflora* species have evolved egg-mimicking spots on their leaves, to discourage the female butterflies from laying more eggs.

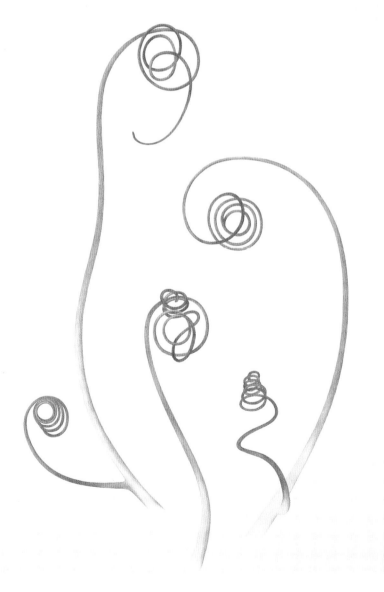

Ann Farrer, b. Melbourne, Australia 1950
Courgette tendrils II
Watercolour on paper, 285 mm x 400 mm
Signed *Annie Farrer 2002*
Shirley Sherwood Collection
←

Georg Dionysius Ehret, b. Heidelberg, Germany, 1708–1770
Granadilla americana
Gouache on vellum, 495 mm x 355 mm
Signed *G. D. Ehret pinxit, 1757*
Kew Collection

Passiflora ligularis sweet or true granadilla, with a swallowtail butterfly. This passion flower, a native of Central America, is widely cultivated for its delicious fruit. It is a subtropical species, growing best at high altitudes in the tropics. The pipevine swallowtail, *Battus philenor*, shown here, is common in North America. It does sometimes visit *Passiflora*, but its larvae feed on various *Aristolochia* species.
→

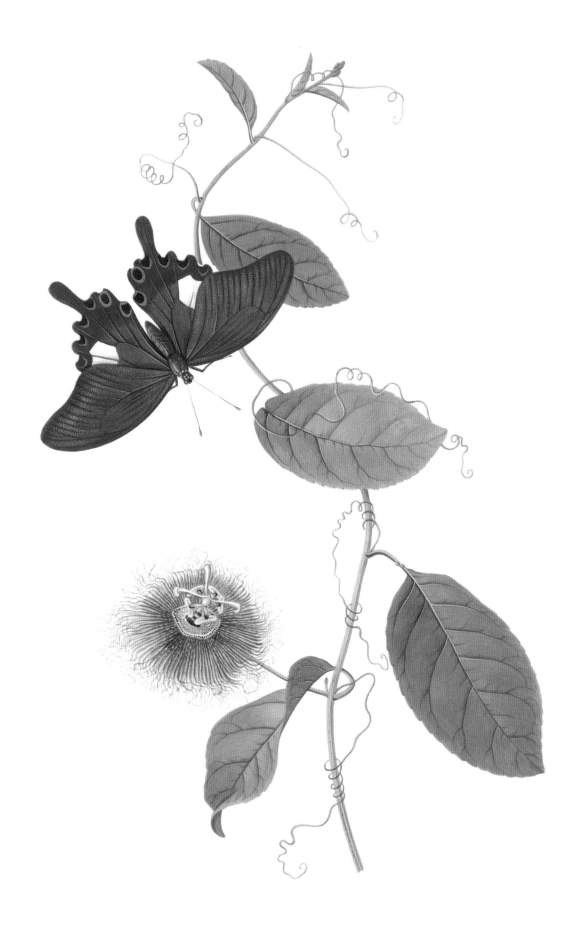

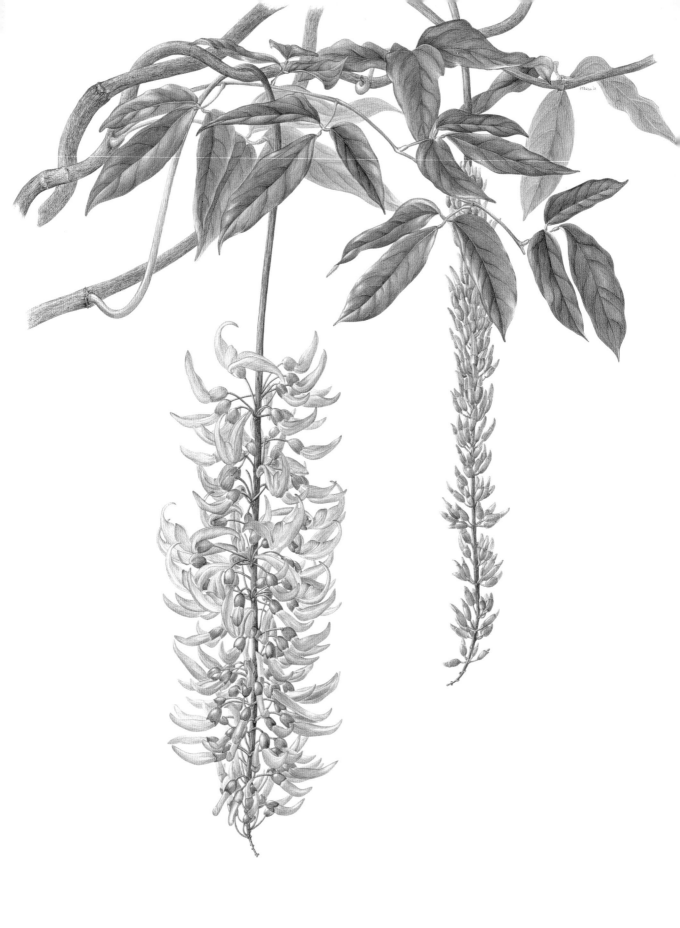

Pauline Dean, b. Brighton,
England 1943–2007
**Jade vine: *Strongylodon
macrobotrys***

Watercolour on paper, 680 mm x 465 mm
Signed *P.M. Dean '01*
Shirley Sherwood Collection

The jade vine, *Strongylodon macrobotrys*
in the family Leguminosae, is a native
of the forests of the Philippines, but
grows well in the Caribbean, and in a
warm humid glasshouse elsewhere.
←

Josephine Hague, b. Liverpool,
England 1928
Morning glory

Watercolour on paper, 310 mm x 360 mm
Signed Josephine Hague 1990
Shirley Sherwood Collection

Ipomoea tricolor is native to Mexico,
but commonly grown as an annual,
flowering in late summer. The pale
blue flowers open at night and, in hot
weather, are dead by the afternoon.

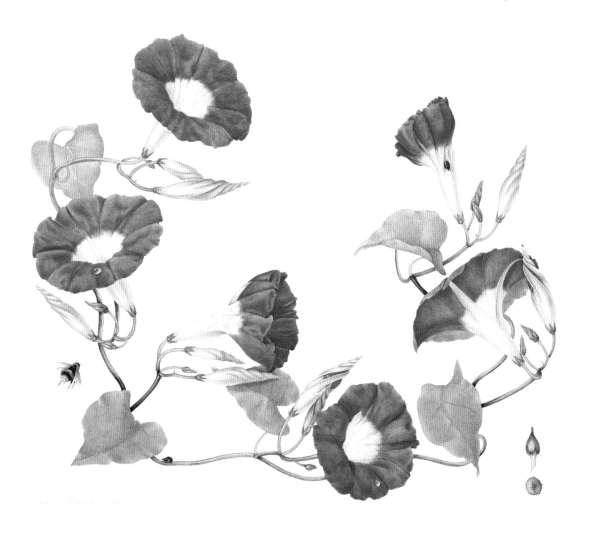

Seiko Kijima, b. Kobe Hyogo, Japan 1948
Akebia quinata **Decne.**
Acrylic and pencil, 545 mm x 385 mm
Signed *Seiko*
Shirley Sherwood Collection

Akebia quinata in the family Lardizabalaceae is an evergreen climber from Japan and China.
→

Pandora Sellars,
b. Herefordshire, England 1936–2017
Glory lily: *Gloriosa rothschildiana*
Watercolour on paper, 280 mm x 370 mm
Signed *Pandora Sellars '90*
Shirley Sherwood Collection

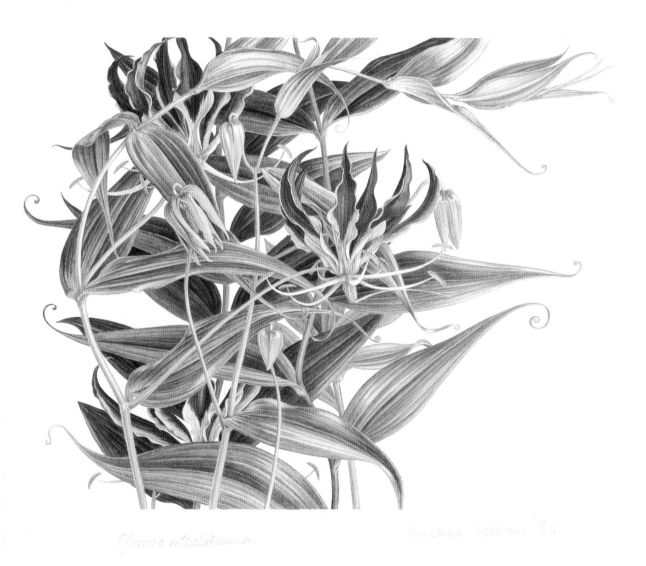

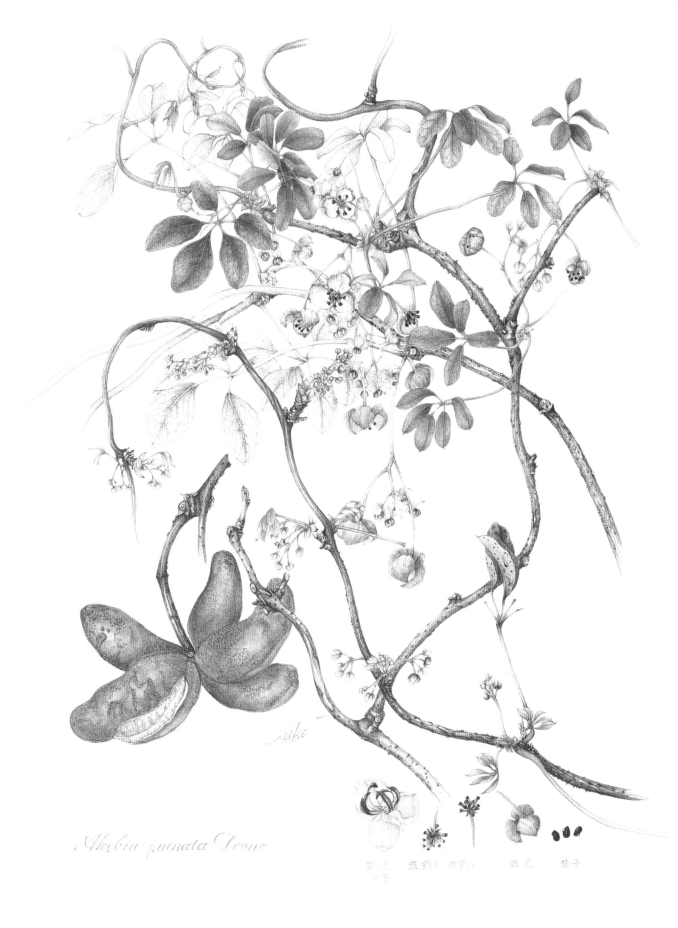

Akebia quinata Decne

雌花　雌ずい　雄ずい　雄花　種子
73

Coral Guest, b. London,
England 1955
Lapageria: *Lapageria rosea* **and
var.** *albiflora*
Watercolour on paper, 770 mm x 570 mm
Signed *Coral Guest '96*
Shirley Sherwood Collection

Lapageria rosea is an evergreen
climber from central Chile, which
grows well in a cool greenhouse or
against a frost-free, shaded wall; the
flowers are usually rich crimson, but
may be pink or white. It is named
after the Empress Joséphine, who
was born Marie Joseph Rose Tascher
de la Pagerie in Martinique in 1763.
Grown by Shirley Sherwood. See
larger reproduction on page 245.

Bryan Poole, b. New Zealand
1953
Three Kings climber:
Tecomanthe speciosa
Copper plate etching, 400 mm x 525 mm
Signed *Bryan Poole – 17/150*
Shirley Sherwood Collection

Tecomanthe speciosa is a temperate
climber of an otherwise tropical
genus, in the Bignonia family; it is
restricted to Three Kings Island, and
was reduced to a single tree before it
was propagated and distributed.

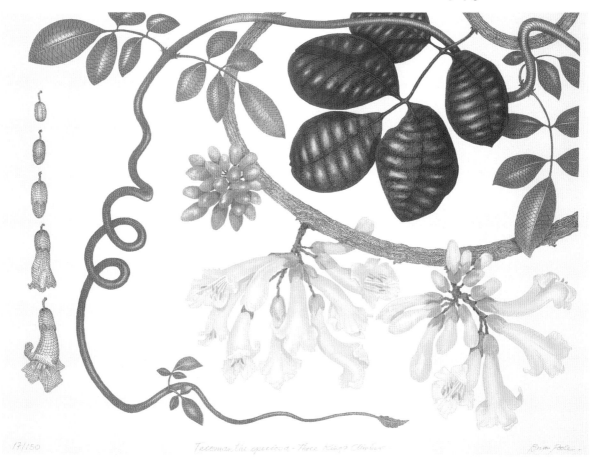

Trees

Ehret's career in England coincided with the introduction of new trees from North America, and two of these were named after his patrons, *Stewartia malacodendron* after John Stuart, Earl of Bute, (unfortunately Linnaeus spelled the name after the other form of the name Stewart) and *Halesia carolina* after the Reverend Stephen Hales. The horse chestnut was still a relatively rare tree when Ehret made the painting on page 81.

Georg Dionysius Ehret,
b. Heidelberg, Germany 1708–1770

Stewartia malacodendron

Watercolour on vellum, 420 mm x 280 mm
Signed *G. D. Ehret pinxit 1764*
Kew Collection

Stewartia malacodendron (Theaceae); this beautiful tree was introduced to Europe from Carolina and first flowered in England in 1742. A drawing was sent to Linnaeus, with a request to name it after John Stuart, Earl of Bute, advisor to Princess Augusta at Kew, and a friend and patron of Ehret.

The work of Ann Ophelia Dowden kept the art of botanical painting alive in America through the middle of the twentieth century, and is a high point in traditional watercolour. She illustrated many books and patiently instructed aspiring artists, while continuing to paint into her nineties.

Martin Allen's geometric unfurling horse chestnut bud recalls the photographs of Karl Blossfeld (1865–1932) who saw plant forms as architectural miniatures, art taken direct from nature. His photographs, published in *Urformen der Kunst* (1928), have inspired later generations of artists and photographers, including Rory McEwen.

Anne Ophelia Dowden,
b. Denver, Colorado, USA 1907–2007

Horse chestnut with flowers and conkers

Watercolour on paper, 415 mm x 345 mm
Signed *Anne Ophelia Dowden*
Shirley Sherwood Collection
Aesculus hippocastanum

Martin Allen, b. Sunderland,
England 1970
Horse chestnut

Watercolour on paper, 495 mm x 720 mm
Signed *M J Allen*
Shirley Sherwood Collection

Aesculus hippocastanum, the horse
chestnut, is rare in the wild, growing
on cliffs in northern Greece. It was
introduced from Istanbul to Italy in
the late 16th century. Until the last
few years it has grown very well, but
it has recently been attacked by both a
leaf-mining moth (*Cameraria
ohridella*), which causes the leaves of
this species to go brown in late
summer, and by a bleeding fungal
canker. Apart from its ornamental
value and use as a shade tree, the
horse chestnut is grown for its nuts
which were used as a tonic for horses
and as conkers by schoolchildren.

Georg Dionysius Ehret,
b. Heidelberg, Germany
1708–1770
Hippocastanum

Watercolour on vellum,
620 mm x 455 mm
Signed *G. D. Ehret pinxit*
Kew Collection
Aesculus hippocastanum

Rory McEwen's *Ginkgo* leaf is part of series of fallen leaves, exhibited in London in 1979 and in Tokyo in 1980; the locality where the leaf was collected formed part of the theme of the painting.

Rory McEwen, b. Berwickshire, Scotland
1932–1982
Ginkgo leaf East 61 Street New York
Watercolour on vellum, 190 mm x 230 mm
Unsigned and undated
Shirley Sherwood Collection

Ginkgo biloba is probably the oldest living species of tree, as its leaves are known from rocks around 170 million years old. It is not known in the wild, but was preserved around temples in China. The orange fruit, which have a rancid smell when ripe, are only produced on female trees. The largest specimen at Kew was planted in 1761, and is mainly male, though the odd branch sometimes bears fruit.

Zhang Tai-Li, b. Jin Zhou, China
1938
Maidenhair tree
Watercolour on paper, 430 mm x 300 mm
Signed with two chops in red and two
Chinese characters in black (painted 1994)
Shirley Sherwood Collection
Ginkgo biloba L.

See larger reproduction on page 271.

Ann Farrer, b. Melbourne,
Australia 1950
Cedar of Lebanon
Watercolour on paper, 550 mm x 680 mm
Signed *Ann Farrer 91/92*
Shirley Sherwood Collection

Cedrus libani is now restricted to a
few groves in the mountains of
Lebanon, but it is common in
southern Turkey. The wonderful, flat-
topped trees, often planted in the
late 18th century, are a feature of
large gardens in Britain.

Ann Farrer, b. Melbourne,
Australia 1950
Swamp Cypress
Watercolour on paper, 490 mm x 690 mm
Signed *Ann Farrer Sept. 1995*
Shirley Sherwood Collection

Taxodium distichum is a tall deciduous
conifer from the southeastern states
of America and Mexico, introduced
to England by John Tradescant the
younger in around 1640. It thrives in
wet places, often forming knob-like
surface roots which stick up above
the water level.

Oaks

The French Royal Court had a tradition, started by Gaston d'Orléans, younger brother of Louis XIII, of collecting botanical and animal paintings. The first outstanding artists to contribute works were Daniel Rabel (1578–1637) and Nicholas Robert (1614–1685). Later Claude Aubriet (1665–1742) and the Dutch artist Gerard van Spaëndonck (1746–1822) continued this tradition, adding to the collection, called Vélins, because they were printed on vellum, until in 1767 there were 70 volumes.

Pierre-Joseph Redouté (1759–1840) was born at St Hubert in the Ardennes, and came to Paris in 1782, and was soon taken up by the wealthy botanist L'Héritier de Brutelle, who instructed him in botany and commissioned numerous illustrations. In 1786 Redouté accompanied L'Héritier on a trip to London, where they visited Kew and were given the use of Sir Joseph Banks's library.

Pierre Joseph Redouté, b. St Hubert, Belgium 1759–1840
Quercus ambigua
Ink and wash on paper, 260 mm x 345 mm
Signed *P.J. Redouté pinx.*
Kew Collection

Michaux's *Quercus ambigua* is now considered a minor variant of *Q. rubra*, the northern red oak, a common tree from New Brunswick to Alabama.

Julie Small, b. Buxton, Derbyshire, England 1948
Turkey oak: *Quercus cerris*
Pencil on paper, 315 mm x 345 mm
Signed *J. A. Small*
Shirley Sherwood Collection

Quercus cerris, the Turkey oak is a magnificent tree, wild in Turkey and commonly planted in northern Europe where it grows very fast. The deeply and irregularly lobed leaves, the spiny acorn cups and the narrow scales around the bud are characteristic of this species.

Pancrace Bessa, b. Paris, France
1772–1835
Quercus discolor, **swamp
white oak**

Ink and wash on paper, 238 mm x 340
mm
Signed *P. Bessa*
Kew Collection

Quercus bicolor, swamp white oak
forms a large tree to 90 m tall, and
grows wild in wet, lowland forest in
the eastern states of America, from
Ontario and Quebec south to
Virginia and Alabama. The largest
leaves can be 180mm long.
 Possibly an illustration for F.A.
Michaux's *The North America Sylva*
(1818–1819); the drawings for the
156 engravings in the book were by
P.J. Redouté and Bessa.

Michiko Toyota, b. Tokyo,
Japan 1952
Seedlings of Oak,
Quercus serrata

Watercolour on paper, 490 mm x 355 mm
Signed *M. Toyota '92*
Shirley Sherwood Collection

Quercus serrata is a deciduous oak,
common in woods in Japan, Korea
and eastern China; this beautiful
painting shows germinating acorns at
various stages of development.

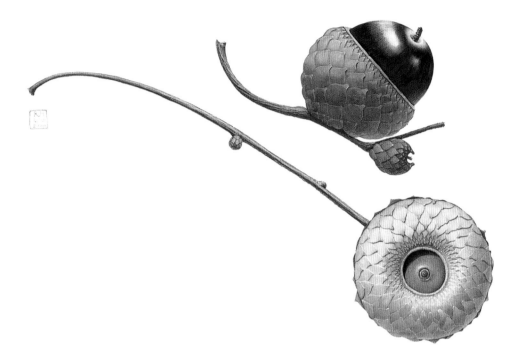

Regine Hagedorn, b. Göttingen,
Germany 1952
Acorns from the Jura: *Quercus robur*
Watercolour on paper (magnified x 3.5),
345 mm x 390 mm
Signed *RH 4.10.2000*
Shirley Sherwood Collection

Quercus robur, the English oak, is a common
tree throughout northwestern Europe; the
long-stalked acorns are characteristic and
distinguish it from the other common
species, *Q. petraea*, the sessile oak, in which
the acorns have very short stalks.

Mieko Ishikawa, b. Tokyo, Japan
1950
Acorns from Brunei
Watercolour on paper, 200 mm x 130 mm
Signed *M. Ishikawa* (undated)
Shirley Sherwood Collection

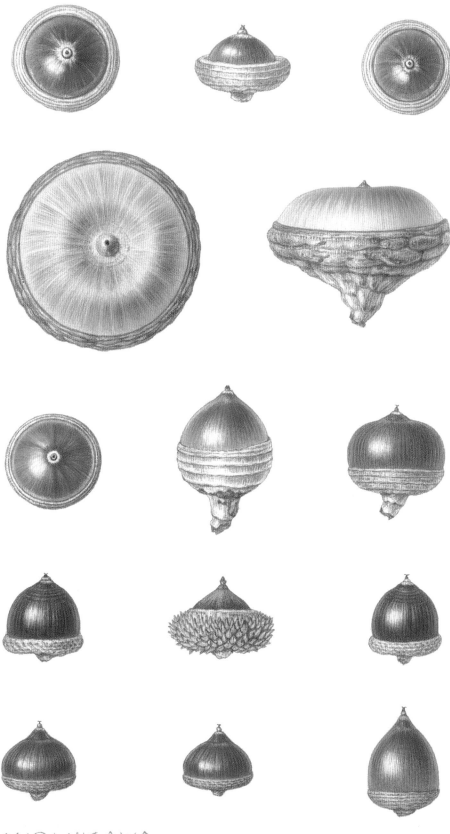

M.ISHIKAWA

Magnolias

From the late eighteenth and throughout the nineteenth century, paintings of flowers were made by Indian and Chinese artists, under the direction of European botanists. Many were commissioned by representatives of the East India Company, either for ornamental or economic interest. These are known as Company School, and large numbers are found in the libraries of Kew, the Natural History Museum,

Siriol Sherlock, b. Nantwich, England 1954
Magnolia campbellii **var.** *mollicomata*
Watercolour on paper, 570 mm x 440 mm
Signed *Siriol Sherlock*
Shirley Sherwood Collection

Magnolia campbellii var. *mollicomata* forms a large tree, often reaching 30 m or more, and particularly spectacular when the leafless tree is covered with pink flowers 25 cm across. The colour varies from white and pale pink, to almost purple. *Magnolia campbellii* var. *campbellii* grows in the Himalaya in eastern Nepal, northern India and Sikkim, var. *mollicomata* in Yunnan and Sichuan. Intermediate populations are found between these two areas.
→

Company School
Artist and date unknown
Talauma
Watercolour on paper, 600 mm x 375 mm
Inscribed: *From Ind. Mus. (Prince of Wales Island) Penang.*
Kew Collection

Magnolia liliifera subsp. *liliifera*. This painting shows the pink bud scales and young leaves, as spectacular as flowers. Probably from the Parry Collection, c. 1810. The tropical genus *Talauma* is now included within *Magnolia*.
←

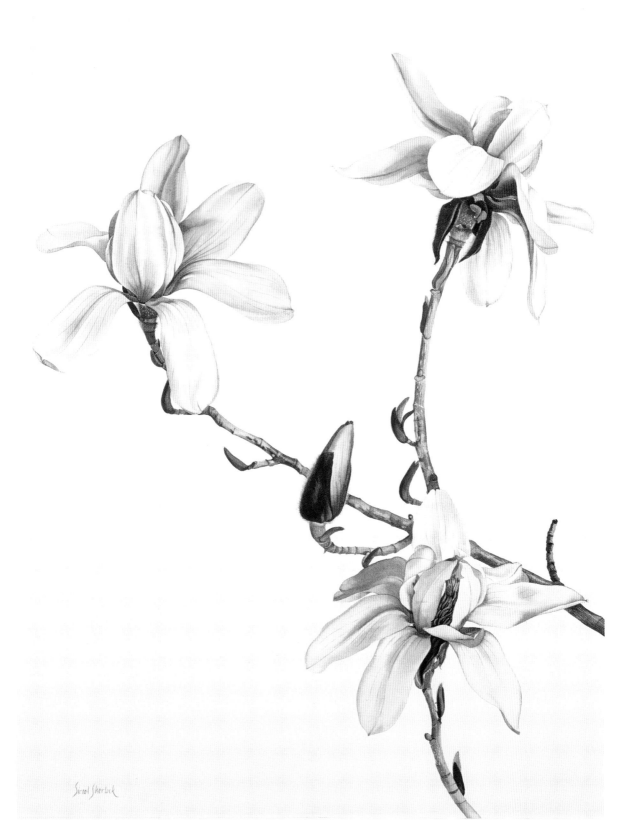

Carol Sherbok

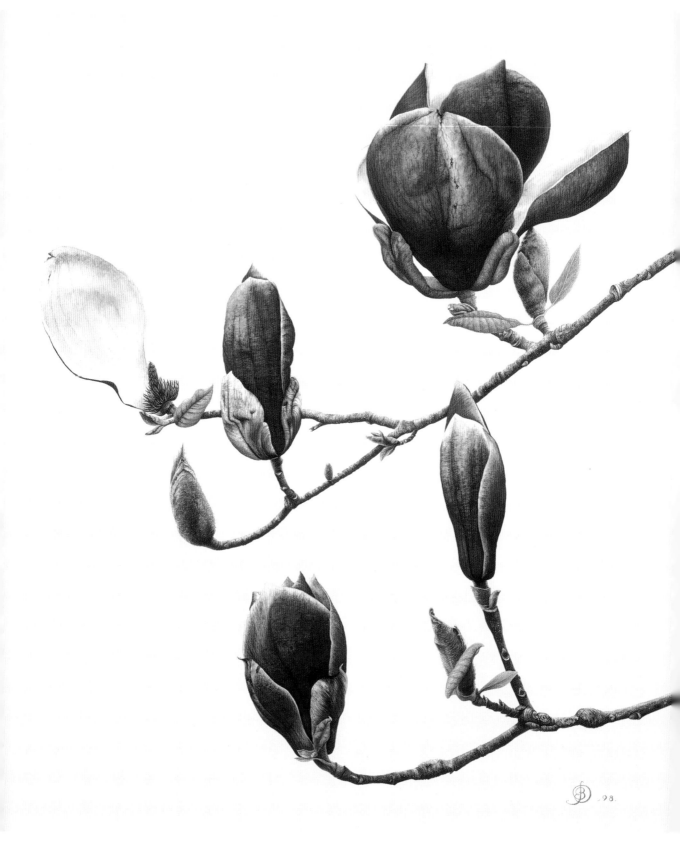

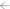

Barbara Oozeerally, b. Poland
1953
Magnolia x *soulangeana*
Watercolour on paper, 430 mm x 350 mm
Signed *BO 98*
Shirley Sherwood Collection
←

the Royal Botanic Garden Edinburgh, and in the India Office (now part of the British Library). Richard Parry, whose collection is at Kew, was Company resident in Sumatra (1807–1811).

J.G. Prêtre arrived in Paris in 1800, and worked there, until his death in 1840, on various projects, painting insects and marine animals, as well as flowers and fruit. This was the period when Paris was full of brilliant botanical artists, many of them associated with the Jardin des Plantes; the Redouté brothers, Bessa, Poiteau and Turpin were all contemporaries.

Paul Jones' naturally hanging branch on the following page is a great contrast to Prêtre's stiff, formal portrait.

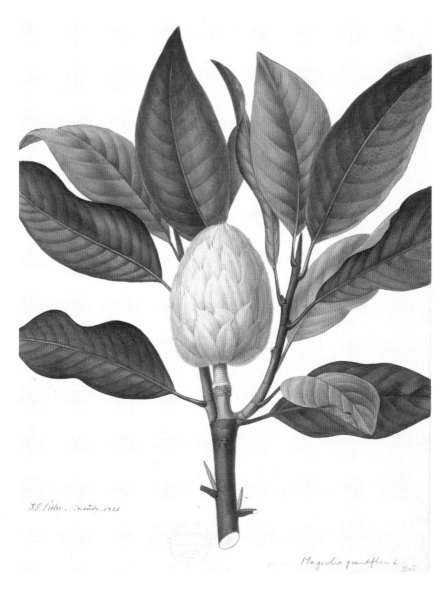

J. G. Prêtre, b. Paris, France fl.
1800–1840
Magnolia fruit
Watercolour on paper, 230 mm x 306 mm
Signed: *J.G. Prêtre. Decembre 1825*
Kew Collection
Magnolia grandiflora
→

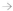

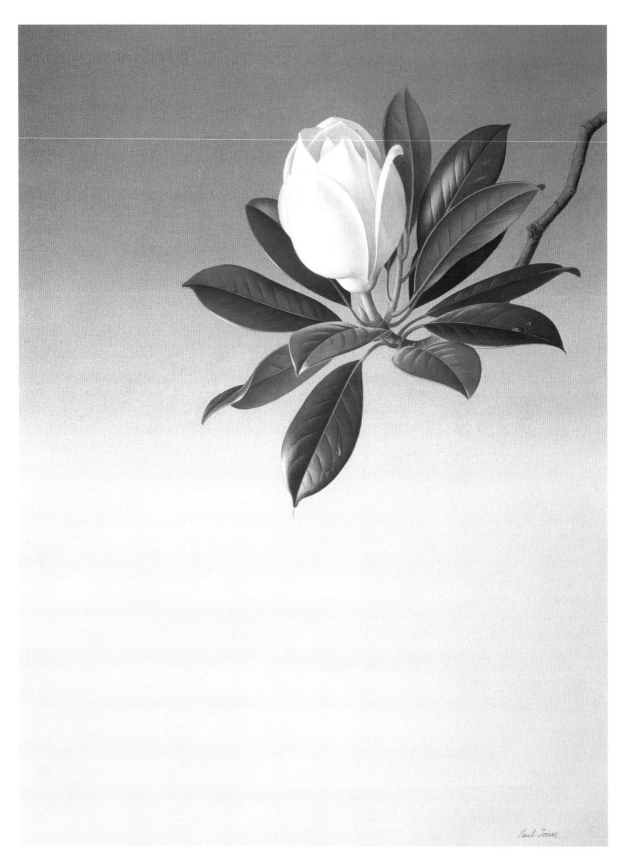

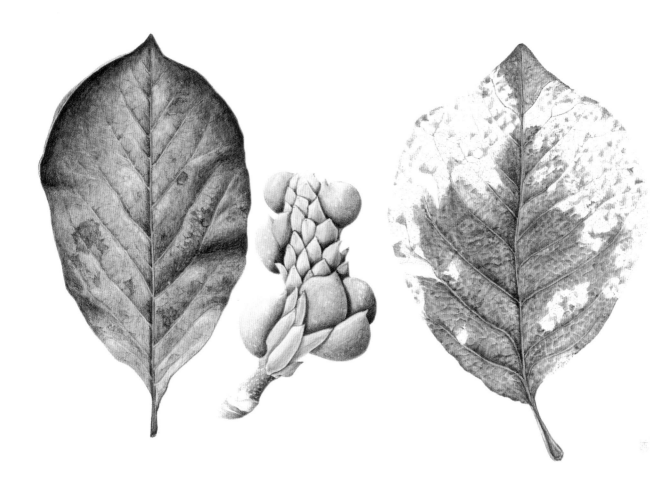

Brigid Edwards, b. London,
England 1940
Magnolia leaves and fruit
Watercolour over pencil on vellum,
180 mm x 250 mm
Signed *BE 87*
Shirley Sherwood Collection

Paul Jones, Sydney, Australia
1921–1997
Magnolia
Acrylic on paper, 710 mm x 540 mm
Signed *Paul Jones* (undated)
Shirley Sherwood Collection

Magnolia grandiflora, the bull bay, is
a native of the warmer south-
eastern states of North America, on
the coastal plain from North
Carolina to Florida and eastern
Texas; it was first grown in Europe
in 1737. The forms shown here have
a particularly beautiful brown
underside to the leaf.

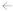

 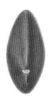

J. G. Prêtre, b. Paris, France fl.
1800–1840
Magnolia seeds
Watercolour on paper, 263 mm x 308 mm
Signed: *J.G. Prêtre. Oct'bre 1822*
Kew Collection
Magnolia grandiflora

Olga Makrushenko, b. Moscow,
Russia 1956
Deep pink Magnolia
Mixed media on paper, 470 mm x 360 mm
Signed *O Makpymenko*
Shirley Sherwood Collection
→

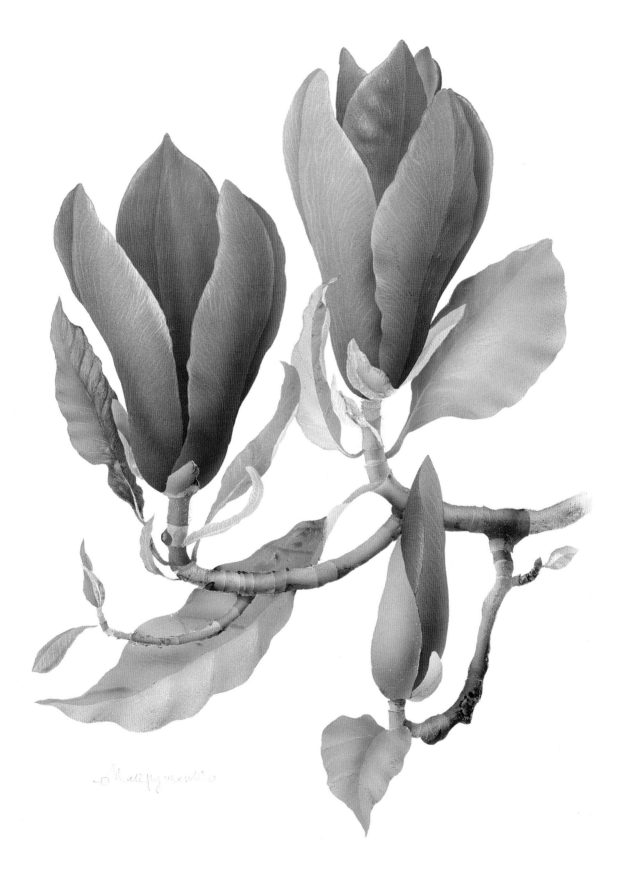

Camellias

Walter Hood Fitch (1817–1892) was trained as a fabric designer in Glasgow, where he was encouraged to paint plants and was trained in botanical illustration by William Jackson Hooker, before he became director of Kew; Fitch followed Hooker to Kew, where he became chief artist, contributing to numerous publications and particularly to *Curtis's Botanical Magazine* in which this painting of *Camellia reticulata* was published in 1857.

Paul Jones (1921–1997) is the most famous Australian flower painter, and camellias were one of his favourites; their smooth shining leaves and formal flowers suited his technique, and a collection of his camellia paintings were published in *Camellia* by E.L. Urquhart and E.G. Waterhouse (1956), as well as *Flora Superba* (1971) and *Flora Magnifica* (1976).

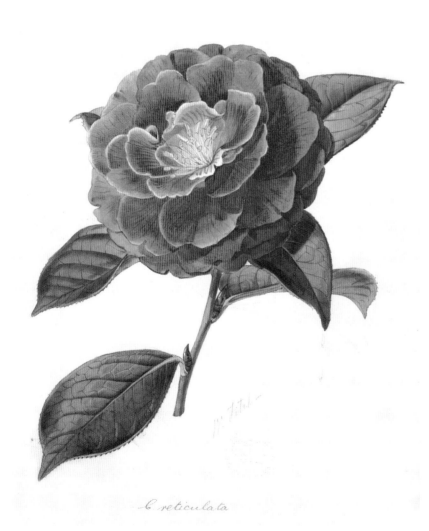

W. H. Fitch, b. Glasgow, Scotland
1817–1892
Camellia reticulata
Watercolour on paper, 315 mm x 260 mm
Camellia reticulata 'Flore Pleno"; original
drawing for *Curtis's Botanical Magazine*,
t. 4976 (1857).
Kew Collection

The first forms of *Camellia reticulata*
to be brought to Europe originated
in gardens in eastern China, brought
by ship from Canton. Later they
were found to have originated in
Yunnan, around the city of
Kunming, where some of the early
cultivars, dating from the 17th
century, are preserved in temple
courtyards.
←

Paul Jones, b. Sydney, Australia
1921–1997
Camellia 'Paul Jones Supreme'
Acrylic on paper, 512 mm x 330 mm
Signed *Paul Jones '77*
Shirley Sherwood Collection

This beautiful, semi-double, striped
camellia was named by E.G.
Waterhouse in 1968.
→

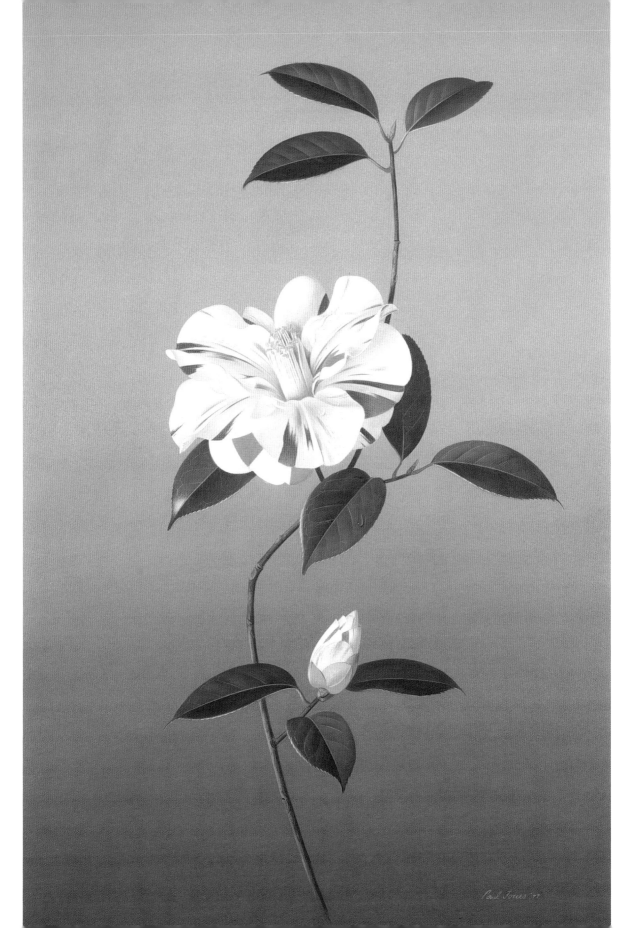

Professor Jinyong Feng worked for many years in the herbarium of the Academia Sinica in Beijing, teaching botanical illustration and providing thousands drawings for *Flora Reipublicae Popularis Sinicae* (1959-1989). He painted them in black ink, using three hairs from a wolf's tail. He is now considered the founder of China's botanical art today.

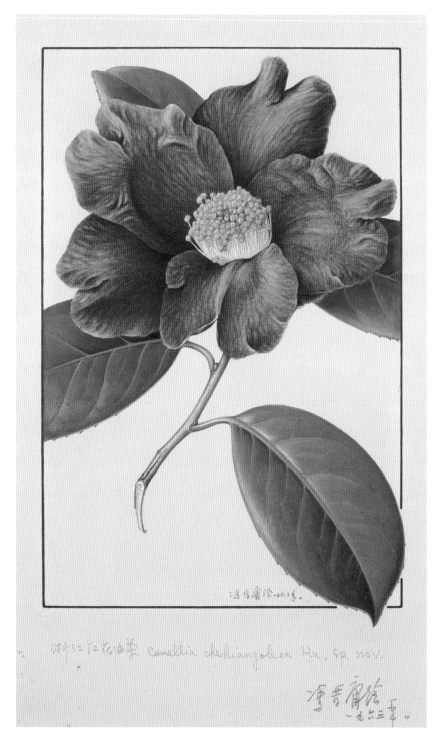

Jinyong Feng, b. Yixing, China 1925
Camellia: *Camellia chekiangoleosa*
Watercolour on paper, 245 mm x 160 mm
Signed with Chinese characters
Shirley Sherwood Collection

Camellia chekiangoleosa is an old cultivated species of great beauty, close to the wild form of *Camellia japonica*. It's seeds are used as a source of edible oil. It is very hardy and will form a large shrub or eventually a small tree.

Paul Jones, b. Sydney, Australia
1921–1997
Camellia 'Sylphide' & violets
Watercolour on paper, 440 mm x 310 mm
Signed *Paul Jones*
Shirley Sherwood Collection

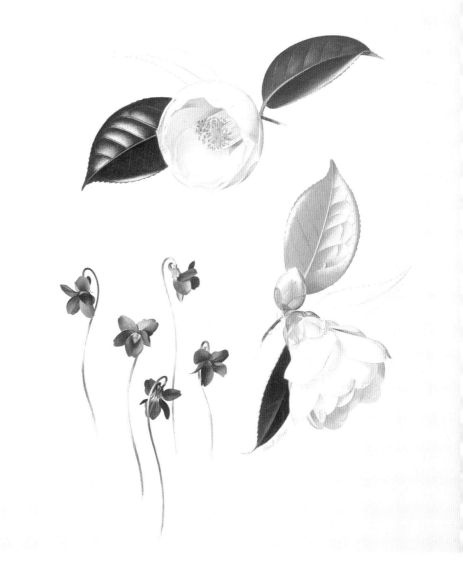

Paul Jones, b. Sydney, Australia
1921–1997
Camellia 'Usu-otome'
Watercolour on paper, 190 mm x 180 mm
Signed *Paul Jones* (undated)
Shirley Sherwood Collection

This is an old formal double variety
from Japan, long cultivated there and
in Europe where it is sometimes
called 'Frau Minna Seidel' or 'Pink
Perfection'.

Cherry blossom

Cherry blossom, Zakura, has special significance in Japan, associated with the rise of civilisation, because flowering cherries thrived in the secondary woodland formed after the first civilisation arrived from the west in the seventh and eighth centuries. The spring 'hanami', viewing the flowers, is still a traditional festival in Japan, and an opportunity for the first picnic of the year. Mieko Ishikawa is a brilliant painter of cherry blossom, and these are wonderful examples of her work.

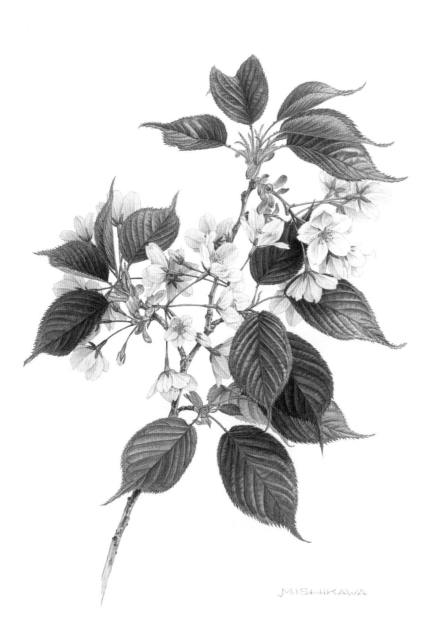

Mieko Ishikawa, b. Tokyo, Japan 1950
White cherry blossom: Oshima Zakura (*Prunus lannesiana* Wilson var. *speciosa* Makino)
Watercolour on paper, 370 mm x 260 mm
Signed: *M. Ishikawa* (undated)
Shirley Sherwood Collection

Prunus serrulata var. *speciosa* Oshima cherry, is a beautiful, large-flowered variety from the island of Oshima, and nearby islets and peninsulas near Tokyo. Other varieties of *Prunus serrulata* are common across Honshu and southern Hokkaido, and are the wild parents of many of the large-flowered Japanese cherries.

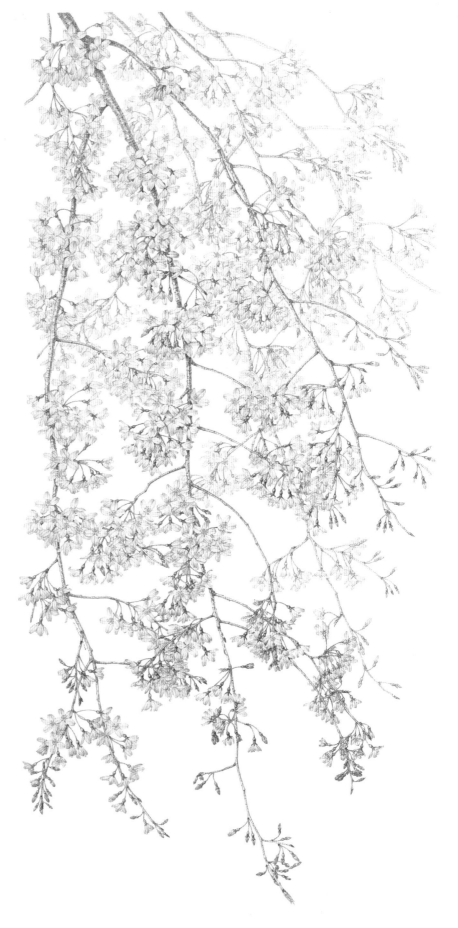

Mieko Ishikawa, b. Tokyo,
Japan 1950
Flowering cherries: *Prunus*
pendula **'Pendula-rosea'**

Watercolour on paper on board,
875 mm x 425 mm
Signed: *Meiko Ishikawa*
Shirley Sherwood Collection
Prunus pendula 'Pendula-rosea' or
'Beni-shidare'

Prunus pendula is a weeping, early-
flowering cherry, found scattered
through the mountains of Honshu.
It is thought to be the parent, with
Prunus incisa, of the familiar *Prunus* x
subhirtella. 'Beni-shidare' is a good,
pink form, which eventually forms a
large tree. The tree needs careful
training when young to produce the
wonderful sprays of flowers as
shown here.

Rhododendrons

Joseph Hooker's most important journey, from the horticultural point of view, was to the Himalaya in Sikkim in 1848. He reached Calcutta in January and spent most of the year in east Nepal and Sikkim, collecting seed of many new species of rhododendrons. The hardier ones were grown at Kew; the more tender ones sent to milder gardens on the west coast of England and Scotland, thus starting the fashion for woodland gardens. Hooker sent partly-coloured field sketches from India to his father at Kew, and from these W. H. Fitch lithographed the illustrations for *The Rhododendrons of Sikkim-Himalaya* (1849).

P. N. Sharma, b. Dehra Dun, India 1922
Rhododendron wightii
Gouache on paper, 580 mm x 440 mm
Signed *P. Sharma 1993*
Shirley Sherwood Collection

Rhododendron wightii, found in eastern Nepal, Bhutan and southeast Tibet, commemorates Robert Wight (1796–1872), one of the most prolific botanists to study the Indian flora, and the subject of a recent study by Henry Noltie (2007).
→

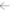

Rhododendron falconeri, Hook.f.

W. H. Fitch, b. Glasgow, Scotland 1817–1892
Rhododendron falconeri
Watercolour on paper, 240mm x 210 mm
For *Curtis's Botanical Magazine* t. 4924 (1856)
Kew Collection
←

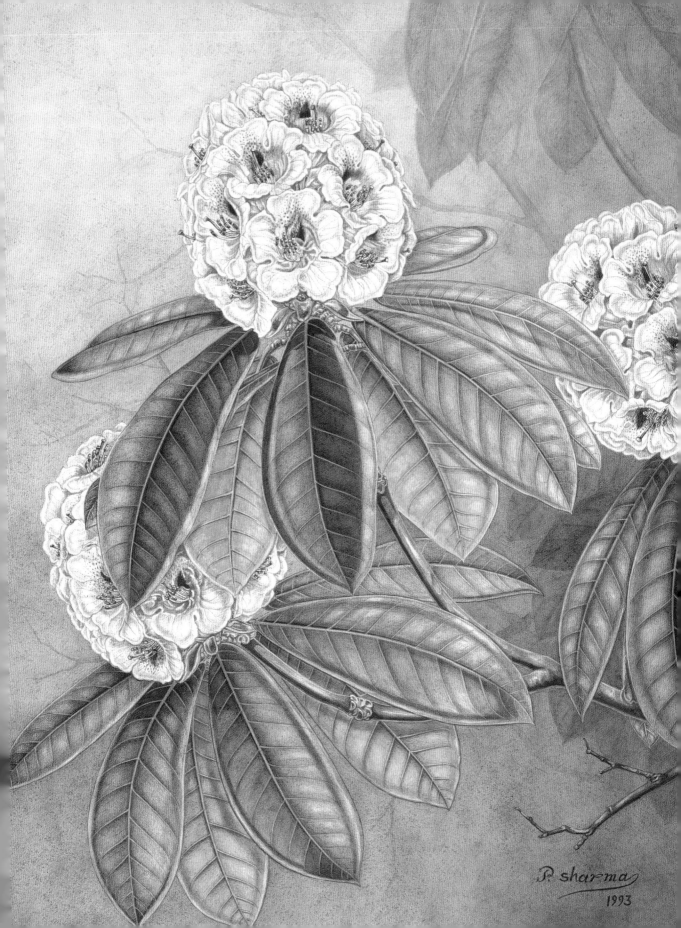

P. sharma
1993

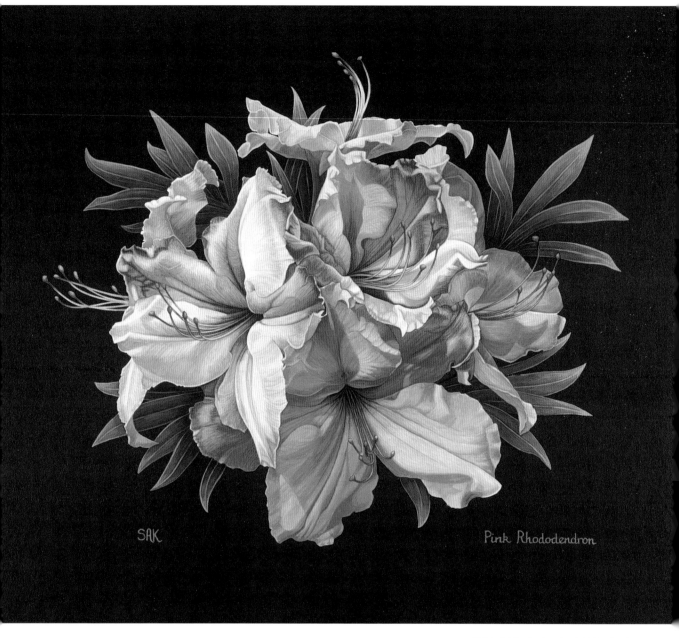

Sally Keir, b. Scotland 1938–2007
Pink rhododendron
Gouache on board, 330 mm x 380 mm
Signed *SAK* (undated) *Pink Rhododendron*
Shirley Sherwood Collection

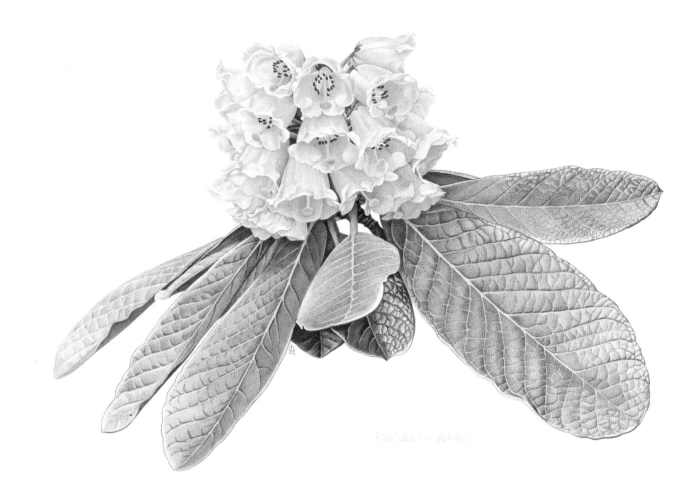

Lawrence Greenwood,
 b. Todmorden, England 1915–1998
Rhododendron: *Rhododendron falconeri*

Watercolour on paper, 335 mm x 455 mm
Signed *LG Rhododendron falconeri*
Shirley Sherwood Collection

Rhododendron falconeri was discovered by Joseph Hooker in 1848 and named in honour of Hugh Falconer, superintendent of Calcutta Botanic Garden and professor of botany at Calcutta Medical College, from 1848 to 1855.

Roses

Ann Lee (1753–1790) was the daughter of the nurseryman James Lee of Hammersmith (1715–1795), who was in partnership with John Kennedy (1759–1842). The Vineyard Nursery, as it was called, thrived between 1780 and around 1890, introducing many new plants to cultivation, particularly from the Cape, America, Australia and from China. The Empress Joséphine ordered roses and other plants from Lee and Kennedy in 1807 and in 1810 a special passport was issued so that her order could pass through the British Naval blockade of the French ports. Ann Lee was a pupil of Sydney Parkinson, and a skilful flower painter, who might be better known had she not died so young.

Ann Lee, b. Hammersmith, Middlesex, England 1753–1790
Moss rose
Red chalk on laid paper,
308 mm x 242 mm
Kew Collection

Moss roses arose as mutants of varieties with ordinary thorns. They were first recorded in around 1650, and became very popular in rose collections. There are two main groups, the Damask mosses, and the mossy *Rosa* x *centifolia*, which is probably the one shown here.

The Hon. Mrs Thomas Hervey
b. England, (before 1729)
Roses

Watercolour on heavy paper, 352 mm x
258 mm
Inscribed: *Painted 1800 by the Hon'ble Mrs
Thomas Hervey, given by her to the
Countess of Pontiville.*
Kew Collection.

The Hon. Thomas Hervey, (1699–
1775) was son of the 1st Earl of
Bristol, MP for Bury St Edmunds
and an equerry to Queen Caroline
(d. 1737). His wife Anne, née
Coughlan was born in the late
1720s.

The roses shown here are a pink
moss rose, *Rosa* x *centifolia* 'Muscosa',
and a dark purple *Rosa gallica*, possibly
'Rose des Maures'.

Raymond Booth, b. Leeds, Yorkshire, England 1929
Rosa moyesii

Oil on paper, 610 mm x 430 mm
Signed *R.C. Booth 1988*
Shirley Sherwood Collection

Rosa moyesii was collected by the
ornithologist and entomologist
Antwerp E. Pratt near Kanding in
western China and named by E.H.
Wilson after the Revd J. Moyes, a
missionary in China. In the wild it
forms a large bush, growing in hedges
and hanging over mountain streams;
there is great variation in colour, from
pink to crimson, and the bright red
flowers of the cultivar 'Geranium' are
most unusual. Apart from the bright
flowers, this species is also grown for
its large bright red hips. See larger
reproduction on page 2.

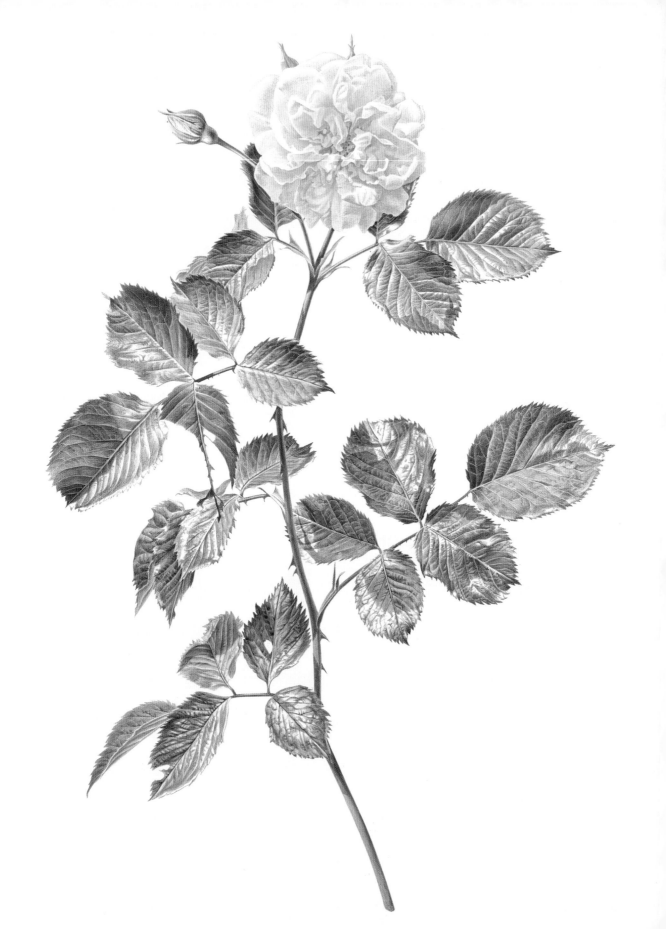

Rory McEwen, b. Berwickshire,
Scotland 1932–1982
Study of a yellow rose
Watercolour on vellum,
570 mm x 470 mm
Signed *Rory McEwen 1977–8*
Shirley Sherwood Collection
←

Rory McEwen, b. Berwickshire,
Scotland 1932–1982
**Old fashioned rose, beech
mast & clover leaf**
Watercolour on vellum,
545 mm x 695 mm
Signed *Rory McEwen* painted 1974
Shirley Sherwood Collection

The rose is, perhaps, President de
Sèze, a gallica introduced in 1828.

Regine Hagedorn,
b. Göttingen, Germany 1952
Rosiers 2000

Watercolour on paper, 497 mm x 357 mm
Signed *RH 15.1.2000*
Shirley Sherwood Collection
→

Regine Hagedorn,
 b. Göttingen, Germany 1952
Roses (2) 2001

Watercolour on paper, 305 mm x 450 mm
Signed *RH 2001*
Shirley Sherwood Collection

ROSIERS
ROSA ROSACEES

R. INERMIS
MORLETII

R. MACROCARPA

R. PIMPINELLIFOLIA

R. ROXBURGHII NORMALIS

R. CALIFORNICA

R. PENDULINA

HYBRIDE DE R. MOSCHATA
"QUEEN OF MUSK"

RAMEAUX DE L'ÉTÉ RÉCÉDENT
REPRÉSENTÉS EN JANVIER 2000
EN TAILLE RÉELLE

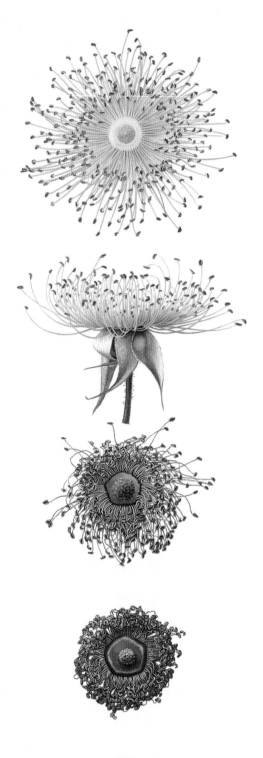

Regine Hagedorn,
b. Göttingen, Germany 1952
Mermaid rose stamens 2002

Watercolour on paper, 240 mm x 150 mm
Signed *RH 2002*
Shirley Sherwood Collection
←

Regine Hagedorn, b. Göttingen,
Germany 1952
Rose 1996

Watercolour on paper, 132 mm x 168 mm
Signed *RH 96*
Shirley Sherwood Collection

Cape heaths

Hills of purple heather are common features of acid soils in England, and cover much of the Scottish hills, where there are great swathes of only three species. The situation is reversed in the Cape region of South Africa, where there are over 600 species, with flowers of all colours, shapes and sizes. Cape heaths had a period of popularity in Europe, as greenhouse plants, in the late eighteenth and early nineteenth centuries, but fell out of favour around 1850, when the emphasis of plant exploration and cultivation turned more towards the humid tropics of Asia and South America. A few species are still sold as winter-flowering pot plants.

Francis Bauer, b. Feldsberg, Austria (now Czech Republic) 1758–1840
Erica mucosa
Hand-coloured engraving, 595 mm x 483 mm
From *Delineations of Exotick plants cultivated in the Royal Gardens at Kew (1796–1803)*.
Shirley Sherwood Collection

Now *Erica ferrea*; this species is found in the Southwestern Cape from Malmerbury to Cape flats.
←

Francis Bauer, b. Feldsberg, Austria (now Czech Republic) 1758–1840
Erica fascicularis
Hand-coloured engraving, 595 mm x 482 mm
From *Delineations of Exotick plants cultivated in the Royal Gardens at Kew (1796–1803)*.
Shirley Sherwood Collection
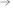

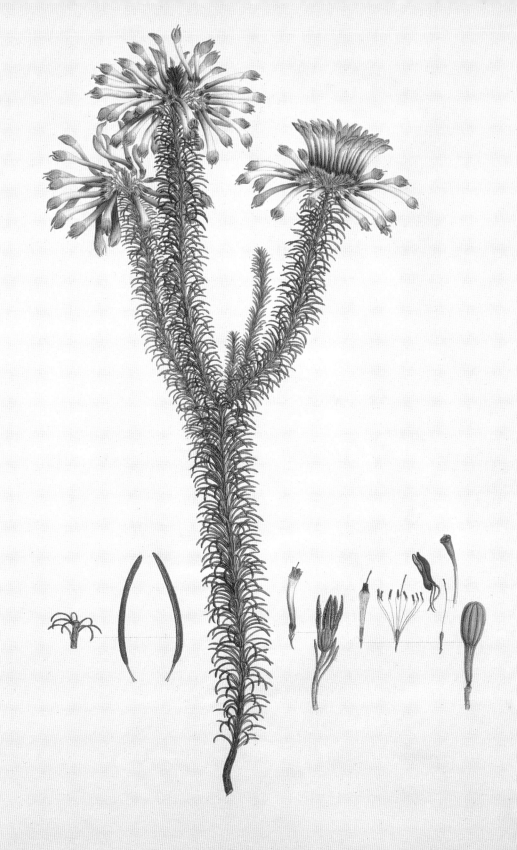

Erica fascicularis.

Franc. Bauer del. Mackenzie sculp.

P. Bessa.

Pancrace Bessa, b. Paris, France
1772–1835
Erica cerinthoides
Watercolour on vellum,
268 mm x 210 mm
Kew Collection

This lovely heather has large red
flowers, and is usually seen
flowering in places which have
been recently burned by a bush fire.
It is also one of the commonest,
growing all over the Cape north
to Lesotho, Swaziland and the
northern Transvaal.

Proteas, Banksias and Proteaceae

The family Proteaceae never reached the same popularity as greenhouse shrubs in the early nineteenth century, as did Cape heaths or pelargoniums. Perhaps this was because they were more difficult to grow, and were intolerant of the phosphate used in fertilisers which were suitable for other plants.

The proteas are some of the most spectacular shrubs or small trees in the Cape, with large artichoke-like heads of small flowers surrounded by decorative, scale-like bracts. Banksias are all Australian, and usually have cone-like or cylindrical heads of small flowers, which are also interesting and unusual when in fruit.

Ann Schweizer, b. Cape Town, South Africa 1930–2014

Protea

Watercolour on paper, 560 mm x 370 mm
Signed *Ann Schweizer* (undated)
Shirley Sherwood Collection

These desiccated flower heads show off Schweizer's distinctive and emphatic watercolour technique.

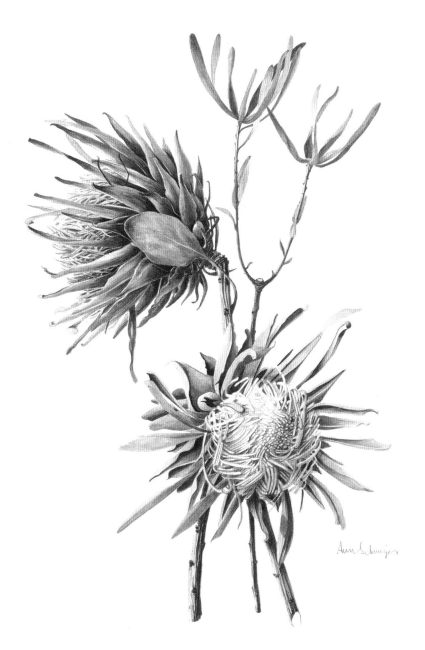

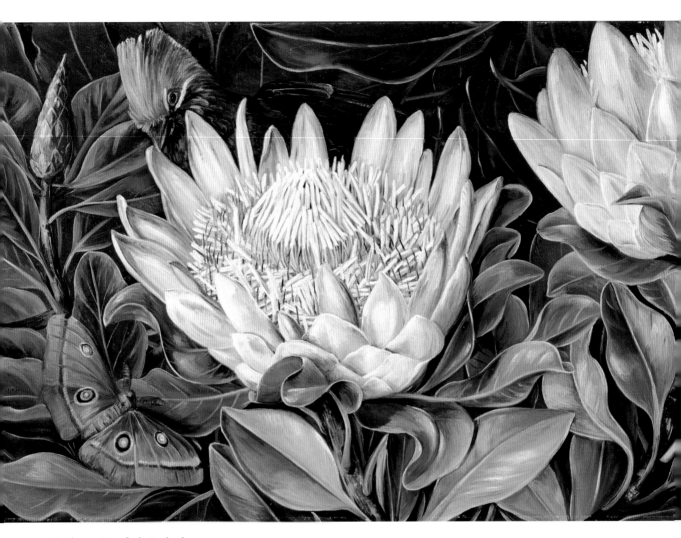

Marianne North, b. England
1830–1890

King protea

Oil on board, 506 mm x 352 mm
Unsigned
Kew Collection

Protea cynaroides has the largest
flower head of all the proteas, and is
also one of the most widespread in
the Cape, from the Cedarberg in the
west to Port Elizabeth and around
Grahamstown in the east.

Peta Stockton,
b. South Africa 1973

Protea coronata

Watercolour on paper, 345 mm x 280 mm
Signed *PS 06/06*
Shirley Sherwood Collection

Protea coronata is found scattered
through the Cape, usually on lower
mountain slopes, and is common on
the Cape peninsula. It forms a sparse
shrub or small tree to 5m tall. The
vivid green of the bracts shown here
looks almost too brilliant – but in
fact the flower is amazingly lurid,
especially after rain.

→

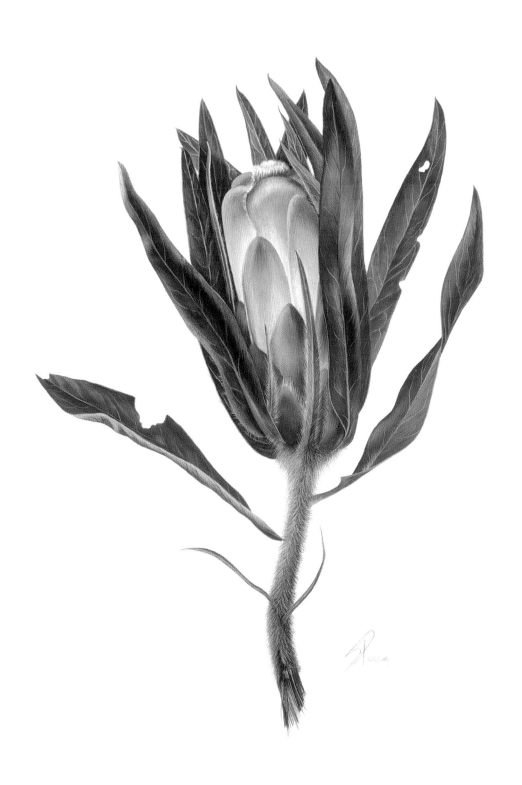

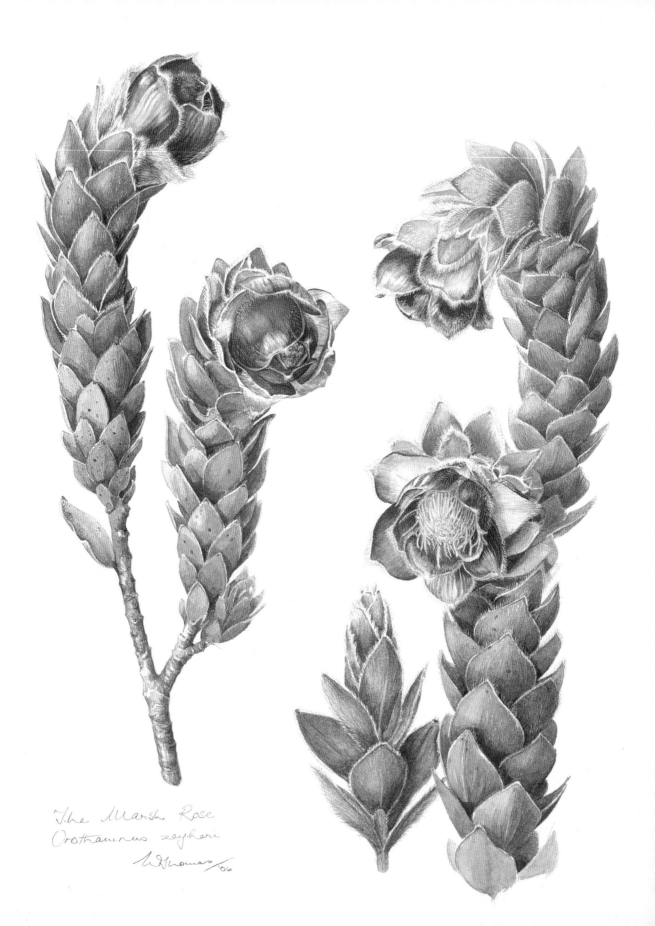

The Marsh Rose
Orothamnus zeyheri
M D Thomas/'06

Brigid Edwards, b. London,
England 1940
Protea 1
Watercolour and gouache over pencil on
vellum, 381 mm x 305 mm
Unsigned and undated
Shirley Sherwood Collection
→

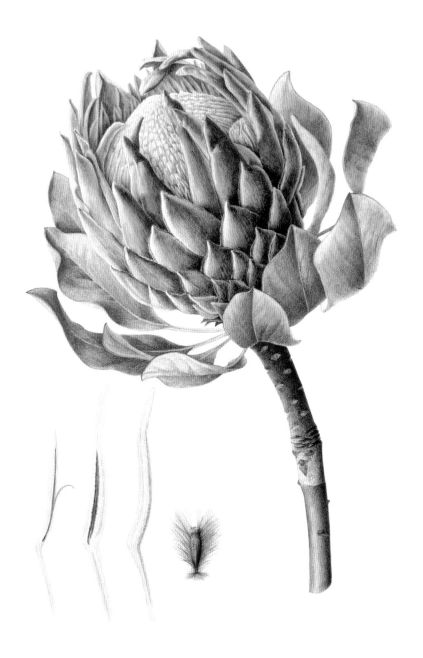

Vicki Thomas, b. South Africa
1951
The marsh rose: *Orothamnus*
zeyherii
Watercolour on paper, 415 mm x 338 mm
Signed *V Thomas '06*
Shirley Sherwood Collection

Orothamnus zeyherii is a rare shrub,
growing on moist slopes in the
mountains from Kogelberg to
Kleinriver.
←

Paul Jones, b. Sydney, Australia
1921–1997
Waratah (unfinished)
Acrylic on paper, 540 mm x 410 mm
Unsigned
Shirley Sherwood Collection

The Waratah, *Telopea speciosissima*, is
a tall shrub, found in eastern New
South Wales, growing in open woods
on moist, sandy soils, particularly on
ridges and plateaux. The large
flower heads are usually crimson,
but pink- and white-flowered forms
are in cultivation. Of the four other
species of *Telopea*, one is found in
Tasmania, one in Victoria and the
other two elsewhere in New South
Wales; the genus is related to the
Chilean *Embothrium*.
→

Marianne North, b. Hastings,
England 1830–1890
Banksia
Oil on board, 354 mm x 508 mm
Unsigned
Kew Collection

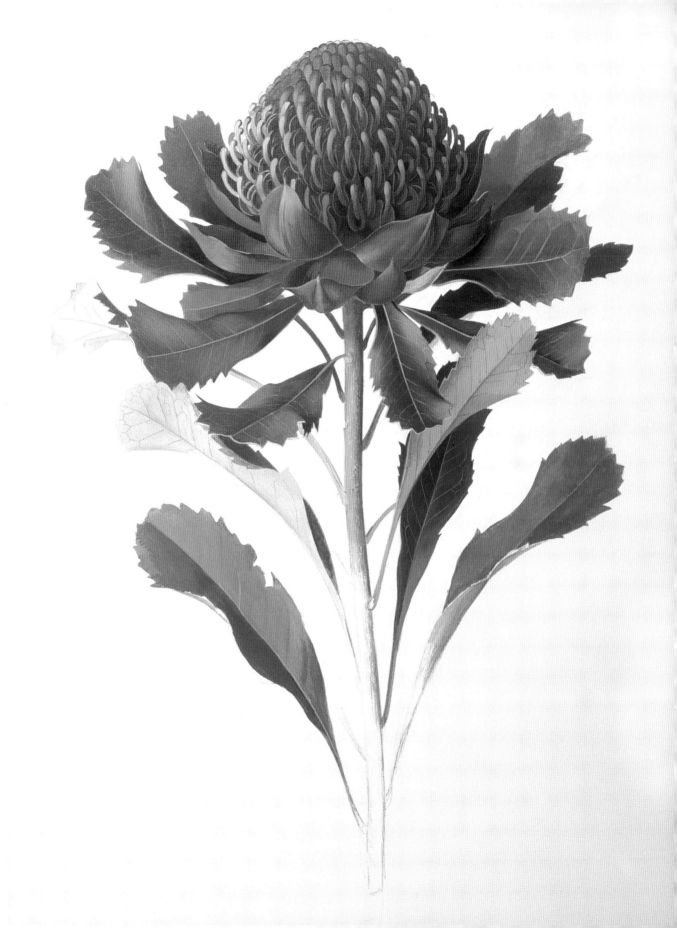

Dawn Undery, b. Cowra, New
South Wales, Australia 1922–2012
Banksia aemula
Watercolour on paper, 510 mm x 370 mm
Signed *Dawn Undery 2002*
Shirley Sherwood Collection

Banksia aemula, the Wallum banksia,
sometimes called *B. serratifolia*, is very
similar to *B. serrata* in its toothed
leaves, but has a blunt and conical
stigma. It is found in Queensland and
New South Wales, often growing in
swampy places. A remarkable
triumph for an 80 year old artist.
→

Celia Rosser, b. Melbourne,
Australia 1930
Saw banksia: ***Banksia serrata***
Watercolour on paper, 760 mm x 560 mm
Signed with her monogram and *Celia
Rosser 1995*
Shirley Sherwood Collection

Banksia serrata, the saw banksia, is
one of the commonest species in
eastern Australia, and one of the first
to be collected by Joseph Banks in
Botany Bay. It eventually forms a tree
to around 20m tall, with large,
cylindrical heads of bluish buds
opening to yellow flowers. It is one
of the easier species to cultivate, and
one of the most widely distributed in
the wild, from Queensland to
Victoria and Tasmania. This is one of
the few examples of Celia Rosser's
work in private hands.
←

Banksia aemula
Dawn Undery 2002

2006

Stella Ross Craig, b. Aldershot,
Hants, England 1906–2006
Banksia serrata
Watercolour on paper, 302 mm x 227 mm
Signed: *S. Ross-Craig* (del.) 14.6.39. Cult.
Roy. Bot. Gard. Edinburgh
Painted for *Curtis's Botanical Magazine*,
t. 9642 (1942)
Kew Collection

See larger reproduction on page 37.
→

Barbara Oozeerally,
b. Poland 1953
**3 Seed heads of *Banksia
menziesii***
Watercolour on paper, 580 mm x 462 mm
Signed *BO 2006*
Shirley Sherwood Collection

Banksia menziesii is a tree-like species
from Western Australia, from Perth
north to Shark Bay. When the
flowers are fully open, the whole
head is golden-yellow. The seed
heads soon lose the dead flowers and
persist as cone-like stems with
scattered fertile seed capsules. In
nearly all banksias the seeds are held
in the capsule until a bush fire causes
it to open and expel the seed.
←

Melastomataceae

The paintings here are of plants belonging to the mainly tropical family Melastomataceae, which can be recognised by its unusual curved stamens, and strongly 5-ribbed leaves.

Walter Hood Fitch (1817–1892) was born in Glasgow, and came with William Hooker to Kew in 1841; he was a most prolific artist, producing over 2,700 paintings for *Curtis's Botanical Magazine*, as well as illustrating numerous other books.

Margaret Ann Eden, b. London, England 1939
Medinilla magnifica
Watercolour on paper,
820 mm x 1000 mm
Signed *M A Eden 2000*
Shirley Sherwood Collection

Medinilla magnifica is an epiphytic shrub growing in wild tropical forest in the Philippines, near Manila; it flowered in cultivation in England for the first time in 1850 and was very popular as a Victorian 'Stove', i.e. hothouse, plant. The much-branched inflorescence hangs down and has very numerous small pinkish flowers are followed by blue, fleshy fruit; the lower whorls of flowers are surrounded by pairs of conspicuous pink bracts.

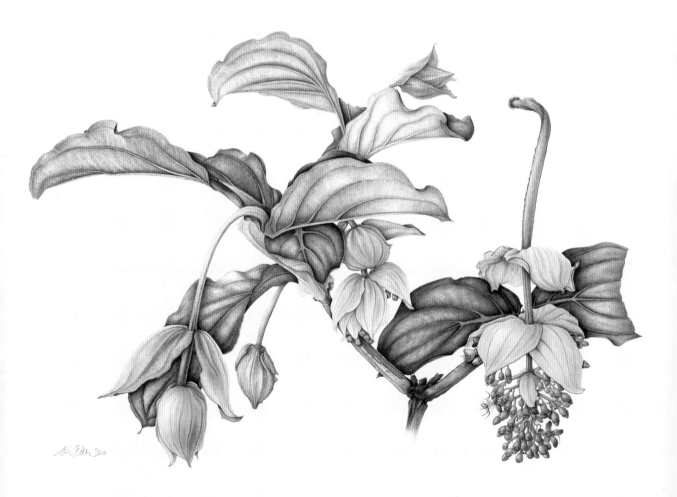

W. H. Fitch, b. Glasgow, Scotland
1817–1892
Pleroma macranthum
Watercolour on paper, 315 mm x 210 mm
Illustration for *Curtis's Botanical Magazine*,
t. 5721 (1868).
Kew Collection

Pleroma semicandrum is a native of
eastern Brazil, in Minas Gerais. Its
beautiful velvety purple flowers, are
produced throughout the summer.
There is much confusion between
this species, *Tibouchina urvillean*a and
T. organensis, all of which are very
similar purple-flowered shrubs. The
unusually shaped stamens show that
this belongs to the mainly tropical
family Melastomaceae.

Lizzie Sanders, b. London,
England 1950
Tibouchina: *Tibouchina
organensis*
Watercolour on paper, 540 mm x 420 mm
Signed *Lizzie Sanders 2001*
Shirley Sherwood Collection

Tibouchina organensis is very similar
to and perhaps the same as *T.
urvilleana*, and originates in the
Organ Mountains, near Rio de
Janiero. Lizzie Sanders has caught
the fabulous blue of the flowers in
this painting.
→

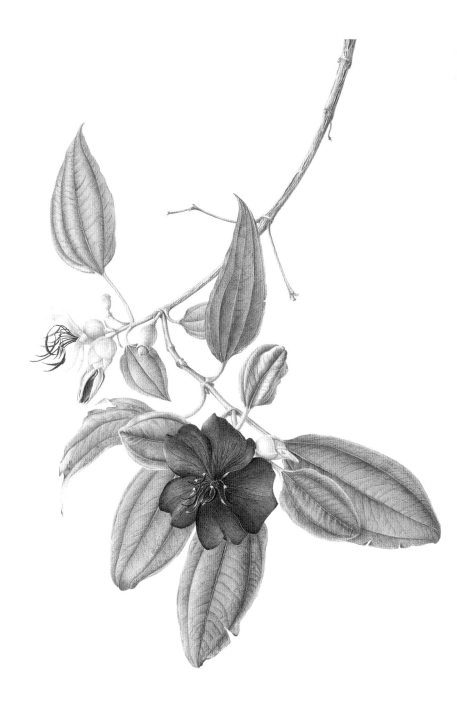

Cacti

Cacti have been popular garden plants ever since they were first introduced from America in the sixteenth century, but the first were either very large, like the prickly pear, or subtropical, like the *Melocactus caroli-linnaei* from the West Indies, which is illustrated in *Hortus Eystettensis*.

One of the first books to cover the cultivation of cacti was *Horti Medici Amstelodamensis Rariorum Plantarum Historia* (history of the rare plants of the Amsterdam physic garden). It was started by Jan Commelin who was director of the garden; part 1 was published in 1697, and part 2 was finished by his nephew Caspar after Jan's death.

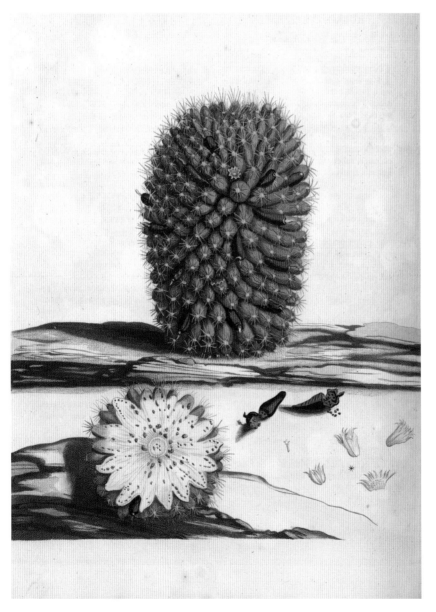

Jan Commelin, b. Amsterdam, The Netherlands 1629–1692
Horti Medici Amstelodamensis Rariorum Plantarum Historia (1697)
Title page, 420 mm x 278 mm
Copper-engraving, hand-coloured
Kew Collection

Flora is shown seated, holding a shield emblazoned with the arms of Amsterdam. The four continents, Europe, Africa, Asia and America offer her bowls of fruit and flowers, which are then distributed to the populace. The ornamental pots, at the foot of the page, contain a pineapple and a succulent *Euphorbia*.
→

Jan Commelin, b. Amsterdam, The Netherlands 1629–1692
Horti Medici Amstelodamensis Rariorum Plantarum Historia (1697)
Cactus mamillaris, 420 mm x 278 mm
Copper-engraving, hand-coloured
Kew Collection

Mammillaria mammillaris grows wild in Venezuela and neighbouring islands. The flowers are small and whitish, followed by fleshy red fruit.
←

HORTI
M E D I C I
AMSTELODAMENSIS
Rariorum
PLANTARVM
HISTORIA.

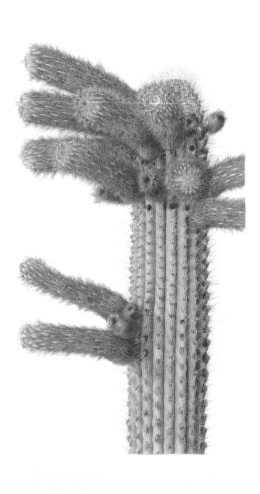

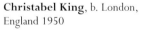

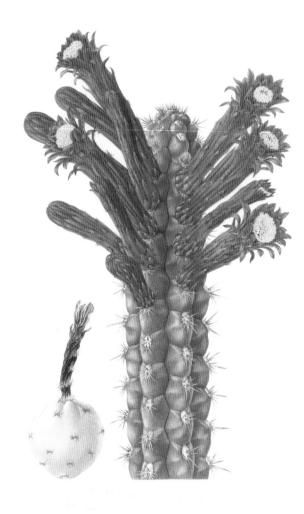

Christabel King, b. London,
England 1950
***Cleistocactus reaci* 1992**
Watercolour on paper, 295 mm x 200 mm
Inscribed: *Cult. R. Mottram 18.7.92.*
Kew Collection

These two paintings were executed
for the Botanical Magazine
monograph of the genus *Cleistocactus*
(in preparation). Most species
originate from Peru, Bolivia,
Argentina, Paraguay and Uruguay,
and the red, tubular, curving
flowers suggest that these cacti may
be pollinated by hummingbirds,
but, apparently, this has never
been observed.

Christabel King, b. London,
England 1950
Cleistocactus fieldianus
Watercolour on paper, 282 mm x 190 mm
Inscribed: *Cult. R. Mottram July 1899, fruit
added Sept. 1988.*
Kew Collection

Christabel King, b. London,
England 1950
Denmoza rhodacantha
Watercolour on paper, 210 mm x 170 mm
Signed *C F King*
Kew Collection.

The genus *Denmoza* comes from the dry
valleys in the Andes in northern Argentina.
→

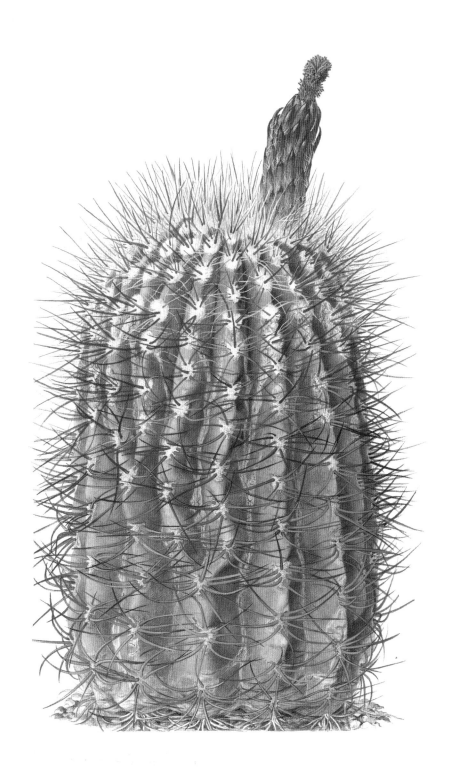

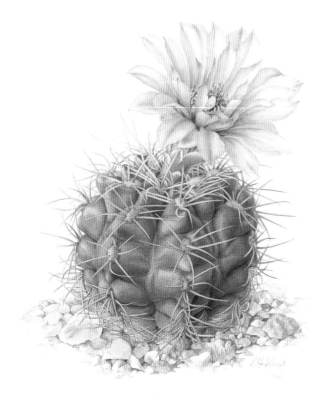

Elvia Esparza, b. Mexico City, Mexico 1944
Echinocereus polyacanthus
Watercolour on paper,
370 mm x 265 mm
Signed *Elvia Esparza,* undated,
painted 2000
Shirley Sherwood Collection

Echinocereus polyacanthus is a beautiful, large-flowered cactus from north-western Mexico; the stems, to 40 cm across, can grow into large clumps
→

Christabel King, b. London, England 1950
Gymnocalcycium* cf. *fleischerianum
Watercolour on paper, 210 mm x 170 mm
Signed *C F King*
Labelled: *Gymnocalcycium* cf. *fleischerianum, Cult C F King 6/8/92*
Shirley Sherwood Collection

Gymnocalycium is a large genus of around 50 species from South America; many species contain the mind-altering alkaloid mescaline.
←

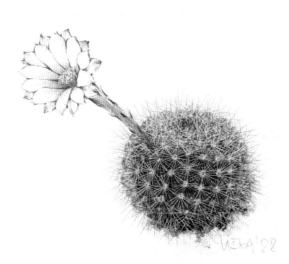

Petr Liška, b. Prague, Czech Republic 1953
Rebutia narvaezensis
Acrylic on paper, 250 mm x 175 mm
Signed *Liška '88*
Shirley Sherwood Collection

Rebutia narvaezensis is a rare, dwarf cactus from the Andes of Bolivia. This painting is Petr Liška's logo.

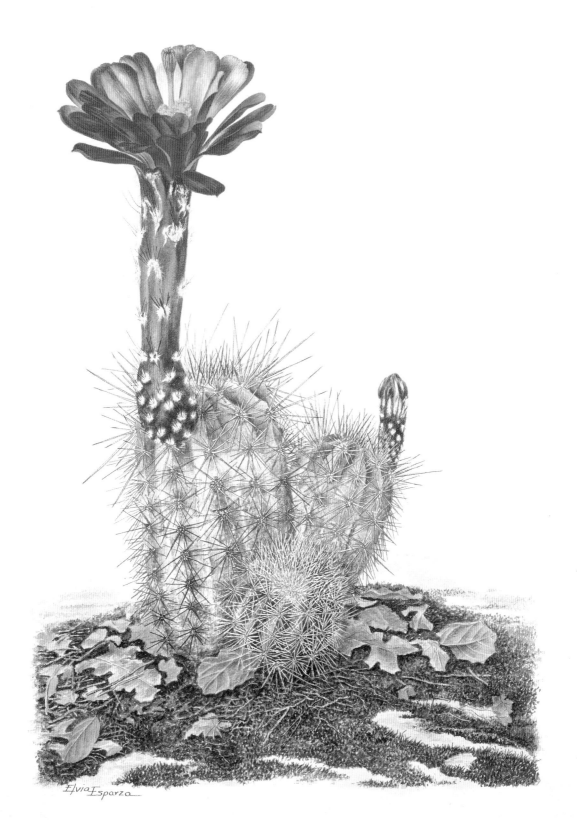

Elvia Esparza

Succulents

Succulents belong to many different families; in America most belong to the Cactus family or the Crassula family; in Africa the Crassula family is also common, but the Mesembryanthemum family is very well represented too. Succulent lily relatives are also frequent, with *Aloe* in Africa, *Agave* and *Yucca* in America. Examples of all these are shown here.

Succulents tend to live in climates which are dry all the year round, and in which rainfall is intermittent and uncertain. Climates with reliable winter rainfall tend

Possibly by Bond or Duncanson, c. 1820s
Pachydendron africanum latum
Ink and watercolour on paper,
500 mm x 325 mm
Unsigned
Kew Collection

Aloe africana, a tree aloe, was one of the earliest aloes to be grown in Europe. It is wild in South Africa, in the eastern Cape, where it forms a single-stemmed shrub.

Peter Brown, fl. 1760–1790s
Crassula orbicularis
Watercolour on vellum, 293 mm x 227 mm
Signed: *P. Brown pinxit.*
Kew Collection

Cotyledon orbiculata is common in the Cape and north to Namibia and the Natal Drakensberg, growing in dry, rocky places, sometimes high in the mountains. The leaves vary from narrow and almost round in section, to flat and wide, as shown here.

Pancrace Bessa, b. Paris, France
1772–1835
Mesembryanthemum linguiforme
Watercolour on velum, 260 mm x 210 mm
Signed: *P. Bessa*
Kew Collection

Glottophyllum linguiforme is found in the Little Karoo, a semi-desert area of the Cape particularly rich in succulents. The family Aizoaceae contains around 1,800 species worldwide, of which a third are found in the Cape.

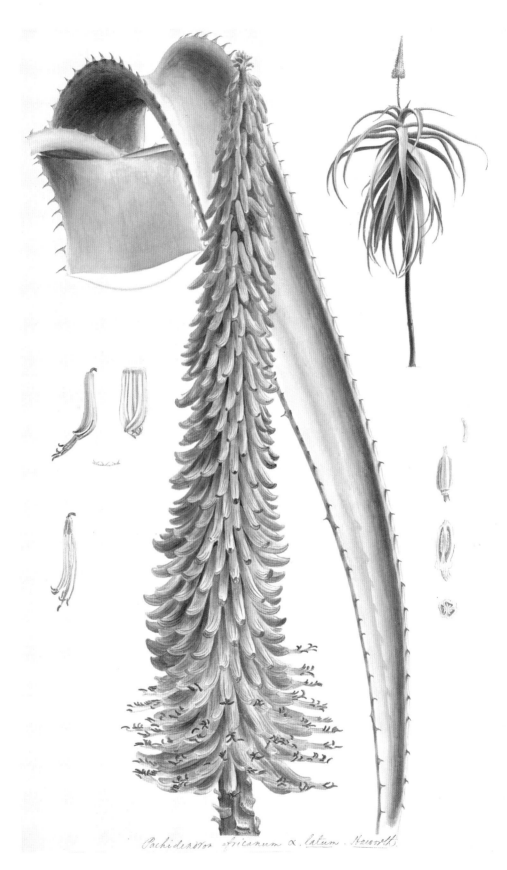

Pachidendron africanum α. latum. Haworth.

to favour bulbous plants or drought-tolerant shrubs. It also seems that it takes many millions of years of dry climate for an area for a rich succulent flora to evolve, and the richest such area is in South Africa. Francis Masson was sent from Kew to the Cape in 1774, and sent back many of the succulents now familiar in cultivation.

Linda Francis, b. Bristol, England 1949
Crassula arborescens
Watercolour on paper, 245 mm x 210 mm
Signed *Linda Francis 1999*
Shirley Sherwood Collection

Crassula arborescens is found wild throughout the Cape, growing on dry, rocky slopes and inland cliffs and forming stout-stemmed, branched shrubs to 2 m tall. The white leaves help it to withstand intense sunlight and its white and pink starry flowers appear in spring and early summer.
←

M. Fatima Zagonel, b. Brazil 1954
Echeveria cante
Watercolour on paper, 705 mm x 500 mm
Signed *M. Fatima S. Zagonel, RBG Kew October 1999. Crassulaceae Echeveria cante. 1999–2161 SHDO*
Shirley Sherwood Collection

Echeveria species are found mainly in California and Mexico. This beautiful species was collected near Mexico City in 1892, and has been cultivated since then, but only recently named, after the Cante Institute near Guanajuato. The leaf rosettes can grow to 30cm across. This was painted while Zagonel was a Margaret Mee scholar at Kew.
→

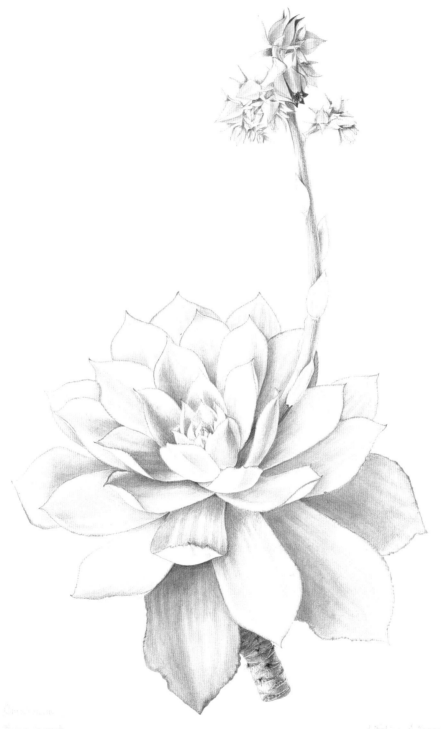

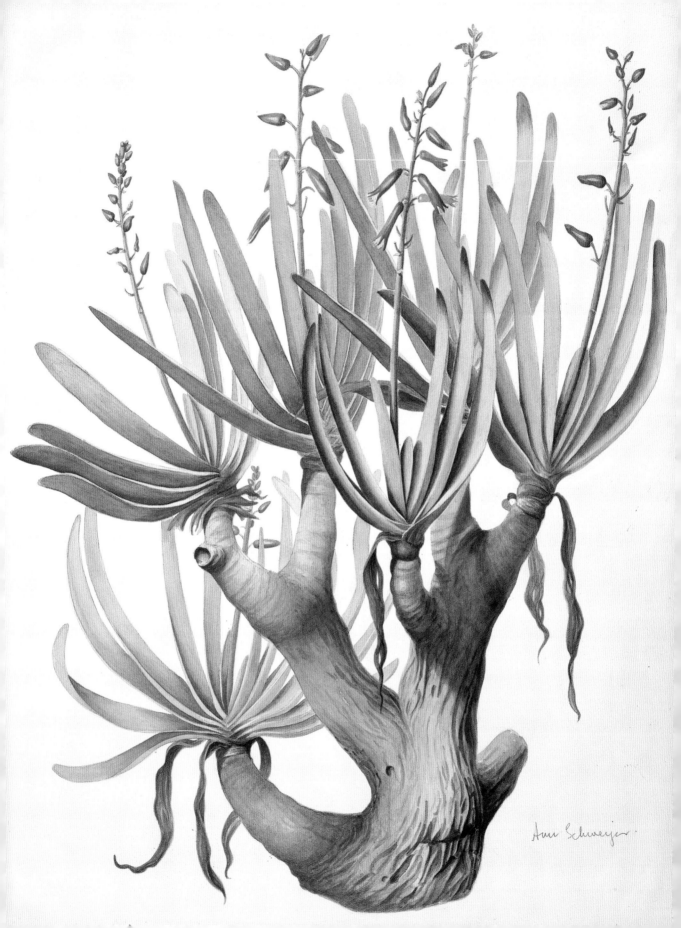

Ann Schweijer.

A. Power, fl. Maidstone,
England 1780–1800
Yucca filamentosa
Watercolour on vellum,
490 mm x 375 mm
Kew Collection

The genus *Yucca* has around 30
species, all in North America. *Yucca
filamentosa* is one of the least
succulent and grows well in
ordinary garden conditions in
Europe. It is found wild from West
Virginia to Florida, growing on
sandy soils. The artist has painted
with great delicacy the curly white
hairs on the leaf margins,
characteristic of this species.
→

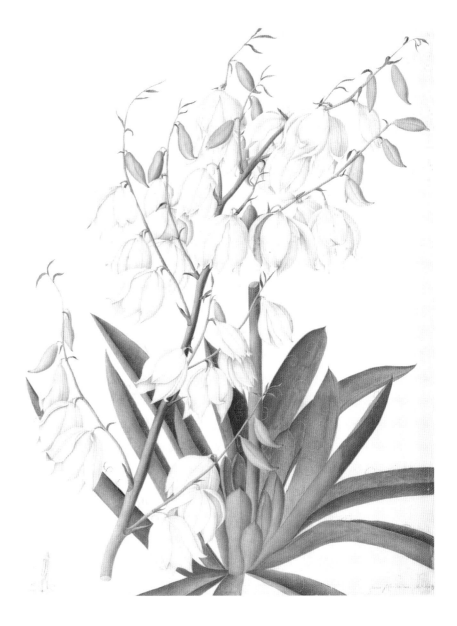

Ann Schweizer, b. Cape Town,
South Africa 1930–2014
Aloe plicatilis
Watercolour on paper, 750 mm x 565 mm
Signed *Ann Schweizer*
Shirley Sherwood Collection

Aloe plicatilis eventually forms a large,
much-branched shrub or small tree to
5m tall and as wide. It is commonly
cultivated in frost-free climates, and
is wild in South Africa, mainly in the
mountains of the western Cape.
←

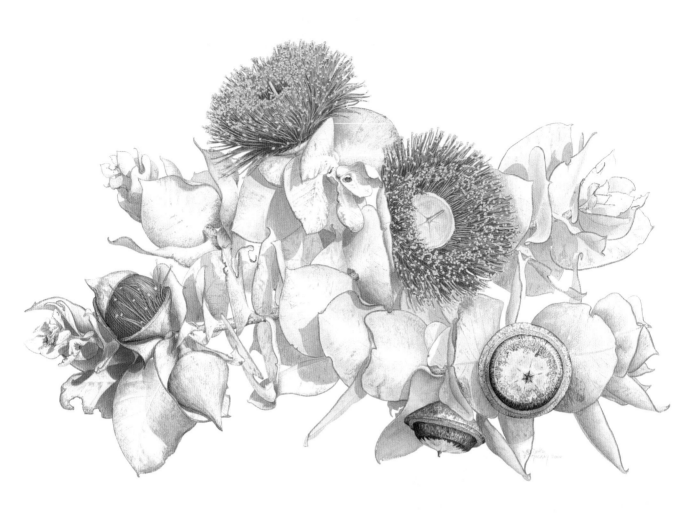

David Mackay, b. Hornsby, New
South Wales, Australia 1958
Eucalyptus macrocarpa
Mottlecah

Acrylic on paper, 750 mm x 735 mm
Signed © *David Mackay 2000*
Shirley Sherwood Collection

Most species of *Eucalyptus* can
survive some drought, but few are as
succulent and well-adapted as this.

Carnivorous plants

Carnivorous plants have evolved the ability to trap and digest insects and other small animals. There is a diversity of structures in different families, and some examples are shown here. Some genera are restricted to one small area, others very widespread, for example, *Drosera,* which is found from Scotland to South Africa, and eastwards to India and Australia.

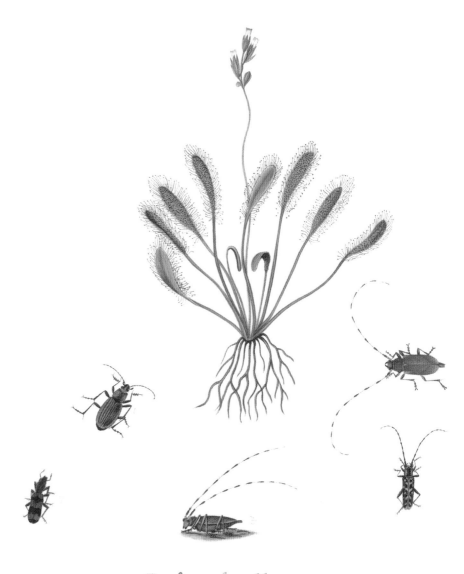

Drosera longifolia.

Thomas Robins the younger,
b. Bath, England 1743–1806
***Drosera longifolia* with beetles**
1774

Watercolour on vellum, 250 mm x 199 mm
Unsigned
Kew Collection

Great sundew, now called *Drosera anglica*, grows in wet, peaty bogs, mainly in western England, Wales, Scotland and Ireland. The two beetles with very long antennae may be females of the Timberman, *Acanthocinus aedilis*; a Longhorn beetle, *Leptura maculata* has a black and yellow wingcases.

Thomas Robins illustrated the wild European *Drosera anglica*, which catches flies with sticky glands on its leaves. Thomas Robins, and his father, also Thomas, were both painters of flowers and landscapes. A surviving series of paintings of Rococco gardens in Gloucestershire was painted by Robins the elder, each embellished by a garland of different exotic flowers; a sketch book which contains the original paintings for some of these is in the Fitzwilliam Museum, Cambridge.

Mariko Imai, b. Kanagawa, Japan 1942
Sarracenia purpurea
Watercolour on paper, 360 mm x 280 mm
Signed *Imai* (days worked on painting and date in Japanese)
Shirley Sherwood Collection

Sarracenia purpurea is found in wet peat bogs and damp rocky places over much of eastern North America, from Newfoundland to Alberta and south to the Gulf coast. The pitchers trap a variety of small animals which are then eaten by midge larvae and other animals living in the water trapped in the pitcher.
→

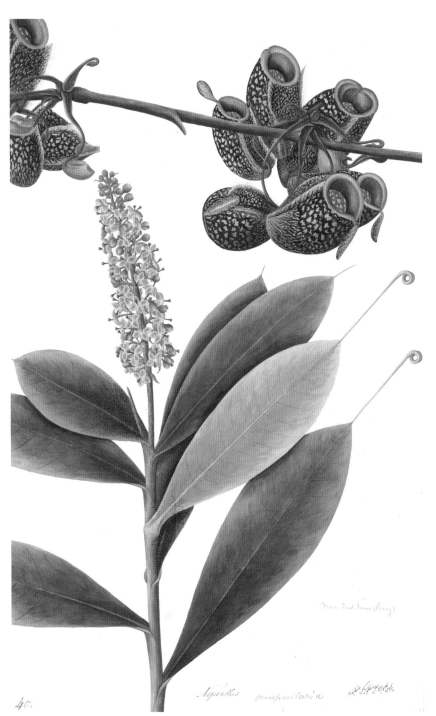

40.

Nepenthes ampullaria

Company School
Artist and date unknown
Nepenthes ampullaria
Watercolour on paper, 475 mm x 293 mm
Kew Collection

This tropical pitcher plant, *Nepenthes ampullaria* is widespread from Malaysia and Thailand to New Guinea, with rather short pitchers, often in clusters, usually half buried in leafmould or moss in openings in the forest. The lid of these pitchers is bent back, so that all sorts of detritus can fall in and be digested.
←

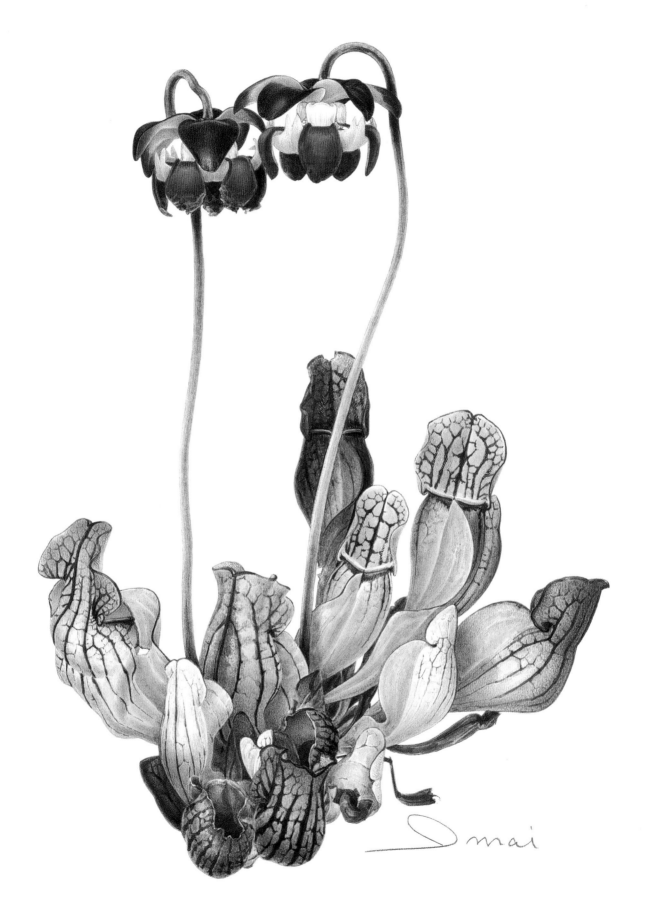

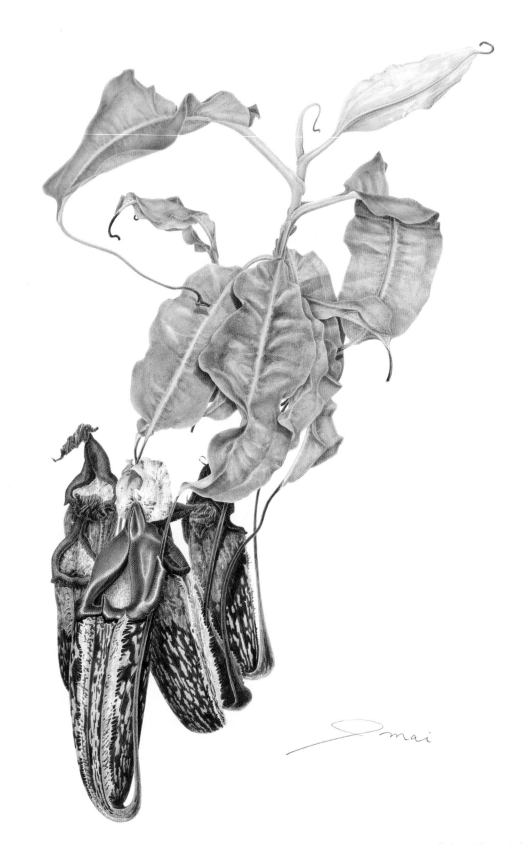

Mariko Imai, b. Kanagawa,
Japan 1942
Nepenthes maxima superba
Watercolour on paper, 765 mm x 585 mm
Signed *Imai*
Shirley Sherwood Collection

Nepenthes maxima 'Superba'. This
pitcher plant grows in montane
forest in Sulawesi; the large pitchers
are produced on the tips of the
leaves, and have a lid to keep out
excessive rain.

Christina Hart-Davies,
b. Shrewsbury, England 1947
Australian pitcher plant:
Cephalotus follicularis
Watercolour on paper, 230 mm x 240 mm
Signed *Christine Hart-Davies* (undated)
Shirley Sherwood Collection

Cephalotus follicularis, the Albany
Pitcher Plant is restricted to the
southwestern tip of western
Australia, where it grows in wet,
sandy places.

The age of the exotic

Philip Reinagle, b. Edinburgh,
Scotland 1749–1833
Lilium superbum **the superb lily**
Mezzotint and aquatint by Earlom (1799)
from Robert Thornton's *Temple of Flora*
(1799–1807)
Kew Collection

Lilium superbum is native of eastern
North America, from New Hampshire
south to Florida and Arkansas, where
it grows in wet woods, meadows and
pine barrens. It is well-named as its
stems can reach 2.8m and have
around 20 flowers. Reinagle's original
painting for this plate is in the
Fitzwilliam Museum in Cambridge.

Lilies

There are around 110 species of true lilies, the genus *Lilium*, found only in the northern hemisphere, and mostly in eastern Asia and western North America, with a few in Europe and eastern North America. Most have either trumpet or turk's cap flowers, and both types are shown in the paintings here, as is an intermediate type, the Japanese *Lilium auratum*. DNA studies have revealed the interesting fact that the trumpet and turk's cap shaped flowers have evolved independently, at least three times in different continents.

Thornton's *Temple of Flora* (see previous page) is famous as one of the greatest white elephants of botanical art. Robert Thornton was born in around 1768 and studied medicine at Guy's Hospital. He was inspired by Thomas Martyn's lectures on botany, and the new ideas of Linnaeus, and in 1797 embarked on an ambitious project *A New Illustration of the Sexual System of Linnaeus*. Volume three of this

Paul Jones, b. Sydney, Australia 1921–1997
Lilium auratum
Acrylic on paper, 650 mm x 500 mm
Signed *Paul Jones* (in white)
Shirley Sherwood Collection

Lilium auratum is found wild in central Japan, often growing in volcanic or acid, sandy soil among bamboos and other low shrubs. Paul Jones painted this lily after he had visited Japan.

→

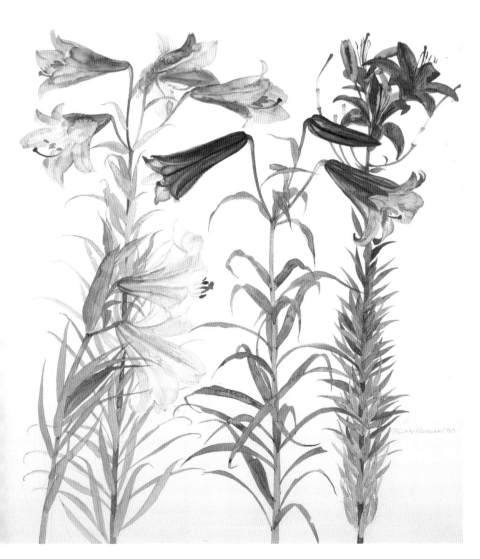

Elizabeth Blackadder, b. Falkirk, Scotland 1931
Lilies
Watercolour on paper, 600 mm x 570 mm
Signed *Elizabeth Blackadder 1989*
Shirley Sherwood Collection

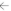

Paul Jones

was the *Temple of Flora*, in which the flowers would be painted in a setting 'appropriated to its subject', rather than a mere garden or greenhouse, so the blue waterlily was set on the Nile, palm trees and an Indian style mosque in the background; the night-blooming cactus had a church tower behind it, the hands on the clock at midnight; the dragon arum had a sinister cloudy background (see page 163) and the superb lily (see page 148) is set against the wild mountains of North America.

The illustrations were painted in oils and are mainly by Peter Henderson and Philip Reinagle, who were known as portrait and landscape painters rather than botanical illustrators. Reinagle in particular specialised in portraits of dogs, hunting scenes and dead game. Other painters were also commissioned, including Abraham Pether, who specialised in moonlight scenes, and drew the background for the cactus; Thornton drew the plate of roses himself.

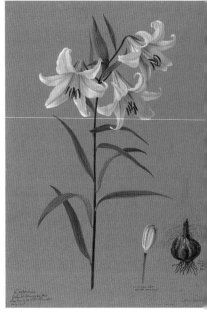

Lilian Snelling, b. St Mary Cray, Kent, England 1879–1972
Lilium japonicum
Watercolour on grey paper, 563 mm x 380 mm
Grown at Scampston Hall by W. H. St Quentin, from a bulb supplied by Wallace's, Tunbridge Wells, 1915.
Kew Collection

Lilium japonicum is found in Honshu, growing in bushy places and in long grass or dwarf bamboo. It is usually pink-flowered, but it can be white in the wild. See larger reproduction on page 34.

William Jackson Hooker, b. Norwich, Norfolk, England 1785–1865
Lilium
Watercolour on thin card, 505 mm x 380 mm
Signed *W. Hooker*
Kew Collection

This looks like an unusually broad-leaved form of the Japanese *Lilium longiflorum*, and is close to var. *alexandrae* which comes from the Liukiu islands.
←

Coral Guest, b. London,
England 1955
Lilium longiflorum **'Ice Queen'**

Watercolour on paper, 760 mm x 570 mm
Signed *Coral Guest 1995*
Shirley Sherwood Collection

It appears that this beautiful lily
should be called 'Snow Queen'. This
painting is renowned for its unusual
design and is a brilliant example of
the painting of white flowers on a
white background.

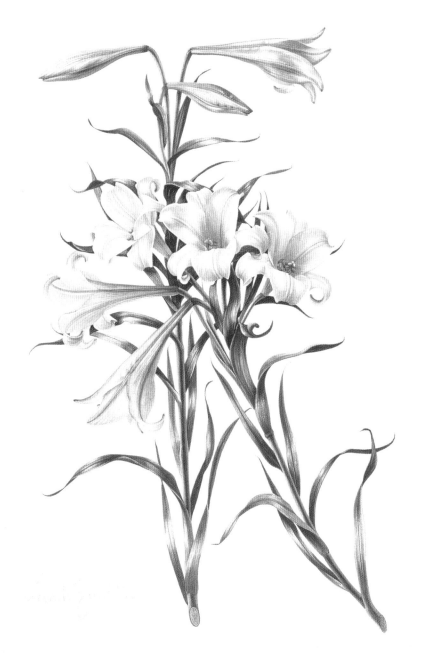

Thornton wrote suitably romantic and flowery prose to go with the plates, but
though the book was produced in parts, starting with the tulips in 1798, he was
soon nearly bankrupt. In 1811 he resorted to setting up the Royal Botanic Lottery,
by act of Parliament, with the support of the Prince Regent, and issued twenty-
thousand tickets at two guineas each, offering ten thousand prizes to the value of
£77,000 and a first prize of the original plates. The lottery seems to have failed to
restore Thornton's finances, and most of the paintings have vanished. The book
however, is famous, and even original printed plates are now very valuable.

Amaryllids

The family Amaryllidaceae is close to Liliaceae, but differs in having the flowers usually in umbels, surrounded by bracts or a spathe, and having an inferior ovary (that is the petals are attached to the top of the ovary, not to its base as in a *Lilium* or tulip). Daffodils and snowdrops are familiar members of the family Amaryllidaceae but there are many more numerous and more spectacular species in southern Africa and in South America. The genus *Crinum* has around 120 species throughout the tropics; *Hippeastrum* is a familiar genus from America; *Nerine* and *Cyrtanthus* from South Africa. Examples of these and other genera of Amaryllidaceae are shown in this section.

Ann Schweizer, b. Cape Town, South Africa 1930–2014
Crinum moorei
Watercolour on paper, 750 mm x 565 mm
Signed *Ann Schweizer* (undated)
Shirley Sherwood Collection

Crinum moorei is a beautiful species, hardy enough to grow outdoors in the warmer parts of Europe. It grows wild in the eastern, summer rainfall part of Cape Province and in KwaZulu-Natal, growing in light shade in scrub and open woods. It was named by J. D. Hooker after Dr David Moore (1807–1879), director of the Glasnevin Botanical Gardens in Dublin, which received the seed from a soldier named Webb, who collected it in Natal during the 1860s.
→

Sydenham Edwards, b. Usk, Wales 1768–1819
Brunsvigia falcata
Watercolour on paper, 255 mm x 320 mm
Inscribed *Amarillis, Lee's, Aug'st. 4 -*
For *Curtis's Botanical Magazine*,
t. 1443 (1812)
Kew Collection

Cybistites longifolia is the only member of its genus, closely related to *Ammocharis* and *Brunsvigia*. Like many species of *Brunsvigia*, the fruiting heads have stiff flower stalks, and the whole inflorescence acts as a tumbleweed, being blown along in wind and dispersing the seeds. The leaves tend to be curved, evergreen, and lie flat on the ground. *Cybistites* is found wild from southern Namibia southwards to the Cape Peninsula. The flowers appear in summer and are fragrant, probably pollinated by moths.
←

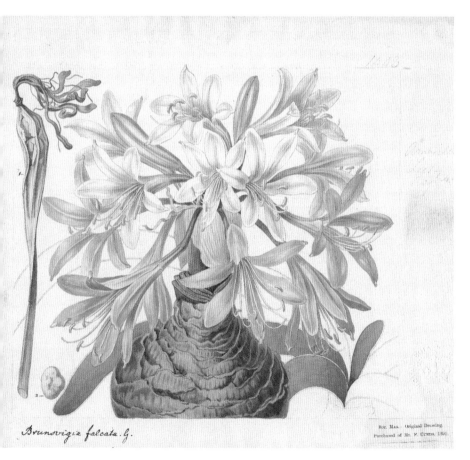

Brunsvigia falcata. G.

Brit. Mus. : Original Drawing.
Purchased of Mr. F. Curtis. 1891.

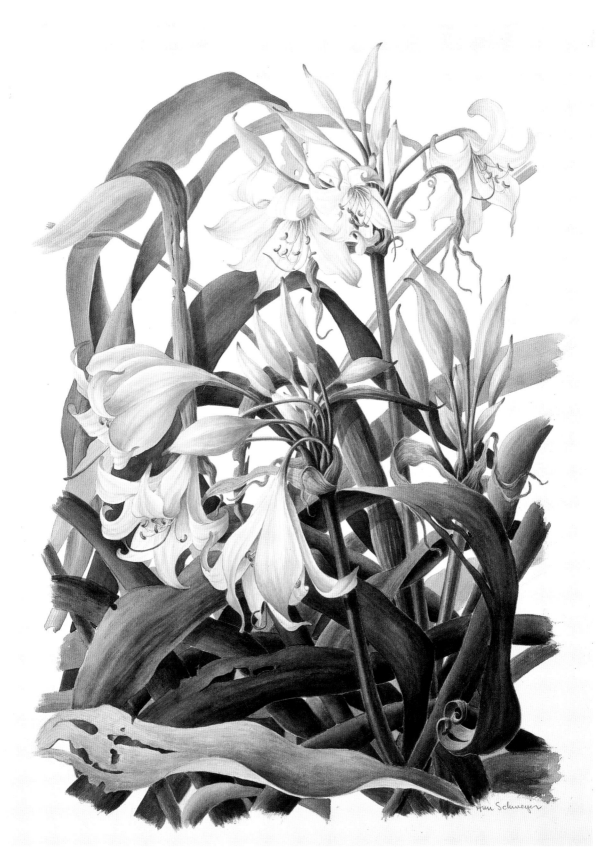

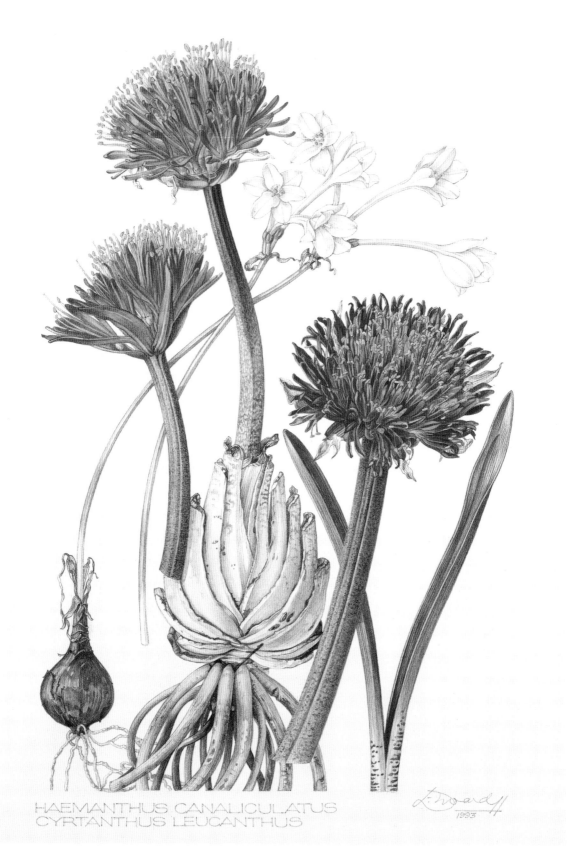

HAEMANTHUS CANALICULATUS
CYRTANTHUS LEUCANTHUS

Ann Lee, b. Hammersmith,
England 1753–1790
Amaryllis

Gouache on vellum, 470 mm x 325 mm
Signed: *A. Lee 1778*
Kew Collection

Shown here is *Hippeastrum vittatum*,
an elegant plant, wild in the Andes
in Peru, but cultivated in Europe
since the mid-18th century. Early
botanists did not differentiate
between *Amaryllis* and *Hippeastrum*,
and indeed there has been some
controversy and rancour between
the Americans who have claimed
Amaryllis as an American genus
(=*Hippeastrum*), and Europeans who
have tended to confine *Amaryllis* to
the one Cape species *A. belladonna*,
now joined by a second,
A. paradisicola, newly discovered in
the Richtersveldt.
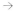

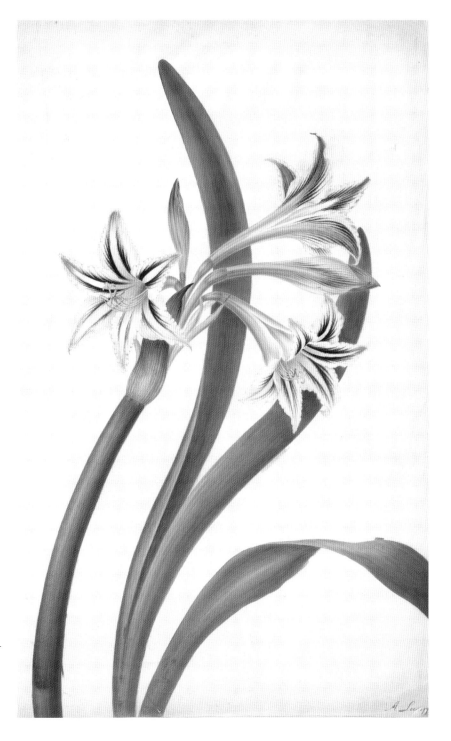

Ellaphie Ward-Hilhorst,
b. Pretoria, South Africa 1920–1994
Haemanthus canaliculatus **and**
Cyrtanthus leucanthus

Watercolour on paper, 380 mm x 280 mm
Signed *E.Ward H. 1993*
Shirley Sherwood Collection

Both *Haemanthus canaliculatus* and
Cyrtanthus leucanthus are found in the
Cape, in the area around Betty's Bay,
and only flower and seed after a fire.
Ellaphie Ward-Hilhorst painted them
both *in situ*, when they were sighted
for the first time in many years.
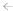

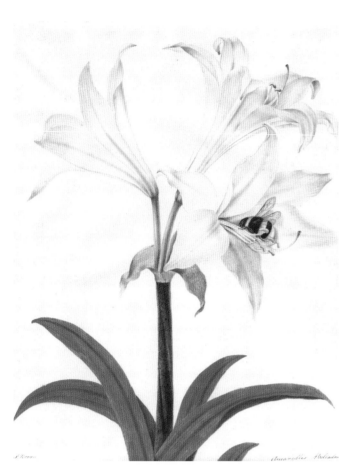

Peter Brown, fl. 1760–1790s
Amaryllis belladonna
Watercolour on vellum, 295 mm x 330 mm
Signed: *P. Brown Amaryllis Belladonna*
Kew Collection

Amaryllis belladonna is found in the
southern Cape from the Oliphants river
to Knysna; it flowers best after a hot
summer followed by a fire. The flowers
are beautifully scented, and are visited by
noctuid moths and carpenter bees. The
bumble bee shown here probably visited
the plant when it flowered at Kew.

Vicki Thomas,
b. South Africa 1951
Haemanthus nortieri
Watercolour on paper, 305 mm x 535 mm
Signed *V Thomas 2002*
Shirley Sherwood Collection

The genus *Haemanthus* contains 22
species, mostly found in South Africa.
They have stiff, broad leaves and clusters
of small flowers surrounded by
conspicuous bracts. *H. nortieri* is a rare
species found only in the Nardouw
mountains in the north-western Cape.
Each bulb has a single, upright leaf; the
leaf is sticky and becomes covered with
sand and grit, which puts off herbivores.

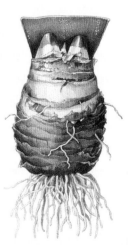

*Haemanthus nortieri Isaac. This rarely seen Haemanthus comes from the Nardouwberg and is
unusual as its single leaf is sticky and sand clings to its surface. This specimen was grown
at Kirstenbosch and has only flowered twice in over twenty years.*

South African *Eucomis* and *Veltheimia*

Recent botanical research has led to the recognition of several smaller families within what was formerly the very large and diverse family Liliaceae. This small group of South African plants belongs to the Asparagaceae (along with the familiar hyacinths and woodland bluebells); the starry and unpleasantly smelly flowers of *Eucomis* attract wasps and flies, while the very different tubular, red flowers of *Veltheimia* are pollinated by several species of sunbirds.

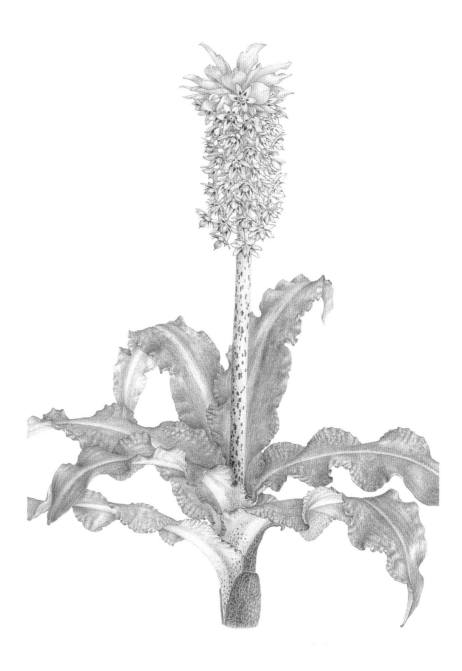

Julie Small, b. Buxton, Derbyshire, England 1948
Eucomis bicolor
Pencil on paper, 575 mm x 420 mm
Signed *J. A. Small* (undated)
Shirley Sherwood Collection

Eucomis bicolor is a summer-flowering bulb from South Africa, where it is found in wet, grassy places in the Drakensberg mountains of Natal. The tuft of leaves at the top of the stem has given rise to the common name pineapple plant, but the flowers have a foetid scent and attract flies and wasps.

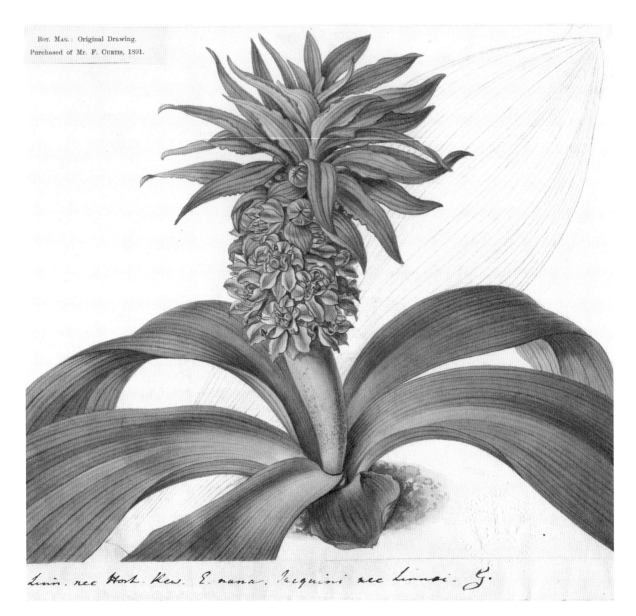

Linn. nec Hort. Kew. E. nana. Jacquini nec Linnaei. G.

Sydenham Edwards, b. Usk,
Wales 1768–1819

Eucomis nana

Watercolour on paper, 266 mm x 416 mm
Inscribed: *Eucomus nevinia,*
Lees May 5 1812
Eucomis regia Linn. nec Hort. Kew,
E. nana Jacquini nec Linnaei.
For *Curtis's Botanical Magazine,*
t. 1495 (1812)
Kew Collection

Eucomis regia is a dwarf species, found
in the Cape, from Namaqualand to
the Karoo, usually in heavy soils on
cool south-facing slopes. The leaves
usually lie flat on the ground.

Raymond Booth, b. Leeds,
Yorkshire, England 1929

Veltheimia bracteata

Oil on paper, 635 mm x 490 mm
Signed *R. C. Booth January 1979*
Shirley Sherwood Collection

Veltheimia bracteata is a bulb from
South Africa, growing in partially
shaded places and flowering in
spring. The leaves are evergreen;
the red or pink tubular flowers
attract sunbirds.

\rightarrow

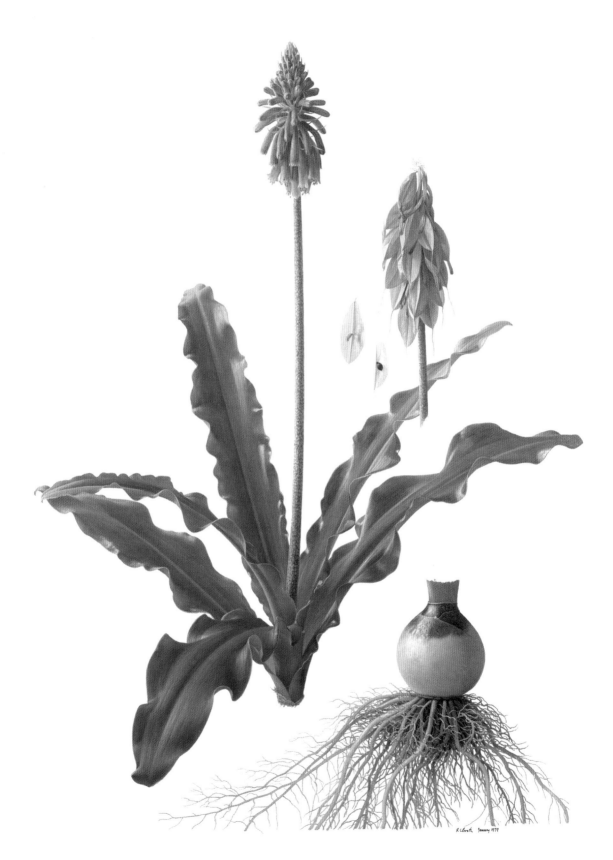

R.C.Booth January 1979

Aroids

The Arum family can be recognised by having small, insignificant flowers crowded onto a thick stem, and usually hidden or protected by a spathe-like bract. The simplest flowers are found in some of the tropical species such as the familiar houseplant *Monstera*, where all the flowers are exposed and develop into a banana-like fruit. The Arums and related temperate families illustrated here have some of the most complex and highly evolved flowers, completely enclosed by the spathe, the male and female separated by rings of hairs, producing unusual scents

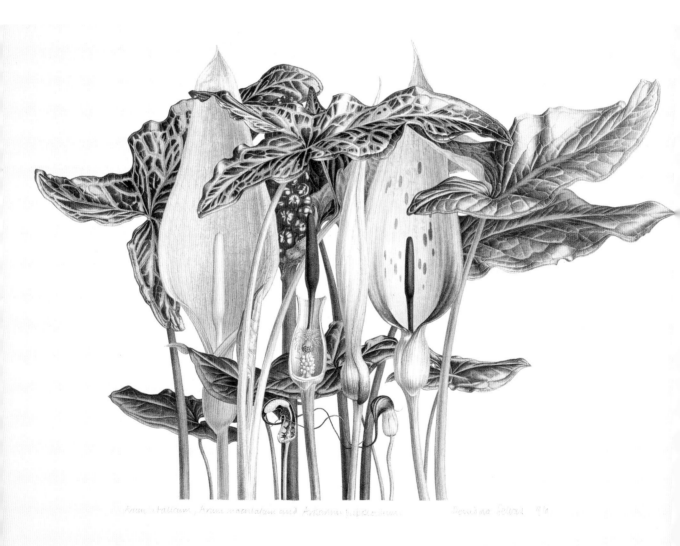

Arum italicum, Arum maculatum and Arisarum proboscideum Brenda Bolton '96

Peter Henderson, fl. 1799–1829

Dragon arum

Mezzotint and aquatint by Ward (1801), 595 mm x 442 mm from Robert Thornton *Temple of Flora* (1799–1807)

Kew Collection

Dracunculus vulgaris is common in waste places in the eastern Mediterranean. This appears to be one of the earlier versions of this plate – later ones had lightning striking the mountain.

→

Pandora Sellars, b. Herefordshire, England 1936–2017

Arum italicum, Arum maculatum and ***Arisarum proboscideum***

Watercolour on paper, 350 mm x 470 mm

Signed *Pandora Sellars '96*

Shirley Sherwood Collection

In this study of *Arum* flowers and fruit, Pandora Sellars shows her skill with the design of overlapping flowers and leaves. Both *Arum italicum* and *Arum maculatum* are found wild in woods and hedges in southern England, the fruit being more conspicuous than the flowers. In *Arisarum proboscideum*, the mouse plant, from southern Italy and south-western Spain, the inflorescence is totally hidden, with only the mouse-like tail emerging from beneath the leaves.

←

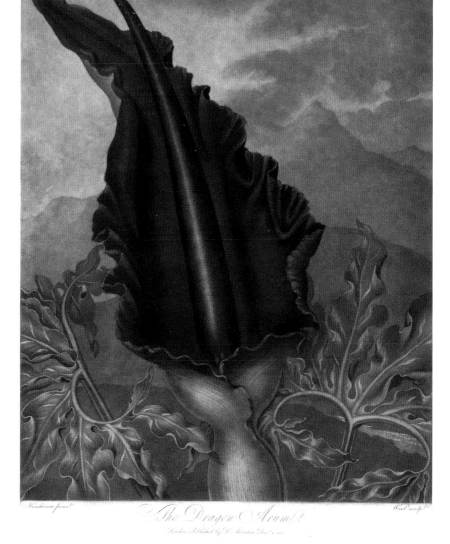

The Dragon Arum.
London Published by D. Thornton Dec.r 1 1801

and temporarily trapping insects which carry the pollen from one flower to the next. In Pandora Sellars' *Arum* paintings the details of the flower are beautifully revealed. In other genera the attractants are less subtle, and both *Biarum* and *Dracunculus* smell strongly of dung or rotten meat, and attract coprophilous flies and beetles, which may crawl around and lay their eggs among the flowers. *Arisarum* and *Arisaema* are both woodland plants with stripes or windows on the spathe, forming kettle-like traps and both genera attract fungus gnats.

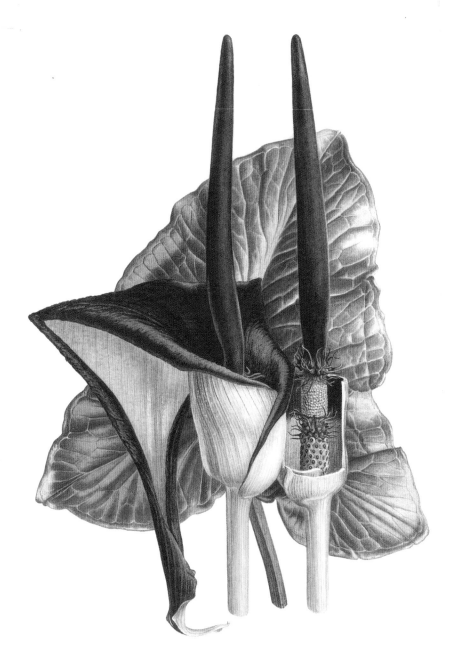

Pandora Sellars,
b. Herefordshire, England 1936–
2017
Arum palaestinum, 1989
Watercolour on paper,
288 mm x 200 mm
For Peter Boyce, *The genus Arum* (1993)
plate 14
Kew Collection

Arum palaestinum is found in Syria,
Lebanon, Israel and possibly
Jordan; the flower usually smells of
fermenting fruit.
←

Pandora Sellars,
b. Herefordshire, England
1936–2017
Arum cyrenaicum, 1988
Watercolour on paper,
330 mm x 245 mm
For Peter Boyce, *The genus Arum* (1993)
plate 6
Kew Collection

Arum cyrenaicum is found in Libya,
and interestingly, also in southern
Crete, perhaps a relic of an ancient
landbridge during a period of hot,
dry climate and lowering of sea
level. The flower has a faint smell
of horse-dung.
→

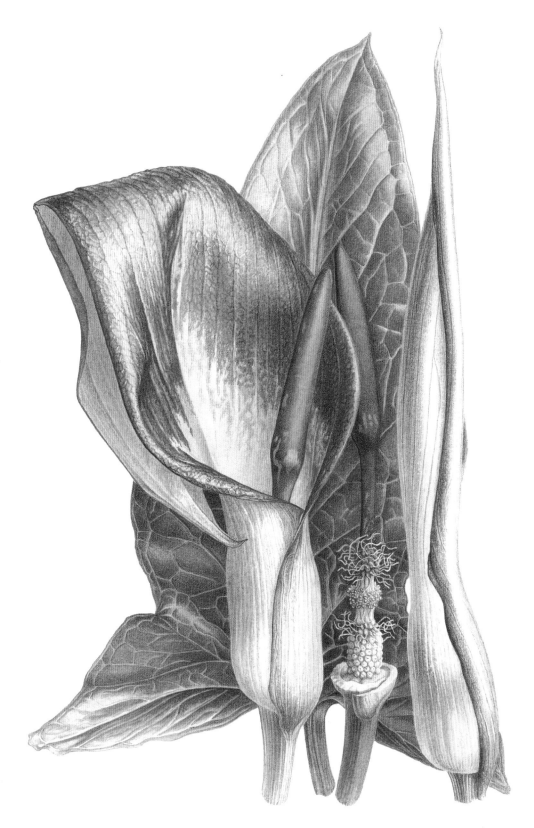

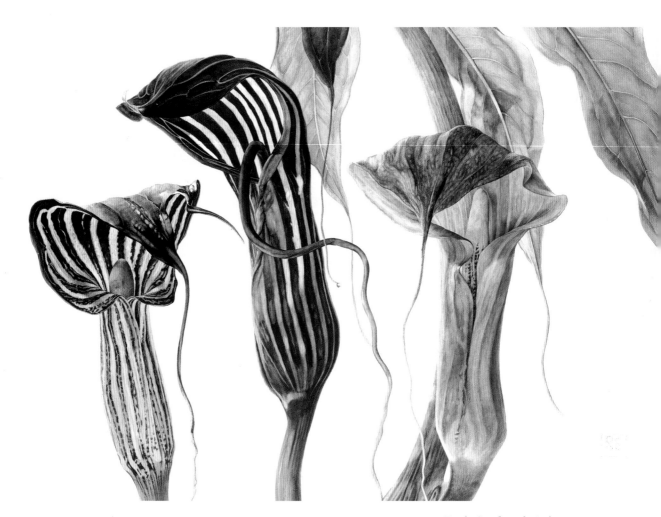

Rosie Sanders, b. Stoke Poges,
Buckinghamshire, England 1944
Arisaema ciliatum, Arisaema
costatum, Arisaema consanguineum
Watercolour on paper, 1020 mm x 1540 mm
Signed *RS* in square
Shirley Sherwood Collection

Arisaema ciliatum and *A. consanguineum* are
both found in China, mainly in western
Sichuan and Yunnan, and *A. costatum* in
Tibet and Nepal, all growing on rocky
banks and in hillside scrub. There are
around 150 species of *Arisaema*, mostly
in temperate Asia, but with one species,
A. triphyllum, jack-in-a-pulpit, in eastern
North America. This relatively
enormous work is a big departure from
Rosie Sanders' usual style.

Dasha Fomicheva, b. Moscow,
Russia 1968
3 arums triptych: *Biarum*
pyrami
Watercolour on paper, 230 x 265 mm,
230 x 335 mm and 230 x 200 mm
Unsigned and undated
Shirley Sherwood Collection

Biarum species often produce their
flowers in late summer and autumn,
before the leaves have begun to
develop. They are generally
unpleasant-smelling, of dung or
urine, and attract beetles and small
flies. *Biarum pyrami* is found in south-
west Turkey, Syria, Lebanon, Jordan
and Israel.

Camilla Speight, b. Oxford, England 1974
Dragon arum: *Dracunculus vulgaris*

Pen and ink drawing, 450 mm x 320 mm
Signed *CS 99*
Shirley Sherwood Collection

Dracunculus vulgaris is found in the Mediterranean from Sardinia east to southern Turkey, growing in rocky places and commonly among ruins and abandoned buildings. The sinister flowers appear in early summer, just as the leaves are beginning to wither. Its foul-smelling flowers are visited by both flies and beetles.
←

Andrew Brown, b. Carshalton, England, 1948
Voodoo lily: *Sauromatum venosum*

Pencil and watercolour on paper, 680 mm x 450 mm
Signed *Andrew Brown 12 August 1994*
Shirley Sherwood Collection

Sauromatum venosum is found in the foothills of the Himalayas, from Nepal to Yunnan, flowering in the spring. It is one of those plants which will begin to grow and even flower without water, while the tubers are apparently dormant. This habit of growth is adapted to the dry Himalayan spring, when the rains come only with the midsummer monsoon.
→

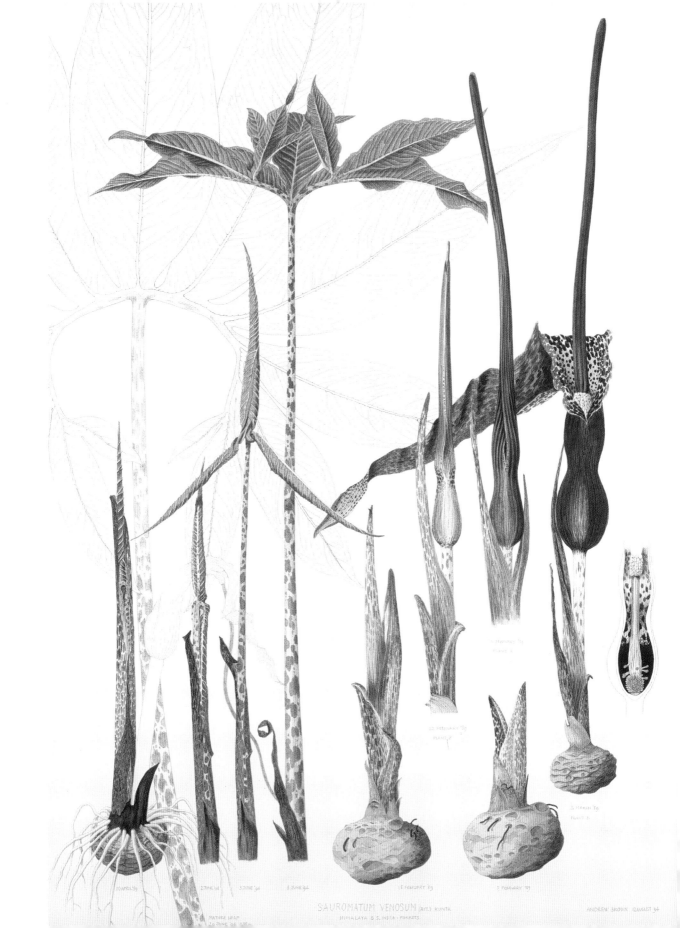

SAUROMATUM VENOSUM (AIT.) KUNTH

HIMALAYA & S. INDIA - FORESTS.

ANDREW BROWN QAV6LGT 94

Orchids

Francis Bauer worked as a botanical artist, mainly at Kew, from 1790 until his death in 1840. He was employed there to draw new plants as they flowered, and at the same time by John Lindley to draw orchids, which he dissected and painted in particularly fine detail. This is one of the few of Bauer's paintings that is still at Kew, as they were left to the British Museum at Bauer's death in 1841, when the garden was in a sad state and its future uncertain.

Sarah-Ann Drake was active in the 1830s and1840s, and specialised in painting orchids for John Lindley, particularly for *Sertum Orchidaceum*. In 1831 she started to work on botanical illustrations under Lindley's instruction. Soon she was contributing to important publications such as Wallich's *Plantae Asiaticae Rariores* and Bateman's elephant folio *Orchidaceae of Mexico and Guatemala*. She also painted hundreds of plants for Lindley's *Botanical Register* and for early parts of *The Transactions of the Horticultural Society*.

Francis Bauer, b. Feldsberg, Austria 1758–1840 (attributed to)
Orchis mascula
Watercolour on paper, 450 mm x 275 mm
Kew Collection

Orchis mascula, the early purple orchid, is one of the commonest of the family in western Europe, familiar in woods and hedgebanks, flowering in April. The leaves usually have scattered spots, but unspotted forms are found on limestone in the west of Ireland and in northern Scotland. The flowers smell faintly unpleasant, of tomcats; the dissections here are particularly refined, painted with a very muted palette.
\rightarrow

Thomas Robins the younger, b. Bath, Somerset, England 1743–1806
Orchis morio
Watercolour on vellum, 205 mm x 295 mm
Kew Collection

Anacamptis morio, the green-winged orchis, was formerly common in meadows on clay and limestone, but has become rare in England, owing to the improvement of grassland. It is usually purple, while pale pink-flowered and white forms are much rarer.
\leftarrow

14. O. mascula

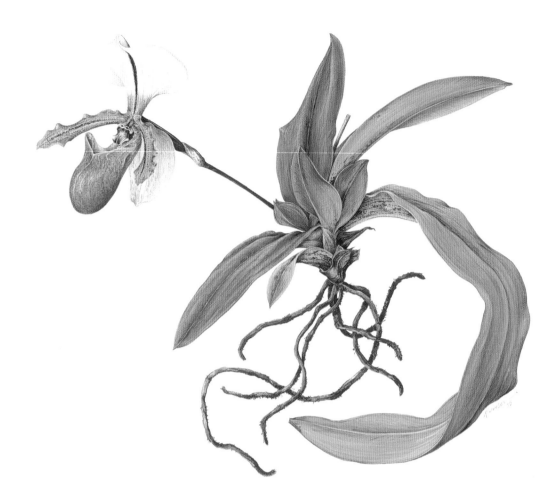

Kate Nessler, b. St Louis,
Missouri, USA 1950
Paphiopedilum spicerianum
Watercolour on paper, 267 mm x 287mm
Signed *Nessler* (undated)
Shirley Sherwood Collection

Paphiopedilum spicerianum is named
after Herbert Spicer of Godalming,
Surrey, in whose collection it first
flowered in 1878. It is found wild in
Assam, northern Burma and possibly
in SW Yunnan, growing in humid
river gorges at around 1500m.

Sarah-Ann Drake, b. Skeyton,
Norfolk, England 1803–1857
Calanthe versicolor
Watercolour on paper, 420 mm x 270 mm
Inscribed: *Miss Drake del. The upper buds
slightly hairy, sweet scented, Sion Gardens,
Aug. 31st 18.*
For John Lindley *Sertum Orchidaceum*
plate 42 (1838).
Kew Collection

Calanthe versicolor Lindl. is now
considered a minor variant of *C.
sylvatica*, a widespread species found in
Africa, Madagascar and India. Syon
House, on the bank of the river Thames
opposite Kew, had large greenhouses
and there were regular exchanges of
plants between the two gardens.
→

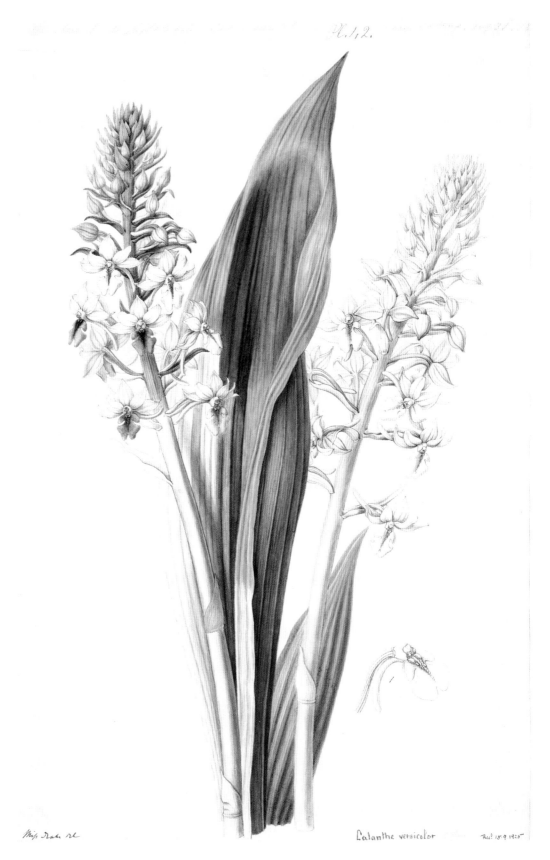

Plt. 1, 2.

Miss Drake del.

Calanthe versicolor

Pub.d 15.9.1835

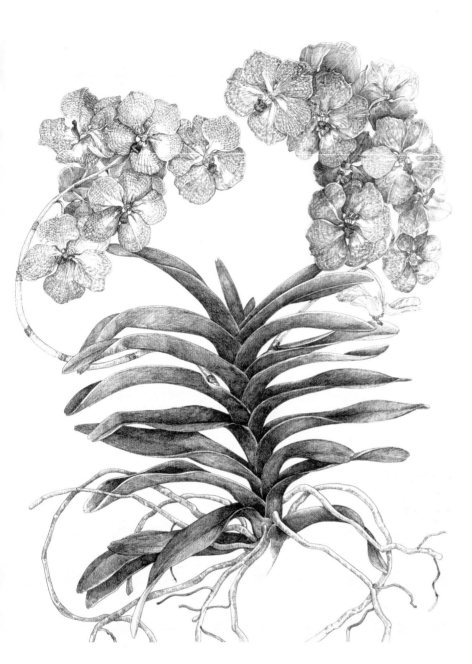

Francesca Anderson,
b. Washington DC, USA 1946
Vanda 'Fuchs Blue'

Pen and ink, 730 mm x 580 mm
Signed *Francesca Anderson for Shirley Sherwood 5/92*
Shirley Sherwood Collection

These blue vandas are hybrids with *Vanda caerulea*, an epiphytic species from India, Burma and Thailand. Francesca Anderson has recently completed a series of orchid drawings for the '21' Club, New York.

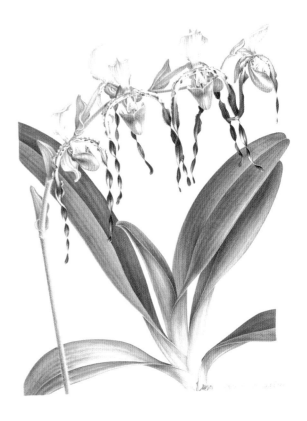

George Bond, b. Shropshire, England
c.1806–1892

Thelymitra forsteri

Watercolour on paper
Sheet 214 mm x 202 mm
Inscribed: *received from New South Wales, from
Mr Cunningham June 1823*
Kew Collection

This scientific drawing of an orchid which
flowered at Kew, shows how some of the
paintings were used in the herbarium
alongside dried specimens. It has a long
annotation:

 'The name written here, "*Thelymitra
forsteri ?*" should refer to a New Zealand
plant. The date pencilled 'June 1823' should
indicate the date when the drawing was made
– presumably from a plant at Kew. …. The ink
record seems to have been done later, when a
large collection of such drawings from various
sources, was written up, probably in part
from memory, and may not be correct, for
the specific name is correct, and I see no
evidence of this form growing in Australia
….'

Pandora Sellars, b. Herefordshire,
England 1936–2017

Paphiopedilum parishii

Watercolour on paper, 430 mm x 300 mm
Signed *Pandora Sellars '83*
Shirley Sherwood Collection

Paphiopedilum parishii is named after the
Reverend Charles Samuel Pollock Parish
(1822–1897), who was born in Calcutta,
but educated and ordained in England,
before returning to become chaplain to
the forces in Moulmein in Burma, in
1852. He collected extensively,
particularly ferns and orchids, which he
sent to England both as living plants and
as drawings by himself and his wife.
Paphiopedilum parishii is found in Burma,
northern Thailand and southern Yunnan,
growing on trees and rocks, and has
fabulously trailing and twisted petals.

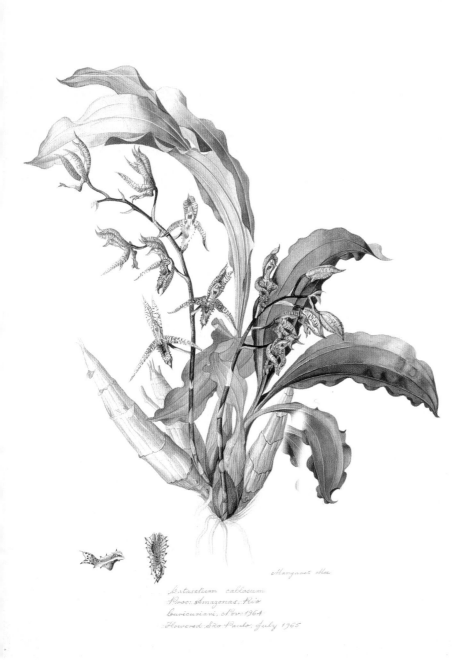

Catasetum callosum
Proc: Amazonas. Rio
Curicuriari, Nov: 1964
Flowered São Paulo, July 1965

Margaret Mee

Margaret Mee, b. Chesham,
England 1909–1988
Catasetum callosum
Watercolour on paper
Signed *Margaret Mee*
Shirley Sherwood Collection

Catasetum callosum is one of those
unusual orchids which has very
different male and female flowers, in
this case on separate inflorescences.
It is found mainly in Venezuela and
Colombia.

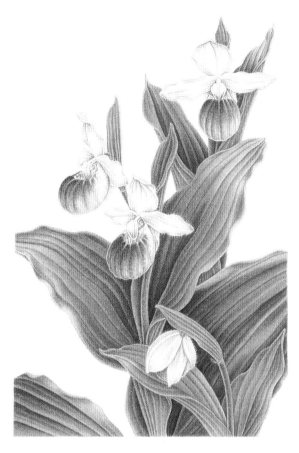

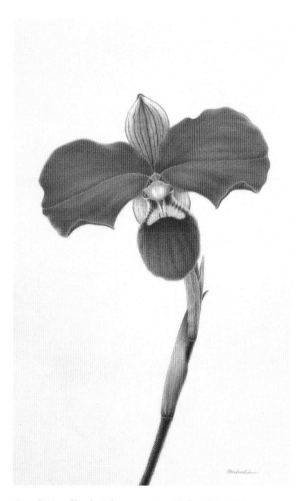

Carol Woodin, b. Salamanca, New York, USA 1956

Showy lady's slipper:
Cypripedium reginae

Watercolour on paper, 550 mm x 420 mm
Signed *Carol Woodin '92*
Shirley Sherwood Collection

Cypripedium reginae is one of the most exciting North American orchids, growing in wet woods and on the margins of swamps, from Newfoundland to Minnesota and south to Tennessee. The stems can be 90cm tall. It is often found in great numbers in wet clearings where deer congregate during the winter.

Carol Woodin, b. Salamanca, New York, USA 1956
Phragmipedium kovachii

Watercolour on vellum, 370 mm x 320 mm
Signed *Carol Woodin*
Shirley Sherwood Collection

Paphiopedilum kovachii is one of the most famous orchids found in recent times, and even has its own website. It was discovered by Michael Kovachs for sale on a roadside stall in Peru, smuggled out of the country and illegally imported to Florida. In the wild it grows on limestone cliffs in wet, windy valleys in tropical cloud forest around 1800m and the gorgeous flowers can be up to 200 mm across. Carol Woodin travelled to Peru in 2004 specially to paint this species in the nursery of Alfredo Manrique, who has official permission to grow and distribute it.

Grass trees

Marianne North visited Australia in 1880, landing at Albany and travelled through the country by police horse, lodging at police stations and with farmers, pausing only to paint scenes such as this clump of grass trees and cycads.

Bronwyn Van de Graaff's arresting portrait of *Xanthorrhoea johnsonii* on page 7 is a clever composition of a difficult subject, with its bizarre black trunk, wildly spiky leaves and spear-like inflorescence, which can be seen in the eucalyptus forests close to Lilianfels on the edge of the Blue Mountains, New South Wales. It contrasts with the oil painting by Marianne North (1830–90) which shows similar species in their natural setting but in far less detail.

Marianne North, b. Hastings, Sussex, England 1830–1890
Grass trees with cycads
Oil on board, 342 mm x 471 mm
Kew Collection

The grass trees, *Xanthorrhoea* species, have a covering of dead leaves until burnt in a bush fire, when the stems become startlingly black. Also in this painting is another grass tree, a species of *Kingia* which is superficially similar to *Xanthorrhoea*, but in a different family, the Dasypogonaceae. The palm-like plants are the cycad *Macrozamia fraseri*, in front of a large *Banksia* with *Eucalyptus* in the background.

Doryanthes

Doryanthes is now placed in its own family, the Doryanthaceae related to *Hemerocallis*, the daylily, in the order Asparagales. There are only two species, both found in eastern Australia. They form huge clumps of upright leaves, and have been grown at Kew for many years.

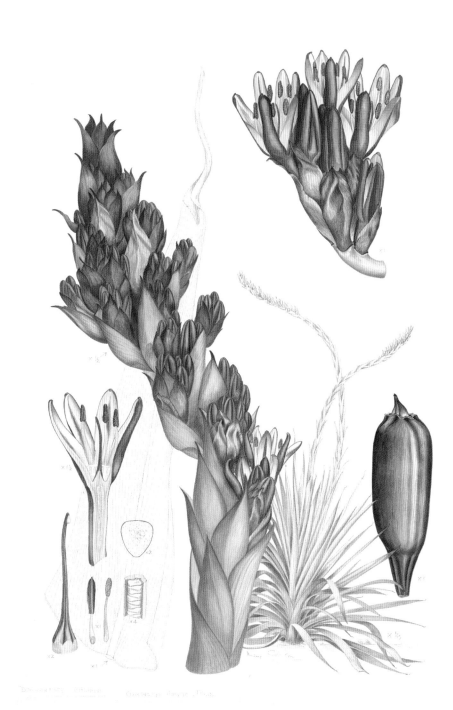

Mary Grierson, b. Wales 1912
Doryanthes palmeri, 1966
Watercolour on heavy paper,
525 mm x 387 mm
Signed *Mary Grierson*
Australia House, Kew
Kew Collection

Doryanthes palmeri, the giant spear lily, grows wild in the extreme north of New South Wales and the southeast of Queensland, on rocky ridges and cliff tops in the wet forest. It is easily distinguished from *D. excelsa* because its flowers are not in a head, but in elongated clusters spaced along the arching inflorescence.

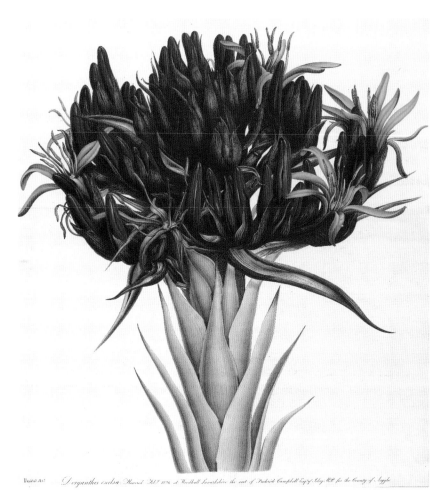

Doryanthes excelsa Flowered Feb'y 1826 at Woodhall Lanarkshire the seat of Frederick Campbell Esq'r of Islay MP for the County of Argyle

E. Weddell, b. England
fl. 1800–1840s
Doryanthes excelsa
Watercolour on paper, with
engraved outline,
620 mm x 555 cm
Inscribed: *Weddell del. Flowered Feb'y.
1826 at Woodhall, Lanarkshire, the seat
of Frederick Campbell Esq. of Islay, MP for
the county of Argyle.*
Kew Collection

Deidre Bean, b. Newcastle,
New South Wales, Australia 1960
Doryanthes excelsa 2006
Watercolour on paper, 360 mm x 360 mm
Kew Collection

Doryanthes excelsa, the gymea lily, is
recognised by its flat-topped or
rounded inflorescence with tight
clusters of red flowers. It grows wild
in coastal parts of New South Wales,
near Sydney and the flower stem
may reach 6m tall.

Strelitzia

Jenny Phillips, b. Boort, Victoria, Australia 1949
Strelitzia 'Mandela's Gold'
Watercolour on paper, 575 mm x 765 mm
Signed *Jenny K. Phillips 2001*
Shirley Sherwood Collection

Strelitzia reginae 'Mandela's Gold'; this study was started in Cape Town, using a flower from Kirstenbosch, and completed in Reid's Hotel, Madeira, where Phillips added the fruit. She felt that the flower was weeping for its progeny, as Mandela must have for his wayward family.

There are four species of *Strelitzia*, all found in South Africa. *Strelitzia reginae*, with blue and orange flowers has upright paddle-shaped leaves and stems around 150cm tall; 'Mandela's Gold' is a variety with golden-yellow rather than orange petals. *Strelitzia alba*, sometimes called *S. augusta*, has white flowers from stems formed by a clump of large, greyish leaves to 6m tall. *S. nicolai* is rather similar to *S. alba*, but is even larger with leaves to 10m tall, and often with bluish petals.

The two coloured studies by Francis Bauer, shown here and a third on page 30, probably from plants grown at Kew, were prepared for a slim book, *Strelitzia Depicta*, published in 1818. The genus was named by Sir Joseph Banks after the wife of George III, Queen Charlotte, who was born Princess Sophie Charlotte of Mecklenburg-Strelitz in 1744.

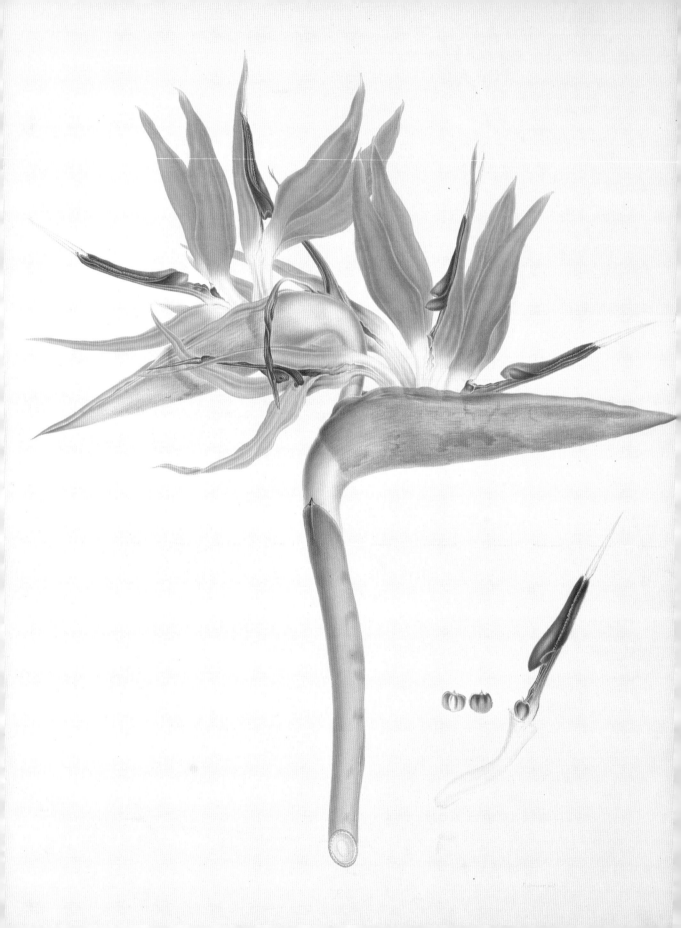

Francis Bauer, b. Austria 1758–
1840
Strelitzia augusta
Hand-coloured lithograph on paper,
548 mm x 395 mm
Kew Collection
Strelitzia alba
→

Francis Bauer, b. Austria 1758–
1840
Strelitzia reginae
Hand-coloured lithograph on paper,
555 mm x 410 mm
Kew Collection

Strelitzia reginae was introduced by
Francis Masson in 1773 from the
Cape where it grows in sandy, peaty
places. It was named by Sir Joseph
Banks after the wife of George III,
Queen Charlotte, who was born
Princess Sophie Charlotte of
Mecklenburg-Strelitz in 1744. The
unusually shaped flowers open in
succession from the green bract;
they are pollinated by sunbirds and
weaverbirds; the orange petals
attract the bird which perches on the
blue stamens, releasing the pollen
onto its breast. Bauer painted a
superb series of *Strelitzia*, some of
which were produced as hand-
coloured lithographs in *Strelitzia
Depicta* (1818).
←

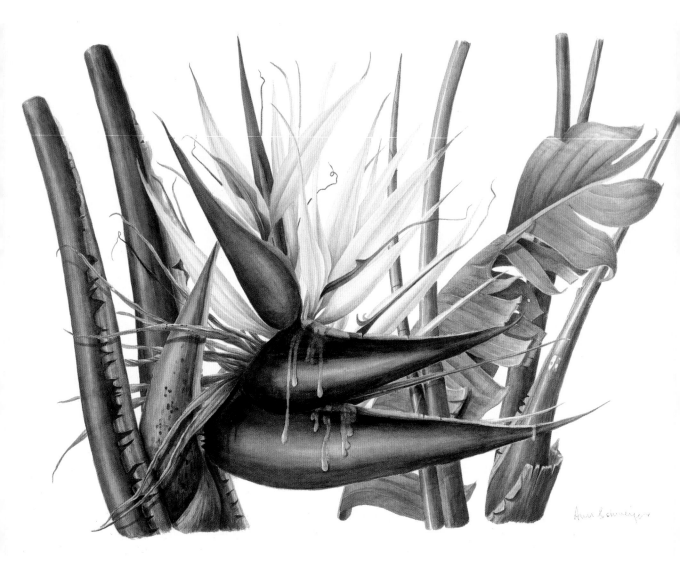

Ann Schweizer, b. Cape Town,
South Africa 1930–2014
Strelitzia nicolai
Watercolour on paper, 540 mm x 750 mm
Signed *Ann Schweizer* (undated)
Shirley Sherwood Collection

Strelitzia nicolai forms a huge clump
of leaves, growing up to 10m tall,
the flowers emerging from between
the bases of the leaves. It grows wild
near the coast of South Africa from
East London to KwaZulu-Natal, and
is spectacular in tropical and
subtropical gardens worldwide.

This striking study is in the
Westcliff Hotel, Johannesburg, in the
Strelitzia conference room.

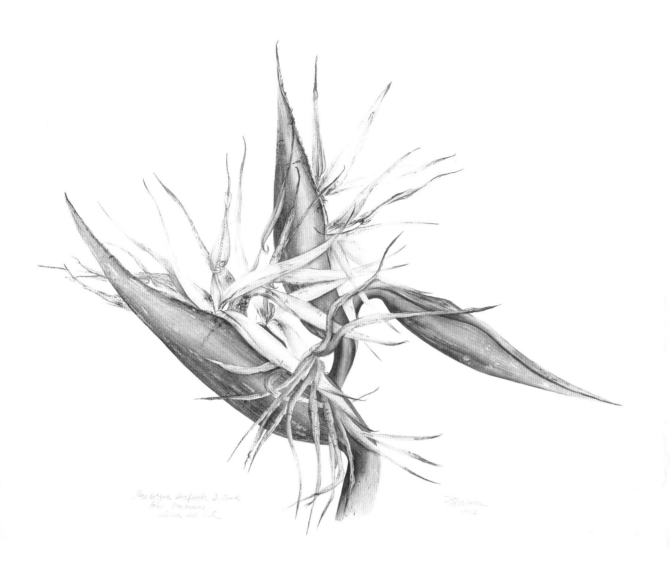

Patricia Arroxellas Villela,
b. Rio de Janeiro, Brazil 1952
Strelitzia: *Strelitzia* **'Enfurta'**

Watercolour on paper, 560 mm x 760 mm
Signed *P A Villela*
Shirley Sherwood Collection

Bromeliads

The bromeliad family, Bromeliaceae, is found almost exclusively in North and South America. Over 2,400 are found in the Americas, one species in West Africa, a similar distribution to the family Cactaceae. Bromeliads include fruits such as the pineapple, and ornamental species which range from dwarf moss or lichen-like epiphytes such as *Tillandsia usneoiodes*, the Spanish moss of the Deep South, to

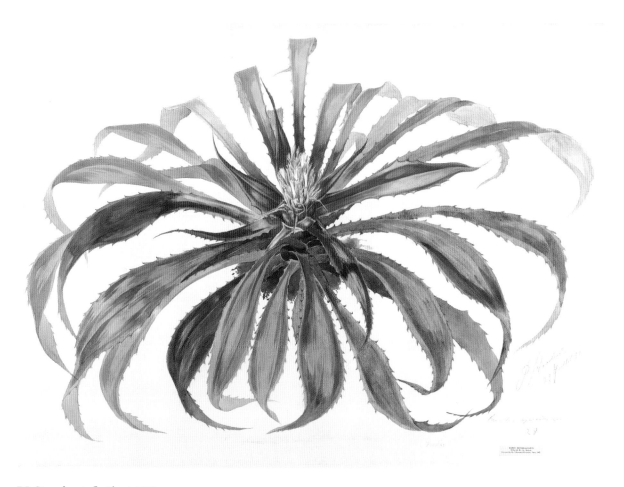

P.J. Stroobant, fl. Ghent 1850–1885

Bromelia agavoides

Watercolour on paper,
705 mm x 104 mm
Kew Collection

Bromelia agavoides Carriere is an obscure species, described from cultivated plants, perhaps the same as *B. morreniana* from Para, Brazil.

Margaret Mee, b. Chesham, Buckinghamshire, England 1909–1988

Neoregelia **sp.**

Pencil and gouache on paper,
640 mm x 465 mm
Signed *Margaret Mee* (undated)
Shirley Sherwood Collection

The genus *Neoregelia* has around 130 species, mostly natives of Brazil.
→

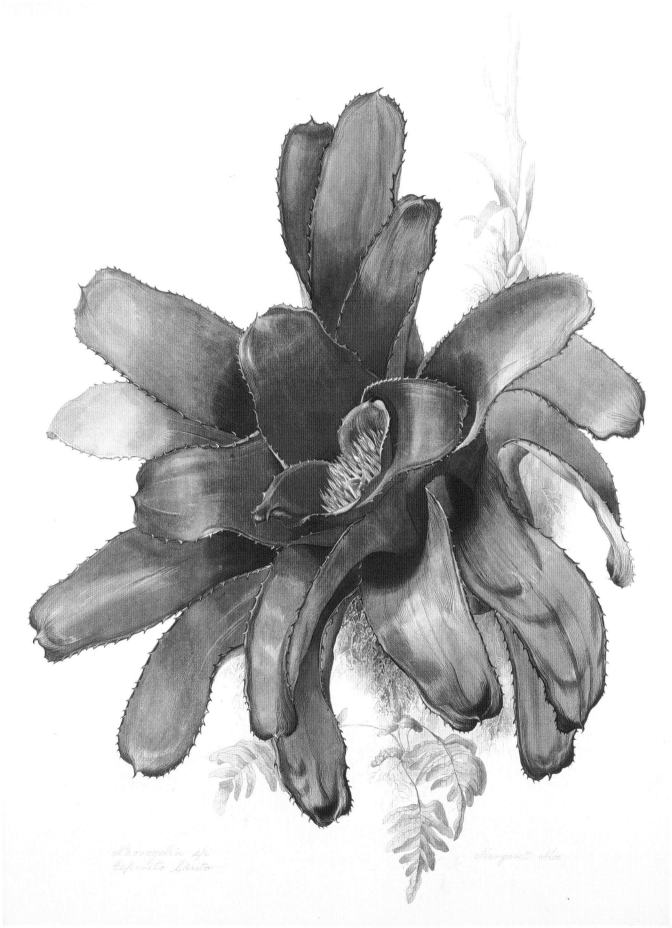

Neoregelia sp.
Espírito Santo

Margaret Mee

giants like *Puya raimondii* of the High Andes of Peru, which has an inflorescence about 10 metres tall. Many species are tank epiphytes, in which the rosettes of leaves form a tank which holds rainwater, making a miniature pond in which live special species of mosquitoes, frogs, crabs and even a species of *Utricularia*, a carnivorous bladderwort. Many bromeliads, both tank plants and so-called air plants, are cultivated as ornamentals in the tropics, and houseplants for their variegated leaves and colourful flowers or reddish bracts around the inflorescence.

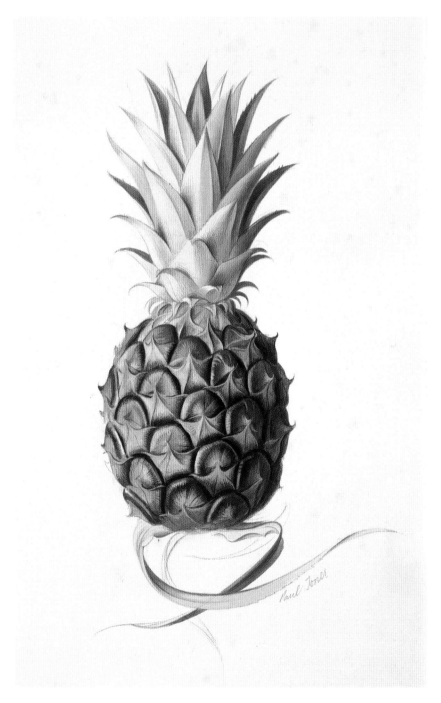

Paul Jones, b. Sydney, Australia 1921–1997
Pineapple
Acrylic on paper, 240 mm x 160 mm
Signed *Paul Jones*
Shirley Sherwood Collection

The pineapple, *Ananas comosus*, has long been cultivated, but almost certainly originated in Brazil. The fruit is the whole inflorescence, formed by a fleshy stem, bracts and ovaries, all fused together.
←

Marianne North, b. Hastings, Kent, England 1850–1890
Pineapples
Oil on board, 507 mm x 352 mm
Unsigned
Kew Collection
Ananas comosus
→

Unknown artist for C.J.E. Morren
Tillandsia hieroglyphica
Watercolour on paper, 975 mm x 705 mm
Kew Collection

Vriesea hieroglyphica is a tall epiphytic bromeliad from Brazil.
←

Etienne Demonte, b. Niteroi, Brazil 1931–2004
Billbergia sanderiana **and humming birds**
Gouache and watercolour,
700 mm x 480 mm
Signed *Etienne Demonte 1994*
Shirley Sherwood Collection

Billbergia sanderiana is native of Brazil. From the 1880s, Messrs Sander's Nursery in St Albans imported huge numbers of orchids, bromeliads and other exotic plants from around the world. H. F. C. Sander was born in Bremen, and came to England in 1865; he also set up orchid nurseries in Summit, New Jersey and in Bruges, Belgium.
→

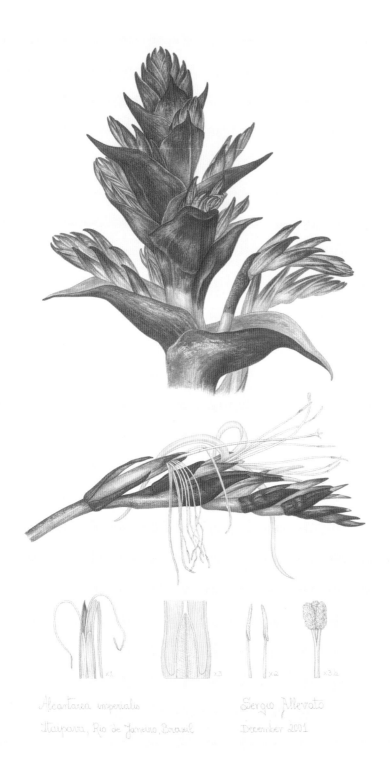

Alcantarea imperialis
Itaipava, Rio de Janeiro, Brazil

Sergio Allevato
December 2001

Sergio Allevato, b. Rio de
Janeiro, Brazil 1971
Alcantarea imperialis (detail)
Watercolour on paper, 580 mm x 400 mm
Signed *Sergio Allevato December 2001*
Shirley Sherwood Collection

This giant bromeliad from Brazil can
reach 9 metres in height.
←

Malena Barretto, b. Rio de
Janeiro, Brazil 1952
Neoregelia magdalenæ
Watercolour on paper,
660 mm x 480 mm
Signed *Malena Baretto 1997*
Shirley Sherwood Collection

Neoregelia magdalenæ is named after
the town of Magdela, near Rio.
→

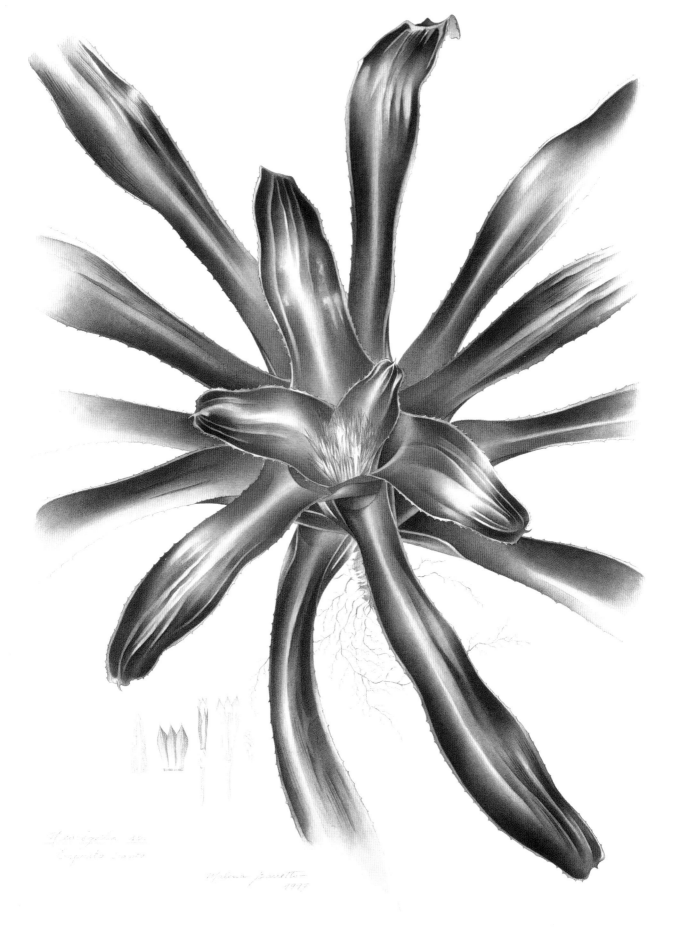

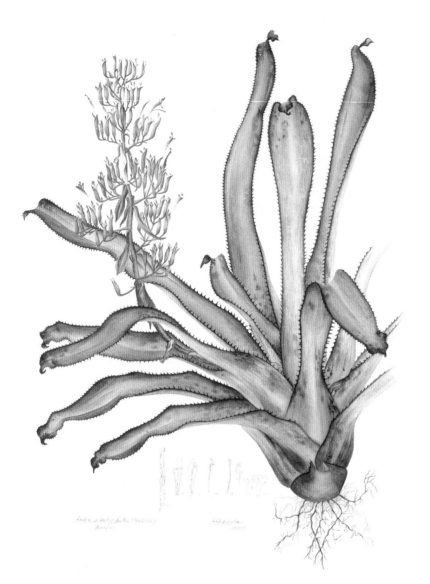

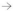

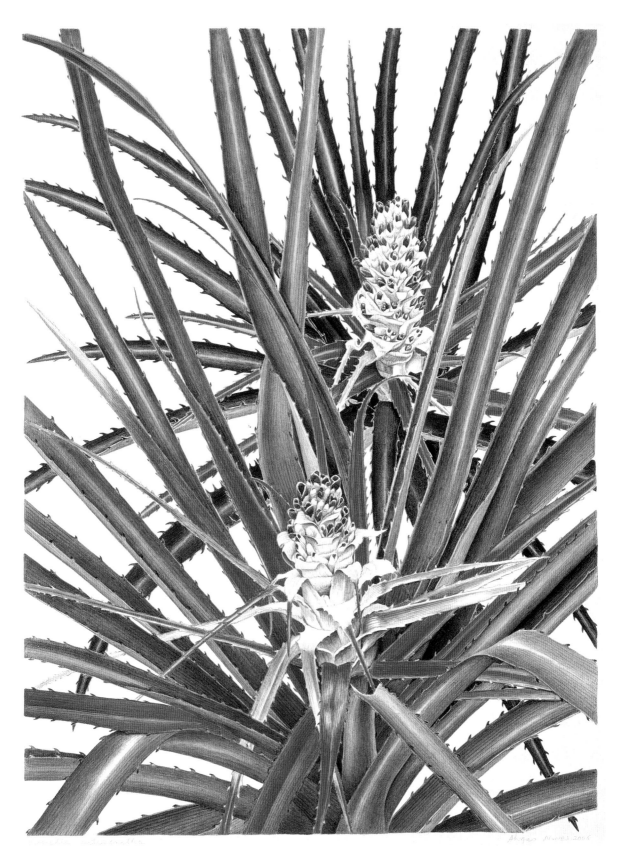

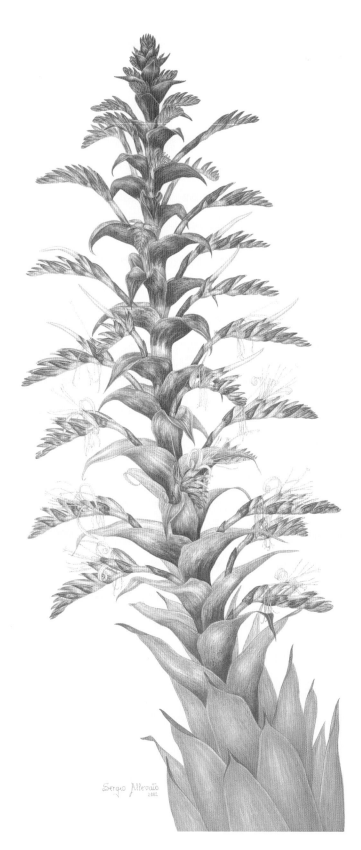

Sergio Allevato,
b. Rio de Janeiro,
Brazil 1971
Alcantarea imperialis
Watercolour on paper,
760 mm x 575 mm
Signed *Sergio Allevato 2002*
Shirley Sherwood Collection

Pandans

The screwpines or pandans are a small family of shrubs, climbers and spreading, palm-like trees, often with stilt roots. The sword-shaped leaves are arranged in a spiral rosette at the ends of thick branches. There are three genera and around 900 species, mostly in the genus *Pandanus*, found in the tropics of the old world. Some species have edible fruit, some are grown, especially in India, for their scented male flowers. Others are used for matting or for fibre.

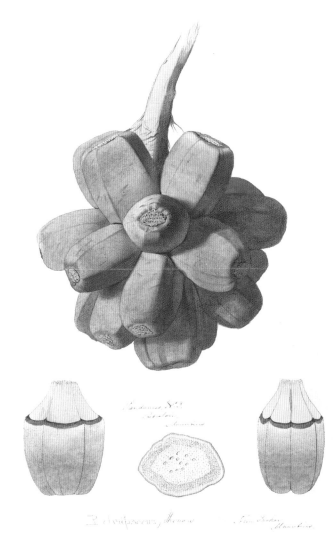

Coral Guest, b. London, England
1955
**Screwpine fruit, Borneo:
Pandanus**
Watercolour on paper, 230 mm x 180 mm
Signed *C.G. '95*
Shirley Sherwood Collection

These strange fruits are used locally
as scrubbing brushes.

John Parker
Pandanus drupaceus
Watercolour on paper, 490 mm x 340 mm
Mauritius
Kew Collection

Pandanus drupaceus is native of
Madagascar, but no doubt cultivated
on nearby Mauritius.

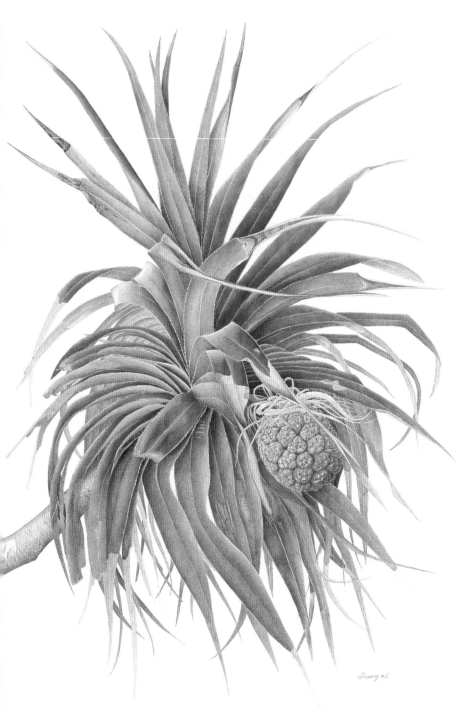

Isogai

Noboru Isogai, b. Gumma,
Japan 1935
Pandanus tectorius

Watercolour on paper, 1230 mm x 890 mm
Signed *Isogai*
Shirley Sherwood Collection

Pandanus tectorius is a very important
economic plant in the Pacific islands,
providing edible fruit as well as fibre
for grass skirts, roofing etc. It forms
a small, spreading tree with leaves to
150cm long.

Palms

The palm family contains about 2,650 species, mostly found in the tropics. Many, such as dates and coconuts, have edible fruit or seeds. Some such as sago palm have edible pithy growing points. Several species are now grown on a very large scale for their oily seeds.

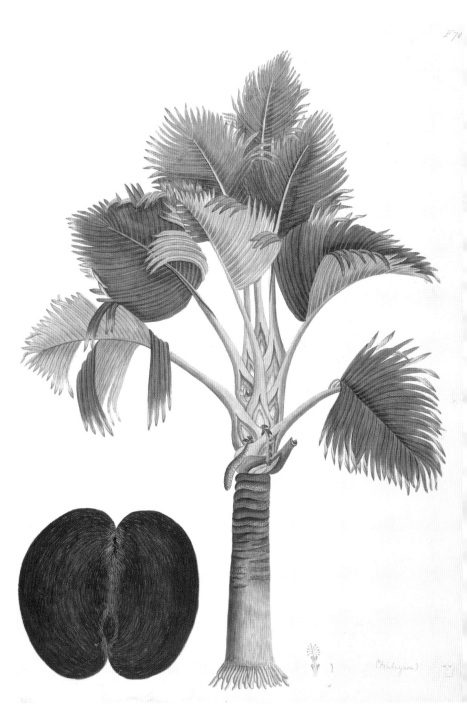

George Finlayson, b. Thurso, Scotland, fl. 1790–1823
Cocos Maldives
535 mm x 365 mm
Kew Collection

Lodoicea maldavica, the coco-de-mer, from the Maldive islands in the Indian ocean.

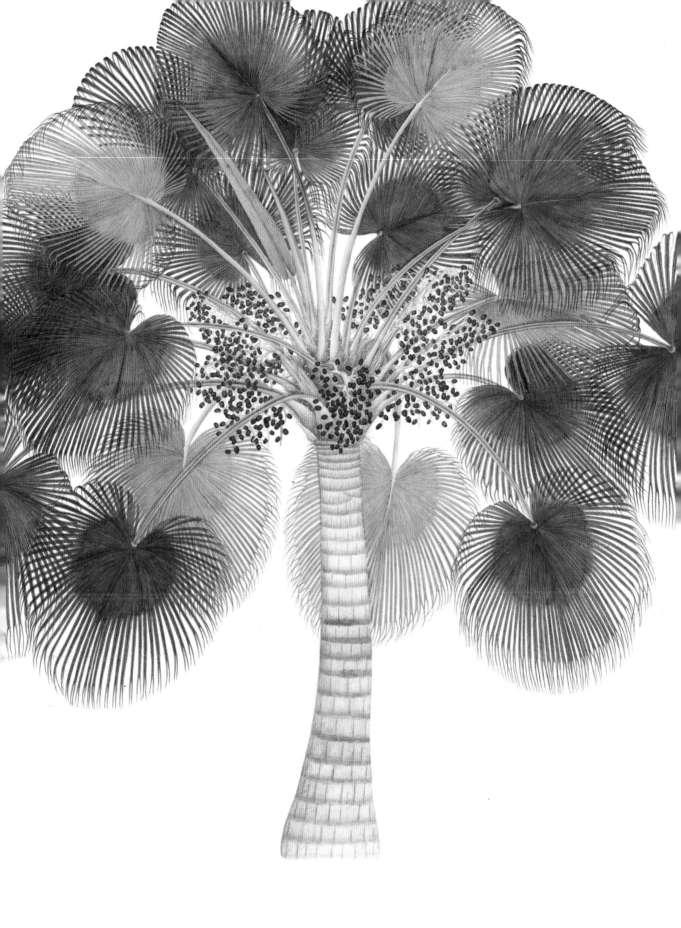

Company School
Artist and date unknown
Livistona mauritiana
Watercolour on paper,
590 mm x 545 mm
Kew Collection

Livistona chinensis is a common fan
palm in temperate parts of China
and eastern Asia, and is commonly
cultivated elsewhere.
←

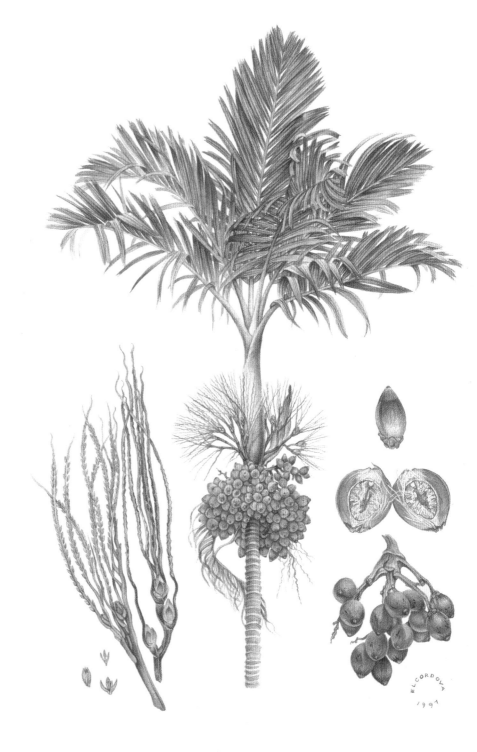

Emmanuel Cordova, b. Pasay
City, Philippines 1960
Areca palm: *Areca catechu*
Watercolour on acid free paper,
500 mm x 380 mm
Signed *E. L. Cordova 1997*
Shirley Sherwood Collection
→

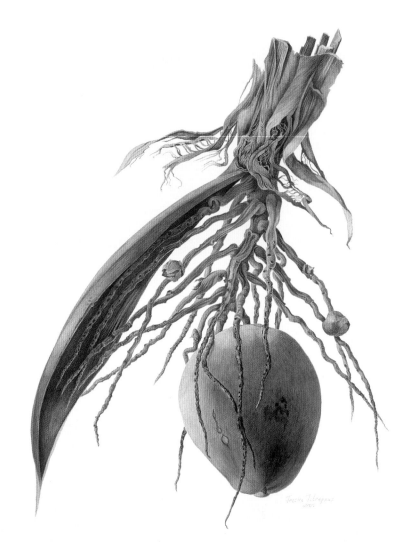

Alice de Rezende, b. Paracambi,
Rio de Janeiro, Brazil 1961
Washington palm:
Washingtonia robusta

Watercolour on paper, 675 mm x 470 mm
Signed *M. Alice Rezende*
Shirley Sherwood Collection

This specimen was painted in the
Palm House at Kew.
\rightarrow

Jessica Tcherepnine,
b. London, England 1938
Coconut: *Cocos nucifera*

Watercolour on paper, 700 mm x 595 mm
Signed *Jessica Tcherepnine 2005*
Shirley Sherwood Collection
\leftarrow

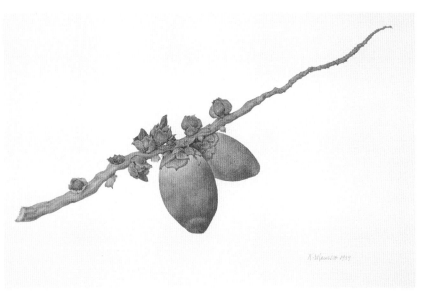

Katherine Manisco, b. London,
England 1935
Fruiting Palm

Watercolour on paper, 280 mm x 450 mm
Signed *K Manisco 1999*
Shirley Sherwood Collection

Cycads

Cycads are very ancient and primitive plants, unrelated to any other living group. They are found mainly in Africa and Asia, with a few species in Australia. Cycads have been recognised in Triassic rocks, and have been in decline since the Jurassic, the age of the dinosaurs. The male and female cones are usually on separate plants, and vary from huge pineapple-like cones, to almost leafy stems with seeds on the margin; they are pollinated by wind or sometimes by beetles. The leaves are often stiff and spiny, and tend to uncoil, like ferns. The roots are thick and much branched and contain nitrogen-fixing cyanobacteria.

Leslie Carol Berge, b. Taunton, Mass., USA 1959–2017
Cycad: female cones of *Encephalartos ferox*
Watercolour and pencil, 700 mm x 510 mm
Signed *L C Berge 1998*
Shirley Sherwood Collection
→

Leslie Carol Berge, b. Taunton, Mass., USA 1959–2017
Cycad: male cones of *Encephalartos woodii*
Watercolour on paper, 570 mm x 760 mm
Signed *L C Berge 1999*
Shirley Sherwood Collection

No female plants of *E. woodii* have ever been found.

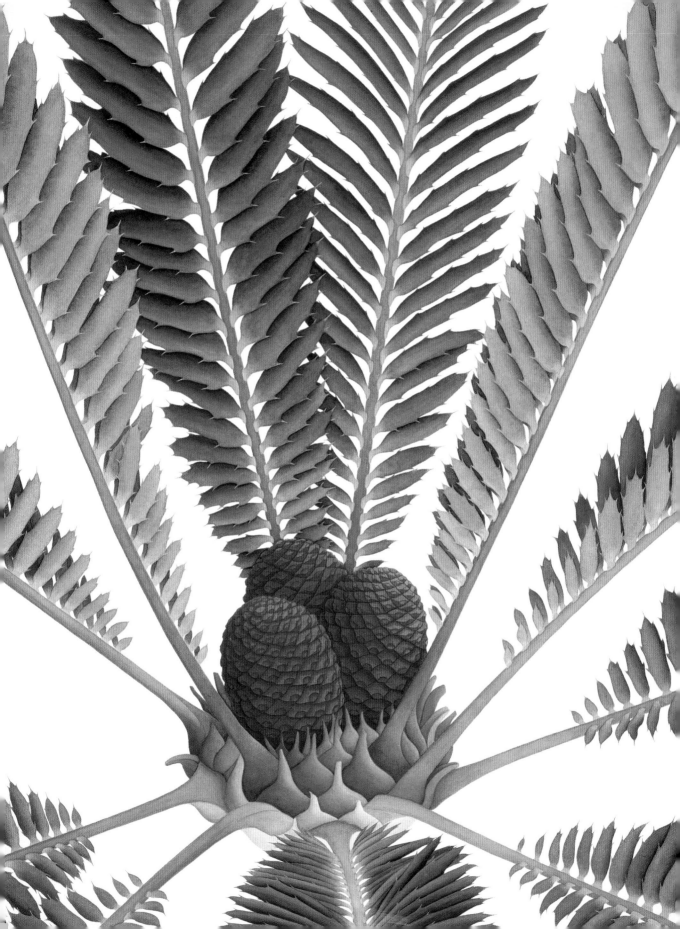

Waterplants

Recent studies of fossil plants have demonstrated that waterlilies were some of the earliest flowering plants, and these ideas have been confirmed by DNA studies which have shown waterlilies to have evolved independently from all other groups.

In spite of its waterlily-like habit, the sacred lotus, *Nelumbo* (see page 239), is not closely related to true waterlilies, but is an isolated family, an evolutionary survival and dead end. The other two aquatic plants shown here, flowering rush, *Butomus umbellatus* and *Pontederia cordata*, are in different families and are more closely related to other monocotyledons.

Margaret Mee, b. Chesham, Buckinghamshire, England 1909–1988

Nymphaea ampla var. ***pulchella***

Pencil and gouache on paper, 630 mm x 460 mm

Signed *Margaret Mee*

Shirley Sherwood Collection

Nymphaea ampla is a common usually white-flowered species in central and South America; the leaves have toothed margins. *Nymphaea elegans* is the American blue-flowered waterlily, and is found mainly around the Gulf of Mexico. Its leaves have smooth margins or are finely toothed.
→

Artist and date unknown

Nuphar

Watercolour on vellum, 275 mm x 220 mm

Kew Collection

This painting seems to be of *Nuphar rubrodisca* which is found wild in north-eastern North America from Nova Scotia to Manitoba. It can be recognised by its 5 sepals, often reddish inside, and leaves with a V-shaped sinus, generally floating on the water surface. *Nuphar advena*, the American spatterdock, was described by Aiton in *Hortus Kewensis* in 1789, usually has 6 or more sepals, which are seldom reddish, and leaves which emerge from the water. It is found mainly in the south-eastern United States, and is also naturalised in parts of Europe.
←

Margaret Mee

Nymphaea amplia
(Salisb.) D.C. var. *pulchella* Casp.

Represa de Santo Amaro.
flowered July, 1957

L. North
Nymphaea caerulea
Watercolour on vellum,
300 mm x 375 mm
Kew Collection
Now *Nymphaea nouchali* var. *caerulea*

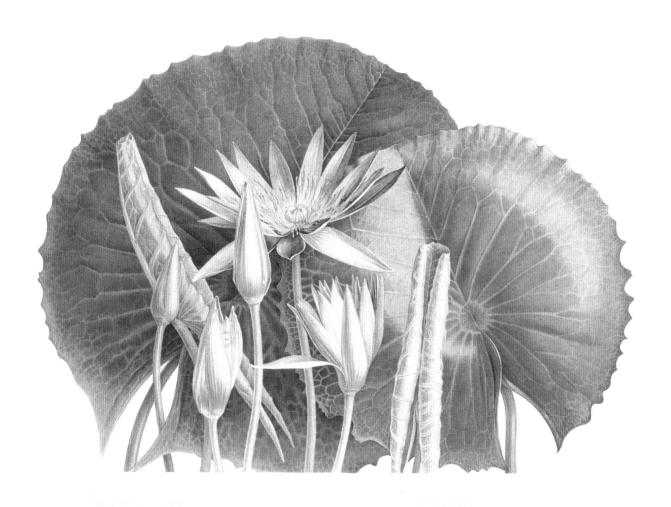

Pandora Sellars,
b. Herefordshire, England 1936–
2017
Blue water lily: *Nymphaea
capensis*

Watercolour on paper, 385 mm x 500 mm
Signed *Pandora Sellars '95*
Shirley Sherwood Collection

Nymphaea nouchali var. *caerulea* is
now the name for both *N. caerulea*
and *N. capensis*, found throughout
Africa from the Nile to the Cape and
in India.

W. H. Fitch, b. Glasgow, Scotland
1817–1892

Victoria amazonica **flower
cross-section**

Pencil and watercolour on paper,
360 mm x 550 mm
Signed: *W.H. Fitch*
Kew Collection

The huge flowers open white the
first night when only the stigmas are
receptive, and by the second night
have changed to pink when the
pollen is shed; the pollen can self-
fertilise its own stigmas on the
second night. Natural pollination is
usually by beetles.

W. H. Fitch, b. Glasgow, Scotland 1817–
1892

Victoria amazonica **leaf cross-section**

Pencil and watercolour on paper, 465 mm x 360 mm
Signed: *W.H. Fitch*
Kew Collection

Victoria amazonica is widespread in South
America, where it grows in slow rivers and
lagoons. The plant is very fast-growing and
there was intense competition among the great
gardens of England to be the first to grow it
well and get it to flower. It was first introduced
to Kew from Bolivia in June 1846, when
Thomas Bridges brought back seeds wrapped
in clay, but though a few seeds germinated,
they soon died. In 1849 around 50 seedlings
were raised at Kew, and distributed to other
gardens including Syon and Chatsworth, whose
gardener, Joseph Paxton was the first to coax it
into flower, in that November. Paxton's design
for the Crystal Palace is said to have been
inspired by the ribs of the Victoria leaf.
→

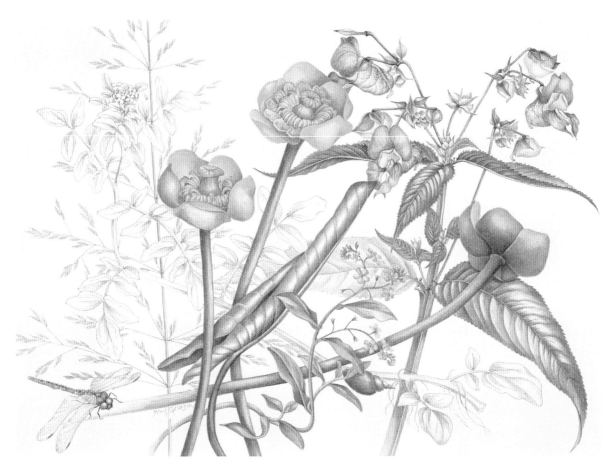

Mary Grierson, b. Bangor, Wales 1912
Yellow waterlily and Himalayan balsam

Watercolour on paper, 260 mm x 340 mm
Signed: *Mary Grierson*
Shirley Sherwood Collection

Nuphar lutea, the European yellow waterlily, is
common in slow rivers and large lakes in most
of Europe and western Asia. In deep water the
submerged leaves look like a soft lettuce. The
flowers are pure yellow and have 5 sepals.

Impatiens glandulifera, Himalayan balsam, was
introduced to England from the Himalayas in
1839, and has become naturalised throughout
the British Isles, especially on the muddy banks
of rivers. Seeds are dispersed by water, and by
mice who collect and hide them for winter
food. The flowers are a rich source of pollen and
nectar in early autumn.

Also shown here are water forget-me-not,
Myosotis scorpioides, watercress, *Nasturtium
officinale*, reed grass, *Glyceria maxima* and
a dragonfly.

Dasha Fomicheva, b. Moscow,
Russia 1968
Butomus umbellatus

Watercolour on paper, 250 mm x 225 mm
Unsigned and undated
Shirley Sherwood Collection

Butomus umbellatus, the flowering
rush, is found in marshes, ditches and
shallow water throughout Europe
and Turkey. It is the only species in
its family.

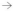

Pontederia cordata. Pandora Sellars '98

Pandora Sellars,
b. Herefordshire, England 1936–2017
Pontederia cordata
Watercolour on paper
Signed *Pandora Sellars '98*
Shirley Sherwood Collection

Pontederia cordata, the pickerel weed, grows in shallow water in eastern North America, extending south to South America. It is related to the beautiful water hyacinth, *Eichhornia crassipes*, a floating plant from northeastern Brazil, which has become a serious weed in many parts of the world.
←

Sue Herbert, b. Darwen, England 1954
Leaf
Watercolour on paper,
690 mm x 460 mm
Signed *Susan Herbert* (undated)
Shirley Sherwood Collection

Found growing on a river bank, painted after pressing under a carpet.
→

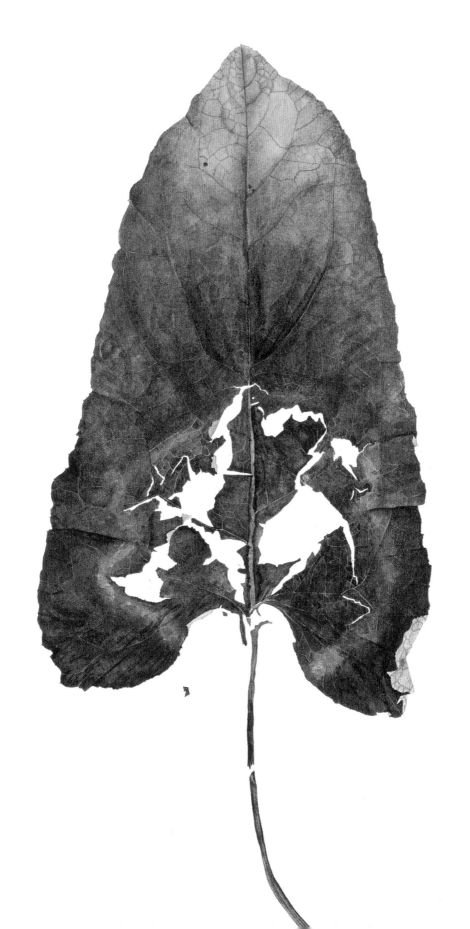

Tropical fruits

Shown here is a selection of different fruits, some edible some poisonous. One of the main activities of the East India Company, and later of the Royal Botanic Gardens, Kew was to study food plants, spices or indeed any natural resource, which might be traded or planted for export to Europe. Mrs Hutton's paintings were part of this study. Janet Hutton née Robertson, was the wife of an East India Merchant resident at Penang from 1802 to 1808, and in Calcutta from 1817 to 1823.

She painted a wide range of tropical economic plants from India and Malaysia, particularly the edible fruits such as mango, durian, guava, pepper and breadfruit.

Margaret Anne Saul,
b. Brisbane, Australia 1951
Peanut tree: *Sterculia quadrifida*
Watercolour with coloured pencil and gouache, 680 mm x 580 mm
Signed *Margaret A. Saul 1995*
Shirley Sherwood Collection

Sterculia quadrifida, also known as peanut tree, is a small tree to around 10 metres tall, from tropical northern Australia. It is found in monsoon forests, in thickets and along streams. The fruits are orange outside and orange or red inside when ripe and have up to 8 black seeds that taste like raw peanuts and may be roasted. Margaret Saul grew this tree in her garden in Brisbane.
→

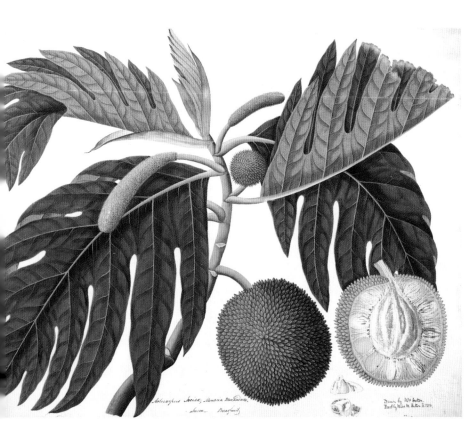

Janet Hutton, b. Scotland
fl. 1802–1824
Artocarpus incisa
Watercolour on paper, 455 mm x 555 mm
Signed: *Drawn by Mrs Hutton. Presented by Miss Hutton, 1894*
Kew Collection

Artocarpus altilis, sometimes included in the variable species *A.communis* is the tropical breadfruit tree, a staple crop in the Pacific. The fruit is starchy, with the consistency of new bread, and the cultivated varieties are seedless. One of the main aims of Captain Bligh's voyage to the Pacific in 1787, was to introduce breadfruit to the Caribbean, to be planted as food for slaves on the plantations.
←

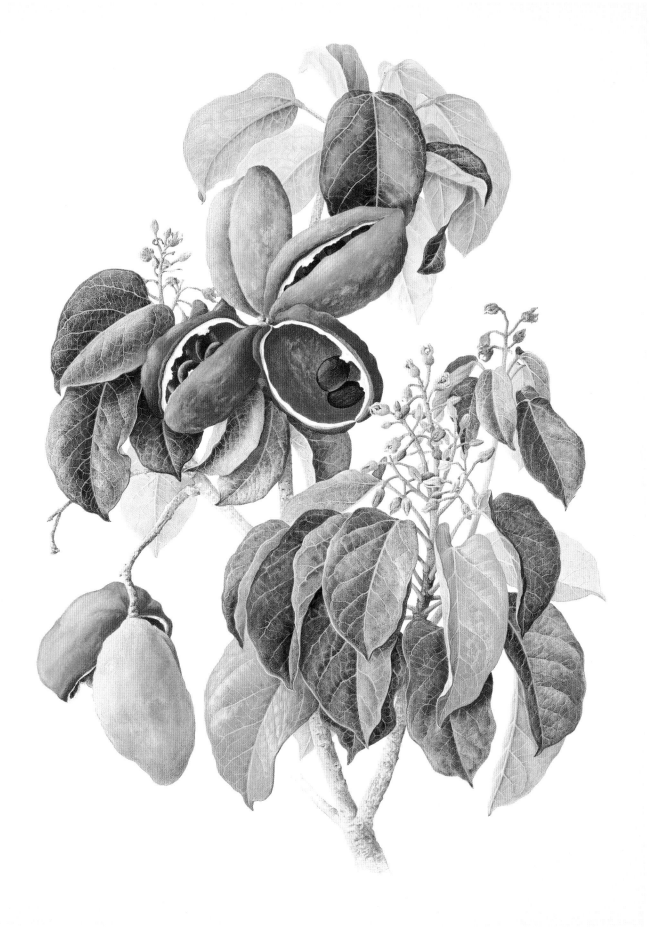

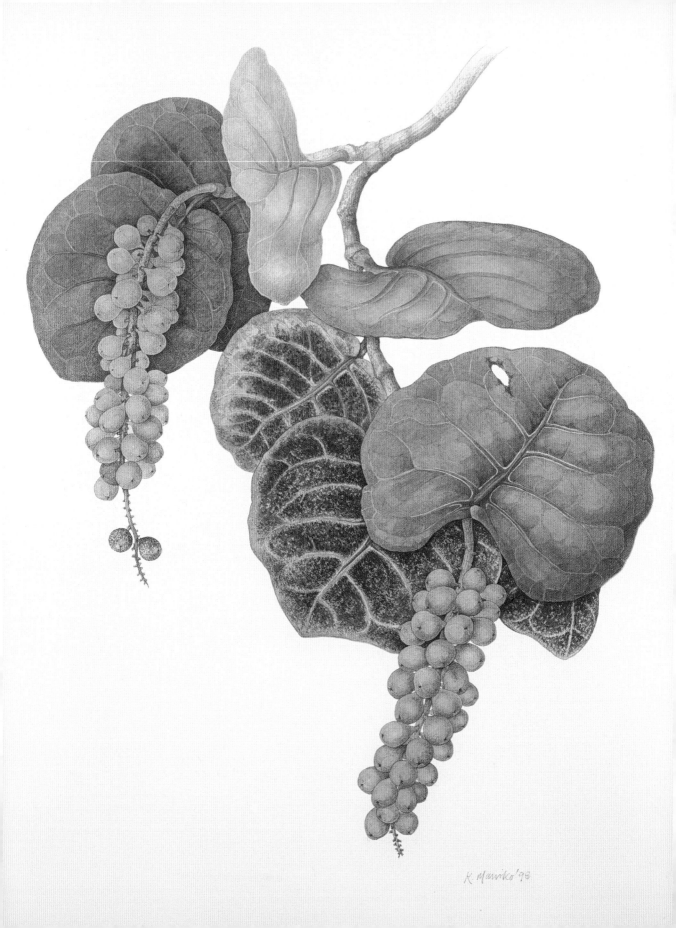

R. Mauriko '98

Katherine Manisco, b. London,
England 1935
Sea grapes
Watercolour on paper, 475 mm x 406 mm
Signed *K Manisco '98*
Shirley Sherwood Collection

The sea grape, *Coccoloba uvifera*, is
found on dunes and on the edges of
shingle banks or mangrove swamps in
Florida and tropical America. It
is common in the Caribbean and in
Bermuda, where it forms a thick-
stemmed shrub or small tree, and as
the large leathery leaves are tolerant
of salt, it forms an excellent first line
of defence for seaside gardens.
Coccoloba belongs to the Polygonaceae,
the same family as rhubarb and sorrel,
and the fruit are edible raw, and can
be made into jelly.
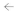

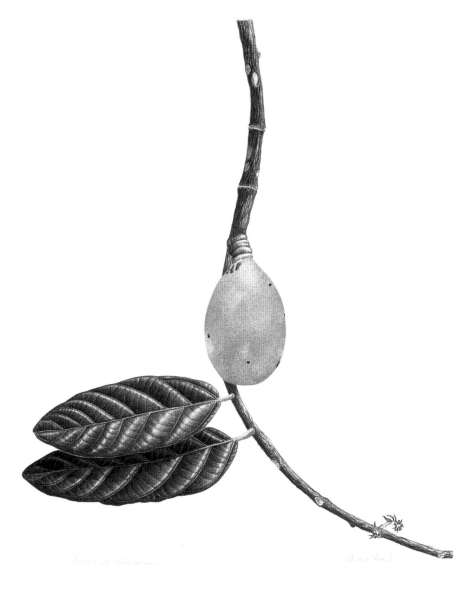

Álvaro Nunes, b. Anápolis,
Goiás, Brazil 1945
Theobroma subincanum
Watercolour on paper, 560 mm x 355 mm
Signed *Álvaro Nunes* (undated)
Shirley Sherwood Collection

Theobroma subincanum, the cupui, is a
small tree related to the cocoa, and
is found wild in Brazil. The fruits are
edible and this species is now being
tested as a possible new crop. The
scientific name *Theobroma*, is derived
from the Greek, 'food of the gods'.

ADENIA HASTATA *V Thomas*

Vicki Thomas,
b. South Africa 1951
Adenia hastata
(Passifloraceae)

Watercolour on paper, 350 mm x 650 mm
Named and signed *V Thomas*
Shirley Sherwood Collection

This unusual climber comes from
KwaZulu-Natal; the huge succulent
rootstock is usually only partly
buried, and it sends up new stems
every year. The orange fruits are
poisonous. This specimen was painted
from the plant in Kirstenbosch
Botanical Garden.

Brigid Edwards,
b. London, England 1940
Squash

Watercolour over pencil on vellum,
382 mm x 305 mm
Signed *Brigid Edwards 1995*
Shirley Sherwood Collection

These ridged Acorn squashes are
varieties of *Cucurbita pepo*, and were
domesticated first in Mexico, before
being introduced to Europe in the
17th century. The flesh is solid and
rich yellow.

\rightarrow

Brigid Edwards, b. London, England 1940
Physalis peruviana
Watercolour over pencil on vellum, 190 mm x 125 mm
Signed *Brigid Edwards 1993*
Shirley Sherwood Collection

Physalis peruviana, the Cape gooseberry, is a very easily-grown annual, with similar requirements to a tomato. The fruits are delicious when ripe, especially when coated in dark chocolate. In spite of its name the Cape gooseberry originated in South America.

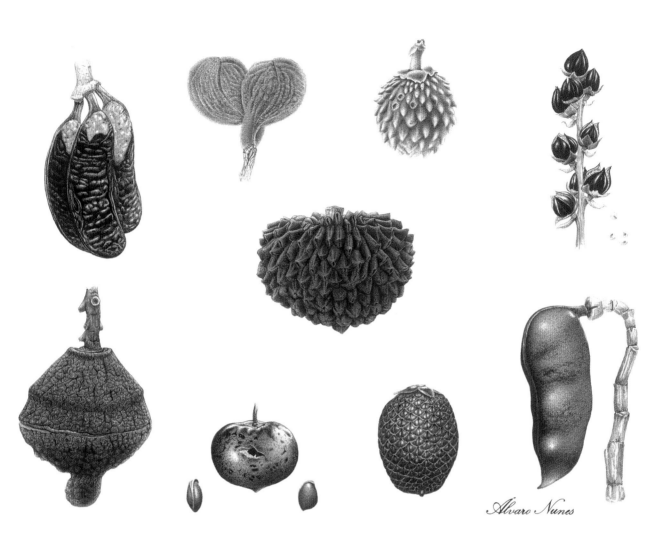

Álvaro Nunes

Álvaro Nunes, b. Anápolis,
Goiás, Brazil 1945
Fruits of Savannah

Watercolour on paper, 330 mm x 440 mm
Signed *Álvaro Nunes* (undated)
Shirley Sherwood Collection

Temperate fruits

Jean Gabriel Prêtre worked in Paris, on various projects, painting birds, various animals as well as flowers, often in collaboration with the Redouté brothers, Bessa, Poiteau and Turpin. His main published works were on the Tussac's *Flore des Antilles* (1808–1827), a book on grasses, and with his sister Joséphine, a romantic little book of flowers and songs with piano accompaniment for young ladies. His fruit book, *Le Panier de Fruits, ou Description Botaniques et Notices Historiques des Principaux Fruits Cultivés en France*, was published in 1807.

Brigid Edwards, b. London, England 1940
Redcurrants

Watercolour over pencil on vellum, 200 mm x 165 mm
Signed *Brigid Edwards 1993*
Shirley Sherwood Collection

Redcurrants, *Ribes rubrum*, are found wild across Europe and are commonly cultivated in northern areas; traditional uses are for summer pudding or to make jelly.
→

J.G. Prêtre b. Paris, France fl. 1800–1840
Eriobotrya **fruit cross-sections**

Watercolour on paper, 350 mm x 253 mm
1822
Kew Collection

Eriobotrya japonica, the loquat, is a relative of the hawthorn, *Crataegus*, and has fruit with a similar structure. It is native of southern China and Japan; the flowers open in autumn and the fruit ripen in late spring.
←

Susan Ogilvy, b. Kent,
England 1948
Cherries

Watercolour on paper, 150 mm x 520 mm
Signed *Susan Ogilvy 1995*
Shirley Sherwood Collection

Gertrude Hamilton, b. Ghent,
Belgium 1968
**Red & black currants,
raspberries, snail & bee 2001**
Watercolour on paper, 120 mm x 240 mm
Signed *GH* in pencil
Shirley Sherwood Collection
←

J.G. Prêtre b. Paris, France
fl. 1800–1840
Eriobotrya **fruit**
Watercolour on paper, 342 mm x 255 mm
1825
Kew Collection
→

Ferns and clubmosses

A small selection of paintings of fern and clubmoss are shown here. Ferdinand Bauer's dwarf *Cheilanthes* is a plate for the magnificent *Flora Graeca*. In 1785 John Sibthorp, Sherardian Professor of Botany at Oxford visited Vienna to study the Byzantine manuscript of Dioscorides, and there met Ferdinand Bauer. The next year Sibthorp, John Hawkins, a classical scholar and botanist and Bauer set out together for Greece and Turkey with the intention of studying the plants and trying to relate what they found to the classical and modern Greek names of plants. Bauer sketched the plants, and later worked up his paintings for the plates used in the 10 volumes of *Flora Graeca*, published between 1806 and 1840, and one of the finest botanical books ever produced.

Company School, Indian Collection
Artist and date unknown
Lycopodium squarrosum
Watercolour on paper, 475 mm x 295 mm
Kew Collection

Phlegmariurus squarrosus is found wild from Madagascar and the Seychelles east to Thailand and Taiwan, and south to Queensland and Fiji. They have beautiful hanging stems and grow on wet rocks or as epiphytes in tropical forest.
→

Ferdinand Bauer, b. Feldsberg, Austria 1760–1826
Acrostichum velleum
Watercolour on paper, 465 mm x 310 mm
Proof plate for *Flora Graeca*
Kew Collection

Cheilanthes catanensis is a Mediterranean fern, found from Spain and Portugal eastwards southern Turkey and Afghanistan and south to Ethiopia. It usually grows on limestone rocks, near the sea in the northern part of its range.
←

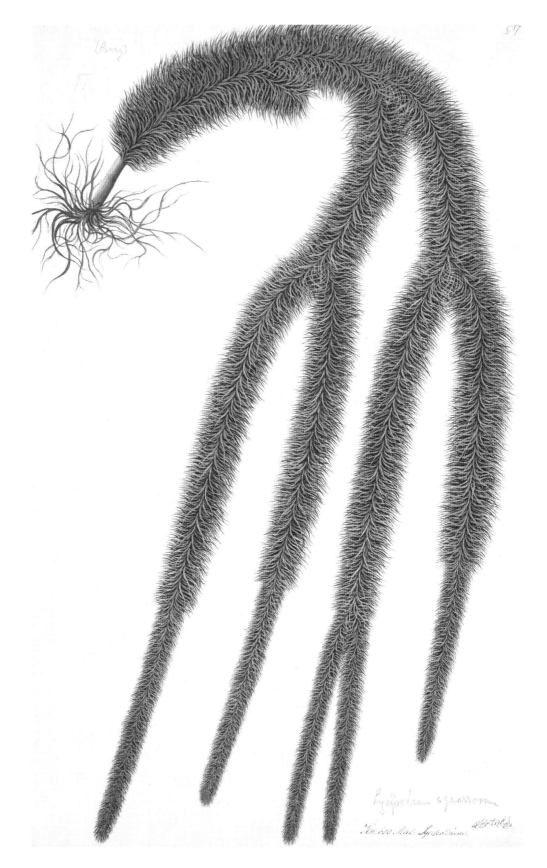

(Bury)

Lygodium scandens

In cos. Bor. Lygodium.

C y a t h e a d e a l b a t a

New Zealand tree fern – "Ponga" – Bryan Poole

Bryan Poole,
b. New Zealand 1953
Tree fern: *Cyathea dealbata*

Copper plate etching, 420 mm x 560 mm
Signed *Bryan Poole – 1/100*
Shirley Sherwood Collection

Cyathea dealbata, Silver fern, is a
beautiful tree fern from New
Zealand, where it is a national floral
emblem; the huge fronds have silvery
undersides and can reach 3 m long
while the stems can reach 10 m high.

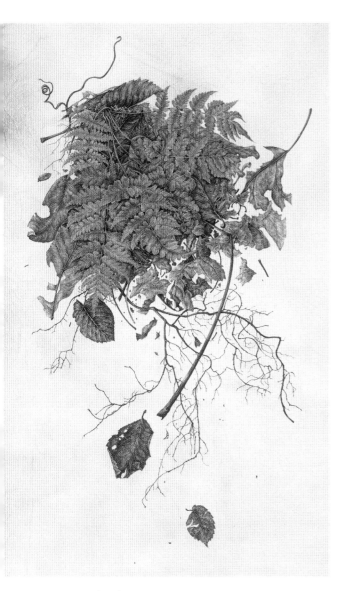

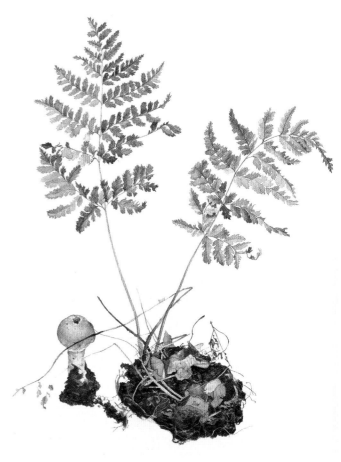

Kate Nessler, b. St Louis,
Missouri, USA 1950
**Fern with beech roots
and leaves**
Watercolour & body colour on vellum,
480 mm x 275 mm
Signed *Nessler* (undated)
Shirley Sherwood Collection

Sue Herbert, b. Darwen,
England 1954
Small ferns with fungus
Watercolour on paper, 445 mm x 313 mm
Signed *Sue Herbert* 1996
Shirley Sherwood Collection

This young fern is probably *Dryopteris
dilatata*, broad buckler fern, a
common woodland fern in Europe
eastwards to Siberia; the mushroom
is perhaps a young specimen of a
puff ball.

Mushrooms

Alexander Viazmensky paints both landscapes and fungi which he collects in the woods near St. Petersburg, gathering them from his favourite secret spots. His paintings of mushrooms have been exhibited by the Royal Horticultural Society (RHS) who have bought works for the Lindley Library. Since 1997 his style has become more detailed and clearly outlined, although he retains his customary scatter of leaves, pine needles and strands of grass.

Pauline Dean was one of the most influential botanical artists of recent times through her courses at the RHS's garden at Wisley, which she continued to teach for eleven years.

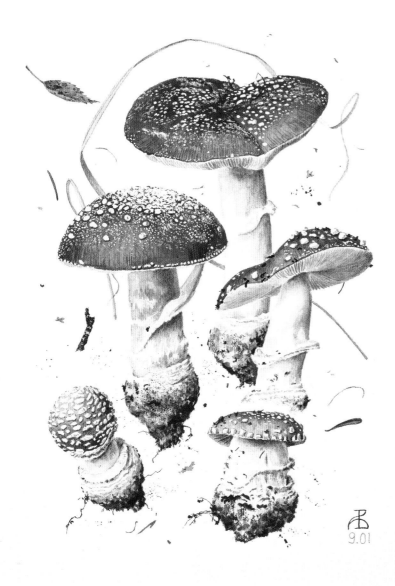

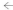

Alexander Viazmensky,
b. Leningrad (St Petersburg),
Russia 1946
***Boletus edulis* and
*Amanita muscaria***
Watercolour on paper, 380 mm x 280 mm
Signed with hieroglyphic *AV* in old Russian
Shirley Sherwood Collection

Boletus edulis, the penny bun, cep or steinpilz, is one of the best edible mushrooms, with a thick stem, white flesh and white tubes which become yellowish and a brownish cap, which can be 25cm across. It is found associated with all sorts of trees, from summer to late autumn.

Amanita muscaria, the fly agaric, is a very common mushroom, usually associated with birch trees (*Betula* species). The red, spotted cap, contrasting with white scales and stem, makes this one of the most conspicuous of all amanitas, and one which has become the subject of many myths. It is poisonous, causing twitching, hallucinations and dizziness, followed by deep sleep. Even after waking, symptoms continue, caused by stimulation of the central nervous system. Fly agaric was regularly eaten as a drug by the shamans of some of the tribes in Siberia, but the effects vary greatly between individuals and the amount of toxin in each mushroom.
→

Alexander Viazmensky,
b. Leningrad (St Petersburg),
Russia 1946
Amanita pantherina
Watercolour on paper, 260 mm x 190 mm
Signed with hieroglyphic *AV* in old
Russian 9.01
Shirley Sherwood Collection

Amanita pantherina, the panther cap is a very poisonous mushroom, related to the deathcap. The cap is around 10cm across, brownish or reddish-brown with white scaly remains of the veil; the gills are white. It grows in coniferous or deciduous woods, and is particularly associated with beech (*Fagus*).
←

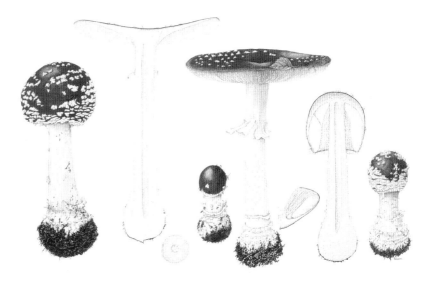

Pauline Dean, b. Brighton,
England 1943–2007
Fly agaric: *Amanita muscaria*
Watercolour on paper, 290 mm x 435 mm
Signed *P.M. Dean* (undated)
Shirley Sherwood Collection

Finale

The two paintings shown here do not fit into any of the previous categories and yet deserve to be shown as fine examples of contemporary botanical art and still life studies.

Kate Nessler, b. St Louis, Missouri, USA 1950
Corn
Watercolour on vellum,
762 mm x 483 mm
Unsigned
Shirley Sherwood Collection
→

Susannah Blaxill, b. Armidale, New South Wales, Australia 1954
Seaweed
Watercolour on paper,
460 mm x 650 mm
Signed *Susannah Blaxill 2002*
Shirley Sherwood Collection

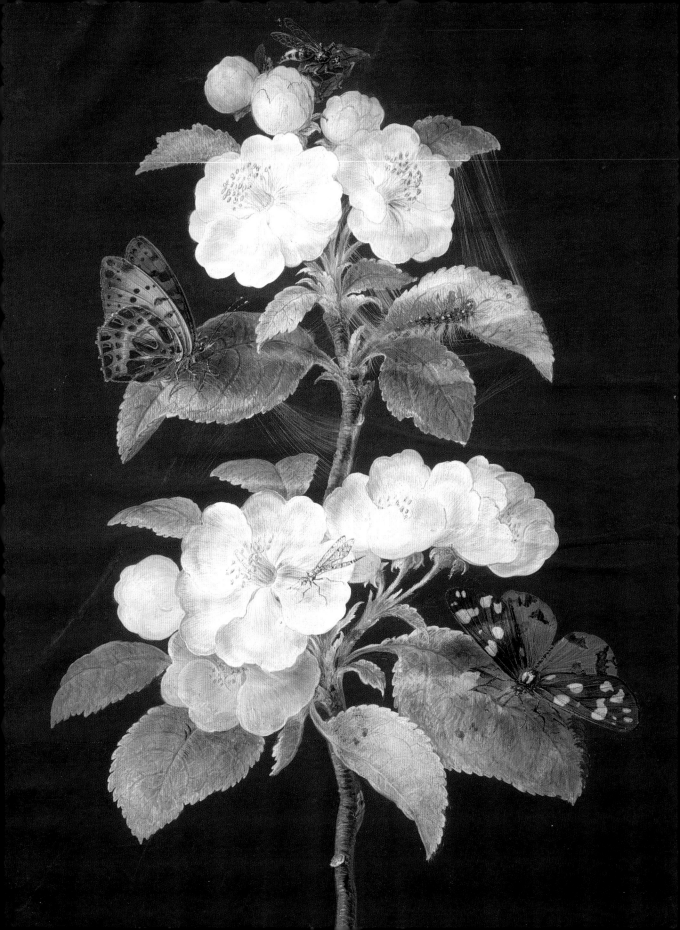

Biographies

ALLEN, Beverly (born Australia, 1945)
Beverly Allen started her career as a botanical artist in 1998, having graduated from Sydney University in 1995. Before that she was a freelance graphic designer and illustrator.

I first saw her work through Botanica, an excellent annual exhibition of Australian artists in Sydney. She has shown at the Lion Gate Lodge in the Royal Botanic Gardens Sydney since 1999. My first purchase there was a blue ginger and my second a spectacular *Strelitzia nicolai*. A scan of the yellow lotus was sent to me and I reserved it otherwise unseen, only to be surprised at its large size when I eventually saw it in Botanica. I checked up in the garden and the lotus flowers are indeed magnificent and just as big as she had portrayed them.

She has exhibited widely in Melbourne as well as Sydney, in New York, Washington and in the Hunt Institute, Pittsburg. I also showed her lotus in Japan in 2006 in the Sompo Japan Museum of Art, Tokyo. After being awarded a gold medal by the RHS her work was selected for Kew and the Lindley Library.

She initiated the Florilegium Society at the Royal Botanic Gardens, Sydney with Margot Child, another great supporter of botanical art. They both felt that Botanica was so successful and the numbers of Australian artists had increased so substantially that a Florilegium was a feasible project. Their ambition was to commission portraits of significant plants in the Mount Tomah Botanical Garden, Mount Annan Botanical Garden, the Domain and the Royal Botanic Gardens, Sydney. This has been a most valuable project both artistically and scientifically, with the added satisfaction that the artists' donated work is held in an archive and exhibited already in Sydney and at Kew. SAMS

ALLEN, Martin (born Sunderland, England 1970)
Having graduated in horticulture from Nottingham, Martin Allen started drawing when he became ill with M.E. He studied painting plants with Colin Swinton, tutor of botanical art courses at the RHS garden at Harlow Carr, Harrogate and began writing on many aspects of botanical art.

He gained two individual RHS gold medals and another group medal with the Chelsea Physic Garden Florilegium Society. He was awarded the Certificate of Botanical Merit in 1996 and 1998 at the Society of Botanical Artists exhibition and was made Emeritus Fellow of the Chelsea Physic Garden Florilegium Society where he has been a most active member. His work has been shown in a number of exhibitions in group shows of the Chelsea Physic Garden Florilegium Society.

He had a solo show 'Seeing Potential' at Gallery 27, Cork Street, London in 2007. I was unable to go to this exhibition so I invited him to show me some of his work later. He arrived with half a dozen large paintings distinctive because only a few were in focus in a conventional way. These intense watercolours were focussed in one plane, in a similar way to a close-up photograph where only one plane is sharp. The detail was fascinating and his different approach interested me, although I felt I would have liked more definition in some of the portraits. Allen is fascinated with buds and their hidden promise of further development, and a number of the paintings he showed me were of them opening. I purchased the magnified horse chestnut bud unfolding (which is

completely in focus) and it compliments the variety of chestnut studies in the exhibition. I felt it had an elegant simplicity, bringing out the cottony buds and the sticky bud cases to perfection. SAMS

ALLEVATO, Sergio (born Rio de Janeiro, Brazil 1971)
Sergio Allevato became a Margaret Mee Scholar at Kew from 1998–1999, and Artist-in-Residence at the Arizona Sonora Desert Museum, Tucson, Arizona in 2001.

His work is held at Kew, the Hunt Institute, where he showed in 2001, the Zoological Society, London and in numerous private collections. He has had solo exhibitions in several galleries in Rio and in Kew, and has been in numerous group shows in the USA, Canada, London, Portugal and Rio de Janeiro. Sergio Allevato's paintings and drawings have been reproduced in *Curtis's Botanical Magazine*, a variety of catalogues and in children's books. He was commissioned to do an excellent calendar for BCN Bank, Brazil.

He appeared in *The Botanical Artist*, a TV programme for Globo News where he was shown painting the huge scarlet bromeliad *Alcanterea imperialis*. I acquired both the life-sized inflorescence as well as a beautifully detailed close-up of a group of the flowers, which he painted on his terrace during the filming. I have seen this plant growing up to nearly three metres high, a truly regal sight and a big undertaking for a plant portrait. A recent watercolour of *Hesteria perianthomega* has been acquired for the National History Museum, London and an exquisite Heliconia for the Smithsonian. He has been given an aquisition prize in Bahia Museum in 2008.

He holds a masters degree in fine arts from Goldsmith College, London. SAMS

ANDERSON, Francesca (born Washington DC, USA 1946)
Francesca Anderson's vigorous yet elegant pen and ink studies are full of energy. She lives in Brooklyn, New York, and at her farm out on the end of Long Island, in what has become her own nature reserve.

She has had many solo exhibitions all over the States and for ten years prepared the plates for two books with M. Baldick on the palms of Belize and on Ayurvedic Herbs. She has been awarded two gold medals at the RHS, and is a leading light in organising the Brooklyn Florilegium Society. She recently became a Fellow of the Linnean Society.

Her work is always full of movement and she chooses large subjects which swirl across her pages. She prefers to work on ten or more similar subjects like her series of amaryllis, brassicas, poisonous plants, vegetables and bulbs. She is currently drawing birds on scratchboard, something that has always fascinated her.

Recently she undertook a commission to draw thirteen orchid portraits to decorate the elegant Orchid Room in the '21' Club in New York. SAMS

BARLOW, Gillian (born Khartoum, Sudan 1944)
Gillian Barlow has always had a career in the arts, attending the Slade School of Fine Art, University College, London in the early sixties and reading for a BA and MA in the history of art at Sussex University. In 1987 she went to India as a visiting professor for the British Council and staged solo exhibitions there during her

Beverly Allen, b. Sydney,
Australia, 1945
Yellow lotus: *Nelumbo lutea*

Watercolour on paper, 770 mm x 1240 mm
Unsigned
Shirley Sherwood Collection

Nelumbo lutea, the yellow lotus is wild
in North America, from Maine to
Ohio southwards to Texas and
Florida, and into Mexico and the
West Indies. Apart from the yellow
flowers and shorter fruits, it differs
little from the Asian pink or white-
flowered *N. nucifera*. Even now both
seeds and tubers are used as food by
local people.

tenure as well as having solo exhibitions in the States. In 1988
she became Herald painter for the College of Arms, London
which involved designing and painting coats of arms for newly
elevated peers.

She won two gold medals from the RHS and was appointed
assistant recording artist for their Orchid Committee from 1995.
She has to paint new varieties of orchids immediately after they
have won awards, in order to register their idiosyncrasies. She also
taught in the English Gardening School at the Chelsea Physic
Garden and has worked for years promoting their Florilegium
Society, overseeing its archive of paintings and helping with its
exhibitions. She was awarded 'Best of the Show' at Longwood's
Flora 2000. She is a member of the RHS Picture Panel. SAMS

BARRETTO, Malena (born Rio de Janeiro, Brazil 1952)
Malena Barretto lives in Rio but has spent a great deal of time
travelling and painting on projects all over Brazil. In 1990 she
came to Britain to study at Kew with Christabel King and to take
various other courses in England, supported by the Margaret Mee
Foundation. She has had a substantial amount of work published,
and has recently been working on a portfolio of rare bromeliads
for Banco Boavista.

She has been much influenced by Margaret Mee's work,
giving her plants a similarly strong outline that sometimes fades
near the edge of the paper.

Malena Barretto has taught at the Rio de Janeiro Botanical Gardens, as well as Belem, Fortaleza, Recife and various other botanically interesting places; she has illustrated a book on Brazilian medicinal herbs produced by Reader's Digest called *Segredos e Virtudes das Plantas Medicinais*. Her book *Malena Barretto*: *Watercolours and drawings of the Brazilian Flora* was published in 2004. Recently she had a solo exhibition in Paris. SAMS

BAUER, Ferdinand (born Feldsberg, Austria, now Valtice, Czech Republic 1760–1826)

Ferdinand Bauer was born into an artistic family. His father, who was court painter to the Prince of Liechtenstein, died early, and Ferdinand and his two brothers Joseph (later Court Painter) and Franz were employed by the Prince's physician and local abbot, Dr Norbert Boccius, to record the plants in the town's monastery garden. The brothers worked assiduously at this task, which was given the title *Liber Regni Vegetabilis*. Some of this enormous collection have recently been published by the Liechtenstein family with an introduction by H.N. Lack in *A Garden for Eternity* (2000). As part of this project, the brothers worked with Nikolaus Joseph von Jaquin, professor of botany and director of the botanic garden of the University of Vienna, and in 1785 Jaquin introduced Ferdinand to Dr John Sibthorp, professor of botany at Oxford, who had come to Vienna to study the ancient manuscripts of Dioscorides. Sibthorp planned to visit Greece and Turkey and duly invited Bauer to accompany him. The pair, with Sibthorp's friend, John Hawkins, set off in 1786, reaching Crete in June, and travelled from there through the Aegean islands to Athens, Smyrna (Izmir), and many other places, including Delphi, Rhodes and Cyprus, arriving back in England in September. Sibthorp and Hawkins made a second trip in 1794, this time unaccompanied by Bauer, and sadly, Sibthorp returned to England in a low state of health, subsequently dying of tuberculosis. After his untimely death, Hawkins was appointed chief executor, and set about the immense task of publishing all the notes and paintings connected with the voyage under the title *Flora Graeca* (1806–1840). J.E. Smith was employed to collate the work, and he saw through the publication of the first six volumes, with the remaining volumes overseen first by Robert Brown and then John Lindley. The finished work was truly magnificent – ten volumes containing one thousand paintings by Bauer, the majority of them engraved by James Sowerby and his family – and rightly regarded as one of the most important botanical works ever published.

Bauer, meanwhile, had been off on another expedition to Australia (1801–5) with Matthew Flinders and the surgeon and botanist Robert Brown. On returning to England, Bauer published *Illustrationes Florae Novae Hollandiae* (1813) containing 15 plates of genera newly described by Brown: all the plates were engraved and hand-coloured by Bauer himself. A further batch of Ferdinand's paintings, depicting plants collected on Norfolk island, were published in 1833 under the title *Prodromus Florae Norfolkicae*. His work also appeared in *Description of the Genus Pinus* (1803–24) by Aylmer Bourke Lambert and Lindley's monograph on *Digitalis*, published in1821. EMR

BAUER, Franz (Francis) Andreas (born Feldsberg, Austria, now Valtice, Czech Republic, 1758–1840)

Franz Bauer's father was court painter to the Prince of Liechtenstein, and after early artistic training and encouragement from his mother, and later Dr Norbert Boccius, the Abbot of Feldsberg, he illustrated plants for Nikolaus Joseph von Jaquin, professor of botany and director of the botanic garden of the University of Vienna. In 1788 he accompanied Nikolaus' son, Baron Joseph Jaquin (1766–1839) to England, where he became known by the anglicised form of his name. His skill was soon spotted by Sir Joseph Banks, a keen botanist and President of the Royal Society. Banks was also *de facto* director of Kew at this time and in 1790 he arranged for Bauer to be employed (at his own expense) as 'Botanick Painter to his Majesty' and to draw new plants flowering at Kew, an arrangement which continued for the rest of Bauer's life. Banks had a high regard for Bauer's work, which is not only artistically satisfying, but also notably precise and scientifically accurate; he examined the plants he drew minutely under a microscope, and had an excellent knowledge of botany. Amongst his finest works are 30 plates of ericas, painted by him for *Delineations of Exotic Plants Cultivated in the Royal Garden at Kew*, published in three parts from 1796–1803. He also illustrated *Strelitzia Depicta*: or *Coloured Figures of the Known Species of the Genus Strelitzia from the Drawings in the Banksian Library* (1818), and worked with John Lindley on *The Genera and Species of Orchidaceous Plants* (1830–8), and *Genera filicum; or Illustrations of the Ferns, and other Allied Genera* (1842) by Sir William Jackson Hooker. Banks had always hoped that in due course a botanical artist would be employed by the King at Kew, but this did not seem to be forthcoming. Having therefore continued to pay Bauer's salary himself, and having also arranged for his executors to continue this arrangement after his death (in 1820), he was the official owner of the latter's work, and intended the paintings and drawings to remain at Kew. By the end of Bauer's life, however, the future of the garden was so uncertain that he agreed that the bulk of his work should be deposited at the British Museum. As a result, only a few of Bauer's works are held in the Kew Collection today, and the bulk of his work is held at the Natural History Museum, London. EMR

BEAN, Deidre (born Newcastle, New South Wales, Australia 1960)

Deidre Bean studied at the university of Newcastle in Australia and then became an operating theatre nurse and medical practice manager, before taking a course in botanical illustration at the Royal Botanic Gardens, Sydney in 1999.

She has been Honorary Secretary of the Florilegium Society at the Royal Botanic Gardens Sydney, and has exhibited in many exhibitions, both in Europe and particularly at the yearly Botanica exhibitions in Sydney. Her work is in many public and private collections and she won an RHS gold medal in London in 2006. EMR

BERGE, Leslie Carol (born Taunton, Mass., USA 1959–2017)

Leslie Berge was born into an artistic and musical family of French origin and educated at the American College in Paris. Her first degree was in art history, painting and drawing in 1981 from Bennington College, Vermont followed by an MA in illustration at the Art Institute of Boston, with an emphasis on children's books.

She worked as a freelance artist and exhibited at the Hunt Institute in 1992 in the 7th International Exhibition. Later she visited South Africa where she enjoyed the different South African flora, in particular the most important collection of cycads in the world, growing in Kirstenbosch, the famous botanical garden on the slopes of Table Mountain.

Her dramatic 1998 painting of the female cones of the cycad *Encephalartos ferox* was chosen to decorate a ceramic plate by Wedgwood for a special series commemorating the Shirley Sherwood Collection. Leslie entered another cycad, *Encephalartis woodii* for Longwood's Flora 2000, Delaware. This painting looks like a giant nest where a goose has laid a cluster of golden eggs, a far cry from that elegant garden's normal image, but appropriate nevertheless, as Longwood has one of the few specimens of this endangered cycad. Sadly she died in 2017. Her family gave me two of her interesting works. It was a great loss of a dear friend. SAMS

BESLER, Basilius (fl. Nürnberg, Germany 1561–1629)

Basil Besler was an apothecary, the author of probably the most impressive of the early 17th century florilegia, *Hortus Eystettensis*, published in two large volumes at Eichstatt near Nürnberg in 1613, under the patronage of the Prince-Bishop of Eichstatt, in whose gardens most of the plants illustrated were grown. Besler worked on and off for sixteen years on the drawings, which were then engraved by a team of at least six people. The resulting 374 plates show the plants at life size, and are arranged in chronological order of flowering, starting with spring and moving through the seasons, providing a wonderful record of what was growing in a plantsman's garden at the time. Most of the plants shown are now familiar, but the range is most impressive for such an early date, featuring plants from as far away as Spain, Corsica, Turkey and the Americas. The garden, in which the plants were arranged geographically, had been started by the botanist Camerarius in 1596 and was continued after his death by Besler.

300 copies of this remarkable work were printed, on the largest size paper then available; some deluxe copies were hand-coloured, but most were black and white; the cost of a coloured copy was 500 florins, then a fifth of the cost of the large town house in Nürnberg which Besler bought himself with his profits from the book. Fewer than 10 of these coloured copies are known to survive today, and when a deluxe coloured copy was sold at Christies a few years ago, it attained the highest price ever bid for a botanical book. SAMS

BESSA, Pancrace (born Paris, France 1772–1835)

Pancrace Bessa was a pupil both of Van Spaëndonck and of Redouté, with whom he worked on Bonpland's *Description des Plantes Rares Cultivées à Malmaison et à Navarre* (1812–17). He was later appointed flower painter at the Jardin des Plantes, both teaching and contributing to the Vélins (paintings on vellum), and gave lessons in painting to his patroness, the Duchesse du Berry. His watercolour paintings of fruit and flowers are elegant and detailed, very similar in style to the early work of Redouté, and like him, Bessa was one of the early practitioners of stipple engraving; he also occasionally ventured into depicting animals and birds. One of his early ventures was *Fleurs et Fruits*, containing 24 coloured engravings, published in Paris in 1808; he also exhibited watercolours of flowers at the Paris Salon from 1806–14. He contributed around 600 plates to the journal, *L'Herbier Général de l'Amateur* (1810–1827), and, by a bizarre twist of fate, many of the originals for these, together with a number of paintings made for the French court, later belonged to the Empress of Brazil (the Duchesse du Berry's sister). Bessa also published the *Album des Roses*, containing 23 colour engravings, in 1830, and nearly 400 of the plates from *L'Herbier Général* reappeared in *Flore des Jardiniers*, a more popular publication, in 1836. EMR

BLACKADDER, Elizabeth (born Falkirk, Scotland 1931)

Elizabeth Blackadder RA is a most distinguished painter whose subjects range far from the classical flower study. She studied at Edinburgh University and Edinburgh College of Art and was decorated with an OBE in 1982. She has had over 40 one-person exhibitions and has work in a huge number of collections, ranging from Scotland to the United States, with paintings in the National Portrait Gallery, London, and the National Museum of Women in the Arts in Washington DC. She designed a lovely series of postage stamps of her cats in 1995 and her paintings are always immediately sold at the Royal Academy Summer Exhibition.

Her flower paintings are wonderfully free and uninhibited, yet most carefully observed. Her watercolours are splashed with spots of paint and stray pencil marks, her vigorous approach far removed from the meticulous style of the traditional botanical painter. Indeed, she herself wrote in a foreword for an etching portfolio catalogue, 'I chose the plants which appealed to me as an artist and which I found visually exciting in terms of shape, colour and structure. I make no claims to botanical truth and accuracy'.

Despite her 'loose and wet' technique, her plants are always immediately identifiable – indeed botanists are often surprised when they make this discovery. Her command of watercolour is quite superb, especially when painting velvety dark iris, mysterious, speckled orchids and stately lilies. SAMS

BLAXILL, Susannah (born Armidale, New South Wales, Australia 1954)

Susannah Blaxill was born in Australia but trained and worked for a period in England, with exhibitions at the David Ker Gallery, London and at Spink in 1994 after she had returned to Australia. Her spectacular beetroot is so notable that it has been chosen by virtually every exhibition curator when the Shirley Sherwood Collection has been shown around the world.

Her painting of seaweed took several months to complete after much initial positioning, producing the most arresting and subtle painting with dense, amazing depths of painting tones. Currently she is working on a camellia, striped pink on a dark background which will be comparable to the two Dietzsch paintings shown here. Its dark background is composed of 32 layers of paint and the flower is in gouache overlaid with watercolour.

She is currently concentrating on commissioned works, but has also exhibited in the Sydney Botanic Gardens show called Botanica in 2005, 2006 and 2007. There is no doubt at all that she is one of the great contemporary botanical artists and yet another example of the strength of botanical art in Australia. SAMS

BOND, George (born Shropshire, England c.1806–1892)
George Bond was a gardener on the staff at Kew, and between 1826 and 1835 he made around 1700 drawings of plants that were flowering in the garden for the head gardener, W. T. Aiton's revision of *Hortus Kewensis*; sadly never published. After leaving Kew, Bond became gardener to the Earl of Powis, at Walcot in Shropshire, where he worked until 1880. Walcot boasts a fine arboretum, containing particularly good specimens of Douglas fir (*Pseudotsuga menziesii*), which had been brought into cultivation in England only a few years before Bond's arrival there. It is not known whether Bond did any further drawings, although a number of the ones he had done at Kew were used as the basis for plates in *Curtis's Botanical Magazine* during Hooker's editorship. He died at Lydbury, in Shropshire. EMR

BOOTH, Raymond (born Leeds, England 1929–2015)
Raymond Booth was considered to be one of the best British painters of plants who, unusually, worked in oil on paper (like Marianne North 1830-90). He went to Leeds College of Art in 1945, but his training period was interrupted by National Service. His work has appeared in a number of publications such as the *Kew Magazine* and *The New Plantsman*. He also did several plates for the Camellia book that Mrs Urquart commissioned in 1956, to which Paul Jones also contributed many paintings.

However his most important collection of published paintings is in the *Japonica Magnifica* written by Don Elick. The original paintings were mounted as a touring show in the States. He lived in Yorkshire and exhibited at The Fine Art Society, London. He had a final show in the spring of 2007 and continued to paint – as he said – for fun. Raymond Booth died in 2015. SAMS

BROWN, Andrew (born Carshalton, England 1948)
Andrew Brown retired from teaching at Westminster School in 2001. Since then he has illustrated freelance for botanists at the Royal Botanic Gardens, Kew, having completed some two hundred pen and ink drawings to date. He was Chairman of the Chelsea Physic Garden Florilegium Society from 2001 to 2007. This Society is producing a modern florilegium for the garden, started by Ann Marie Evans who taught in the English Gardening School there for many years.

He has been awarded three individual gold medals and three group medals from the RHS, concentrating mainly on bulbs and iris. Seventeen of his watercolour illustrations and several black and white drawings are held in the archive of the Physic Garden. SAMS

BROWN, Peter (fl. 1760–1790s)
Peter Brown was a natural history artist who contributed illustrations to some important works, including Thomas Pennant's *Arctic Zoology* (1784–5), and in 1776 published his own *New Illustrations of Zoology*, containing 50 hand-coloured plates of birds and animals. Brown was commissioned by Emanuel Mendes de Costa (1717–91) a keen collector of fossils and minerals, friend of Pennant and sometime clerk to the Royal Society (until he was found to have embezzled some of the funds), to produce watercolours of shells on vellum, and these were engraved and published in *Conchology*, or *Natural History of Shells* (1771). Little is known about Brown's

botanical paintings, or his work for the Prince of Wales (later George IV), but his style is not dissimilar to that of Ehret, and it is thought (although firm evidence is hard to find) that he may have been one of Ehret's pupils. Brown exhibited at the Royal Academy and the Free Society of Artists in London from 1766 to 1791. EMR

CHRISTOPHER-COULSON, Susan (born Durham, England 1955)
Susan Christopher-Coulson trained as a fashion and textile designer, gaining a degree at Kingston Polytechnic in 1977. She then worked in the fashion industry while also teaching on the Art Foundation Course at Colchester Institute.

In 1994 she began concentrating on botanical work and by 1997 was exhibiting and selling her drawings. She was awarded two RHS gold medals, with a technique of coloured pencils used dry. She has showed in a number of exhibitions in the north of England including Leeds, Harrogate and York.

She was elected to the Society of Botanical Artists in 2001 and has shown regularly in their annual show, which is where I acquired her work of scattered violets in 2007. The drawing has a delightfully fresh look but is also reminiscent of the violets that can sometimes be found decorating the borders of old illuminated manuscripts. SAMS

COMMELIN, Jan (c.1629–1692)
Jan Commelin was a botanist and director of the Amsterdam Physic Garden, who enjoyed a thriving trade in herbs and medicines. His book, *Nederlantze Hesperides* (1676–1684), contains illustrations of citrus fruit for the hothouse, and he was also instrumental in publishing other works on exotic plants from the East and West Indies. He is remembered today, however, for *Horti Medici Amstelodamensis Rariorum Plantarum Descriptio et Icones*, which described and illustrated the rare plants of the Amsterdam Physic Garden. Jan saw the first part published in 1697, and after his death the work was completed by his nephew Caspar, with the second part published 1701. Many of the plants illustrated are exotics from America or Asia, brought to Holland by the Dutch ships engaged in the expanding spice trade. The original paintings were mainly by Johan and Maria Moninckx. EMR

COMPANY SCHOOL (fl. 18th century–19th century)
In the late eighteenth and early nineteenth centuries, there was a fashion for British merchants who were based in India and China, to commission local artists to make paintings of plants, animals and local scenes. Because the main employer was the East India Company, these paintings became known as 'Company School'. Often these paintings were the only known images of Chinese and Indian plants, and so were a valuable addition to the collections of dried specimens in the herbarium. Joseph Hooker collected Company School flower paintings to use in his *Flora of India* (1875–1897), and others have been added to the Kew library since then. Useful or medicinal plants are a particular focus of these collections.

Company School paintings combine the scientific accuracy of European botanical art, often with a certain flatness, but with eastern elegance of design, perhaps because they were drawn from flattened specimens prepared for the herbarium. EMR

CORDOVA, Emmanuel L. (born Pasay City, Philippines 1960)
Emmanuel Cordova took a degree in advertising at the University of Santo Thomas and joined an advertising company for a few years before going freelance in 1990. He has had annual one-person exhibitions called Botanicals Elcordova at the Ayala Museum, Makati City since 1991 and been hung in several group exhibitions. He has executed a number of large commissions for some of the top hotels in Manila, including murals, botanical paintings and prints. In 1994 he was sponsored by the Amon Trading Corporation to travel widely in Europe to do a modern grand tour, visiting museums, galleries and gardens to broaden his experience.

In 1999 he painted the largest botanical paintings he had ever attempted, for a private home. He created eight large panels from floor to ceiling, featuring plants that can be found around Mindoro, where the resthouse was built. He sent me a photograph of this lovely project, with each panel showing different examples of palms, bamboos and ferns, an elegant backdrop of cool green and golden brown plants on a white background.

He completed the illustrations for the republication of a medicinal plant book that was first produced in Madrid in 1892. Called *Plantas Medicinales de Filipinas* by Dr Trinidad H. Pardo de Tavera, the original edition was not illustrated. Emmanuel Cordova was commissioned to produce twenty-six paintings for the new edition by Fr Joey Cruz of the Ateneo University, and it came out in English and Spanish in 2000.

In 1996 I commissioned him to paint a palm as a subject and a few months later a splendidly informative and charming study arrived of the Areca palm, *Areca catechu*. He has sold several oil paintings in Sotheby's auctions in South East Asian Art in Singapore and another in Hong Kong in a sale by Christies. In 2008 he held a solo show in Cebu in the Southern Philippines. SAMS

DEAN, Pauline (born Brighton, England 1943–2007)
Pauline Dean exhibited her meticulous watercolours of plants over a long period. She started in 1987 after being trained as a registered nurse but she had no formal training as a botanical artist. She died after a long, courageous struggle with cancer.

She was awarded eight gold medals and two further 'joint' ones' by the RHS. She had a solo exhibition at the Botanical Garden in Geneva in 1999 and exhibited at the Linnean Society in London, the Hunt Institute in Pittsburgh, the Everard Read Gallery, Johannesburg and also illustrated books. *The New Plantsman* commissioned her to paint a number of plants. Until prevented by ill health she taught botanical art at the RHS garden at Wisley in Surrey for eleven years to 2002, and designed the successful series of 'Winter Flower' ceramic plates for the RHS made by Royal Worcester.

In 2004 she published her beautifully illustrated biography, *Pauline Dean – Portfolio of a Botanical Artist,* which shows many of her paintings, mostly of plants growing at Wisley. In 2006 she was invited to the International Exhibition and Conference on Botanical Illustration for Tropical Plants at the Queen Sirikit Botanic Garden in Chang Mai, Thailand where examples of her work were shown and she gave an illustrated talk on botanical painting. SAMS

DEMONTE, Etienne (born Niteroi, Brazil 1931–2004)
Etienne Demonte achieved a great deal for botanical art in Brazil in his lifetime, as well as being a famous painter of birds. He lived in Petropolis, a city above Rio in the cooler Atlantic rainforest, as part of a large family of wild-life painters who were passionate about saving the unique environments of Brazil and triggering conservation through their artistic output and records. He was an influential teacher.

From the 1960s onwards he had over two dozen shows in Brazil and exhibited widely internationally in Greece, the UK, the Smithsonian Institution in Washington, in Madrid and many other Spanish cities, and at the Hunt Institute. He featured with his sisters in a National Geographic film for an 'Explorer' programme, showing his research and painting in the Bahia region, in the bay of the San Francisco river.

His painting of *Bilbergia sanderiana* and humming birds (page 192 shows all his skill in its composition, and its meticulous and yet romantic evocation of the rainforest. SAMS

DE REZENDE, Maria Alice (born Paracambi, Rio de Janeiro, Brazil 1961)
I met Alice de Rezende during her stay at Kew as a Margaret Mee scholar in 2004. She had painted the Washington Palm in the Palm House there during her period of tuition by Christabel King. Since then I have seen her again in Rio, where she showed me a range of paintings and a few of her outstanding technical pen and ink illustrations.

She has taken a number of courses in watercolour, gouache and black and white techniques in Rio and has worked for the Botanical Gardens of Rio de Janeiro and New York. She has received awards in Rio and Marinha do Brasil. She is an enthusiastic professional and an example of how the Margaret Mee Foundation can encourage the development of Brazilian artists. SAMS

DIETZSCH, Johann Christoph (born Nürnberg, Germany, 1710–1769)
The Dietzsch family, in common with several others in Nürnberg at that period, boasted a number of artistic members, many of whom who continued to paint in the tradition of van Kessel (1626–79) and Maria Sibylla Merian (1647–1717), in which flowers and insects were illustrated together. Johann Israel Dietzsch (1681–1754) was an artist, whose daughters Barbara Regina (1706–1783), Margaretha Barbara (1716–95) and son Johann Christoph (1710–69) were all talented painters. Johann, to whom one of the paintings illustrated in this book is tentatively attributed, worked with his father and sisters at the Court in Nürnberg, and was particularly known for his landscape paintings, although he also produced a number of flower paintings, and was also an etcher and engraver. Both he and his sister Barbara Regina, who often worked in gouache, appear to have painted flowers on a black background, and thistles with butterflies were among their favoured subjects, so it is difficult to be certain who painted these pictures. EMR

DOWDEN, Anne Ophelia (born Denver, Colorado, USA 1907–2007)

Anne Ophelia Dowden can be considered the 'grandmother' of America's contemporary botanical artists in much the same way that Mary Grierson fills that role in the UK. Both have produced many books and patiently instructed aspiring artists, continuing to paint in later years.

I met Anne Ophelia Dowden in July 1998 for the first time in her apartment in Boulder, Colorado close to where she grew up. She was very organised, with her drawings and notebooks arranged meticulously. She used these repeatedly as source material over the years when she was writing, illustrating and publishing her books.

She was worried about her failing eyesight which made it impossible for her to continue painting in the detail that botanical subjects demand. But she could easily see the huge banner of her Autumn foliage painting blown up outside the Denver Art Museum at a major show I organised there in 2002. She was certainly not forgotten in her later years. The American Society of Botanical Artists gave her its annual award for her achievements as an illustrator and author in 1996 and she had another award from the Garden Club of American Zone XII in the same year. In January 1999 she received given the Gertrude B. Foster Award for Excellence in Herbal Literature from the Herb Society of America. SAMS

DRAKE, Sarah-Ann (born Skeyton, Norfolk, England 1803–1857)

Sarah-Ann Drake came from Norfolk, of which county John Lindley (1799–1865) was also a native. Sarah-Ann and Lindley's sister were friends, and thus began a lifelong connection between the families. In around 1830 Sarah-Ann moved into the Lindley household in London, possibly initially as governess to the children, but by 1831 she had started to undertake botanical illustrations, particularly of orchids, under Lindley's instruction. She contributed one plate for Wallich's magnificent work on Indian plants, *Plantae Asiaticae Rariores* (1829–1832), and was soon working on important publications such as Lindley's *Sertum Orchidaceum* (1837–41) and James Bateman's elephant folio *The Orchidaceae of Mexico and Guatemala* (1837–43).

She produced numerous paintings for Lindley's other works, including *Fossil Flora of Great Britain* (1831–37), *Ladies Botany* (1834–37), *The Botanical Register* (1815–47) and early parts of the *Transactions of the Horticultural Society*. In 1847, her work on *The Botanical Register* completed, she returned to Norfolk and in 1852 married John Sutton Hastings, a prosperous widowed farmer. She died five years later, her name commemorated in the orchid genus *Drakaea*. EMR

DUNCANSON, Thomas (fl. Kew 1822–26)

Little is known about Thomas Duncanson, except that he was a young gardener at Kew who was charged with making plant illustrations for the head gardener, W.T. Aiton's revision of *Hortus Kewensis*. The book was never published, but around 300 drawings of Duncanson's survive in the collection at Kew, along with those of George Bond, who took over this work after Duncanson was forced to retire due to ill-health. EMR

EDEN, Margaret Ann (born London, England 1939)

Lady Margaret Ann Eden studied at the English Gardening School in the Chelsea Physic Garden at the botanical art classes taught by Elizabeth Jane Lloyd and later by Ann-Marie Evans. These impressive courses have been responsible for fine-tuning some of today's best British botanical artists.

Margaret Ann Eden spent most of her childhood in Canada and Hong Kong. She started painting early and in 1959 she went to the Byam Shaw School of Art; she later studied portrait, life and still-life painting with Bernard Adams. She began painting flowers in watercolours at the end of the 1960's.

She has an unerring eye for an interesting subject. Her study of *Medinilla magnifica* is from the island of Luzon in the Philippines. It is an epiphyte, perching on tree-trunks which likes warmth and humidity but no direct sunlight. Her watercolour shows each stage of the opening bud and the cascade of flowers. Yet it is not a laboured exercise in botanical illustration but has become a work of art. It has been chosen for a special series of ceramic plates by Wedgwood, commemorating the Shirley Sherwood Collection. SAMS

EDWARDS, Brigid (born London, England 1940)

Inspired by the works of the Bauer brothers and Ehret, Brigid Edwards started painting plants in the mid 1980's. She has been a trail blazer and has exhibited her work widely; a beautiful study in the Shirley Sherwood Collection of two magnolia leaves, the mature one separated from an old leaf by a fruit placed between them, was in the 1990 summer show of the Royal Academy, a regrettably rare honour for botanical artists today.

In 1994 she was part of a group show at the Kew Gardens Gallery and she has had major exhibitions at the Thomas Gibson Gallery, London (1995 and 1997), and the William Beadleston Gallery, New York (2000). In 2006 she surprised everyone in the botanical art world by showing a series of much enlarged insects at Thomas Gibson Fine Art.

Coral Guest, b. London, England 1955

Lapageria: *Lapageria rosea* and var. *albiflora*

Watercolour on paper, 770 mm x 570 mm
Signed *Coral Guest '96*
Shirley Sherwood Collection

Lapageria rosea is an evergreen climber from central Chile, which grows well in a cool greenhouse or against a frost-free, shaded wall; the flowers are usually rich crimson, but may be pink or white. It is named after the Empress Joséphine, who was born Marie Joseph Rose Tascher de la Pagerie in Martinique in 1763. Grown by Shirley Sherwood.

→

In the catalogue of her 1997 show, Ian Burton wrote 'The fine painting of the detail on the vellum is uncanny, but when these single objects are arranged and suspended in a contemplative space, they achieve their greatest power, and as a result of this creative act of attention, they have an almost religious intensity. There is a gloriously 'abandoned' Oriental Poppy with papery purple and white petals and hundreds of lovingly counted stamens gathered around a central mandala'. SAMS

EDWARDS, Sydenham Teast (born Usk, Monmouth, Wales 1768–1819)

Sydenham Edwards spent most of his career in London, where he worked with William Curtis, who trained him as an artist. Edwards had a prodigious output, producing over 1200 plates for *Curtis's Botanical Magazine*, between 1787 and 1814. His work was however not confined to plants, and by 1792 he had exhibited a bird painting at the Royal Academy; he continued to produce detailed studies of butterflies, insects, birds and dogs, using both watercolour and gouache. Other work for Curtis included 27 plates for *Flora Londinensis* (1775–98) and illustrations for his lectures on botany, collected together and published by Curtis's son-in-law Samuel in 1805.

Edwards contributed one plate, that of hyacinths, to Thornton's *Temple of Flora*, and painted and engraved 61 plates for the *Representation of 150 Rare and Curious Ornamental Plants* (1809). In 1804 he was elected a fellow of the Linnean Society, and the following year he produced the paintings for Alex MacDonald's (whose real name was R W Dickson) *Complete Dictionary of Practical Gardening*, and then for his *The New Botanic Garden (1812)*. He contributed paintings to the *Annals of Botany (1805–6)*, and after his death plates copied from his paintings appeared in *Encyclographie du Règne Végétal (1833–38)*. Curtis died in 1799, and in 1815, Edwards left Curtis's magazine to found his own rival journal, *The Botanical Register*, whose editorship was later taken over by John Lindley. EMR

EDWARDS, Yvonne (born South Australia, 1942)

Although she was born in a rural part of South Australia, Yvonne Edwards has lived in England for most of her adult life. She feels her early freedom to explore ignited a lifelong passion for plants.

Now living near Salisbury, Wiltshire she grows a wide range of plants, observing them growing before painting them. Largely self-taught she has exhibited regularly with the Society of Botanical Artists, and was awarded their Certificate of Botanical Merit in 1997 and 2000.

Immediately I saw her painting of the mandrake with its sinuous roots entwining each other I guessed she might have been inspired by a Ferdinand Bauer painting that I had chosen from *Flora Graeca* for an exhibition at the Ashmolean Museum, Oxford in 2005. In antiquity the mandrake was reputed to shriek if torn from the ground and to cause the death of anyone who heard it. The remedy was to chain a dog to the plant and retire out of ear shot while the dog yanked out the evil root. Bauer's mandrake is quite suggestively male but I feel that Edwards' is definitely female. It compliments the female version of the mandragon found in the oldest exhibit from Kew, in the *Hortus Sanitatis*. SAMS

EHRET, Georg Dionysius (born Heidelberg, Germany 1708–1770)

Ehret was the son of a gardener, who after his father's early death was obliged to work as a gardener himself, first near Darmstadt, and then at Karlsruhe, the garden of the Margrave of Baden-Durlach. He was artistically talented from a young age, but it was not until he left Karlsrühe in 1728, and went to Regensburg, where he was employed by an apothecary, that he was able to concentrate on painting full time. Ehret then worked for a banker, Loeschenkohl, recording the plants in his garden, and hand-colouring engravings, and was also introduced to Johann Ambrosius Beurer, an apprentice apothecary and keen botanist, who was to become a lifelong friend and admirer of his work.

Johann Beurer was a cousin of Dr Jacob Trew (1695–1769) of Nürnberg, and through Beurer, Trew commissioned Ehret to paint exotic plants for himself. Trew also helped Ehret to travel around Europe, meeting many influential botanists and gardeners. Ehret spent much of 1734–5 in France, mostly based at the Jardin des Plantes, where he received further instruction and encouragement, this time from Bernard de Jussieu, the demonstrateur there, who also arranged for him to receive letters of recommendation for his first visit to England.

His first visit to London lasted only a year, although he managed to get to know both Sir Hans Sloane and Philip Miller in that time, and he soon headed off to Amsterdam, where he met George Clifford, and his young Swedish physician and garden manager, Linnaeus, who was to become another lifelong friend. Ehret supplied 20 plates for Linnaeus' sumptuously printed *Hortus Cliffortianus*, an account of the rare plants in Clifford's garden, published in 1738, and also drew and engraved a table, showing Linnaeus' system of plant taxonomy, which was later published by Linnaeus in his *Genera Plantarum* (1737). In 1736 Ehret returned to England, and worked at illustrating both botanical and zoological books, often at the Chelsea Physic Garden, where Philip Miller was curator. He married Miller's sister-in-law, and from then on made his home in England, working for many rich patrons including the Reverend Stephen Hales and the Earl of Bute, advisors to Princess Augusta at Kew. In 1750 Ehret took up the position of gardener/curator at Oxford Botanic Garden, a position offered to him by Humphrey Sibthorp, the Sherardian Professor of Botany; the two men soon fell out, and Ehret resigned after only a year, though he stayed on in Oxford until 1755. As a teacher he was highly successful, although he was forced to give up almost all his work in the autumn of 1768 as his eyesight was failing, and he died two years later leaving behind a large body of drawings (over 3,000 are still extant) in addition to the engraved plates in various publications. EMR

ESPARZA, Elvia (born Mexico City, Mexico 1944)

Elvia Esparza has been scientific illustrator at the Institute of Biology and professor at Universidad Nacional Autónoma de México (UNAM), Mexico City. She was founder president of the Mexican Academy of Scientific Illustration from 1991 to 1998 and has had her work reproduced in an impressive number of books and journals; she is especially well known for her paintings in *Flora de Veracruz*. She has had over a dozen solo exhibitions, mostly in

Mexico, and in England, at the Linnean Society, RHS Wisley, Kew Gardens and the botany department of the Natural History Museum, London in 1999. Her work is held at Kew and in the Hunt Institute as well as at UNAM.

She was awarded a gold medal by the RHS in 1999 for paintings of dramatic Mexican cacti and desert plants, set in their natural habitat. She has taught a variety of courses and workshops internationally, and the Museo de las Ciencias (UNIVERSUM) celebrated its first ten years with an exhibition including fifty of her paintings in 2000–1. She paints animals and insects as well as plants in a lively and yet accurate way; she was awarded the 'Best Botanical Artist' and another gold medal at the RHS exhibition in Birmingham in 2004. SAMS

FARRER, Ann (born Melbourne, Australia 1950)
Ann Farrer took a degree in English and history of art at Manchester University. In 1977 she was awarded a Churchill travelling scholarship which took her to Kashmir and Ladakh to draw the illustrations for *Flowers of the Himalaya* by O.Polunin and A.Stainton (1984). She often travels to the Himalaya having led treks there for 15 years: she may have inherited this passion for far-away places from her famous relative, the botanical explorer, Reginald Farrer (1880–1920) who travelled widely in China and Burma and introduced many plants into Western gardens.

Ann Farrer has been awarded 6 gold medals by the RHS and was the first recipient of the Jill Smythies award by the Linnean Society in London in 1988. She has illustrated many books, including *Grasses of Bolivia* and has taught two courses in botanical illustration at Kew. She has painted innumerable plates for *Curtis's Botanical Magazine*, *The Plantsman*, and the *New Plantsman*. Her paintings have been exhibited in the Kew Gardens Gallery, at Lancaster University in the Peter Scott Gallery, at Hortus and at the Hunt Institute's International Exhibition. She is an active member of RHS Picture Committee.

Recently she has been experimenting with mixed media and in 2008 had an exhibition at The Folly, Settle, North Yorkshire. SAMS

FENG, Jinyong (born Yixing, Jiangsu Province, China 1925)
I met Professor Feng in Beijing in 1994. He had all the appearance of a distinguished Chinese academic with a fresh and rosy face, white hair, twinkling eyes and a relaxed, friendly and yet dignified manner. He has taught most of the botanical illustrators in China during the course of his long career and won major prizes in his own country as well as exhibiting abroad at the Hunt Institute, the Missouri Botanical Gardens in Sydney, in Japan and at the Everard Read Gallery in Johannesburg. He is now retired from his final position, which he described as 'senior engineer' at the Botanical Institute in Beijing.

I found his work exceptionally fine, particularly his older pieces painted some years previously. He showed me some line drawings of great beauty, executed with a brush made of just three hairs from a wolf's tail; even under a powerful magnifying glass they were breathtaking. Thousands were done for Volumes I–78 of the vast *Flora Reipublicae Popularis Sinicae* (1959–1989), where every plant is illustrated by a small line drawing on each flimsy page. He also had a number of watercolours, some gouache and some studies

that appeared to have been done on paper with oil. (All the artists that I met in Beijing were particularly proud of their oil paintings, but I generally found them much less refined than watercolour or gouache). I wanted to buy some of Feng's older paintings of camellias but he was very reluctant and offered to copy them for me. This is a very alien approach for a Westerner, but it is totally within the Chinese tradition.

Eventually we agreed that I would buy one older painting, a small treasure of *Camellia chekiangolesa* that has already been published as a journal cover, and a recent painting of the newly discovered *Camellia chrysantha* executed on Winsor & Newton paper brought back from his visit to Canada. Feng also parted with a lyrical, less formal oil painting of a pink hibiscus, *H. syriacus*. As a charming gesture he gave me a flowing brush-painting of iris mounted on a silk surround, called 'Butterflies before the Wind', which is slightly reminiscent of Elizabeth Blackadder's work. At the end of our meeting I agreed, rather uncertainly, that he would copy a white *Camelia vietnamensis* for me. It is a success and has almost the quality of the original which he painted when he was younger. SAMS

FINLAYSON, George (born Thurso, Scotland fl. 1790–1823)
In 1821 Dr George Finlayson joined John Crawfurd's East India Company expedition to Siam (Thailand) and Cochin (Vietnam) as surgeon and naturalist, and collected plants in Malaya and Siam.

Finlayson's account of his travels, containing descriptions of the fauna and flora he observed, was published after his death in 1826 under the title *The Mission to Siam and Hué, the Capital of Cochin China, in the Years 1821–1822*, with an introduction by Sir Stamford Raffles (1781–1826). Finlayson painted a variety of animals, birds and plants, and was thrilled with the richness of the flora of the offshore islands of Thailand, especially a giant epiphytic orchid with an inflorescence 2m long. After surviving a serious bout of consumption in 1822, he died at sea on the journey from Calcutta to England. EMR

FITCH, Walter Hood (born Glasgow, Scotland 1817–1892)
At a young age Fitch became an assistant to the topographical artist Andrew Donaldson, before moving on to learn the art of lithography. He was then apprenticed as a fabric designer in a mill owned by Henry Monteith, a friend of William Jackson Hooker. Hooker was impressed by Fitch's artistic ability, and bought him out of his apprenticeship, putting him to work on drawing plants, and encouraging him to learn more about botany. Soon Fitch was able to draw sufficiently well to be allowed by Hooker to illustrate plants for *Curtis's Botanical Magazine* and was kept busy preparing drawings to accompany Hooker's lectures, many of which were published in Hooker's *Botanical Illustrations* (1837); at the same time he was the chief illustrator for *The Botany of Captain Beechey's Voyage* (1830–41) and *Flora Boreali-Americana* (1829–40), as well as lithographing drawings by himself and Francis Bauer for Hooker's *Genera Filicum* (1838–42).

In 1841 Hooker was appointed Director of the Royal Gardens at Kew, and Fitch followed him there to become chief artist, contributing to numerous publications and particularly to *Curtis's Botanical Magazine*. He was expert in fitting a large plant into the

rather cramped format of the magazine, but during his time many double-sized plates were also produced, which could be folded when bound in. Fitch continued to work hard – *The Botany of the Antarctic Voyage* (1845) and the *Rhododendrons of Sikkim-Himalaya*, by Hooker's son Joseph, with plates redrawn by Fitch, was published to great acclaim in 1849, and Hooker's more beautiful *Illustrations of Himalayan Plants* in 1855. At this time Fitch produced well over a thousand line drawings for Bentham's *Handbook of the British Flora*, and these illustrations continued to be reprinted into the second half of the 20th century.

William Hooker died in 1865, and his son Joseph took over as Director of Kew and Editor of *Curtis's Botanical Magazine*. Fitch continued his work for the magazine, though with less enthusiasm, and was glad to do other work, such as plates for *Refugium Botanicum* (1868–73) by W.W Saunders, articles and engravings for *The Gardener's Chronicle,* and plates for Elwes' *A Monograph of the Genus Lilium*. Fitch finally gave up work on *Curtis's Botanical Magazine* in 1877 after 44 years, having produced over 2,700 plates, and at last was able to spend a little time on drawing landscapes and less exacting work for *The Gardeners' Chronicle*. He also taught a number of pupils, including Matilda Smith, a distant relation of Sir Joseph Hooker, who was to become the chief artist for the *Botanical Magazine* until the early 1920s. In 1880, Hooker managed to arrange for Fitch to receive a pension from the Civil List, which was an enormous relief to him, and enabled him to continue working in a more relaxed manner. He died after suffering a stroke, aged 74. EMR

FOMICHEVA, Dasha (born Moscow, Russia 1968)
For ten years Dasha Formicheva divided her time between Jordan and Russia, working primarily for the Jordanian Royal Family. She earned an honours degree in Stage Design from Moscow Art College in 1986, a master's in painting from Surikoff State Academy, Moscow in 1993 and watercolour studies with Sergey Andriaka, People's Artist of Russia.

She painted watercolour interiors of the Kremlin Cathedrals for the Kremlin State Museums and landscapes of Petra for the Jordanian Royal Family in 1993 and 1994, 160 military paintings and drawings of the history of the Hashemite Kingdom for HRH Prince Abdullah; she also paints portraits and lectures in fine art theory.

Since 1993 she has exhibited in Moscow, Amman and London, participating in *Botanical Artists of the World* at the Tryon Gallery in London in 2001. One project supported by HRH Queen Rania resulted in the publication of *Jordan in Bloom: Wildflowers of the Holy Land* which contained 53 beautiful watercolours by Fomicheva with a fluent, luminous technique. I asked her to paint the extraordinary, rather sinister purple-black arum found in Jordan, *Biarum angustatum*. She sent me three dramatic studies which I arranged as a triptych. The unique colour and form of the spathe is offset by its disgusting smell, designed to attract insect pollinators when it flowers in the autumn. SAMS

FRANCIS, LINDA (born Bristol, England 1949)
Linda Francis now lives in Kingston, Surrey. She went to art school in Coventry and graduated after a Graphic Design Dip AD course at Maidstone. She followed this by ten years in the publishing world,

working for Thames & Hudson, Mitchell Beazley and Marshall Cavendish as a designer, art editor and commissioner of art work and photography. She worked on illustrated books, specialising in architecture, archaeology, history and gardening (which was becoming much more popular at that time).

She felt that this period in the 1970s was the golden era of publishing and was not going to return. She decided to change careers and worked for a time in an accountancy business. A few years later she started to paint again. She took a four-day course with Coral Guest at Kew in 1996 and had some individual tuition with Gillian Barlow.

I saw her work for the first time in 1997, at one of the RHS's autumn shows at Vincent Square, London where she was awarded a gold medal. She exhibited eight strong plant portraits, each with a firm sense of design, some shown from an interesting and unusual angle. I felt that here was a new 'voice', and that she had an original viewpoint. I bought two more of her paintings, from another gold medal series at the RHS in 1999, this time particularly focused on leaves. Again, I felt she had a strong sense of design and an appreciation of texture, particularly noticeable in the *Crassula* hybrid. The leaf texture in the *Crassula* painting was fascinating, with great depth. She achieved this 3-D effect by doing a darkish underpainting, then painted over this with titanium white mixed with green, trailed over in a cross-hatched style, layer upon layer.

In 2004 she showed 'Floral Grandiosity' at the RHS, a display of 'over-the-top' plants and later I acquired a spectacular *Strelitzia* for a special display at the Westcliff Hotel, Johannesburg. Sadly she decided that her eyesight is not good enough to continue the very precise and detailed work demanded by botanical art. SAMS

GREENWOOD, Lawrence (born Todmorden, England 1915–1998)
Before World War II Lawrence Greenwood worked as a carpet designer, engineering draughtsman and a general manager in industry. He started painting flowers in 1968 and attended evening classes at his local art school for five years. For over 20 years he exhibited his work at the shows of the Alpine Garden Society and Scottish Rock Garden Club. He showed 40 paintings at each of the 5th and 6th Rock Garden Conferences held at Nottingham University in 1981 and Warwick University in 1991.

Lawrence produced two kinds of painting. The first was the traditional botanical illustration of a plant set on a white background; the rhododendron shown here is an example. The second is of the plant set in its habitat, perhaps a woodland plant growing among fallen dead leaves or an alpine species nestling in the rocks and stones of a scree slope: the background was painted in as much careful detail as the botanical subject of the study.

Lawrence Greenwood was one of those unusual painters who was able to produce a painting from a photograph provided that the latter was of high quality. Because of this skill he was able to paint plants which are not in cultivation by using transparencies taken by botanists on their plant-hunting travels around the world, painting rare and inaccessible species from the Himalaya, Chile and Argentina. SAMS

GRIERSON, Mary (born Bangor, North Wales 1912–2012)

Mary Grierson was one of those warm, attractive women who must be everyone's favourite aunt. I met her first at Kew and then later as one of the judges on the RHS flower painting panel. The first of her paintings that I bought were from an exhibition at Spink, London where she showed for many years.

She honed her observational skills as a Women's Auxiliary Air Force flight officer interpreting aerial photographs during World War II, and later worked as a cartographer. But in 1960, when she was nearing 50, she started a new career as the official botanical illustrator at Kew, encouraged by John Nash RA whom she first encountered at a series of courses on botanical painting at Flatford Mill, Essex, which she used to attend during her holidays. She remained at Kew until the early 1970s and was to be seen at all the important shows in its Cambridge Cottage gallery. She was awarded five gold medals by the RHS and received their Veitch Memorial Medal in 1984. In 1986 she received an honorary doctorate in philosophy from Reading University.

She produced postage stamps and many designs for the Franklin Mint's commemorative china and her work is in the British Museum, the Natural History Museum, London and at Kew. She illustrated a plethora of books from *Mountain flowers* by Anthony Huxley in 1967 to *Hellebores* by Brian Mathew in 1989, as well as painting numerous plates for *Curtis's Botanical Magazine*. She also painted the plates for the huge *Orchidaceae* by P. F. Hunt.

She was invited to Hawaii in the 1970s and 1980s to record its native flora. That work has been published as *A Hawai'ian Florilegium*. Mary Grierson died on 9th March 2012, aged 99. SAMS

GUEST, Coral (born London, England 1955)

Coral Guest was an established artist and teacher by the early 1990s; she has been much influenced by her early training in Japan and at Chelsea School of Art, London. She paints landscape as well as her outstanding plant portraits.

She has taught at Kew, giving lectures, courses and workshops; in the Nature in Art Gallery, Gloucestershire, in Monet's garden at Giverny and at Harewood House, Leeds.

In 1997 she was tutor for one of the first botanical classes that used to be held in Orient-Express Hotels around the world. She has been exhibited in all 17 shows organised by Shirley Sherwood. She is one of the most important botanical artists working today; her *Painting Flowers in Watercolour – A Naturalistic Approach* (2001) is an excellent teaching book.

She painted me a magnificent dark purple iris over 6ft tall when framed, with a velvety flower, perfectly delineated leaves and a tangle of roots emerging from the rhizome. It has tremendous impact and could hang alongside Dürer's great iris in Kunsthaller in Bremen. She repeated the triumph with a regale lily of similar dimensions. Her *Lilium longiflorum* 'Ice Queen' is a remarkable composition, most subtly painted, comparable with the work of Redouté, Merian or with early medieval religious art. SAMS

HAGEDORN, Regine (born Göttingen, Germany 1952)

Regine Hagedorn was educated in Switzerland and France and decided to study design and jewellery at the Ecole des Arts Décoratifs in Geneva. She designed jewellery and established a graphic design studio, but also made botanical paintings and designed a private garden near Geneva.

She won three gold medals at the RHS between 1998 and 2005. Her tight, meticulous studies of thorns, stems, rose hips and tree buds are laid out almost like a child's exercise in neat rows, so exquisitely painted that they can be best appreciated under a magnifying glass. Each is labelled in minute, delicate pencil script, an essential element in her composition which gives an added dimension to her work. These water-colours have an intense, introspective quality that is hard to convey in reproduction. Some of her rose paintings are lush yet detailed, very exquisite and romantic. She is currently designing wine labels. SAMS

HAGUE, Josephine (born Liverpool, England 1928)

Josephine Hague studied textile design at Liverpool College of Art, from 1979 to 1985 she followed a freelance career in textile design and illustration.

Her work has been exhibited in many galleries including Kew, the National Theatre in London and the Tryon Gallery, London. Between 1984 and 1988, the RHS awarded her four gold medals and in 1993 she was invited to become artist in residence at the Liverpool Museum of Natural History. She has designed a series of British wildflower ceramic plates for the Conservation Foundation. She exhibited at the Hunt in 1997 and at the National Botanical Gardens of Wales in 2002; she painted a *Meconopsis* for the RHS's Lindley Library in 2000. Ness Gardens, the botanic gardens attached to the University of Liverpool, provides many of her subjects.

She completed two paintings for the *Highgrove Florilegium*, and one was reproduced as a print for Prince Charles to give as gifts. SAMS

HAMILTON, Gertrude (born Ghent, Belgium 1968)

Gertrude Hamilton was born in Belgium and trained in graphic design there. She received further art education in the Atelier Letellier, Paris and figure drawing in New York. She worked as a freelance graphic designer in Paris from 1988–96 and has concentrated on botanical subjects since then.

We met at her solo exhibition at Ursus Galleries, New York in 2001 where I acquired this small, delightful work (see page 226). She had clearly studied and been influenced by the work of artists like Van de Kessel (1626–1679) and Georg Hoefnagel (1542–1601) and relished the small perfection of their paintings. SAMS

HART-DAVIES, Christina (born Shrewsbury, England 1947)

Christina Hart-Davies read fine art and typography at Reading University and then worked for several years on the design and production of educational books. Since settling in Dorset she has become well-known for her precise botanical watercolours.

She has held many successful exhibitions and her work is included in collections worldwide, notably in the Hunt Institute of Botanical Documentation in the USA. She has illustrated many books and contributed illustrations to publications such as *Kew Magazine* and the *RHS New Dictionary of Gardening*. From 2003 she worked exclusively on illustrations for the *Collins Wild Flower Guide*, published in 2009.

Margaret Mee

Aristolochia eriantha
Mart. & Zucc.
Instituto de Botânica. S. Paulo.
March. 1959

She has three times been awarded the RHS gold medal for paintings of mosses and lichens. She also holds an RHS gold medal and a World Orchid Conference Bronze for her paintings of Australian and European native orchids.

She is a committed member of several conservation organisations and travels extensively in Europe, Australia and the Americas to study and paint the native flora. In 1992 she joined an expedition to Sumatra to paint plants of the rainforest and mountain areas, and some of the resulting paintings were included in a three-artist exhibition at Kew in 1994.

Christina was a Founder Member (and Honorary Secretary 1985–95) of the Society of Botanical Artists but retired to concentrate on illustration. Her painting shows the tiny Albany pitcher plant, *Cephalotus follicularis*, with its small, barrel-shaped leaves crowded together on a mossy bank waiting for some unwary insect to venture in. SAMS

HAYWOOD, Helen (born London, England 1964)

Helen Haywood spent her childhood in Sussex, near Ashdown Forest and moved to Wales in her teens. She studied for her BA degree at Gwent and took a Masters in Illustration at Birmingham. She did some teaching and enjoyed making jewellery.

She had always had a passionate interest in nature and in conservation and won the Young Illustrator of the Year award in 1988, presented to her by Sir David Attenborough. She has done illustrations for *The Kew Magazine* and the Reader's Digest *A Garden For All Seasons*.

Margaret Mee, b. Chesham, Buckinghamshire, England 1909–88

Aristolochia eriantha

Pencil and gouache on paper, 640 mm x 470 mm
Signed *Margaret Mee*
Shirley Sherwood Collection

The small flowers of this *Aristolochia eriantha* are distinctly hairy.

←

The work shown here was bought in 1994 at the Museum of Garden History in London. The thistle is one of the best studies of prickles I have ever seen, and makes an interesting comparison with the thistle by Simon Taylor (fl.1760–77) and the very different study by Johann Dietzsch (1710–69) which is shown covered with insects and spiders webs. SAMS

HEGEDÜS, Celia (born London, England 1949)

Celia Hegedüs was taught painting by her mother, a stage set designer; she trained at the Hammersmith School of Art in 1966 and the City and Guilds, London. She continued to paint while bringing up her family and showed at the Royal Academy Summer Exhibition in 1993, 1995 and 1997. Meanwhile she exhibited her work at the RHS where she has gained six gold medals. One of her iris watercolours has been acquired by the Lindley Library. She has had four solo exhibitions at Waterman Fine Art in London and was also invited to show at the Tryon & Swann's International Exhibition in November 1998.

Among her best works are three iris paintings on vellum acquired for the Shirley Sherwood Collection in 1996, *Iris foetidissima, Iris pseudacorus* and *Iris sibirica*. Recently she has been painting outsize tulips, magnified to show the striped and patterned petals. In each case she has caught the character and essence of the different plants and has created a wonderful translucence with the light penetrating the vellum. SAMS

HENDERSON, Peter Charles (fl. London 1799–1829)

Very little is known about Henderson, apart from the fact that between 1801 and 1804 he contributed 14 oil paintings of exotic flowers to Robert Thornton's *Temple of Flora* (see page 163). EMR

HERBERT, Sue (born Darwen, England 1954)

Sue Herbert was trained at Blackpool College of Art and Technology and Sunderland College of Art. She has shown in a number of group exhibitions in London, including the Tryon & Swann Gallery in 1998.

I was first introduced to her work at the Hunt Institute's 7th International Exhibition in 1992, where I saw one of her huge leaf paintings. She presses a leaf under a carpet (it would be too large for a conventional flower press) and then executes the work in watercolour when it has dried out. It was an exciting, arresting watercolour and I asked her to show me more when I returned to London. Since then I have showed her work in my collection in exhibitions all over the world.

More recently I commissioned her to paint me a *Gunnera* leaf and I photographed the picture's development at several stages. This plant has the most enormous leaves, as much as 6ft across, and I have grown them near water for many years. To celebrate the Millenium I planted some behind a solid stone seat, intending them to become green, living 'umbrellas' for my small grandchildren to shelter under while exploring my new water feature.

Her leaves complement Ruskin's quotation 'If you can paint *one* leaf you can paint the world', although he certainly did not contemplate painting such massive subjects. SAMS

HOOKER, Sir Joseph Dalton (born Suffolk, England 1817–1911)

Joseph Hooker was the son of William Jackson Hooker and was a keen naturalist. He trained as a doctor at Glasgow, before taking part in various expeditions to the Antarctic, California, Morocco, and the Himalaya, publishing the results in several works including *The Botany of the Antarctic Voyage* (1844–60), *The Rhododendrons of Sikkim-Himalaya* (1849–51) and *Illustrations of Himalayan Plants* (1855). He collected many new species of alpines and rhododendrons, and was an artist of some skill, producing not only drawings of the plants he had seen, but also sketches of the landscape, and most of these were copied and improved for him by the long-suffering Fitch. On the death of his father, Joseph became Director of Kew, at which post which he excelled. He became one of the most eminent and influential botanists of his generation. EMR

HOOKER, Sir William Jackson (born Norwich, Norfolk, England 1785–1865)

William Jackson Hooker was a keen naturalist and artist who was elected a Fellow of the Linnean Society at the age of 21. Through the Society he met Sir Joseph Banks, and with his help was appointed Regius Professor of Botany at Glasgow University. Whilst there he wrote several books, including *Exotic Flora* (1823–7) and *Icones Filicum* (1827–32), but always wanted to return south to work in London. In 1841 Hooker became Director of Kew and embarked on a programme of expansion, turning the garden from a declining Royal Park into a world class Botanic Garden and research institution. He brought W. H. Fitch with him to Kew, but was also a fine botanical illustrator himself, and drew over 640 plates for *Curtis's Botanical Magazine*, of which he was Editor, as well as numerous ferns and mosses for other books. EMR

HUTTON, Janet née Robertson (fl. 1802–1824)

Janet Hutton was the wife of an East India Merchant who was Resident at Penang from 1802 to 1808, and was in Calcutta from 1817 to 1823. She painted a wide range of tropical plants from India and Malaysia, particularly edible fruits such as mango, durian, guava, pepper and breadfruit. She worked in watercolour with gum Arabic highlights, the details picked out in gouache. In 1894, about 200 of these drawings were presented to Kew by her daughter, Mary Hutton. EMR

IMAI, Mariko (born Kanagawa, Japan 1942)

Mariko Imai is undoubtedly one of the world's most important botanical artists; she works for long, sustained periods on a particular plant family to produce a series of definitive portraits.

She has had many exhibitions in Japan and Canada, produced the illustrations for several books, some for children, and has executed superb covers for the Japanese version of the RHS magazine. There are four of these in the Shirley Sherwood Collection. In 1996 twenty-five of her botanical paintings were shown at the 5th Exhibition of 'The World's Precious Plants' at Tobu Department Store in Tokyo; later ten of these were awarded a gold medal at the RHS in London and were donated to the Lindley Library. One of her major contributions is her superb plates in an important

multi-lingual book *Masdevallia and Dracula* by Y. Udagawa (1994).

She teaches botanical painting at Mito Botanical Gardens and has painted a number of plants for the *Endangered Plants of Japan: a Florilegium* (2004) issued by the Japan Botanical Art Association. In 2006 she illustrated a book for children called *The Climbing Plant – Towards the Sunlight* published by Fukuinkan-shoten Japan. She has been painting *Asarum,* concentrating solely on this one group with the hope of producing a book after many years' work. SAMS

ISHIKAWA, Mieko (born Tokyo, Japan 1950)

Mieko Ishikawa trained at Musashino Art University and she has since taught in the Agahi Cultural Centre and other institutions in Tokyo, including the Tokyo Metropolitan Jindai Botanical Park, Chofu, Tokyo. Her work is held in the Hunt Institute, Tokyo Metropolitan Jindai, Botanical Park, Chofu and the Flower Museum, Chiba-city, Chiba. Since 1980 she has illustrated a large number of books and had several solo exhibitions at the Tama Forest Science Garden, Hachiojie, Tokyo.

Recently Mieko Ishikawa has been concentrating on painting cherry blossom, conifers and rainforest plants. Her watercolours are immensely delicate with the blossom petals faintly outlined with pencil, very characteristic of Japanese artists. The works deserved the closest examination for their meticulous detail. Her two spectacular drawings of *Prunus pendula* 'Pendula-rosea' caused gasps of amazement at the RHS show in 2006 and were awarded a gold medal; she must be one of the best artists today to portray this fleeting blossom which is her own passion and has such significance in Japan. SAMS

ISOGAI, Noboru (born Gumma, Japan 1935)

Noboru Isogai graduated as a mechanical engineer from the University of Tokyo in 1959 and worked at Seiko Instruments, Tokyo until 1998. Then he became a teacher in botanical art at the cultural centre at Chiba, where he lives. He is a member of the Seiko Art Association, Japan and the Society of Botanical Artists, UK.

He started showing his work in 1995 in Tokyo and since 1999 has exhibited every year at the Society of Botanical Artists in London and the Agape Gallery, Tokyo. His *Pandanus tectorius* is a large, beautifully painted watercolour of swirling leaves, notable for its energy and exquisite design. SAMS

JONES, Paul (born Sydney, Australia 1921–1997)

Paul Jones was one of the foremost Australian flower painters, in a country where there has been a strong re-emergence of excellent botanical artists in recent years. He produced wonderful material for a series of books, becoming an expert on camellias one of which is named after him and is shown on pages 97 and 99.

He created a series of drawings in the romantic style of Thornton's *Temple of Flora*, published as *Flora Magnifica* by the Tryon Gallery in 1976. He started by painting his subject in watercolour on plain white paper, then prepared a coloured background of acrylic and painted a second version on top of the

acrylic background. One of the works in my collection is the original watercolour painting for the sunflower in the Tryon book, strong and vigorous, in fact so striking that it was chosen for the poster in the exhibition of my collection at Stockholm at Millesgarden Museum (1999).

He gave me an essay just before he died entitled *Thoughts on Flower Painting* which ends: 'Sureness of touch comes with unrelenting practice. A blank sheet of paper is very intimidating. There must be perfect co-ordination between the eye which observes, the hand which is directed by the eye, and the brain which makes the decisions. All must work in perfect unison. But the real worth and true quality of a memorable drawing can only come from the heart. Every part of one's being is involved and it is total. Talent raises the drawing from ordinary documentation. Flawless technique can astonish only, but fails to capture that particular 'something' which can only be described as 'magic'.'
SAMS

KEIR, Sally (born Scotland 1938–2007)

As with so many women painters, Sally Keir did not start her artistic career until she was in her mid-forties because of family commitments. She took a degree in design, specialising in jewellery and silversmithing, at Duncan of Jordanstone College, Dundee. At the same time she started painting, initially in watercolour but graduating to gouache to give the more intense and dramatic jewel-tones that make her flowers glow from a dark background. Since 1985 she also worked as a lecturer in metalwork.

She was awarded a number of medals by the RHS in the early 1990s and has shown widely in Britain and abroad. I saw her work at the Hunt Institute and was interested in its intensity and the way she had achieved depth and fleshy texture through shadows. It is quite different from anything else in my collection. She continued painting through a long illness until she was overcome by cancer in 2007. SAMS

KIJIMA, Seiko (born Kobe Hyogo, Japan 1948)

Educated in drama at Tama Art College in 1967–70, Seiko Kijima later became a freelance botanical illustrator and instructor, teaching children at Kobe Municipal Arboretum, the Museum of Nature and Human Activities at Hyogo and in the Miracle Planet Museum of Plants. She has shown in numerous group exhibitions in Japan and in the New York Botanical Gardens and the Horticultural Society of New York. She was in the Hunt Institute for Botanical Documentation in 2001.

She works in pencil and acrylic, painting with great delicacy and well thought-out design. Her *Akebia quinata* is an example of exquisite detail, which she reproduced on the front of a catalogue of her work. SAMS

KING, Christabel (born London, England 1950)

Christabel King has an honours degree in Botany from University College London, and studied scientific illustration for two years at Middlesex Polytechnic, now Middlesex University. Since 1975 she has produced an extraordinary number of illustrations for *Curtis's Botanical Magazine* at Kew. She illustrated several books in the

1980s and more recently has painted plates for eight Kew monographs, with more to come, the most recent being *The Genus Roscoea* by Jill Cowley (2007). Her illustration in *All Good Things Around Us* by Pamela Mitchell re-appeared in a new book *Edible Wild Plants and Herbs*, again in 2007. She received the prestigious Jill Smythies Prize from the Linnean Society in 1989.

Her highly professional work is characterised by meticulous handling and subtle colours. She is particularly good at cacti, where she achieves a wonderful contrast between their fleshy, succulent, spiny stems and their delicate flowers. Like Pandora Sellars, her work is always immediately recognisable.

Since 1990, Christabel King has been an inspiring and memorable tutor to many Brazilian students who come to the Royal Botanic Gardens, Kew under the Margaret Mee Fellowship scheme. In 1994 she visited Brazil and taught courses in Rio de Janeiro, Sao Paulo and Caxiuanã, in Pará province, running further courses in 2003 which Brazilian artists still talk about. Since 2002 she has been training botanical artists in Turkey, as well as teaching in London. SAMS

KING TAM, Geraldine (born Toronto, Canada 1920–2015)

Gerry King Tam lived on Kauai, Hawaii, but was born far away in Toronto and took her first degree in English and French at McMaster University, Hamilton, Ontario. After teaching for two years she gained an MA in art education at Columbia University, New York. Like many other botanical artists she had a period as a textile designer, as well as teaching jewellery design, but her main occupation from 1955 to 1976 was teaching art at the Dalton School, New York. During this period she married the celebrated Kauai-born poet and artist Reuben Tam who greatly influenced her later work in Hawaii. While they were based in New York they spent their summers at an artists' colony on Monhegan, an island off the coast of Maine, where she started recording the native plants. She had a solo exhibition of fifty of these drawings in 1968 at Syracuse University.

In 1980 she and her husband moved to Kauai to start a new part of their lives. Reuben wanted to grow the flowers and fruit trees he had known as a child and he encouraged Gerry to paint them. Her style changed as she was challenged and exhilarated by the exotic tropical flora around her, and her plant portraits became striking with their flowing lines, true colours and beautiful designs. Her graceful paintings capture the spirit and essence of her subjects.

Gerry King Tam described the flowers of the yellow granadilla as 'fragrant, beautiful and delicate, hanging down like an umbrella. Had to do a cross section to show the typical *Passiflora* insides'. The plant is native to north-eastern South America and the West Indies and arrived in Hawaii before 1871.

Gerry King Tam worked from fresh plants, growing many in her own garden. The garden was wrecked by Hurricane Iniki in 1992 and she herself was knocked unconscious and her studio flooded, but miraculously, none of her work was destroyed. It was after this, in 1994, that she met James White and decided to give thirty-one of her paintings to the Hunt Institute of Botanical Documentation in Pittsburgh so they would be preserved in a museum environment.

She produced a lovely book, with text by David J. Mabberley, which is aptly entitled *Paradisus*. It contains sixty superb plates of flowering and fruiting tropical plants that grow in the Hawaiian Islands, some native, but many introduced as food plants by Polynesian settlers, others later by Chinese and European immigrants. She was designated as a Living Treasure by the Kauai Museum in Lihue and honoured by McMaster University. SAMS

LEE, Ann (born Hammersmith, Middlesex, England 1753–1790)
Ann Lee was the daughter of the nurseryman James Lee of Hammersmith (1715–1795), who was in partnership with John Kennedy (1759–1842). The Vineyard Nursery, as it was called, thrived between 1780 and around 1890, and introduced many new plants to cultivation, particularly from the Cape, America, Australia and from China. The Empress Josephine ordered hundreds of roses and other plants from Lee and Kennedy in 1807 and in 1810 a special passport was issued so that her order could pass through the British Naval blockade of the French ports. Ann Lee was a pupil of Sydney Parkinson, and a skilful flower painter, who might be better known had she not died so young. EMR

LEE, Katie (born Eldoret, Kenya 1942)
Katie Lee is a renowned botanical and wildlife artist and instructor and now works in the USA. She graduated from the New York Botanical Garden Botanical Illustration program and has been an instructor there for the past 16 years. She teaches drawing, watercolour, gouache and illustration courses at various programmes worldwide.

Katie has led numerous sketching safaris in Botswana for Orient-Express Safaris and field sketching trips to South America. Her uniquely realistic botanical and zoological paintings have been successfully exhibited in one-person shows in both the United States and abroad. Katie's work can be found in private collections in England, Australia, the United States and South Africa. Her work has been accepted into the prestigious Leigh Yawkey Woodson Art Museum's 'Birds in Art' 2002 and 2003. She is represented in the collection of the Hunt Institute for Botanical Documentation, Carnegie Mellon University, Pittsburgh, PA, Bell Museum of National History, University of Minnesota, MN, Weisman Museum, Minneapolis, MN, Tryon Swann Gallery, London, England and the Bruce Museum, Greenwich, CT.

She has illustrated a number of beautiful books for children, including *Puffin's Homecoming*, *Black Bear Cub*, *Loggerhead Turtle* and several more. Her *A Visit to Galapagos* published by Harry N. Abrams, was particularly attractive.

She received the Gold Medal for Excellence, and Best of the Show in 2004 at Kirstenbosch Botanical Garden and the Don Harrington Discovery Centre Merit Award for Excellence. SAMS

LIŠKA, Petr (born Prague, Czech Republic 1953)
Petr Liška trained between 1968 and 1972 at the High School of Graphic Arts in Prague. In 1980 he became head of the publicity department at the Medical Plants Company and created designs and illustrations for a variety of printed material. Since 1991 he has worked as a freelance artist. He works in tempera and his paintings have been reproduced in a number of Czech magazines. His work was exhibited in the 6th International Exhibition at the Hunt Institute in 1988, and at the Everard Read Gallery in Johannesburg. His illustrations have appeared in several books including *The Illustrated Guide to Cacti* by Rudolf Slaba (1992), *Les Fruits* by Dlouhá, Richter and Valíček (1995) and *Le Jardin de Rocaille* by V. Vodicková (1995).

When I visited his apartment on the outskirts of Prague he showed me some small paintings in acrylic on paper, sitting in his tidy well-organised studio-room lined with the books he has illustrated.

This tiny painting of *Rebutia narvaezensis* has become his logo, and is an amusing foil to Christabel King's superb cacti. SAMS

MACKAY, David (born Hornsby, New South Wales, Australia 1958)
David Mackay began his professional career in the 1970s by preparing botanical illustrations for the Papua New Guinea National Botanic Gardens in his school holidays. Since then he has worked at a number of botanic gardens and universities in Australia and overseas, including over ten years at the Royal Botanic Gardens Sydney as a botanical illustrator. During that period he took a BSc (Hons) at the University of Sydney.

Barbara Oozeerally, b. Poland 1953
Cone of *Pinus pinaster*
Watercolour on paper, 225 mm x 190 mm.
Signed *BO 2002*
Shirley Sherwood Collection

Pinus pinaster, the maritime pine, is found in southern Europe and the Mediterranean. The large cones stay closed on the tree, and only open when the forest is swept by a fire, clearing space for the seedling trees. Maritime pines easily reach 30m tall in sheltered gardens.
→

2002

His work has received much acclaim and is represented in public and private collections in Australia, Great Britain and the United States. He began exhibiting in 1989 and has since made major contributions to numerous group shows in Sydney (including the Art Gallery of New South Wales), Adelaide and elsewhere in New South Wales and northern Queensland. Thousands of his drawings and paintings have been published in over a hundred books and scientific papers as well as calendars, magazines, greeting cards and other media. He honed his skills under a family friend, the well-known Australian wildlife artist William T. Cooper. He now works freelance from his home and studio in Armidale, New South Wales, producing excellent prints and postcards.

His *Eucalyptus macrocarpa* or mottlecah which is a spreading glaucous scrub eucalyptus growing as tall as 5 metres, is restricted to southern Western Australia on undulating heathland south from Enneabba and in remnant vegetation in the wheatbelt near inland Corrigin. The large solitary flowers are very showy, the largest in the genus and indeed of any Australian *Myrtaceae*. The rare, relatively small-fruited form illustrated here is recognised by some botanists as a distinct subspecies, *E. macrocarpa* subsp. *elechantha*. SAMS

MAKRUSHENKO, Olga (born Moscow, Russia 1956)
Trained at the Moscow Institute of Engineering and Physics, Olga Makrushenko was employed as a mathematical engineer for ten years from 1979 at the Kurchatov Institute of Atomic Energy.

She studied painting at the Department of Painting, Moscow State Pedagogical Institute and took various courses on colour techniques. After Russians were allowed to travel more freely she established a connection with Broadland Art Centre, Norfolk, and Nature in Art, Gloucester, England and demonstrated her elaborate technique there, combining watercolour, pencil and air brush.

She has exhibited widely in Moscow, at the Hunt Institute in 2006 and in Focus on Nature in 2006. She visited Chang-Mai, Thailand for the first South East Asian Conference on Botanical Art in 2006 entitled 'Botanical Illustration for Tropical Plants'. She is particularly fond of iris, lilies and magnolia which are good subjects for her lush and elaborate technique. SAMS

MANISCO, Katherine (born London, England 1935)
A graduate of the Slade School of Fine Art, London, Katherine Manisco studied painting at the Accademia dell'Arte in Florence. She is a member of the American Society of Botanical Artists and the Chelsea Physic Garden Florilegium Society. She also contributes work to the new Brooklyn Florilegium Society.

Her work is included in the permanent collections of the Victoria and Albert Museum, the Fitzwilliam Museum, Cambridge and the Hunt Institute. She has exhibited in New York and elsewhere, including a strong show at Colnaghi, London in 2003 and a delightful display of lemons in the renovated Limonaia in the Boboli Gardens, Florence in 2004. She had a most successful solo show at the W. M. Brady Gallery in New York in 2006 and was elected a Fellow of the Linnean Society in 2004. She divides her time between New York City and Rome. SAMS

McEWEN, Rory (born Berwickshire, Scotland 1932–1982)
Rory McEwen's work influenced the development of a number of artists in my collection; Brigid Edwards, Jenny Brasier, Susannah Blaxill and Lindsay Megarrity are examples. I regret that I never met him and I missed the memorial exhibition of his work shown in Scotland and at the Serpentine Gallery, London in 1988.

He painted flowers from the age of eight and was encouraged by Wilfrid Blunt, his art teacher at Eton, to look at the works of Redouté and Ehret. Blunt described him as, 'perhaps the most gifted artist to pass through my hands'. He had no formal training at an art school, but by the time he left Cambridge University his illustrations had been published in *Old carnations and pinks* by Charles Oscar Moreton (1955). He illustrated *The Auricula* in 1964, and painted many of the plates for a revision of Wilfrid Blunt's *Tulips and Tulipomania* (Basilisk Press 1977). He travelled widely, especially in the Far East, and showed his work in Japan and also in a number of modern art galleries including MOMA, New York.

His exhibition 'True Facts of Nature' at the Redfern Gallery, London in 1974 attracted a great deal of attention. Plants and vegetables were sometimes painted in the same frame, always with the space between them being as important as the objects themselves. He was much influenced by the past and his studies of the botanical masters like Robert, Redouté, Ehret and Aubriet are reflected in his work. When I was looking at Ehret's drawings of tulips in the Victoria and Albert Museum I had an immediate, uncanny sense of recognition (I have a tulip painted by McEwen). His work on vellum is particularly noteworthy and he encouraged many recent artists to try this medium. SAMS

MEE, Margaret (born Chesham, Buckinghamshire, England 1909–1988)
Over the last few years Margaret Mee's influence has been steadily growing among botanical artists, environmentalists and ecologists. Hers was one of the first voices raised to alert the world about the exploitation of the Amazonian rainforest. The 58 plates that she painted for her second book *Flores do Amazons – Flowers of the Amazon* were shown at Kew in 1988, shortly before her death in a car accident. These paintings of Brazilian rainforest plants were acquired by Kew in 1995 and became the core of an important travelling exhibition which has been to many venues in the USA and has been seen by thousands of people, raising interest in the Amazon as well as Kew's work.

Margaret Mee trained as an artist in London at St Martin's School of Art, the Central Art School and Camberwell Art School. She moved to Brazil in the early 1950's, became fascinated with the exotic flora and started organising solo journeys into the rainforest, searching for exciting plants to paint. This seemingly frail, petite woman went on fifteen challenging collecting trips into the Amazon, generally with only Indian guides to accompany her. She would sketch specimens *in situ* and then try to get them back to Rio so they could be cultivated. (She sometimes lost them if her dugout canoe overturned). She brought back hundreds of valuable plants and four previously unknown species were named after her.

She has inspired many Brazilian artists such as the Demonte family, Marlena Barretto, Patricia Villela and Álvaro Nunes, and The

Margaret Mee Foundation has raised money to finance the exchange of dozens of scholars between Kew and Brazil. Each Brazilian artist works with Christabel King at Kew for several months and then goes back to South America with freshly honed skills to teach others there. The Foundation organises exhibitions and competitions in Brazil which have a steadily increasing standard. A beautifully illustrated book was put together by members of the Foundation (*Margaret Mee 1909–88*, published by Fundação Botânica Margaret Mee, 2006) which contains the largest number of her works to be drawn together, from all over the world. She has become an icon in South America and her life was even chosen as the theme for a Samba School for the Rio Carnival with three thousand eco-friendly dancers parading to a Margaret Mee theme song – there is no greater accolade than that in Brazil!

Kew launched another exhibition initiative of her work by a showing in Paris at the Mona Bismarck Foundation, 2007, and I attended a ceremony naming a tree-lined avenue for her in the Rio de Janeiro Botanical Gardens, celebrated by some of her old friends and several young botanical artists. SAMS

MEEN, Margaret (b. ?Bungay, Suffolk, England fl.1775–1824)

Margaret Meen came to London from Suffolk in around 1775, and made hundreds of paintings of Kew plants. She exhibited at the Royal Academy between 1775 and 1785, and at the Watercolour Society in 1810. Her paintings on vellum were particularly elegant, as can be seen from the *Castanea* on page 31. In 1790 she founded the journal *Exotic Plants from the Royal Gardens at Kew* but, sadly, it ceased publication after only two issues. A number of her paintings arrived at Kew from the Tankerville Collection, which was formerly at Chillingham Castle, Northumberland. EMR

MERIAN, Maria Sibylla (born Frankfurt, Germany 1647–1717)

Maria Sibylla's father, Mattheus Merian, was a well-respected publisher and copperplate engraver. He had eight children by his first wife, Maria Sibylla being his daughter by his second wife, Johanna. Mattheus (known as 'the Elder' to differentiate him from his son) died when Maria was only three years old, and her mother married Jacob Marrel, an artist who had specialised in flower painting whilst living in Utrecht. It was in his workshop that she met her future husband, Johann Andreas Graff, another painter, engraver and publisher, whom she married in 1665. In 1670 the young couple moved to Nürnberg, at that time a centre of printing and publishing, and Maria continued her work, and taught her two daughters, and others, to draw, paint and sew. Her *New Book of Flowers* originally appeared between 1675 and 1680 as three volumes of engravings, designed to be used as a teaching aid in her painting and embroidery classes; she reprinted it in book form in 1680.

Maria and her daughters moved to Amsterdam, where Maria worked as a freelance watercolour artist, painting flowers and insects. After her elder daughter married a merchant who traded with the Dutch colony of Surinam, Maria and her younger daughter

travelled there and stayed for two years, during which time Maria was able to study and paint the exotic flora and fauna; they returned to Amsterdam in the autumn of 1701, loaded with notes and sketches of plants and insects, as well as natural history specimens. These formed the basis of her great (and last) work *Metamorphosis Insectorum Surinamensium* (1705) which contained 60 large plates and accompanying text. This remarkable work shows butterflies, reptiles, worms and insects, living on their respective food plants, and some of the plates were hand coloured by Maria herself. Maria died in Amsterdam on January 13, 1717, the very day that she had agreed to sell a two-volume collection of her paintings to the Tsar's physician, who duly took them back to St Petersburg; they eventually became the property of the Academy of Sciences. EMR

MONINCKX, Johan (born Leende, Noord-Brabant, The Netherlands c.1656–1714)

Johan Moninckx was from an artistic family and is best known for the nine-volume *Moninckx Atlas*, a collection of paintings of rare plants growing in the Amsterdam Botanic Garden, commissioned by Jan Commeljin and Joan Huydecoper, the mayor of Amsterdam. Jan contributed 273 paintings to the project, and his daughter Maria painted another 101. In addition, Johanna Helena Herolt-Graff, daughter of Maria Sibylla Merian painted two sheets, Alida Withoos, thirteen, and the remaining 31 watercolours were unsigned. The five watercolours making up the ninth volume were added later. These watercolours were used as the basis for the engravings in Commelijn's *Amstelodamensis Rariorum Plantarum Descriptio et Icones* (1697–1701), illustrated on pages 130 and 131. EMR

NESSLER, Kate (born St Louis, Missouri, USA 1950)

With exhibitions in the Park Walk Gallery, London, Kate Nessler has confirmed her position as one of today's most important botanical artists. She has had six solo shows there since 1995.

I now have twelve Nessler paintings, collected since our first meeting at the RHS where she was awarded three gold medals in the early 1990s. Her recent works are all on vellum which has had an impact on her style, making her more introspective and detailed. Although she was still showing some classical portraits of garden flowers in her show in 1999, she seemed to be moving into more intense studies of plants in their natural surroundings, with snowdrops breaking through a covering of dried, dead leaves, a clump of bird's foot violet nestling on sticks and stones, and a brilliant study of rose hips, oak leaves and an acorn withered at the onset of winter.

The last few years have been packed with her achievements. Apart from her solo exhibitions in London she has been represented in 'Celebrating Orchids', shown at the Kew Gardens Gallery, and in the American Society of Botanical Artists' exhibition in Chicago Botanic Gardens in 1997. The next year she showed in London in 'Botanical Artists of the World' in the Tryon and Swann Gallery.

She was involved with the American Society of Botanical Artists from its onset, becoming its president and receiving its most important accolade, the American Society of Botanical Artists award

of excellence in 1997. She has paintings in the Hunt Institute and the Lindley Library, and her exhibition 'The Baker Prairie Wild Flower Collection' has travelled in Arkansas in co-operation with the Arkansas Natural Heritage Commission, helping educate children about their local plants.

Her work is collected in the Morton Arboretum, Lisle, Illinois, USA, the Highgrove Florilegium, Brooklyn Botanical Garden Florilegium, New York and the US National Museum of Women in the Arts, Washington, DC.

The orchid shown on page 172 is watercolour on paper, while the fern and corn studies are on vellum. The withered corn husk is redolent of the prairie, painted on an uneven, streaked brownish skin that complements the sombre picture, epitomising the onset of winter. SAMS

NORTH, Marianne (born Hastings, Sussex 1830–1890)
Marianne North was a Victorian lady traveller in the mould of Isabella Bishop or Gertrude Bell. After years looking after her invalid father, in 1871 she took her paints, and travelled across the world, staying in embassies and with friends, and painting the local vegetation, often with detailed flowers in the foreground. There is hardly a continent she did not visit.

After she gave up travelling, she gave all her paintings, with a gallery to house them, to Kew. Her work must have appeared even more remarkable when her gallery opened in 1882. Colour photography was unknown, and travel restricted to only a few. Visitors to Kew could now see the plants cultivated in the glasshouses, as they looked when growing in their native habitat. She painted in oil on board, and though some of her work may

Marilena Pistoia, b. Milan, Italy 1933
Dandelion
Watercolour on paper, 175 mm x 265 mm.
Signed *M Pistoia*
Shirley Sherwood Collection

seem crude compared with the delicate watercolours of studio painters, she captured well the light of the tropics and the often garish flowers that were growing there with an emphatic style. During her visit to South Africa she climbed the Drakensberg mountains in the north-eastern Cape, and discovered the giant red hot poker, later called *Kniphofia northiae*. EMR

NUNES, Álvaro Evando Xavier (born Anápolis, Goiás, Brazil 1945)

Álvaro Nunes is still based in his birthplace Anápolis,but spends long periods away, working in remote areas of Brazil. He is particularly interested in the Brazilian savannah and has painted many of the fruits of native trees from the savannah, Amazonia and the Pantanal. Finding the specimens has involved long journeys of up to eight months to these isolated parts of the country.

He qualified as an architect at the Federal University of Brasilia in 1971 and then worked for the government of Brazil on local urban projects until 1981. His botanical studies started with a six-month internship in the botanical department of Brasilia Federal University in 1989 where he focused on the flora of the Brazilian savannah. He also attended a painting course taught by Christabel King at São Paulo Botanical Institute in 1993.

He participated in botanical drawing workshops in the Federal Universities of Brasilia, Juiz de Fora, Minas Gerais, Goiás; and at the 'Swamp-land campus' of the University of Matto Groso do Sul. His drawings have been published in a number of books including *Fruiteras da Amazonia (Fruit Trees From the Amazon), Peixes do Pantanal (Fishes of the Brazilian Swampland)* and a series of books *Plantar* and *Frutex* all published by Embrapa, the Brazilian Institute for Rural Research.

He has had six one-person exhibitions during the last ten years and shown in several group shows including the 9th International Exhibition at the Hunt Institute for Botanical Documentation in 1998.

The 'Fruits of Savannah' is a group of beautifully painted and detailed seed-cases, shown in sombre, dried-up hues, while the most elegant of his paintings is the striking *Theobroma subincanum*, with flower and fruit on the same stem. The execution of this painting is quite remarkable with the voluptuous fruit, angled leaves and tiny, pink-mauve flower at the end of the stem, making the design perfectly complete and satisfying. The bromeliad *Bromelia antiacantha* was painted using two plants, one grown in the shade with green leaves, the other in the sunshine with magenta and greenish blue leaf colouration. The work shows a spirited departure from his usual rather sombre style. SAMS

OGILVY, Susan (born Kent, England 1948)

Susan Ogilvy qualified as an occupational therapist in 1969 and completed a foundation course at Luton School of Art one year later. She went to work at a mental hospital just north of London and found it both fascinating and rewarding. Her marriage led to travel and sojourns abroad, and she returned to painting, including portraying the exotic flowers in the gardens around the British Embassy at Muscat.

She has exhibited at the RHS where she was awarded a gold medal in 1997; she has had several successful solo exhibitions at Jonathan Cooper's Park Walk Gallery in London. She has shown an arresting collection of grass and fern studies interspersed with wild flowers, viewed from above, painted from locations around her home. Inevitably one thinks of Dürer and his *A Large Piece of Turf*. SAMS

OOZEERALLY, Barbara (born Poland 1953)

Barbara Oozeerally glows with her passion for flower painting. She trained as an architect in Warsaw and worked there from 1976 to 1979; she then became a fashion designer and has only been painting full-time in England since 1996. She has exhibited her work several times at the RHS gaining two gold medals, at the Graphic Fine Art and the Chelsea Society.

She appears at Chelsea Flower Show regularly and her paintings are in the Lindley Library, London and the Hunt Institute in the USA. She exhibits with the American Society of Botanical Artists in New York and has taken part in shows in Melbourne, Australia and Cape Town. She has been awarded two Certificates of Botanical Merit in London and the USA and has been given the prestigious Diana Bouchier Founder's Award for excellence in Botanical Art.

She is currently obsessed with magnolias and is travelling widely to paint them *in situ*. In her beautiful portrait of a magnolia painted at Kew, she has lovingly observed all the stages of flowering from a young furry bud through the opening and expanding of the petals to the newly-developed fruit. Her pine cone and *Banksia* seedheads show that she can approach more austere subjects with great skill as well. SAMS

PHILLIPS, Jenny (born Boort, Victoria, Australia 1949)

I first met Jenny Phillips at the RHS in 1993, when she was visiting from Melbourne, although she had started painting plants in 1971 and had her first show in 1978. She showed eight examples of euphorbias and was awarded a gold medal. She told me she was rather uncertain which way she should go with her painting and had spent some months studying in Europe, looking at the old masters of the past, stored in the rich libraries and collections of the Italian, English and French museums.

Shortly after this she established her Botanical Art School of Melbourne which I visited in 1995. Now she has a purpose-designed studio there. She has trained several teachers to work with the classes while she is travelling and the School is an undoubted success with students not only from Melbourne, but from Europe, the States and Japan. As I suspected when I first visited her studio, she has proved an inspired and influential force with hundreds of devoted pupils.

When I initiated botanical painting classes in Orient-Express Hotels in 1997 I asked Jenny to become one of the teachers. Since 1998 she has given master classes in Sydney, Lilianfels in the Blue Mountains; the Mount Nelson Hotel, Cape Town, in Johannesburg; Hotel Cipriani, Venice, and Charleston Place, Charleston and has become the most sought-after teacher of botanic art in the world.

Her first class at the Observatory Hotel, Sydney was planned to coincide with the opening in January 1998 of my collection in the S.

H. Ervin Gallery, almost next to the hotel. By chance there was a Ferdinand Bauer exhibition showing simultaneously in the Sydney Museum. It was the first time most of the original Bauer paintings had ever been displayed and Jenny and I took the class early in the morning to see his paintings, executed on the Flinders expedition in which Flinders and Bauer explored the coast of Queensland and circumnavigated Australia from 1801–1803. I challenged Jenny to do something comparable.

She set to work on her return to Melbourne, choosing a tremendously complex flower to paint on vellum, which was often Bauer's medium. This pink gum tree has an incredibly close 'look-a-like' called *Eucalyptus calophylla* which can only be distinguished by a spur on one of the petals. As Jenny had painted the individual flowers and fruit in the style of Ferdinand Bauer, it was indeed possible to identify this specimen as *Corymbia ficifolia*. It is interesting that now, with DNA analysis, it should be possible to see how close these almost identical but theoretically distantly related trees are to one another.

Her beautifully painted *Strelitzia* stands alongside four superb studies by Franz Bauer (1758–1840) of the same plant. Kew's four original works are some of their greatest treasures and yet Jenny Phillips portrait can bear the closest comparison. SAMS

PISTOIA, Marilena (born Milan, Italy 1933)

There are more botanical artists in Italy now, but when Marilena Pistoia started she was an exception, with a large body of work in several big glossy books published by Mondadori (Milan) and Calderini (Bologna). The flowers are always most beautifully arranged upon the page, often curved in soft swathes around the centre, and painted in a sensitive and yet decisive way.

When I visited her austere studio near Modena, she had specially retrieved her flower paintings from the bank to show me. I understood her caution when she told me that several years ago a publisher had lost 52 of her original paintings. Then she said, 'I stopped painting flowers, it was a different period of my life and it is completely finished. I only did it to make a living'. She was quite adamant and now only draws futuristic globes delineated with a fine compass-operated pen. She spends the rest of her time as professor at the Accademia di Belle Arte di Bologna where she has taught etching since 1980.

I tried to persuade her to draw something for me or to let me buy one of her flower paintings. She refused, kindly, but firmly, but she gave me this delicate painting as a consolation (see page 258). The fluffy dandelion clock is so finely and lightly drawn that it is almost impossible to reproduce, but I often look at it and hope she starts painting flowers again. SAMS

POOLE, Bryan (born New Zealand, 1953)

Having studied politics and economics at the University of Otago, New Zealand, Bryan Poole changed direction and worked on botanical illustration with Dr Chris Grey-Wilson at Kew for six years from 1980. He has been a botanical and natural history illustrator since 1981. He works with aquatint etching, woodblock relief printing, egg tempera, watercolour, gouache and pen-and-ink.

His work is held in numerous collections including Kew; the Natural History Museum, London, the National Museum of Natural

History, the Lindley Library, Smithsonian Institution, the Museum of New Zealand and the New Zealand Parliament building. He is an associate member of the Royal Society of Painter Printmakers and in 2006 became a Royal Etcher. He has had several solo shows and a range of commissions. He was awarded a gold medal by the RHS in 2007.

He has just drawn a remarkable portrait of the New Zealand Fern, *Cyathea dealbata* which will be etched and printed in time for the first exhibition in the Shirley Sherwood Gallery of Botanical Art. SAMS

POWER, A. (from Maidstone, Kent, England fl. 1780 –1800)

A. Power, who painted the *Yucca filamentosa* shown on page 141, exhibited at the Royal Academy in 1800. His botanical paintings are at the Victoria Albert Museum and at Kew, but biographical details seem to be unrecorded. EMR

PRÊTRE, Jean Gabriel (born Paris, France fl. 1800–1840)

J. G. Prêtre worked in Paris, painting birds, and various other animals as well as flowers, often in collaboration with the Redouté brothers, Bessa, Poiteau and Turpin. His main published works were in Tussac's *Flore des Antilles* (1808–1827), a book on grasses, and with his sister Joséphine, a romantic little book of flowers and songs with piano accompaniment for young ladies. His fruit book, *Le Panier de Fruits, ou Description Botaniques et Notices Historiques des Principaux Fruits Cultivés en France*, was published in 1807. EMR

PURVES, Rodella (born Paisley, Renfrewshire, Scotland 1945–2008)

Rodella Purves had a long career in the botanical world. Educated in Edinburgh, she took a diploma in agricultural botany followed by another in seed testing. She went briefly to New Zealand before returning to Scotland to work on exhibitions at the Royal Botanic Garden, Edinburgh. She made her first attempt at portraying plants when she was helping to put up a large introductory panel for an exhibition, featuring a pansy. Other displays followed and eventually she was introduced to the refinements of botanical painting in 1971 with an illustration course at Flatford Mill with John Nash RA and an interpretative course at Edinburgh College of Art by Robin Phillipson, tutored by Edward Gage. From 1976 she became a freelance artist producing work for both private and public collections.

She published work in *Curtis's Botanical Magazine* and *The Plantsman,* as well as more general magazine titles. Her work has appeared in *The Orchid Book* by James Cullen, 1992, in *The Rhododendron Species* by H. H. Davidian, Volumes 1–4, and *The New RHS Dictionary of Gardening* and she is included in *The Flower Artists of Kew* by W. T. Stearn (1990).

She has exhibited regularly after 1975 and was represented in the Hunt Institute's 4th International Exhibition in 1976, but probably her most important show was a retrospective of twenty years' work in 1996 at the City Art Centre, Edinburgh for which she was able to provide an impressive display of sixty-nine watercolours.

I had to wait several years before Rodella Purves could fulfil my commission. We decided on a blue *Meconopsis*, a wonderful azure

poppy that blooms briefly in May and flourishes in the Royal Botanic Garden, Edinburgh. At last it arrived, a composition with the hairy leaves as beautifully observed as the opening buds and the striking, spectacular flowers. Her recent (2007) solo exhibition at the National Botanic Garden, Glasnevin, Dublin was of 21 paintings, tracing the connection between Scottish and Irish plants and plant collections and was a satisfying sell-out. SAMS

REDOUTÉ, Pierre Joseph (born St Hubert, Belgium 1759–1840)

Pierre Joseph Redouté was born in the Ardennes and came to Paris in 1782, where he was soon taken up by the wealthy botanist L'Héritier de Brutelle, who instructed him in botany and commissioned numerous illustrations. In 1786 Redouté accompanied L'Héritier on a visit to London, where they visited Kew and were given the use of Sir Joseph Banks's library in Soho Square.

On his return to Paris Redouté was appointed draughtsman to the cabinet of Marie Antoinette, and worked for her, even visiting her while she was in prison in 1789. After the Revolution, the collection of vélins and the post of official artist were transferred to the Muséum National d'Histoire Naturelle at the Jardin Botanique, and Redouté continued to work there, learning the techniques of painting and engraving from van Spaendonck and preparing illustrations for scientific publications.

Under Napoléon and with the patronage of the Empress Joséphine there was a great flowering of botanical art in France. Pierre Joseph Redouté and his brother Henri Joseph 1766–1852, Pierre-Antoine Poiteau (1766–1854), Pierre J. F. Turpin (1775–1840), and P. Bessa, were all active at the same time, working on both scientific and horticultural projects. For example, all four contributed the paintings to E.P.Ventenat's *Choix des Plantes* (1803).

Pierre-Joseph Redouté is still probably the most popular of all botanical artists, and his roses, published between 1817 and 1824, are the most often reproduced of all flower paintings. EMR

REINAGLE, Philip (born Edinburgh, Scotland 1749–1833)

Reinagle was the son of a Hungarian musician, and began his career as a portrait painter and copyist, working with Allan Ramsay (1713–1784), whom he assisted in turning out numerous portraits of George III and Queen Charlotte. In 1769 he entered the Royal Academy Schools, London, and exhibited there from 1773 onwards, his work consisting almost exclusively of portraits at first, but later diversifying into painting birds and animals. He became particularly successful in his treatment of sporting scenes and dogs, and in around 1802 was commissioned to paint a series depicting the various breeds of dogs; engravings of these appeared in the *Sportsman's Cabinet*, a periodical of the time. He also spent some time in Norwich during the 1780's and became interested in landscape painting.

In 1797 he was commissioned by Robert Thornton, to help with the latter's grandiose project, *A New Illustration of the Sexual System of Linnaeus, v*olume three of which was entitled the *Temple of Flora*. Thornton's idea was to illustrate flowers in a setting 'appropriate to its subject', and Reinagle duly produced fourteen paintings for his work, depicting auriculas, liles and tulips, and also

the exotic 'Night-blowing Cereus'. Each plate consisted of a close-up of the plant set against a backdrop, designed to give an idea of the plant's natural habitat and/or habit of growth. Some of these backgrounds were wild and romantic – not always particularly 'appropriate', but almost as detailed and interesting as the plants themselves. Reinagle seems to have painted both the plant and the background for his plates, with the exception of the cactus picture, the backdrop for which was painted by Abraham Pether. As with so many botanical art projects, the *Temple of Flora* was a financial disaster for Thornton, and Reinagle himself seems to have been perpetually financially straitened. EMR

ROBINS, Thomas the younger (born Bath, Somerset, England 1743–1806)

Thomas Robins, and his father, also Thomas, were both painters of flowers and landscapes. A series of Rococco gardens in Gloucestershire was painted by Robins the Elder, embellished by a garland of different exotic flowers; a sketch book which contains the original paintings for some of these is in the Fitzwilliam Museum, Cambridge.

The younger Robins is best known for his illustrations for a book of hybrid mints, *Menthae Britannicae* 1798, by William Sole, a botanist and apothecary who practised in Bath. A notice in the *Bath Chronicle* 29th November 1787 reads: 'Mr. Robins begs to announce that his pictures of exotic plants and insects may be seen at his apartments in Chandos buildings and at Mr Richard's print shop, Broad Street.' EMR

ROSS CRAIG, Stella (born Aldershot, Hants, England 1906–2006)

Stella Ross Craig spent her life working at Kew, which she joined at the age of 23, and where she met her husband Robert Sealy, a botanist. She is best known for her pen and ink studies, *Drawings of the British Plants*, published between 1948 and 1973; for Hooker's *Icones Plantarum* she drew an impressive 50 species of *Fritillaria*, mostly from herbarium specimens, as well as numerous other plants. Her colour work was also superb and she produced three colour plates for G.H. Johnstone's *Asiatic Magnolias in Cultivation*. She was the chief artist on *Curtis's Botanical Magazine* from 1949 to 1970, painting clearly and accurately, and annotating her paintings carefully with date, grower and collector, where known. EMR

ROSSER, Celia (born Melbourne, Australia 1930)

Celia Rosser can certainly claim her place in history through her remarkable work on the Australian genus *Banksia*. These paintings have been reproduced in three volumes by Monash University: Volume I published in 1981, Volume II published in 1988 and the long anticipated Volume III in 2000. She became Science Faculty Artist at Monash University, Melbourne, Australia in 1970, started her monumental work there on the banksias in 1971 and has been painting them ever since. Every time the end was in sight another new species was found, so the last volume contains portraits and descriptions of four extra species, bringing the total in all three volumes to seventy-six.

The text for the three volumes has been written by Alex George, known throughout Australia as the 'Banksia man'. George

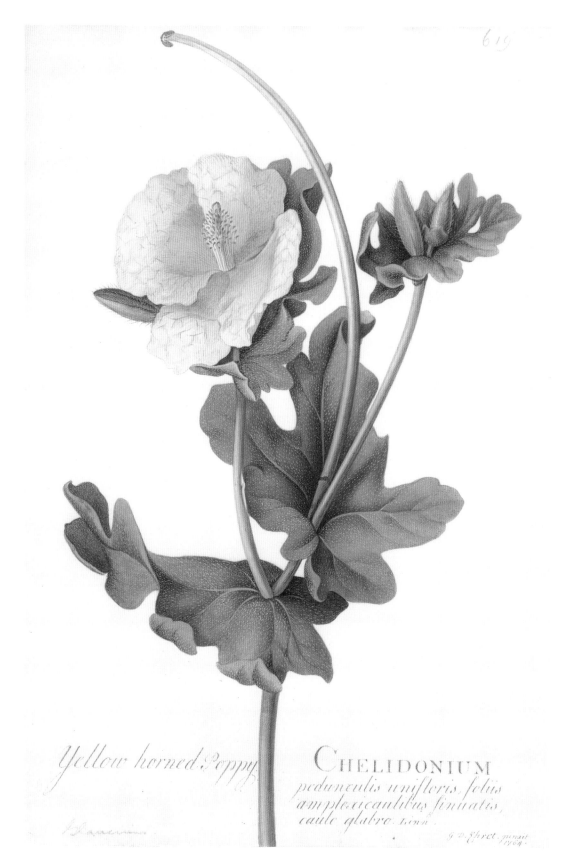

619

Yellow horned Poppy Chelidonium
pedunculis unifloris, foliis
amplexicaulibus sinuatis,
caule glabro. Linn.

G. D. Ehret pinxit
1764.

and Rosser travelled all over the country for rare specimens and George's unrivalled knowledge meant that they could collect specimens at the right time of flowering or fruiting.

I consider *The Banksias* one of the very best publications in any field produced in the twentieth century, or indeed in any century, and it represents a truly colossal achievement. It is beautifully printed, compares faultlessly with the original watercolours, has authoritative text – in fact every page is magnificent.

Celia Rosser has received a number of accolades for this mighty work, including the Jill Smythies Award for Botanical Illustration from the Linnean Society of London in 1997 and an Honorary Master of Science and PhD from Monash University. Her painting *Banksia serrata* in my collection has been shown all over the world from Kew to Tokyo and from Sydney to Stockholm, including the Museum of Modern Art in Edinburgh, part of the National Galleries of Scotland. Celia came to the opening in Edinburgh, which happily coincided with her Linnean Society award. SAMS

RUST, Graham (born Hertfordshire, England 1942)

Graham Rust is best known for his murals and his ceiling paintings which adorn houses all over the world. Perhaps the most remarkable is 'The Temptation', his spectacular mural at Ragley Hall, Warwickshire which took him over ten years to complete.

But besides his skills as a muralist he is a wonderfully accomplished painter of flowers and a prolific illustrator of books. He put many of his mural designs together to produce *The Painted House*, a best-selling book now published in four languages. He has done a sequel, *Revisiting the Painted House*, published in 2005. I well remember my delight in finding, by chance, his *The Secret Garden* which became a treasured Christmas present for one of my grandchildren. His flower paintings were used to illustrate a very successful edition of Vita Sackville-West's essays, *Some Flowers* in 1996.

Georg Dionysius Ehret, b. Heidelberg, 1708–1770

Chelidonium

Watercolour on vellum, 255 mm x 173 mm
Signed *G.D. Ehret 1764*
Kew Collection

Glaucium flavum, the yellow horned poppy, is a common plant of seaside shingle, with characteristic long curved seed pods and bluish-green leaves.

←

He was trained in art schools in London and New York and has had an amazing twenty seven solo exhibitions ranging from Panama to Chicago, New York, San Francisco and London, including four in aid of the Royal Commonwealth Society for the Blind. SAMS

SANDERS, Lizzie (born London, England 1950)

Although Lizzie Sanders was born in London she considers herself Scottish, as her family is Scottish and she lives in Edinburgh. She was the founder partner and director of a graphic design consultancy and was a former Scottish Designer of the Year. She has been a judge for several design awards and involved in projects for the National Museum of Scotland, British Waterways, Scottish Ballet and the Scottish Tourist Board, among much other creative work. She has lectured widely in Scotland at art schools in Edinburgh, Dundee and Glasgow and has been particularly involved with the Duncan of Jordanstone College of Art, Dundee where she herself qualified.

She showed at the 14th World Orchid Show with other students of the Royal Botanic Garden, Edinburgh in 1993, at the Royal Society of Arts, Edinburgh and in a touring exhibition organised by Inverness Museum of Art Gallery where she won an award in 1998. She has also shown in the Royal Botanic Garden, Edinburgh and at the RHS, where she was awarded a gold medal for her paintings of an interesting group of plants from Socotra. She has won gold medals in 2000, 2002 and 2004 and in the 11th International Exhibition at the Hunt Institute in 2005.

Her portrait of *Tibouchina organensis* was acquired at an RHS show in 2002 and is a lovely painting of the vivid blue flower and velvety leaves. SAMS

SANDERS, Rosie (born Stoke Poges, Buckinghamshire, England 1944)

I suppose that Rosie Sanders is best known for her superlative studies of fruit, apples in particular. She lives in Devon, in cider country, and has devoted much of her time to painting old varieties, culminating in her book *The English Apple*, published in 1988. I bought two apple paintings from her in 1992 which have been widely exhibited since.

She went to High Wycombe College of Art and started as a freelance botanical artist in 1974. She has been awarded five RHS Gold medals and received the Royal Academy Miniature Award in 1985. Her work has been exhibited in Britain, and appeared in the 7th International Exhibition at the Hunt Institute in 1992. She has been commissioned to do paintings for HM Queen Elizabeth II, HM the Queen Mother, for the RHS, the Royal National Rose Society and to design a set of wild plant stamps for Barbados.

She is not only interested in plant studies but has been involved in a number of crafts as well, particularly print making. She was made a member of the Devon Guild of Craftsmen in 1997 and in the same year was involved in the compilation of *A Printmakers Flora*. In it her subtle, fragile dandelion 'clocks' seem to float from page to page and her print of rose hips was a delight. In 1999 I bought a study of a striking string of garlic which she said she could not resist painting when she hung it in her kitchen

Since then she has changed her subject matter and the way she paints dramatically. In 2004 she had an extraordinary innovative show at Jonathan Cooper's Park Walk Gallery of huge carnivorous plants, vastly magnified yet still in watercolour. Her spectacular *Sarracenia* hybrid is at the extreme edge of botanical art, as is the remarkable, huge study of *Arisaema* shown here. SAMS

SAUL, Margaret (born Brisbane, Australia 1957)

She was born into a family of artists with a keen interest in the Australian native plants that grew around their home in Brisbane, Australia, Margaret had four years of traditional art school education, followed by staff positions as a natural science illustrator at various institutions in Australia, She has produced artwork for numerous botanical publications as the Queensland Herbarium's first staff illustrator, a position that led to her interest in botanical art.

During her most recent stay in the USA she was instrumental in establishing the Brookside Gardens School of Botanical Art and Illustration, Maryland in 2004 which attracts students from Washington DC and surrounding states. She has developed the school's policy and the curriculum for a certificate programme based on three main criteria that she views as essential for botanical art and which has been adopted by the American Society of Botanical Artists in their guidelines for jurors. The programme also involves school exhibitions and botanical art projects associated with the Brookside Gardens.

In 2007 Margaret Saul moved to live in Italy where her husband heads the Novartis Vaccine Institute for Global Health in Siena, in order to develop new vaccines for neglected diseases. She continues to direct her school in Maryland and is extending the school's programme to Siena. With less teaching she is looking forward to having more time to paint. She has worked in conjunction with the ASBA developing a resource for botanical art teachers that focuses on drawing – including programme design, delivery, drawing techniques and applications.

She has been painting since 1976 and is represented internationally in numerous public and private collections including The Hunt Institute For Botanical Documentation, USA, where two of her paintings were exhibited in the 12th International Exhibition of Botanical Art and Illustration 2007. Her botanical portraits are published in three books that specifically document botanical art. Her favoured media are watercolour with dry-colour pencils.

She initiated the establishment of the ever growing Botanical Artists' Society of Queensland (2004) after closing her Australian school and the Botanical Art Society-National Capital Region, US, Australia (2004). She has been a member of the Guild of Natural Science Illustrators since 1968; Hon Life Member Botanical Art Society of Australia, and a director of the American Society of Botanical Artists (Chair, Education). SAMS

SCHEDEL, Sebastian (b. Germany 1570–1628)

A charming album in the library at Kew, entitled *Calendarium* and dating from 1610, contains watercolours of numerous flowers and was perhaps a calender record of plants from gardens in northern Germany, and particularly from the Prince-Bishop's garden in

Eichstadt, featured in *Hortus Eystettensis*. Indeed of the many artists who contributed to this huge project, Sebastian Schedel 'a talented painter from a well-to-do local family' is the only one whose name is known. EMR

SCHÖFFER, Peter (born Gernsheim, Germany 1425–1502)

Peter Schöffer studied in Mainz and later went to Paris where he was employed as a calligrapher and copyist, and is thought to have studied law. He returned to Mainz and became associated with Johannes Gutenberg, the pioneering printer, assisting in the production of the Gutenberg Bible (1455), one of the first books to use moveable metal type.

Schöffer took over Gutenberg's business, and continued to print and publish religious books, psalters and editions of the classics, and by 1470 had 21 titles in his list. His first two printed herbals were *Herbarius* (1484), and in 1485 the larger *Hortus Sanitatis*, which was particularly successful, appearing in thirteen editions and several languages by 1500. The text of *Hortus Sanitatis* was probably by Johann of Cuba, a physician from Frankfurt; the artist who drew the plates for the 375 woodcuts is unknown. EMR

SCHWEIZER, Ann (born Cape Town, South Africa 1930–2014)

Ann Schweizer enjoyed a wide range of academic interests. Her first degree was in art and languages from Rhodes University, Grahamstown and she studied fine art practical studies under Maurice van Essche. Later she took another degree at the University of Cape Town in archaeology, followed by further courses in botany and geography. She became a scene painter at the Hofmeyr Theatre, Cape Town for a year and then was resident artist at the South African Museum. From 1963 she became freelance, doing botanical and plant painting; archaeological and ethnological drawing; book illustration and posters; designs for silk-screen printing and – perhaps most unusual of all – drawing a cartoon strip Travels of William Burchell for the Botanical Society of South Africa.

She exhibited at the Everard Read Gallery, Johannesburg and in several galleries near Cape Town, mostly showing botanical subjects. She caused a sensation in the first Kirstenbosch Biennale Exhibition when she presented a dramatic branch of figs and a spectacular *Strelitzia*.

She completed a remarkable series of bamboo studies in 2003 which now hang in the Bamboo Room in Westcliff Hotel, Johannesburg and she painted fruit with a sure touch and flowing use of watercolour. In 2007 I selected several studies from her work of succulents and lilies some of which are shown here. SAMS

SELLARS, Pandora (born Herefordshire, England 1936–2017)

Trained initially as a designer, Pandora Sellars then studied at the Cheltenham School of Art and Manchester College of Art. She became a teacher and freelance botanical artist, exhibiting widely in Britain and abroad since 1972. She had a successful solo exhibition at the Kew Gardens Gallery in 1990; her work is widely reproduced, and the RHS awarded her a gold medal. Pandora

Sellars has done a number of studies of *Arum* species and it became one of her favourite genera while she illustrated the Kew monograph on *The Genus Arum* by P. Boyce (1993).

She received the Jill Smythies Award in 1999 from the Linnean Society and Wedgwood selected her painting of the Gloriosa Lily for a ceramic plate celebrating the Shirley Sherwood Collection. She enjoyed teaching students from Japan, USA and Canada.

I am not alone in considering Pandora Sellars one of the most important botanical artists of all time. It goes without saying that her work is scientifically accurate, but here is an artist who has transcended the pedantic plant study to paint true works of art. Hers is a subtle approach, restrained and yet surprising. Her paintings have an immediately recognisable stamp to them and probably her leaves are amongst the most beautiful yet accurate that have ever been painted. SAMS

SHARMA, P. N. (born Dehra Dun, India 1922)

P. N. Sharma became a freelance botanical illustrator in 1945 and joined the Botany Branch of the Forest Research Institute at Dehra Dun in 1946. He was inspired and trained by Thaku Ganga Singh (1895–1970), an artist also in the Shirley Sherwood Collection.

He showed in many exhibitions in India and has paintings in Parliament House, New Delhi and various universities and Indian embassies abroad. He has illustrated a most impressive list of publications. He retired from his position as senior artist at Dehra Dun Research Institute in 1980 but still continues painting and lives nearby.

His style in painting rhododendrons is very reminiscent of the work of J. D. Hooker (1817–1911) and the work shown here is derived from one of Hooker's paintings held in Kew – only Sharma has drawn three versions of the same branch at different angles. SAMS

SHERLOCK, Siriol (born, Nantwich, England 1954)

I have known Siriol Sherlock since I first started collecting botanical art in 1990 and she has taught several of the master classes in Orient-Express Hotels initiated when I started exhibiting my collection around the world.

She studied Textile Design at the Winchester School of Art and then worked in the textile business producing floral furnishing designs. She began exhibiting in 1986 and has continued ever since. She has shown with the Society of Botanical Artists annually since 1988 and had a solo show at Kew in 1992. She has painted detailed botanical studies for *Curtis's Botanical Magazine* and *The New Plantsman* and undertaken numerous other commissions. She was a member of the RHS Picture Committee for eight years until 2006.

I have a number of her beautiful, free watercolours, impressive for their design, translucent colour and fresh, crisp detail. She rarely uses pencil and teaches her pupils how to plunge in straight away with water colour and achieve astonishingly good results far more swiftly than the average botanical artist. But this is not at the expense of detail, as she shows how this can be achieved as well as retaining and capturing the original fluidity that comes with speed. She has put her

teaching experience to good use in producing her book *Exploring Flowers in Water-colour*. This is an excellent book for beginners and also for experienced artists who have got too 'tight' and long to loosen up. It won The Art Instruction Book of the Year award in 1998. SAMS

SMALL, Julie (born Buxton, Derbyshire, England 1948)

Now living in St Helen's, Lancashire Julie Small has become one of the most outstanding botanical artists working in pencil. She started teaching biology in 1969, had a break to bring up her family, and then returned to teaching part time.

Her career in botanical art started in 1996 and she became a member of the Society of Botanical Artists. She began showing with them each year as well as locally. She was awarded a gold medal by the RHS in 2000 as well as an award for the best new exhibitor and the SBA Certificate of Botanical Merit in 1996 and 1997. She showed at the 10th Exhibition at the Hunt Institute in 2002. Her pencil studies show amazing depth and precision and have been collected for the RHS's Lindley Library, the Hunt Institute, the National Museum and Gallery of Wales, Cardiff and Sheffield Botanical Gardens. She has her work reproduced in two books by Margaret Stevens.

The two pencil studies shown here are extremely subtle, with graduations of density and amazing detail. The drawing of oak was given to a friend to commemorate his ancient oak forest – the oldest in Ireland. I could not resist the *Eucomis bicolor* with its exquisitely spotted stem and complex inflorescence drawn to show its texture. SAMS

SNELLING, Lilian (born St Mary Cray, Kent, England 1879–1972)

Lilian Snelling spent her life as a professional scientific botanical illustrator, first at the Royal Botanic Garden, Edinburgh from 1916 to 1921, and then from 1922 until 1952 at the Royal Botanic Gardens, Kew, where she was chief artist on *Curtis's Botanical Magazine*. During this period she contributed paintings to several important and lavish monographs published by the RHS such as the *Supplement to Elwes' Monograph of the Genus Lilium* (1934–40), and F. C. Stern's *Study of the Genus Paeonia* (1946).

Lilian Snelling's work, of which the lily shown here is a good example, was always elegant and artistic, painted in a relaxed style, but at the same time scientifically accurate. Most of her work is now at Kew. EMR

SPEIGHT, Camilla (born Oxford, England 1974)

After her first year of tuition at Camberwell College of Art in 1992–1993, Camilla Speight launched herself as a freelance botanical artist when only 20 years old. Her draughtsmanship was quite remarkable and for the first few years she contented herself with exquisite line drawings in pen and ink although she did experiment with colour at one stage.

Initially she worked freelance for Macmillan, and produced the line drawings for a series of RHS manuals and dictionaries published by them. These covered climbers and wall plants, grasses, orchids and bulbs. They were masterminded by Mark Griffiths and horticultural experts in those fields. From 1995 she

prepared illustrations for the RHS *Concise Gardener's Dictionary* by Mark Griffiths and Michael Pollock (1997) and worked on drawings of *Anguloa* species for D. Henry Oakley, who holds the British National Collection of *Anguloas* and *Lycastes*.

She started showing plates of line drawings from 1995 onwards at the RHS, winning a gold medal each time and was awarded the Garden Writers Guild special award for the RHS *Manual of Orchids*. She started working at the Herbarium, Kew in 1997.

In 1999 I saw her remarkable *Dracunculus vulgaris* in a Waterman Fine Art exhibition. She has managed to convey the sinister spathe in all its strength and drama in one of the best pen and ink studies I have seen. It makes an interesting counterpoint to the dramatic arum spathe shown in Thornton's *Temple of Flora* 1807 and shows how potent pen and ink studies can be. SAMS

STOCKTON, Peta (born South Africa 1973)
Having moved to London, Peta Stockton started painting full time in 2004 and went on that same year to win a gold medal at the prestigious Kirstenbosch Biennale in Cape Town as well as being awarded a gold medal at the RHS. She had previously taken a Foundation Course in Graphics at the Ruth Prowse School of Art and majored in English and History of Art of the University of Cape Town. Her background of growing up in Kirstenbosch Botanical Garden has heavily influenced her choice of subject, as she remained firmly wedded to *Protea* even after moving to Vienna for several years where she could only paint dried specimens.

She showed two *Protea* of great quality at the Hunt Institute in 2007. The vivid green *Protea coronata* shown here looks almost too brilliant – but in fact the flower is amazingly lurid, especially after rain. Her detail is truly remarkable and her work rewards very close inspection. SAMS

STONES, Margaret (born Victoria, Australia 1920–2018)
Margaret Stones studied at the Swinburne and National Gallery Schools in Melbourne. During the Second World War she trained as a nurse, but contracted tuberculosis and in her convalescence took up painting the wildflowers which visitors brought to her bedside. She came to England in 1951, and her work soon came to the notice of botanists at the British Museum (Natural History) and at Kew. In 1958 she became the chief artist on *Curtis's Botanical Magazine*. She also produced the paintings for other important projects, such as the 250 plates for *The Endemic Flora of Tasmania* (1967–78), and lily paintings for the *Supplement to Elwes' Monograph of the Genus Lilium* (1934–40). In 1976 she started a project to paint some of the wildflowers of Louisiana for the bicentenary celebrations, and this culminated in over 200 paintings published in *Flora of Louisiana* (1991); they were exhibited that year at the Fitzwilliam Museum, Cambridge, in Edinburgh and in Oxford. In many of these paintings, Margaret Stones drew the plant life size, and included on the plate enlarged details of flower or fruit, in the style of Ferdinand Bauer.

Her paintings have always been of the highest scientific standard, accurate and artistic, and she scrupulously annotated each painting with date and provenance of the specimen, and the magnification of any details, a fine example to any aspiring botanical artist. She retired to Australia and died in 2018. EMR

STROOBANT, P. J. (fl. Ghent 1850–1885)
P. J. Stroobant was a botanical artist who worked mainly in Ghent, providing illustrations for garden plant journals and books, including monographs on azaleas and camellias. He was one of a group of artists who pioneered the use of chromolithography for botanical illustration. EMR

TAYLOR, Simon (born England 1742–c.1796)
Simon Taylor trained at Shipley's drawing school in the Strand, and when he was about seventeen he was employed by Lord Bute as a flower painter, and worked with Ehret. On 28th December 1770 John Ellis wrote to Linnaeus 'I suppose you know Ehret is dead. We have nobody to supply his place in point of elegance. We have a young man, one Taylor, who draws all the rare plants of Kew garden for Lord Bute; he does it tolerably well'.

Most of Taylor's paintings are not signed, and his style is very close to that of Ehret; Taylor, however, tended to make use of thick highlights of lead white. Many of Taylor's paintings were commissioned by John Fothergill (1712–1780) of plants in his garden, and on the sale of Fothergill's estate in 1781, were bought at Sotheby's by Catherine, Empress of Russia. 611 of Fothergill's paintings have recently surfaced at the Komarov Botanical Institute in St Petersburg.

Few of Taylor's paintings have been published, but one of them, of the coffee plant, was engraved by John Miller and printed by Ellis in *An Historical Account of Coffee* (1774), a treatise designed to promote the cultivation of coffee in the West Indies. EMR

TCHEREPNINE, Jessica (born London, England 1938–2018)
Jessica Tcherepnine lived and worked in New York although she visited England regularly and showed in London. She described herself as having 'no relevant education and no career' but she did start painting flowers from her family's garden in Sussex at an early age. Later, she studied drawing in Florence and learned that important facet of botanical art – intense observation.

She had many solo exhibitions regularly from the early 1980s onwards, showing in London, New York, Paris and Palm Beach, Florida. One was at Harris Lindsay, London in 2005 where I acquired her strong painting of a coconut. The RHS has twice awarded her their gold medal. I first met her when I bought her *Fritillaria imperialis* from Shepherd's Gallery in New York in 1991. I had noticed a large banner floating from the gallery showing a vastly magnified drawing of the crown imperial fritillary. I saw the original painting which had been used as a poster for the New York Flower Show. I assumed the artist was American but was not unduly surprised to discover she was born in England, as many botanical artists working in the United States – Katie Lee and Katherine Manisco, for example – turn out to have British roots.

Her work is held at the Hunt Institute, the Natural History Museum, London the RHS's Lindley Library and the Benois Family Museum, St Petersburg, Russia, as well as in private hands. She

contributed to the *Florilegium at Highgrove* as well as being a founding member of the Brooklyn Florigelium Society. She was also a founding member of the American Society of Botanical Artists and a director of the Horticultural Society of New York.

She was a strong and consistently good painter, producing many excellent works over a long period. SAMS

THOMAS, Vicki (born South Africa 1951)
Vicki Thomas is an energetic botanical artist and teacher living in Betty's Bay, in the Cape, South Africa. Her artwork is in collections around the world, including the Highgrove Florilegium, a permanent record of the flora in HRH Prince of Wales' garden in England. Her work has been exhibited in the USA and Japan as part of the Shirley Sherwood collection of contemporary botanical art, and in other prestigious exhibitions in the UK and South Africa. Her painting of *Brunsvigia orientalis* was on display in the Hunt Institute for Botanical Documentation's 12th International Exhibition of Botanical Art Illustration.

A book *The Southern African Plectranthus – and the art of turning shade to glade* has been published by Fernwood Press (2007), and contains over 60 exquisite paintings of *Plectranthus*. The Botanical Society of South Africa's calendar for 2007 features her paintings of indigenous flowers.

I was having lunch with her in Cape Town when she was called away to a bad fire in Betty's Bay. She raced home to find her house safe, and then drove on to the site of one of the Cape plants she was painting for me– as she was waiting to complete the work with a ripe fruit capsule which was endangered by the fire. A number of artists in my collection have painted the flora of this area after fire.

She has worked on illustrations for a monograph on *Lobostemon* and has had scientific illustrations published in many botanical journals and in two books dedicated to botanical illustration. She has gold and silver medals from Kirstenbosch Biennale Exhibitions.

Vicki teaches a course in scientific illustration to Stellenbosch University students and has taught botanical illustration through the University of Cape Town's extra mural studies for several years. She regularly holds courses around South Africa. She is a founder member of the Botanical Artists' Association of Southern Africa and a past chairperson. SAMS

THORNTON, Robert (born England, c.1768–1837)
Robert Thornton studied at Cambridge University and Guy's Hospital before setting up in practice as a doctor in London. Always interested in natural history, he became increasingly interested in botany, until in 1797 he resolved to publish a massive work entitled *A New Illustration of the Sexual System of Linnaeus*, which, sadly, was to become famous as one of the greatest white elephants of botanical art. The work, dedicated to Queen Charlotte, consort of George III, was to be issued in parts, paid for by Thornton himself out of his inheritance, and he determined that it was to be of the highest quality, with text by himself and illustrations by some of the finest artists of the day.

Volume three of the overall work was entitled the *Temple of Flora or Garden of Nature* and Thornton's idea was to depict each plant in a setting 'appropriate to its subject', so for

example the background to the blue waterlily was the River Nile, with palm trees and mosque in the background. The illustrations were painted in oils and are mainly by Peter Henderson and Philip Reinagle, both of whom were known as portrait and landscape painters rather than botanical illustrators; Sydenham Teast Edwards also contributed a plate, and Abraham Pether a couple of others. Thornton himself painted the picture of assorted roses and wrote suitably romantic and flowery prose to accompany the plates. The book, illustrated with engraved plates, was produced in parts from 1798, but, despite Thornton's insistence on the very highest standards of production, sales seem to have been disappointing. In 1804 he assembled all the drawings and paintings made for the book and exhibited them in London, accompanied by a catalogue, and in 1807 the parts were reissued in book form, containing 31 plates, with another edition produced in 1810. By this time Thornton was nearly bankrupt, and he resorted to setting up the Royal Botanic Lottery, with the support of the Prince Regent, printing thousands of tickets and offering portfolios of the plates as prizes, with all the original paintings as the first prize. The lottery was finally drawn in 1813, and seems signally to have failed to restore Thornton's finances. As is so often the case, however, the book itself is famous to this day, and even the original printed plates are now very valuable.

Thornton continued to practise as a doctor, and even ventured into publishing again, another unhappy experience, this time involving the production of an edition of Virgil, illustrated by William Blake. His last book was a *New Translation of the Lord's Prayer*, about which Blake made some interesting comments. He died, intestate, in London in 1837. EMR

TOYOTA, Michiko (born Tokyo, Japan 1952)
Having started as a kimono designer in Yuzen, Michiko Toyota works as a freelance botanical artist and instructor in painting at the Botanic Gardens of Toyama. She has won a variety of awards including the Superiority Prize at the International Orchid Festival, Tokyo, 1994. Since 1983 she has exhibited in a number of galleries and botanical gardens from Tokyo to Nagoya, Mito, Yokohama and the Hunt Institute in 1988. Her work has been used for posters and to illustrate several books and pamphlets.

Her unusual study of oak tree seedlings shows every stage of germination and has a big visual impact. SAMS

UCHIJO, Yoko (born Tokyo, Japan 1949)
Yoko Uchijo has illustrated a number of books for children and works freelance in Tokyo.

She is a good botanical painter although she has had no formal education in this field. Immediately after leaving school she was employed by a company that produced animated films, but she has also worked at the Asahi Cultural Centre for Botanical Art, Tama, Tokyo. She is a member of the prestigious Japanese Botanical Art Association.

She exhibited in the Hunt Institute's 7th International exhibition in 1992 and I saw more of her work when I met her in Tokyo in 1994. Yoko Uchijo uses pencil to define her watercolour and places her images very well on the paper. SAMS

UNDERY, Dawn (born Cowra, New South Wales, Australia 1922–2012)
Well-known for drawing *Banksia*, Dawn Undery painted the fine portrait shown here in 2002, aged 80. Still living in New South Wales she studied art and textile design at East Sydney Technical College. After World War II she worked in the drawing office of the Department of Main Roads and later in the Australian Atomic Energy Commission as an illustrator of medical papers.

She retired in 1977 and turned her passion for fine detail and accuracy to botanical subjects. She had botanical prints on sale at the Royal Botanic Gardens, Sydney from 1984 and she showed her work in numerous group exhibitions from Botanica in Sydney to Brisbane Ashgrove and Evans Head Gallery.

The well composed, assured and beautifully detailed *Banksia aemula* is a triumph. SAMS

VAN DE GRAAFF, Bronwyn (born Australia 1964)
Bronwyn Van de Graaff lives at Avoca Beach near Sydney and is both a professional artist and a lawyer, having graduated from the University of Sydney in 1989. She showed in the annual Botanica, in Sydney from 2000 to 2003 and in the Botanical Art Society of Australia over the same period.

In 2003 I commissioned her to paint the recently discovered prehistoric Wollemi pine for Lilianfels, an Orient-Express Hotel, which is situated on a ridge overlooking the Blue Mountains only a few miles from where this remarkable tree was found. I wanted to make Lilianfels a 'shrine' for the Wollemi pine, so we planted several young trees there when they became available recently. Her painting, one of the first depicting the new discovery, hangs in the main room.

In 2005 she joined with a number of other artists in my collection in an exhibition at the Fernbrook Gallery, Kurrajong Heights celebrating a wine trial at Hawkesbury, with a splendid branch of grapes illustrated by her on the cover of the catalogue.

I saw her grass tree watercolour in the Hunt Institute in 2005 in the 11th International Exhibition and acquired it the same year. This arresting portrait of *Xanthorrhoea johnsonii* is a clever composition of a difficult subject, with its bizarre black trunk, wildly spiky leaves and spear-like inflorescence which I had seen in the eucalyptus forests close to Lilianfels. It complements the oil painting by Marianne North (1830–90) which shows it in its natural setting but in far less detail. SAMS

VERELST, Simon Petersz. (born ?Antwerp, The Netherlands c.1644–c.1721)
Simon Verelst is thought to have been born in Antwerp and brought up in the Hague, although exact details are disputed, partly due to the fact that several members of the Verelst family were accomplished artists. Simon came to London in 1169, and not long after he arrrived, was visited by Pepys, who noted the encounter in his diary.

Verelst seems to have found popularity at the court in London, where he initially painted still life scenes of game and bouquets of flowers as well as the large flower pieces popular at the time. Apparently encouraged by his success in this genre, he then turned his hand to portraiture, painting such notable people as Nell Gwynn and the Duke of Buckingham, and many of these were engraved for popular sale. It is said that success went to his head and he spent some time in an asylum, but the date and circumstancies of his death are uncertain. EMR

VIAZMENSKY, Alexander (born Leningrad now St Petersburg, Russia 1946)
Alexander Viazmensky paints both fungi and landscapes. Each summer he ventures deep into the woods near St Petersburg for his specimens, visiting secret spots for his trophies. His fungi paintings were one of the great successes of the Tryon & Swann International Exhibition in 1998 and the Denver Art Museum in 2002.

Since 1997 his style has become more detailed and clearly outlined, although he retains his customary clutter of leaves, pine needles and strands of grass. His work is held at the RHS's Lindley Library.

He produces excellent prints of his work which can be seen in the Grand Hotel Europe, St Petersburg. He taught at the Minnesota School of Botanical Art Master Classes in 2004 and 2006 and had illustrations in the *Red Data Book of Nature of St Petersburg*. He had a solo show in 2007 as part of the XV Congress of European Mycologists. SAMS

VILLELA, Patricia Arroxellas (born Rio de Janeiro, Brazil 1952)
Initially trained at the School of Visual Arts, Rio in the 1970s Patricia Villela restarted her career in the early 1990s by attending the Rio de Janeiro Botanical Institute. Later she was taught by Malena Barretto, Christabel King, Etienne Demonte and Jenevora Searight. She also attended a workshop by Katie Lee in Tuscon, Arizona.

She has been awarded a number of prizes including first place in the Margaret Mee Foundation's Annual Contest in 1996, the Brazilian Bromeliad Society in 1997 and the Mexican Biological Institute in 1998. She has shown at the Hunt Institute, at several bromeliad exhibitions, in Mexico and extensively in Rio.

Her work is strong yet subtle. She has a good sense of design and obviously enjoys painting the exotic plants of Brazil. I have bought a range of works from her, some to show with my collection, others to hang in the Copacabana Palace Hotel in Rio. These include bromeliads, *Strelitzia* and heliconias. Her *Strelitzia* with its beautiful blue 'carapace' is a striking example of a spectacular species and compares interestingly with the *Strelitzia* series of watercolours painted by Francis Bauer (1758–1840), one of Kew's treasures. SAMS

WARD–HILHORST, Ellaphie (born Pretoria, South Africa 1920–1994)
Ellaphie Ward-Hilhorst must certainly be placed among South Africa's greatest botanical artists and her work was recognised much further afield.

She started her career as a botanical artist in 1973. She had always loved pelargoniums and decided to paint all the known species. She collaborated with botanists at Kirstenbosch,

producing the illustrations for three remarkable volumes on the pelargonium, involving 314 watercolours and 160 habit sketches. When I visited her studio early in 1994 she signed all three volumes for me, while I admired her more recent work.

Ellaphie Ward-Hilhorst was involved with many other distinguished publications, including the journal *Flowering Plants of Africa*. The book *Gasterias of South Africa* was published just after her death and yet other monographs which will use her illustrations are being prepared. She had a prodigious output, producing 800 plant portraits, mostly in watercolour, during her 24 years as an active botanical artist.

She also produced some larger plant portraits for commissions (studies for book plates are often rather small) and she showed at the Hunt Institute, the Everard Read Gallery in Johannesburg and in 'Art meets Science', a South African touring exhibition. She was awarded the Botanical Society of South Africa's Cythna Letty Gold Medal and a gold medal at the RHS for her *Haemanthus* paintings. She is well represented in the most recent edition of *The Art of Botanical Illustration* by Wilfrid Blunt and William T. Stearn (1994) with two plates, one of *Haemanthus*, the other one of her famous pelargoniums, *Pelargonium tetragonum*. Her accuracy with pelargoniums was such that one research worker told me she did not need to measure a living specimen, she could get all the information she required from Ellaphie's meticulously accurate and yet beautiful plates.

Her work can be compared in quality with succulents painted by Ferdinand Bauer (1760–1826) for the *Flora Graeca* (from 1786) and with the elegant *Cotyledon* painted by Peter Brown (fl.1758–99). SAMS

WEDDELL, E.S. (b. England fl. 1800–1840s)

E. S. Weddell is not well-known as a botanical artist, but seems to have worked mainly as an engraver and possibly studied or at least worked with Francis Bauer. He made the paintings and engraved the plates of pines for the Duke of Bedford's *Pinetum Woburnense* which was published in a limited edition in 1839, and he also worked on some editions of Lambert's *A Description of the Genus Pinus*. The painting shown here of *Doryanthes palmeri,* was painted at Woodhall, Lanarkshire, in February 1826. He appears to have worked as the engraver with John Curtis (1791–1862) in London on John Lindley's *Collectanea Botanica* (1821) and Robert Sweet's *Cistineae* (1825–30). He also lithographed some of the plates in Wallich's *Plantae Asiaticae Rariores* (1830–1832). EMR

WILKINSON, John (born Northampton, England 1934)

John Wilkinson worked at a print works in Watford for over twenty years. At the age of forty he changed course and became a painter full-time, working in a variety of media including watercolour, oil, acrylic, egg tempera and pastel.

He illustrated a considerable number of books in the 1980s including *Trees* by Alan Mitchell. His work had been shown at the 5th International Exhibition of Botanical Arts at the Hunt Institute in the United States in 1983 and I made contact with him through James White, their curator of art, who greatly admired his technical skill and artistry.

He has shown at a number of RHS shows, being awarded two gold medals. In the 1980s he produced many designs for plates and vases for the Franklin Mint and painted the 1987 Chelsea Flower Show plate. He was the founder vice-president of the Society of Botanical Artists in 1986, a group which shows annually in the Westminster Halls, London, in April. He has shown in a number of English galleries and currently exhibits at the Bromley Galleries, Bromley, Kent.

He produced the illustrations and text for *The Artist's Guide* (1998) and *The Easy Edible Mushroom Guide* (1999). Besides these he has illustrated books on butterflies and moths, two on trees, two other books on mushrooms and one of the English countryside. Most have been translated into several European languages.

His splendid plant portrait of *Ligularia clivorum* 'Desdemona' was painted against a Chinese background. The small insects with a brilliant metallic sheen resting on the flower are some of the little beetles that are often associated with bright yellow flowers. Hoverflies are also attracted to the flowers. The moth on the leaf is the common Silver Y, which flies in the daytime. He has always been interested in moths, and many of them feature in his paintings. He feels all plants, real or painted, are more alive with their attendant insects. SAMS

WOODIN Carol (born Salamanca, New York, USA 1956)

In recent years Carol Woodin has become one of the most outstanding of the botanical artists working in the States. She has concentrated on orchids and started working on vellum, a surface on which she achieves an astonishing translucency.

She became a full-time botanical artist in 1990 and had two solo exhibitions at the Pennsylvania Horticultural Society, Philadelphia in 1996 and the Buffalo Museum of Science in 1995. She has been involved in many group shows and been awarded a gold medal at the RHS. She won the 1998 Award for Excellence in Botanical Art from the American Society of Botanical Artists, as well as the 'Best of Show' at the National Orchid Society from 1992 to 1996. Her work is held at the Hunt Institute, at Kew and the Niagara Parks Commission, Canada as well as in many private collections. She was awarded a gold medal in 2005 at the World Orchid Conference in Dijon. Currently she is exhibitions co-ordinator for the American Society of Botanical Artists where she is a very active member.

I saw a painting of *Disa* which she painted a few years back and I asked her to do the same subject for me. *Disa uniflora* is a dramatic orchid which lives under waterfalls on the Cape in South Africa. Every year when I visit I have tried to catch a closer glimpse of its vivid scarlet flowers high up on the Cape escarpments through binoculars. Despite its conservation status, it is sometimes collected to the danger of life and limb and every year there seem to be some resultant accidents. Carol Woodin got her specimen of *Disa uniflora* from the well-known orchid breeder, Warren Stoutamire of Ohio.

She made several trips to South America to prepare plates for the monograph *Slipper Orchids of the Tropical Americas* by Phlilip Cribb and went to Peru to paint *Phragmipedium kovachii*. I had seen and acquired the first painting of this exciting new discovery

by Angela Mirro and I was anxious to have Carol paint it in an entirely different, 'full-faced' way. She has led two fascinated groups of painters to Machu Picchu to see the local orchids for botanical painting classes organised by me. SAMS

ZAGONEL, M. Fatima (born Brazil 1954)

Fatima Zagonel lives in Curitiba, Paraná in south Brazil, and graduated from the Pontificia Universidade Catolica do Parana in 1976. In 1993 she took a postgraduate degree in publicity and advertising. She also attended courses in art, design and watercolour in the late 1970s.

While working as a graphic designer for some twenty years she became interested in botanical illustration and in 1998 studied at Curitiba with Diana Carneiro, exhibiting in the same year in a presentation made by the Curitiba Botanical Gardens in Mexico.

In May 1999 Fatima Zagonel was awarded a Margaret Mee Fellowship to study with Christabel King at the Royal Botanic Gardens, Kew, followed by a small exhibition at Kew of the work she had completed there. She now works in Curitiba, helping other aspiring botanical artists.

She has had illustrations published in *Foresta Atlantica – Reserva da Biosphera* and *Arvores Historicas na Paisagem de Curitiba* and also in a calendar of plants from the Paraná. SAMS

ZHANG, Tai-Li (born Jin Zhou, China 1938)

Tai-Li Zhang has worked as a botanical painter all her life, training at the School of Botanical Painting, Institute of Botany, Academia Sinica, Beijing from 1958 to 1960 and then working for 35 years for the department of plant taxonomy in the Institute of Botany, in several of the volumes that won prizes. SAMS

SAMS – Shirley Sherwood
EMR – Martyn Rix

Tai-Li Zhang , b. Jin Zhou, China 1938
Maidenhair Tree
Watercolour on paper, 430 mm x 300 mm
Signed with two chops in red and two
Chinese characters in black (painted 1994)
Shirley Sherwood Collection
Ginkgo biloba L.
→

銀 杏

Select bibliography

General books

Allen, B. Morris, C. & Murray, L. 2017. *The Florilegium: Royal Botanic Gardens, Sydney*. Royal Botanic Gardens, Kew in association with the Royal Botanic Gardens, Sydney.

Arnold, Marion. 2001. *South African Botanical Art. Peeling Back the Petals*. Fernwood Press in association with Art Link, South Africa.

Barker, Nicholas. 1994. *Hortus Eystettensis. The Bishop's Garden and Besler's Magnificent Book*. The British Library, London and Harry N. Abrams, NY.

Blunt, W. & Stearn, W. T. 1950. *The Art of Botanical Illustration*. Collins, London.

—— 1994. *The Art of Botanical Illustration* (2nd edn). Antique Collectors' Club, Woodbridge, UK in association with Royal Botanic Gardens, Kew.

Blunt, W. 2001. *The Compleat Naturalist, A Life of Linnaeus*. Frances Lincoln Ltd, London.

Blunt, W. & Raphael, S. 1994. *The Illustrated Herbal*. Frances Lincoln Ltd, London.

Calman, G. 1977. *Ehret. Flower Painter Extraordinary*. Phaidon Press Ltd, Oxford.

De Bray, L. 1989. *The Art of Botanical Illustration*. Christopher Helm, Bromley & Wellfleet Press, NJ.

Desmond, Ray and Ellwood, Christine. 1994. *Dictionary of British and Irish Botanists and Horticulturalists: including plant collectors, flower painters and garden designers*. Taylor & Francis, London.

Desmond, Ray. 2007. *The History of the Royal Botanic Gardens, Kew*. 2nd ed., Royal Botanic Gardens, Kew.

Elliott, B. 1994. *Treasures of the Royal Horticultural Society*. Herbert Press in association with the RHS, London and Sagapress/Timber Press, OR.

—— 2001. *Flora: An Illustrated History of the Garden Flower*. The Royal Horticultural Society.

Harris, Stephen 2007. *The Magnificent Flora Graeca*, Bodleian Library, Oxford.

Hendrix, L. & Vignau-Wilberg, T. 1992. *Mira Calligraphiae Monumenta*. Thames & Hudson Ltd, London.

—— 1997. *Nature Illuminated. Flora and Fauna from the Court of the Emperor Rudolf II*. Thames & Hudson Ltd, London and the J. Paul Getty Museum, Los Angeles. (A selection of the illustrations in the 1992 publication.)

Henerey, Blanche 1975. *British Botanical and Horticultural Literature before 1800*. Oxford University Press.

Hewsen, H. J. 1999. *Australia. 300 Years of Botanical Illustration*. CSIRO Publishing, Australia and 2000 Antique Collectors' Club, Woodbridge.

Hooker, J. D. 1849–51. *Rhododendrons of Sikkim Himalaya*. lithographed by W.H. Fitch.

Kress, W. J. & Sherwood, S. 2009. *The Art of Plant Evolution*. Royal Botanic Gardens, Kew.

Lack, H. W. with Mabberley, D. 1999 *The Flora Graeca Story: Sibthorp, Bauer and Hawkins in the Levant*. Oxford University Press, Oxford.

Lack, H. W. 2000. *A Garden for Eternity. The Liechtenstein Codex*. Benteli Verlag AG, Switzerland and Antique Collectors' Club, Woodbridge, UK.

—— 2001. *Garden Eden*. Taschen, Köln and London.

Leith-Ross, P. 2000. *The Florilegium of Alexander Marshal at Windsor Castle*. Royal Collection Enterprises Ltd and Thames & Hudson Ltd, USA.

Mabberley, D. J. 2017. *Mabberley's Plant Book*, 4th edition. Cambridge University Press.

—— 1999. *Ferdinand Bauer: The Nature of Discovery*. Merrell Holberton Publishers Ltd., London and the Natural History Museum, London.

Mallary, P. & F. 1986. *A Redouté Treasury. 468 Watercolours from Les Liliacées*. The Vendome Press, NY.

Merian, M. S. 1999. *New Book of Flowers*. Prestel, Munich, London and NY.

—— 1998. *Maria Sibylla Merian: artist and naturalist 1647–1717*, edited by Kurt Wettengl. Verlag Gerd Hatje, Ostfildern.

Mills, C. 2016. *The Botanical Treasury*. Andre Deutsch in association with the Royal Botanic Gardens, Kew.

Nissen, C. 1966. *Die Botanische Buchillustration*. 2nd auflage Anton Hiersemann, Stuttgart.

Noltie, H. J. 1999. *Indian Botanical Drawings 1793–1868, from the Royal Botanic Garden Edinburgh*. Royal Botanic Garden, Edinburgh.

North, Marianne 1993. *A Vision of Eden*. 2nd ed., Royal Botanic Gardens, Kew.

North, Marianne 2018. *Marianne North: The Kew Collection*. Royal Botanic Gardens, Kew.

Payne, M. 2016. *Marianne North: A very intrepid painter*. Revised edition. Royal Botanic Gardens, Kew.

Rice, A. & T. 1999. *Voyages of Discovery*. Scriptum Editions, UK in association with the Natural History Museum, London, and Clarkson N. Potter, NY.

Rix, M. 1981. *The Art of the Botanist*. Lutterworth Press, Guildford & London. (Published in the USA by the Overlook Press as *The Art of the Plant World: the Great Botanical Illustrators and their Work*.) Reprinted 1989 by Bracken Books, London as *The Art of Botanical Illustration*.

Rix, M. 2012. *The Golden Age of Botanical Art*. Andre Deutsch in association with the Royal Botanic Gardens, Kew.

—— and Rix, A. 1990. *The Redouté Album*. Dorset Press, New York and Studio editions, London.

Roach, F. A. & Stearn, W. T. 1989. *Hooker's Finest Fruits*. Herbert Press, London and Prentice Hall Press, NY.

Saunders, G. 1995. *Picturing Plants*. Zwemmer, in association with the V & A Museum, London and University of California Press, CA.

Scrase, D. 1997. *Flower Drawings*. Cambridge University Press, Cambridge.

Sherwood, S. 1996. *Contemporary Botanical Artists: The Shirley Sherwood Collection*. Weidenfeld & Nicolson, London.

—— 2000. *A Passion for Plants*. Cassell & Co, London.

—— 2005. *A New Flowering: 1000 Years of Botanical Art*. Ashmolean Museum, Oxford

Snow, C. P. 1959. *The Two Cultures and the Scientific Revolution* (Reid Lecture, 1959).

Stearn, W. T. 1990. *Flower Artists of Kew*. Herbert Press, London in association with the Royal Botanic Gardens, Kew. American edition published as *Botanical Masters, Plant Portraits by Contemporary Artists* by Prentice Hall Press, NY.

—— 1999. (ed.) *John Lindley 1799–1865. Gardener–Botanist and Orchidologist*. Antique Collectors Club, Woodbridge, in association with the Royal Horticultural Society.

—— & Rix, M. 1987. *Redouté's Fairest Flowers*. Prentice Hall Press, NY.

Stewart, J. & Stearn, W .T. 1993. *The Orchid Paintings of Franz Bauer*. Herbert Press, London in association with the Natural History Museum, London and Timber Press, OR.

Tomasi, L. T. 1997. *An Oak Spring Flora*. Oak Spring Garden Library, New Haven.

Watts, P., Pomfrett, J. A. & Mabberley, D. 1997. *An Exquisite Eye, The Australian Flora & Fauna Drawings 1801–1820 of Ferdinand Bauer*. Historic Houses of New South Wales, Glebe, New South Wales.

Wettengl, K. (Ed.) 1998 *Maria Sibylla Merian 1647–1717 Artist and Naturalist*. Verlag Gerd Hatje, Ostfildern.

White, J. J. & Farole, A. M. 1994. *Natural-history Paintings from Rajasthan*. Hunt Institute for Botanical Documentation, Carnegie Mellon University, Pittsburgh

Wilenski, R. H. 1960. *Flemish Painters 1430–1830*, vol.1. Faber and Faber Ltd, London.

Catalogues and journals

Catalogues of the International Exhibitions held at the Hunt Institute for Botanical Documentation, Carnegie Mellon University, Pittsburgh, Pennsylvania, USA are an important source of information on contemporary botanical artists. There are 15 covering exhibitions, from 1964 to 2016.

Curtis's Botanical Magazine (Kew) and *The New Plantsman* (RHS)are quarterly journals which contain illustrations by contemporary botanical artists.

Lack, H. W. 1999. *The Flora Graeca Story.* An exhibition at the Bodleian Library, Oxford.

Images from Nature. 1998. Natural History Museum, London.

Flowers in Art from East and West. Hulton, Paul and Smith, Lawrence. British Museum, 1979

Yamanaka, M. & Rix, M. 2017 *Flora Japonica*. Royal Botanic Gardens, Kew.

Books illustrated by contemporary artists

The artists are listed alphabetically by surname, listing only books which have been illustrated wholly or partly by the artist.

Barretto, Malena

Barretto, M. 1999. *Segredos e Virtudes das Plantas Medincais.* Reader's Digest

—— 2005. *Malena Barretto watercolours and drawings of the Brazilian Flora*

Booth, Raymond C.

Elick, D. & Booth, R. 1992. *Japonica Magnifica*. Alan Sutton, Stroud in association with the Fine Art Society and Sagapress/Timber Press OR.

Urquhart, B. L. (ed.). 1956–60. *The Camellia*. 2 volumes. Leslie Urquhart Press, Sharpthorne, Sussex.

Dean, Pauline

Dean, P. 2004. *Pauline Dean – Portfolio of a Botanical Artist*.

Demonte, Etienne

Ferraz Blower, C. D. 1990. *Fauna e Flora do Brasil – Fauna and Flora of Brazil*. Salamandra, Rio de Janeiro.

White, J. J. (comp.) 1985. *For Love of Nature: Brazilian Flora and Fauna in Watercolour by Etienne, Rosália and Yvonne Demonte*. Hunt Institute, Pittsburgh and Wave Hill, NY.

Esparza, Elvia

Work reproduced in: *Flora of Veracruz*, numbers 1–16. 1978–81

Edwards, Brigid

Richards, J. 1993. *Primula*. Batsford, London and Timber Press, OR.

Fomicheva, Dasha

Musselman, L. J. (text), watercolours by Dasha Formicheva. 2000. *Jordan in Bloom Wildflowers of the Holy Land*. Jordan River Foundation, Amman.

Guest, Coral

Guest, C. 1992. *The Royal Roses of London*. Victoria's Secret Garden, London.

—— 2001. *Painting flowers in watercolour – a naturalistic approach*. A&C Black, London

Imai, Mariko

Udagawa, Y. 1983–84. *The Story of Orchids*. K. K. Shin Kikaku, Tokyo.

—— 1994. *Masdevallia and Dracula*. Nigensha Publishing, Tokyo.

Jones, Paul

Blunt, W. 1971. *Flora Superba*. Tryon Gallery, London.

—— 1976. *Flora Magnifica*. Tryon Gallery, London.

Urquhart, B. L. (ed.). 1956–60. *The Camellia*. 2 volumes. Leslie Urquhart Press, Sharpthorne, Sussex.

King, Christabel

Cowley, Jill 2007. *The Genus Roscoea*. Royal Botanic Gardens, Kew.

Cribb, P. & Butterfield, I. 1988. *The Genus Pleione*. Royal Botanic Gardens, Kew in association with Christopher Helm, Bromley and Timber Press, OR.

Davis, A. P. 1999. *The Genus Galanthus*. Royal Botanic Gardens, Kew, in association with Timber Press, OR.

Heywood, V. H. (Ed.) 1978. *Flowering Plants of the World*. Elsevier, Oxford and Mayflower Books, NY.

Heywood, V. H. (Ed.) et. al. 2007. *Flowering Plants Families of the World*. Revised Edition. Royal Botanic Gardens, Kew and Firefly Books, Toronto.

King, Christabel. 2015. *The Kew Book of Botanical Illustration*. Search Press in association with the Royal Botanic Gardens, Kew.

Mathew, B. 1989. *The Genus Lewisia*. Royal Botanic Gardens, Kew in association with Christopher Helm, Bromley and Timber Press, OR.

Michael, P. 1980. *All Good Things Around Us*. Ernest Benn, London and Holt, Reinhart & Winston, NY.

Taylor, N. P. 1985. *The Genus Echinocereus*. Royal Botanic Gardens, Kew in association with Collingridge, Middlesex.

Yeoman, G. 1989. *Africa's Mountains of the Moon*. Elm Tree Books, London, and Universe Books, NY.

Liska, Petr

Slaba, R. 1992. *The Illustrated Guide to Cacti*. Sterling Publishing Co., Inc. New York.

McEwen, Rory

Blunt, W. 1977. *Tulips and Tulipomania*. Basilisk Press, London.

Moreton, O. C. 1955. *Old Carnations and Pinks*. George Rainbird in association with Collins, London.

—— 1964. *The Auricula*. The Ariel Press, London.

Rory McEwen: the Botanical Paintings. 1988. Royal Botanic Garden, Edinburgh Catalogue of exhibition, in association with the Serpentine Gallery, London.

Rix, M. (ed.) 2015. *Rory McEwen The Colours of Reality*. Revised edition. Royal Botanic Gardens, Kew.

Mee, Margaret

Mayo, S. 1988. *Margaret Mee's Amazon.* Royal Botanic Gardens, Kew.

Mee, M. 1980. *Flores do Amazonas – Flowers of the Amazon.* Record, Rio de Janeiro.

—— 1968. *Flowers of the Brazilian Forests.* Tryon Gallery, London.

—— (ed. T. Morrison). 1988. *In Search of Flowers of the Amazon Forests.* Nonesuch Expeditions, Suffolk.

—— 2004. *Margaret Mee's Amazon. Diaries of an Artist Explorer.* Antique Collectors' Club in association with the Royal Botanic Gardens, Kew

—— 2007. *Margaret Mee.* Fundacio Botanica Margaret Mee

Rust, Graham

Sackville-West, V. 1993. *Some Flowers.* Pavilion, London in association with The National Trust.

—— 2001. *The Painted Ceiling.* Constable, London

Sanders, Rosie

Sanders, R. 2010. *The Apple Book*, Frances Lincoln, London in association with the Royal Horticultural Society.

Sellars, Pandora

Boyce, P. 1993. *The Genus Arum.* HMSO, London in association with the Royal Botanic Gardens, Kew.

Cribb, P. 1987. *The Genus Paphiopedilum.* Royal Botanic Gardens, Kew in association with Collingridge, Middlesex.

—— 1998. *The Genus Paphiopedilum.* 2nd Ed. Natural History Publications, Borneo in association with the Royal Botanic Gardens, Kew.

Sherlock, Siriol

Sherlock, S. 1998. *Exploring Flowers in Watercolour, techniques and images.* B. T. Batsford Ltd., London

Speight, Camilla

Has contributed to many books including RHS manuals by Macmillan, London.

Green, P. 1997. *The Flore de la Nouvelle Calédonie et Dépendances.* Muséum National D'Histoire Naturelle, Paris.

Radcliffe-Smith, A. 1997. *The Euphorbiaceae.* Royal Botanic Gardens, Kew.

Stones, Margaret

Curtis, W. and Stones, M. 1967–78. *The Endemic Flora of Tasmania.* Ariel press, London.

Stones, M. 1991. *Flora of Louisiana.* Louisiana State University Press, Baton Rouge.

Woodin, Carol

Cribb, P. 1998. *The Genus Paphiopedilum.* 2nd Ed. Natural History Publications (Borneo) in association with the Royal Botanic Gardens, Kew.

Cribb, P. *The Genus Phragmipedium* (in preparation)

Acknowledgements

First and foremost I want to thank my husband James Sherwood, my two sons and five grandchildren for their wonderful support for the gallery. And thanks too for John Mills who sculpted a fine bronze to go inside it.

I spent many long hours in the library at Kew with Laura Giuffrida and Marilyn Ward, choosing works from the past which would interweave with my collection of contemporary art. Their enthusiasm and discernment are responsible for Kew's selection for the first exhibition in the new gallery, which Laura also hung.

Over the last few years Linda Rudd has been indefatigable in cataloguing the Shirley Sherwood Collection and helping me with this manuscript, while Andrew Donaldson has shifted innumerable paintings with immense good humour.

Kew Publishing has dealt patiently with an author who is constantly travelling and Jeff Eden designed the book beautifully. Finally I could not have had a more knowledgeable and pleasant co-author than Martyn Rix.

Shirley Sherwood

Shirley Sherwood, Martyn Rix and Kew Publishing would like to thank, in addition to those above, Julia Buckley, Paul Little, Christopher Mills, Lynn Parker, Alison Rix and Julie Rose.

Index